ALCHEMY
&
MYSTICISM

D0761509

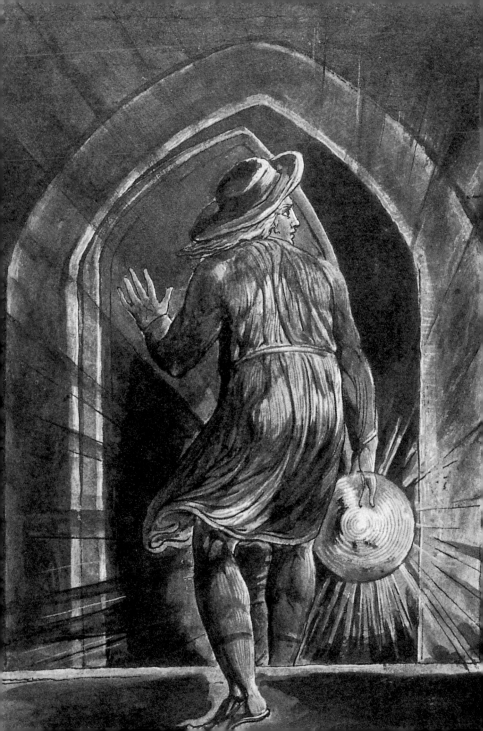

THE HERMETIC MUSEUM:

ALCHEMY

&

MYSTICISM

ALEXANDER ROOB

TASCHEN

KÖLN LISBOA LONDON NEW YORK PARIS TOKYO

Illustrations: Cover: Miniature painting by
Jehan Perréal, 1516 (p. 504); Back Cover:
Donum Dei, 17th century (p. 443); p. 2,
from: William Blake: *Jerusalem*,
1804–1820; p. 6, from: Michael Maier;
Viatorium, Oppenheim, 1618; p. 34, 122,
612, from: J. Typotius: *Symbola
divina et humana*, Prague, 1601–1603;
p. 532, from: Basilius Valentius:
Chymische Schriften, Leipzig, 1769

© 1997 Benedikt Taschen Verlag GmbH
Hohenzollernring 53, D-50672 Köln
© 1996 VG Bild-Kunst, Bonn, for the
illustrations of Joseph Beuys, Marcel
Duchamp and Yves Klein
Cover design: Angelika Taschen, Cologne;
Mark Thomson, London
English translation: Shaun Whiteside, London

Printed in Italy
ISBN 3-8228-8653-X
GB

Contents

INTRODUCTION

"It will be apparent that it is difficult
to discern which properties each thing
possesses in reality."
(Democritus, 8th century B.C.)

The hermetic museum

A rich world of images has etched itself into the memory of modern man, despite the fact that it is not available in public collections, but lies hidden in old manuscripts and prints.

These are the eternal "halls of Los", the prophet of the imagination, which are filled with the exemplary images and Platonic figures that govern our understanding of the world and ourselves, and of which the poet William Blake (1757–1827) wrote that "all things acted on earth are seen in them", and that "every age renews its powers from these works". (*Jerusalem*, 1804–1820)

Puzzle pictures & linguistic riddles
By imbuing them with a special hieroglyphic aura, the creators of these pictures sought to suggest the very great age of their art and to acknowledge the source of their wisdom: the patriarch of natural mysticism and alchemy, Hermes Trismegistus.

It was Greek colonists in late classical Egypt who identified their healing, winged messenger of the gods, Hermes (Lat. *Mercurius*) with the ancient Egyptian Thoth, the 'Thrice Greatest'. Thoth was the god of writing and magic, worshipped, like Hermes, as the "psychopompos", the souls' guide through the underworld. The mythical figure of Hermes Trismegistus was also linked to a legendary pharaoh who was supposed to have taught the Egyptians all their knowledge of natural and supernatural things, including their knowledge of hieroglyphic script. The alchemists saw him as their "Moses" who had handed down the divine commandments of their art in the "emerald tablet". This "Tabula Smaragdina", now believed to date back to the 6th-8th centuries A.D., became known to the Christian world after the fourteenth century through translations from the Arabic.

There was hardly a single alchemist in either the laboratory or the speculative, mystical camp who was not prepared to bring his discoveries into line with the solemn and verbatim message of these twelve theses:

"True, true. Without doubt. Certain: / The below is as the above, and the above as the below, to perfect the wonders of the

The Emerald
Tablet, the central
monument to the
hermetic imagin-
ation.

*Heinrich Khunrath,
Amphitheatrum
sapientiae aeter-
nae, Hanover, 1606*

One. / And as all things came from the One, from the meditation
of the One, so all things are born from this One by adaptation. / Its
father is the Sun, its mother the Moon; the Wind carries it in its
belly; its nurse is the Earth. / It is the father of all the wonders of
the whole world. Its power is perfect when it is transformed into
Earth. / Separate the Earth from Fire and the subtle from the
gross, cautiously and judiciously. / It ascends from Earth to
Heaven and then returns back to the Earth, so that it receives the
power of the upper and the lower. Thus you will possess the
brightness of the whole world, and all darkness will flee you. / This
is the force of all forces, for it overcomes all that is subtle and
penetrates solid things. / Thus was the world created. / From this
wonderful adaptations are effected, and the means are given
here. / And Hermes Trismegistus is my name, because I possess the
three parts of the wisdom of the whole world."

Also from Hermes, messenger of the gods, comes *hermeneu-
tics*, the art of textual interpretation, and according to the author
of the *Buch der Heiligen Dreifaltigkeit* (Book of the Holy Trinity,
1415), the first alchemical text in the German language, this occurs

Introduction

"The wind bears it in its belly."

The birth of the philosophers' stone occurs in the air.

M. Maier,
Atalanta fugiens,
Oppenheim, 1618

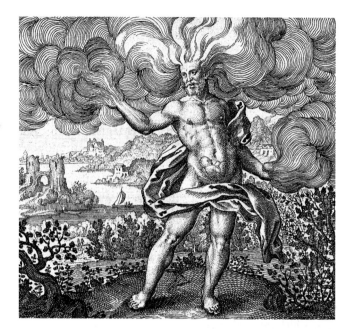

"Its nurse is the Earth."

Mercurial water nourishes it.

M. Maier,
Atalanta fugiens,
Oppenheim, 1618

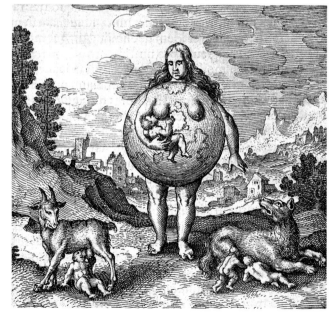

in four directions: in the natural, supernatural, divine and human sense. As used by its most distinguished representatives, alchemical literature possesses a suggestive language, rich in allegories, homophony and word-play which, often through the mediation of Jacob Böhme's theosophical works, has had a profound effect on the poetry of Romanticism (Blake, Novalis), the philosophy of German idealism (Hegel, Schelling) and on modern literature (Yeats, Joyce, Rimbaud, Breton, Artaud).

Many voices, even from within their own ranks, were raised against the "obscure idioms" of the alchemists. And their own account of their communication technique hardly sounds more encouraging: "Wherever we have spoken openly we have (actually) said nothing. But where we have written something in code and in pictures we have concealed the truth." (*Rosarium philosophorum*, Weinheim edition, 1990)

Anyone who inadvertently enters this linguistic arena will suddenly find himself in a chaotic system of references, a network of constantly changing code-names and symbols for arcane substances, in which everything can always apparently mean everything else, and in which even specialist, Baroque dictionaries and modern lists of synonyms provide few clues. This kind of profusion of diffuse concepts always required simplifying measures. These might be said to include the influential attempts at interpretation by the Swiss psychoanalyst C.G. Jung (1875–1961), who was solely interested in the internal nature of the hybrid form of alchemy and only acknowledged its external, chemical workings as the scientific projection of psychological developments.

But the hermetic philosophers can be heard "more freely, distinctly or clearly" "with a silent speech or without speech in the illustrations of the mysteries, both in the riddles presented with figures and in the words". (C. Horlacher, *Kern und Stern...*, Frankfurt, 1707). With their thought-pictures they attempted, according to a motto of the Rosicrucian Michael Maier, "to reach the intellect via the senses". To this extent, their highly cryptic, pictorial world can be placed under the heading of one of its favourite motifs, the hermaphrodite, as a cross between sensual stimulus (Aphrodite) and intellectual appeal (Hermes). It is aimed at man's intuitive insight into the essential connections, not at his discursive ability,

which is largely held to be a destructive force. "That which lives on reason lives against the spirit", wrote Paracelsus. Along with him, many lived in expectation of the "Third Empire of the Holy Spirit" prophesied by Joachim of Fiore (1130–1202), in which visionary insight would replace literal, textual understanding. The primal language of paradise, which names all things according to their true essence, would then be revealed again, and all the mysteries of nature would be presented as an open book.

The tendency towards arcane language in "obscure speeches", in numbers and in enigmatic pictures, is explained by a profound scepticism about the expressive possibilities of literal language, subjected to Babylonian corruption, which holds the Holy Spirit fettered in its grammatical bonds. The prehistoric knowledge, the *prisca sapientia* that was revealed directly to Adam and Moses by God, and which was handed down in a long, elite chain of tradition, had to be preserved in such a way that it was protected against the abuse of the profane. To this end, Hermes Trismegistus, who, like Zoroaster, Pythagoras and Plato, was seen as a major link in this hermetic chain, developed hieroglyphs. The Renaissance idea of Egyptian hieroglyphs took them to be a symbolic, rebus-like, esoteric script. This was influenced by the treatise of a 5th century Egyptian by the name of Horapollo, in which he provided a symbolic key to some 200 signs. This work, entitled 'Hieroglyphica', which was published in many translations and illustrated by Albrecht Dürer, among others, prompted the artists of the Renaissance, including Bellini, Giorgione, Titian and Bosch, to develop the language of signs in their own imaginative way.

Horapollo's 'Hieroglyphica' also formed the basis for the development, in the mid-16th century, of emblems, symbols which

Copy of Dürer's illustrations to Horapollo

1 "Hour-watching"

2 Impossible

3 Heart (Ibis)

Introduction

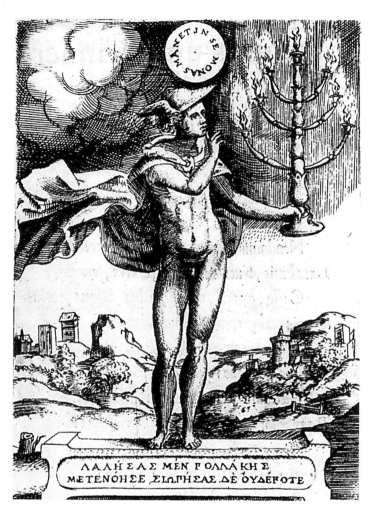

Hermes-Mercury, god of trade and communication, urges silence. Mercurial eloquence refers to the phenomenal periphery, the revealed world of appearances. The experience of the effects of the spiritual centre (Unit or Monas) is inaccessible to the expressive possibilities of language.

In the cosmic visions of Giordano Bruno (1548–1600) the monads, the divine nuclei of all living creatures, correspond to the gravitational centres of the stars.

Achilles Bocchius, Symbolicarum quaestionum…, Bologna, 1555

are always connected with a short motto and generally accompanied by an explanatory commentary. They were very popular in the Baroque, and proved to be an ideal vehicle for the communication of paradoxical alchemical teaching aids and maxims. Pseudo-hieroglyphs were thus connected with pseudo-ancient Egyptian wisdoms, since the majority of the hermetic scripts that tended to be found in attics or the niches of old walls proved to be pseudo-epigraphs masquerading as works by eminent figures in the hermetic tradition.

Emphasizing their broad theoretical foundations, the alchemists often termed themselves "philosophers", describing their work simply as "art" (ars) or "philosophical art". Although the alchemical concept of art is derived from Aristotle's *téchne*, and refers very generally to skill in both theoretical and practical matters, its similarity to the extended concepts of art in the modern age is unmistakable. It is not, as one might immediately assume, the illustrative and fantastic spheres of the traditional visual arts, in which the links to the hermetic *Opus Magnum*, the 'Great Work' of the alchemists, are revealed, but rather those areas that involve the aspect of process in the experience of reality, such as Conceptual Art and Fluxus.

The heyday of hermetic emblems and the art of illustration coincided with the decline in "classical" alchemy, which was still capable of combining technical skills and practical experience with spiritual components. Theosophical alchemists like the Rosicrucians and practising laboratory chemists like Andreas Libavius, who sought to improve the empirical foundations of alchemy and thereby brought it closer to analytical chemistry, were already irreconcilable by the beginning of the 17th century. Although Rosicrucians did boast that "godless and accursed gold-making" was easy for them, this was a ludicrous and marginal pursuit in comparison with the main pursuit of inner purification: their gold was the spiritual gold of the theologians.

But these two divergent trends could lay claim to the same founding father, Theophrastus Bombastus von Hohenheim, also known as Paracelsus (1493–1541). In his work, the empirical study of nature takes place against a visionary and mystical background. His prodigious body of work contains both numerous instructions

for the manufacture of pharmaceutical preparations on a vegetable and metallic basis and a practically inexhaustible wealth of natural mystical concepts in the spheres of astral magic, the Cabala and Christian mysticism. Dressing these up in highly individual "bombastic" linguistic creations did nothing to reduce their wide dissemination. These writings would exert an influence for centuries, extending from the speculative interpreters of alchemy, from Valentin Weigel, the Rosicrucians and Jacob Böhme, to the Romantics and modern branches of anthroposophy and theosophy.

With their two playful manifestos, in which they promised more gold "than the king of Spain brings back from the two Indias", a group of Protestant theology students had given a powerful boost to the production of alchemical writings at the beginning of the 17th century. Even in the 18th century this kind of printed matter, dealing with the search for the *lapis*, the Philosophers' Stone, were seen in such numbers at German book fairs "that one could make the road from Frankfurt to Leipzig lovely and soft and even with them". (J. G. Volckamer the Younger, *Adeptus Fatalis*, Freiburg, 1721; quoted in: J. Telle, "Bemerkungen zum 'Rosarium philosophorum'", in: *Rosarium philosophorum*, Weinheim 1992)

One of the many sympathizers with the invisible Lutheran fraternity was Lucas Jennis, the publisher of the first 'Musaeum Hermeticum', published in Frankfurt in 1625. Although the number of illustrations in this collection of treatises hardly does justice to its title, it does contain a number of excellent engravings by Matthäus Merian (1593–1650). A year previously, under the title of *Viridarium Chymicum* or *Chymisches Lustgärtlein* (Chymical Garden of Delights), Jennis had published a collection of alchemical illustrations taken from books published by his company. The individual illustrations are accompanied by rather unenlightening lines from the pen of Daniel Stolcius von Stolcenberg, a pupil of the Paracelsian physician Michael Maier (1568–1622). Maier had been physician to Emperor Rudolf II, known as the 'German Hermes', whose Prague court was home to the most famous esoteric scientists of the day. In 1618 Maier published his famous collection of emblems 'Atalanta fugiens' with the Oppenheim publisher Theodor de Bry. To Merian's marriage to de Bry's daughter we owe

Introduction

The Kircher
Museum in the
Collegium
Romanum

*A. Kircher, Turris
Babel, Amsterdam,
1679*

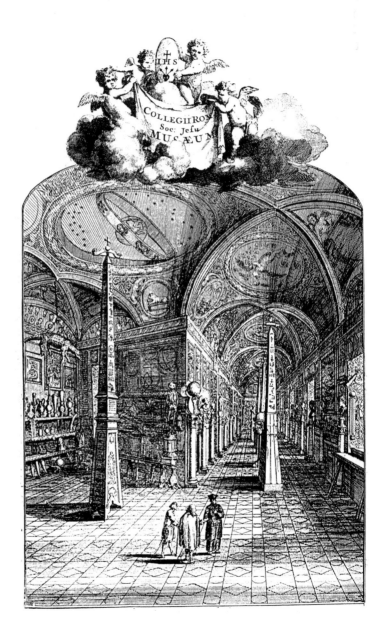

not only the illustrations to the 'Atalanta' but also many of the engravings for the gigantic book-publishing enterprise of Maier's English friend and colleague Robert Fludd (1574–1637), the *Utriusque Cosmi (...) Historia* (The History of the Two Worlds) in several volumes.

Identifying his intellectual background with some exactitude, detractors called Fludd Trismegistian-Platonick-Rosy-crucian Doctor. His actual achievements in the field of natural science may not have been of any great significance, but the vivid expression which he gave to many contemporary impulses are important for an understanding of Elizabethan culture, particularly the dramas of Shakespeare. Fludd deserves a status within cultural history which has hitherto been withheld from him. (I am grateful to Dietrich von Donat for informing me that Fludd gave the de Bry printing works very detailed drawings on which to base their engravings.)

In the next generation, however, Fludd found a competitor in the Counter-Reformation camp, in the Jesuit Athanasius Kircher (1602–1680), who would far exceed the former's encyclopaedic achievement in almost every area. The universal scholar Kircher is seen above all as the founder of Egyptology, and until Champollion's triumph his symbolic deciphering of hieroglyphs was unchallenged.

His extensive work, which included – alongside his many richly illustrated volumes – his famous scientific collection (kept at the 'Museum Kircherianum' in the Collegium Romanum in Rome until 1876), is permeated by his scientific knowledge, esoteric interests and evidence of a pronounced belief in miracles. In this, and also in his early attention to oriental and Asiatic systems of religion, he prepared the ground for the adventurous syncretism of the Theosophical Society at the end of the 19th century.

Gnosis and Neoplatonism

For the art historian Aby Warburg (1866–1929), who did pioneering interdisciplinary work in the early years of this century, late classical Alexandria represented the epitome of the dark, superstitious side of man. Here, in the first century A.D., in the former centre of Greek culture on Egyptian soil, with its highly diverse mixture of

peoples, Greek and Roman colonists, Egyptians and Jews, the threads of all the individual disciplines making up the complex of hermetic philosophy came together: alchemy, astral magic and the Cabala. The complementary syncretic systems that nourished them, hybrids of Hellenic philosophies and oriental religions and mystery cults, are known by the two concepts of Gnosis and Neoplatonism. Both are fundamentally animistic, filled with many demonic and angelic creatures, whose power and influence determine human fate.

Gnosis means knowledge, and the Gnostics acquired this in a number of ways. The first and most fundamental form of knowledge is good news, and concerns the divine nature of one's own essence: the soul appears as a divine spark of light. The second is bad news and concerns the "terror of the situation": the spark of light is subject to the influence of external dark forces, in the exile of matter. Imprisoned within the coarse dungeon of the body, it is betrayed by the external senses; the demonic stars sully and bewitch the divine essence of one's nature in order to prevent a return to the divine home.

Under the stimulus of Zoroastrian and Platonic dualism, a painful gulf opened up between the interior and the external, between subjective and objective experience, between spirit and matter. It was cosmologically established by Aristotle (384–322 B.C.) in the 4th century B.C., with a strict division of the universe into the eternal, ethereal heaven and the transient sublunary sphere. This model, only slightly modified by the Alexandrian Gnostic Claudio Ptolemy (c. A.D. 100–178), suppressed all efforts at a unified explanation of the world for two millennia.

In Gnosis, *pleroma*, the spiritual plenitude of the divine world of light stands immediately opposite *kenoma*, the material void of the earthly world of phenomena. The ungrateful task of creation falls to a creator god who works against the good god of light or "unknown father", and who often bears the despotic traits of the Old Testament Jehovah. He is the *demiurge*, a word which simply means artist or craftsman.

While in Plato's world creation myth, "Timaeus", the demiurge, also called "the poet", forms a well-proportioned cosmos out of the primal world, in the form of an organism with a soul,

which "contains all mortal and immortal things", the Gnostic demiurge produces a terrible chaos, a corrupt and imperfect creation which, in the belief of the alchemists, must be improved and completed through their "art" with a new organization or reorganization.

In many Gnostic myths man is given an autonomous task of creation: in order to heal the sick organism of the world, he must lead the divine sparks of light, spiritual gold, through the seven planetary spheres of the Ptolemaic cosmos and back to their heavenly home. To the outermost sphere of Saturn corresponds the "sullied garment of the soul", the grossest material, lead. Passing through this sphere meant physical death and the putrefaction of matter that is a necessary prerequisite transformation. The subsequent stages were: Jupiter-tin, Mars-iron, Venus-copper, Mercury-quicksilver, Moon-silver and Sun-gold.

The individual metals were taken to represent various degrees of maturity or illness of the same basic material on its way to perfection, to gold. To ease its passage through the seven gates of the planetary demons, *gnosis*, the knowledge of astral magic practices, was required.

The Neoplatonists took the various diverging concepts that their master had put forward dialectically in his dialogues and poured them into the tight corset of tiered, pyramid-shaped world orders. Like a descending scale of creation, the universe overflows from the uppermost One, the good, its intervals following the harmonic laws linked with the name of the philosopher Pythagoras (6th century B.C.) and his doctrine of the music of the spheres. The inner discord of the Gnostics was unknown to them. Between the two poles of Plato's philosophy, the static and immortal world of the celestial forms and the moving and transient world of their likenesses on earth, they inserted a series of mediating authorities.

Corresponding to the tripartite division of the small world of man (*microcosm*) into body, soul and spirit was a cosmic soul which dwelled in the realm of the stars. This cosmic soul reflected the ideas of the higher, transcendental sphere of the divine intellect, and through the influence of the stars these ideas imprinted their eternal "symbols" on the lower, physical transient sphere.

Introduction Man thereby has the possibility of manipulating events in the earthly sphere, using magical practices such as the manufacture of talismans, spells and other such things to affect this middle sphere of the cosmic soul. Contact is established through the fine material of the "sidereal" or "astral body" that invisibly surrounds man. Before the Fall, according to the Gnostic-Cabalistic myths, the whole of heaven was a single human being of fine material, the giant, androgynous, primordial Adam, who is now in every human being, in the shrunken form of this invisible body, and who is waiting to be brought back to heaven. Man can communicate with the *macrocosm* through this sidereal medium, and thus receives premonitions and prophecies in dreams.

The equivalent in man of the demiurgic, world-creating urge of the outer stars is the creative capacity of the imagination, which Paracelsus calls "the inner star". Imagination is not to be confused with fantasy. The former is seen as a solar, structuring force aimed at the *eida*, the paradigmatic forms in the "real world", the latter as a lunatic delusion related to the *eidola*, the shadowy likenesses of the "apparent world".

"If someone really possessed these inner ideas of which Plato speaks, then he could draw his whole life from them and create artwork after artwork without ever reaching an end." (Albrecht Dürer)

Paracelsus likens the imagination to a magnet which, with its power of attraction, draws the things of the external world within man, to reshape them there. Its activity is thus captured in the image of the inner alchemist, the sculptor or the blacksmith. It is crucial to master them, for what man thinks "is what he is, and a thing is as he thinks it. If he thinks a fire, he is a fire". (Paracelsus)

For the Greek natural philosopher Democritus (470–c. 380 B.C.), who originated the idea of the microcosm, all images, whether of phenomena, ideas or thoughts, are concretely material things whose qualities can impress themselves upon the viewer; even the soul, according to him, consists of subtle, fiery atoms. Most streams of thought in mysticism oscillate between the fundamental dualism of spirit and matter and a form of monism derived from Democritus. Thus, for the Neoplatonists, the visible and tangible sphere represents only the gross residue of a long

sequence of increasingly subtle degrees of matter. We come across this materialism once again in the modern spiritualist and occult movements, whose important representative, the Swedish visionary Emanuel Swedenborg (1688–1772), went in search of the materiality of the soul and the life-spirits in his early scientific phase.

In the Middle Ages Neoplatonism chiefly found its way into the mysticism of the Eastern Church. Although it was by no means incompatible with the rigidly hierarchical structures of the medieval state and Church, in the West it led a shadowy existence on the edge of the great scholastic system of theories. The Church believed it had finally put a stop to the attempted invasion of gnostic "heresies" in the sense of a self-determining and liberal consciousness of salvation, in its destruction of the heresies of the Cathars and Waldensians at the beginning of the 13th century, and in the subsequent establishment of the "Holy Inquisition".

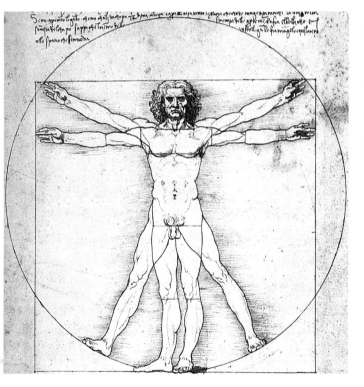

Leonardo da Vinci (1452–1519) was familiar with the ideas of Florentine Neoplatonism, particularly the *Corpus Hermeticum* in Marsilio Ficino's translation.

Study of proportions after Vitruvius

Introduction But in the Renaissance the flow of Alexandrian tradition forged powerfully ahead: in 1463 Marsilio Ficino (1433–1499), the central figure in the Florentine Platonic Academy, was commissioned by Cosimo de Medici to translate a collection of fourteen Gnostic and Neoplatonist treatises from the early Christian period. Also attributed to the "Thrice Greatest Hermes", this collection was well-known under the title *Corpus Hermeticum*. These texts made a profound impression on the humanist intellectual world, for although they were ostensibly ancient, pagan writings permeated with various concepts of magic, they still seemed to be written entirely in the tone of the New Testament, and to be imbued with the Christian spirit. Moreover, the idea of ancient Jewish teachings that reached all the way back to Moses – the Cabala – as conveyed by Picino's friend, Pico della Mirandola (1463–1494) reinforced the suspicion of a *prisca sapientia* in the Christian spirit. (In fact the Cabala, in its familiar form, was only developed out of its Alexandrian foundations in Spain and Southern France in the 12th and 13th centuries.)

The effects of Gnostic consciousness on European intellectual life are so comprehensive and omnipresent that their extent is hard to assess: the man of the *Corpus Hermeticum,* blessed with divine creative powers, merges with the image of the Renaissance man, who has begun to free himself from the bonds of the tiered, medieval cosmos and thereby moves towards the centre of the universe.

The Gnostic spark of light, which strives for divine knowledge out of the darkness of the world, is reflected in the individual Protestant soul's struggle for salvation. Over the centuries, Lutheran orthodoxy managed to erase from its own ranks almost all memories of natural mystical reform movements deriving from alchemy and the Cabala, since they opposed "walled Christianity and literal faith" from the first.

William Blake rightly described the deistic God of the progress-loving Enlightenment, who abandons the machinery of creation once he has set it in motion, leaving it to continue blindly on its course, as a Gnostic demiurge. And the broad path of modern science was only able to open up on the basis of the motif of an imperfect creation in need of improvement . Interestingly, it was

also Gnostic thinkers such as Paracelsus and Böhme who drew the picture of the dark matter of enchanted, divine, nature, and thus stimulated the later Romantic worship of nature.

Only a few alchemists were familiar with the *Corpus Hermeticum*. For them all, however, Hermes was associated with the figure who had brought them the Emerald Tablet, and with the moist, "mercurial" principle which they called the "beginning and end of the Work". The veneration of this "divine water" reached back to the upper, pneumatic waters of Gnosis which, in Greek writings from the early years of alchemy, in reference to the descent of the Gnostic Christ, flowed down into the darkness of matter to awaken the dead bodies of their metals from their slumber.

These writings also deal with the rites of the dismemberment and resurrection of metals which recall the Egyptian myth of Osiris, as well as the Orphic and Dionysian cults, which are kept alive to this day in the rites of Freemasonry. The scholar of comparative religions, Mircea Eliade, refers to the idea of the "entwined and dramatic life of matter" that derives from the ancient, metallurgical practices of the Egyptian and Mesopotamian cultures, whose inner development and form in visionary images were only possible "through the knowledge of the Greek-Oriental mysteries". *(Schmiede und Alchemisten* [Smiths and Alchemists] *Stuttgart,* 1980)

There was no strict division between the organic and inorganic study of matter, and thus the process of transmutation was imagined as a kind of fermentation, in which certain metals were able to transfer their properties like an enzyme or a yeast.

However, alchemy, as it reached Christian Europe via Spain in the 12th and 13th centuries, is much richer and more mysterious than the mystical writings of the early Alexandrian alchemists would suggest. To do justice to the "Royal Art", we might use the tripartite separation much loved by the Hermetics: according to which the part corresponding to the soul was to be found in Egyptian Alexandria. But it owes its corpus, its great wealth of practical experiences, of technical knowledge, code names, maxims and allegorical images, to its development by the Arabs. And its spirit, finally, lies within the natural philosophy of ancient Greece, where its theoretical foundations were laid in the 5th century B.C.

Introduction

The divine
mercurial water.

Baro Urbigerus,
Besondere
Chymische
Schriften,
Hamburg, 1705

Concepts of natural philosophy

It is said of the philosopher and thaumaturge Empedocles that he claimed the existence of two suns. The hermetic doctrines also include a double sun, and distinguish between a bright spirit-sun, the *philosophical gold*, and the dark natural sun, corresponding to *material gold*. The former consists of the essential fire that is conjoined with the ether or the 'glowing air'. The idea of the vivifying fire – Heraclitus (6th century B.C.) calls it the 'artistic' fire running through all things – is a legacy of Persian magic. Its invisible effect supposedly distinguishes the Work of the alchemists from that of the profane chemists. The natural sun, however, consists of the known, consuming fire, whose precisely dosed use also determines the success of the enterprise.

Empedocles also taught that all life lay in the movement resulting from the clash between the two polar forces, love and conflict. In the *Opus Magnum* these correspond to the two alternating processes of dissolution and coagulation, disintegration and bonding, distillation and condensation, systole and diastole, "the yes and no in all things". (J. Böhme) They correspond to the two polar agents of Arabic alchemy: mercury and sulphur, philosophical quicksilver and brimstone, sun and moon, white woman and red man. The climax of the Work is the moment of *conjunctio*, the conjunction of the male and female principle in the marriage of heaven and earth, of fiery spirit and watery matter (*materia* from the Latin *mater*, mother). The indestructible product of this cosmic sex act is the *lapis*, the "red son of the Sun".

William Blake identified the male principle with time and the female with space. The interpenetration of the two results in diverse reverberations of individual events, all of which, taken as a whole – totality, the micro-macrocosmic body of Christ in the image of the "human and the divine imagination – occur in a state of relative simultaneity. Each individual element opens up, in passing, into the permanent present of this fluctuating organism and in the process attains its "fourfold", complete form, which Blake calls "Jerusalem". This vision generated the kaleidoscopic, narrative structures of his late poems, which reveal themselves to the reader as a multi-layered structure of perspectival relations – aimed against the prevailing idea of a simple location of events in

the absolutes of linear time and space, which Newton (1643–1727) took as his foundation in formulating his physical laws.

Behind the often crude imaginings of the English painter-poet, with all necessary clarity of detail, lies the most intelligent and far-sighted critique of the materialist-mechanistic cosmology of the 17th and 18th centuries, a cosmology whose terrible influence still prevails to this day, on a global scale.

In alchemy, the female mercurial principle symbolizes the protean aspect of natural processes, their fluid changeability. "The process laboratory-workers wanted to rule him (Mercurius) … and force him into (*the*) process", writes Johannis de Monte Raphim; but he constantly escapes, and if one thinks about him, he turns into thoughts, and if one passes judgment upon him, he is judgment itself. ("Vorbothe der Morgenröthe", in: *Deutsches Theatrum Chemicum*, Nuremberg, 1728)

Francis Bacon,
Study from the
death mask of
William Blake,
1955 (detail)

The physicists of the 20th century encountered this oscillating principle behind the iron curtain of Newtonian physics in the depths of quantum mechanics, where it has proven impossible to determine both precisely and simultaneously the position and the impulse of minute particles. It has also been demonstrated that the appearance of subatomic particles is dependent on the act of observation itself. With regard to the work of the alchemists, we could discuss the problem of *projection,* of transference through imagination, at a purely psychological level. But at the microphysical level it has been shown that the subject and object of perception are ontologically, inextricably linked. Subjectivity was recognized as a formative influence within the process of nature in its entirety which, according to the statements of some alchemists, consists in the constant reversal of inner and outer.

In his final lecture in 1941, the mathematician Alfred North Whitehead (1861–1947), who in his Platonically inspired 'organismic philosophy' developed concepts to overcome the 'bifurcation of nature' into the spheres of subjective perception and objective facts, boiled down the philosophical consistency of the mercurial discoveries of modern physics to the concise observation: "Exactness is a fake".

In alchemy, the necessary counterforce to mercury, a force which also defines and shapes, is represented by male sulphur.

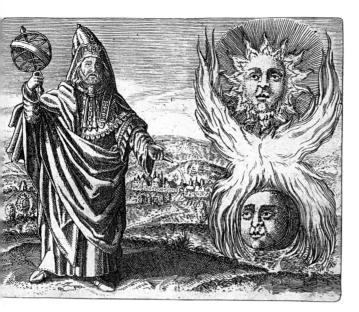

Hermes Trismegistus and the creative fire that unites the polarities.

D. Stolcius von Stolcenberg, Viridarium chymicum, Frankfurt, 1624

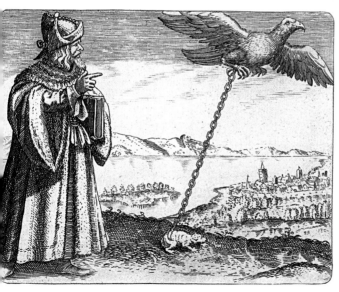

Dissolution and bonding, or mercury and sulphur in the image of eagle and toad.

D. Stolcius von Stolcenberg, Viridarium chymicum, Frankfurt, 1624

Paracelsus added a further principle to the medieval doctrine of the dual principles, thereby making a decisive contribution to a more dynamic view of the natural processes. Paracelsus identified the third fundamental principle as salt. Its property as a solid corresponds to that of the body. Sulphur, with its property of greasy, oily combustibility, mediates in the position of the soul. And mercury, the fluid principle with a propensity to sublimation, is the volatile intellect.

These Paracelsian "Tria Prima" are not chemical substances, but spiritual forces, from whose changeable proportions the invisible blacksmiths or craftsmen of nature produce the transient material compositions of the objective world. In more modern, speculative alchemy, particularly in the Masonic beliefs of the 18th century, the arcanum salt finally moved into the centre of hermetic, gnostic mysticism. Because of its curative properties it was often interpreted in Christological terms as the "coagulated light of the world", the "secret central fire" or the "salt of wisdom".

The doctrine of the four elements also goes back to Empedocles. He referred to them as the "four roots of all things: earth, water, air and fire. Hippocrates applied it as the theory of the four humours to the microcosm, and in the 4th century B.C. this theory was considerably refined by Aristotle. He traced all elements back to a common, prime matter, the *proté hyle* or *prima materia*. The alchemists also described this as "our chaos" or the "dark lump" that resulted from the fall of Lucifer and Adam. Accordingly, to sublimate it and elevate it to the lapis meant nothing less than bringing fallen creation back to its paradisal, primal state. Finding the correct source material for the Work was the chief concern of every alchemist, his specific secret, well-protected by code names. And the riddles had it that nothing was easier than finding it, because it is at home in all elements, even in the dust of the street; and although, like Christ, it is really the most precious thing in the world, to the ignorant it is the "most wretched of earthly things".

According to Aristotle, the *prima materia* conjoins with the four qualities of dryness, coldness, moisture and heat, thus developing to form the four elements. By manipulating these qualities, it was also possible, so he thought, to change the ele-

Introduction

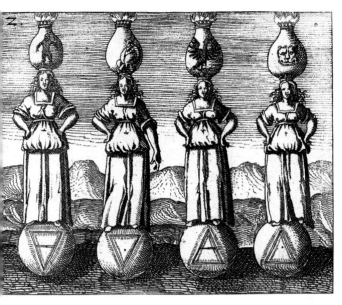

Corresponding to the four elements (left to right: earth, water, air and fire) are the four phases in the alchemical Work and four degrees of fire.

D. Stolcius von Stolcenberg, Viridarium chymicum, Frankfurt, 1624

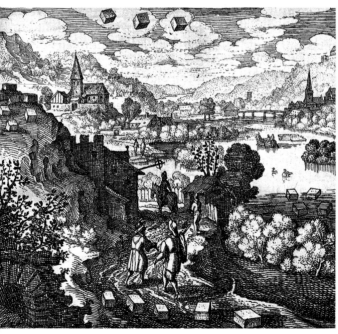

The source material for the lapis can be found everywhere: in the earth, on the mountains, in the air and in the nourishing water.

M. Maier, Atalanta fugiens, Oppenheim, 1618

mental combinations of materials, thereby bringing about their transmutation.

Accordingly, the work of the alchemist lies "only in the rotation of the elements. For the material of the stone passes from one nature into another, the elements are gradually extracted, and in turn relinquish their powers (...) until all are turned downwards together and rest there". (J. d'Espagnet, "Das Geheime Werk", in: *Deutsches Theatrum chemicum*, Nuremberg, 1728)

According to a law attributed to Pythagoras, quadernity defines the spectrum of all earthly possibilities. The Aristotelian fifth element, the refined *quintessence*, is thus found only in the upper divine fiery heaven. It was the goal of all alchemists to bring this fifth element down to earth though the repeated transmutations that their work entailed. This meant that they would often be distilling alcohol or imagining the divine light to be within salt.

The alchemist's journey required him to pass through that outermost circle of the underworld – the serpent's circle of Saturn. Saturn is identical to Chronos, the Greek god of time, and in overcoming him one has broken with transient, sequential time and reverted to a Golden Age of eternal youth and the divine benevolence, that allows one to merge into another. This dream was to be be fulfilled by a rejuvenating elixir, "drinkable gold", the legend of which had probably reached early, medieval Arabia via China and India.

The very earliest Greek text with an alchemical content, bearing the programmatic title *Physika kai Mystika* (of natural and hidden things), divides the *Opus Magnum* into four phases according to the colours that it produces: blackening (*nigredo*), whitening (*albedo*), yellowing *(citrinitas)* and reddening (*rubedo*). This division has survived the entire history of alchemy. Later, there appeared other, highly divergent subdivisions of "lower astronomy", as alchemy was also known. These were based on planets and metals, as well as on the twelve signs of the zodiac. In his *Dictionnaire Mytho-Hermétique* (Paris, 1787), J. Pernety listed the following phases: 1. *calcinatio*: oxidization – Aries; 2. *congelatio*: crystallization – Taurus; 3. *fixatio*: fixation – Gemini; 4. *solutio*: dissolution, melting – Cancer; 5. *digestio*: dismemberment – Leo; 6. *distillatio*: separation of the solid from the liquid – Virgo; 7. *sublimatio*:

Introduction

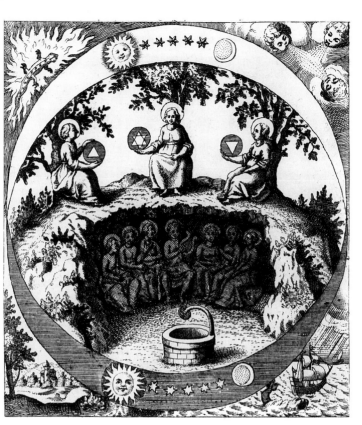

The eternal lapis ✿ is produced by the rotation of the elements, in the unification of upper and lower, of fire △ and water ▽. It is the celestial image of earthly gold, shown here as Apollo in the underworld, amongst the six Muses or metals.

Musaeum Hermeticum, Frankfurt edition, 1749

refinement through sublimation – Libra; 8. *separatio*: separation, division – Scorpio; 9. *ceratio*: fixing in a waxy state – Sagittarius; 10. *fermentatio*: fermentation – Capricorn; 11. *multiplicatio*: multiplication – Aquarius; 12. *projectio*: scattering of the lapis on the base metals in the form of dust – Pisces.

The aforementioned early alchemical text from the 1st-2nd century B.C. was published by a follower of Democritus, using the latter's name. Democritus himself traced all phenomena capable of being experienced by the senses, including colours, back to the movements and changing combinations of minute particles without quality, which he called atoms, "indivisible". This atomic reality behind the illusory world of appearances was of an inconceivable depth and secrecy.

A history of practical alchemy could begin with the mystical atomist and non-alchemist Democritus, and it could end with the non-alchemystical atomists of the 20th century, who 200 years after the refutation of all scientific foundations of the hermetic art succeeded, by fusing atomic nuclei (admittedly using uneconomical amounts of energy) in transmuting the elements.

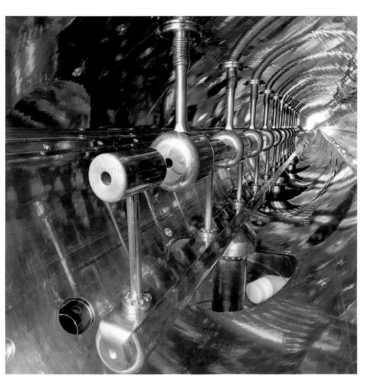

View of the inside of the linear accelerator of the Society for Heavy Ion Research in Darmstadt. Here, electrically charged atomic nuclei, for example, of tin, with the atomic number 50, are accelerated to a speed ten percent of the speed of light. Only then is the repulsive power of other atomic nuclei such as copper, with the atomic number 29, overcome, making fusion possible. The result would be a nucleus with 79 protons – gold.

Macrocosm

For Plato, the universe or great world order
was created by God the creator as a manifestation
and illustration of his own perfection: "(...) and
so he formed it as a single visible living thing which
was to include all related creatures (...).
By turning it he shaped it into a sphere (...), giving
it the most perfect form of all."
(Timaeus, c. 410 BC)

The World

"I assure you that anyone who attempts a literal understanding of the writings of the hermetic philosophers will lose himself in the twists and turns of a labyrinth from which he will never find the way out." (*Livre de Artephius*, Bibl. des Philosophes Chimiques, Paris, 1741)

In the courtyard: sulphur and mercury, the two basic components of matter. The three walls symbolize the three phases of the Work, which begins in spring under the zodiac sign of Aries and the decaying corpse. In summer, in the sign of Leo, the conjunction of spirit and soul occurs, and in December, in the sign of Sagittarius, the indestructible, red spirit-body emerges, the elixir or the "drinkable gold of eternal youth".

Janus Lacinius, Pretiosa Margarita novella, 1577–1583

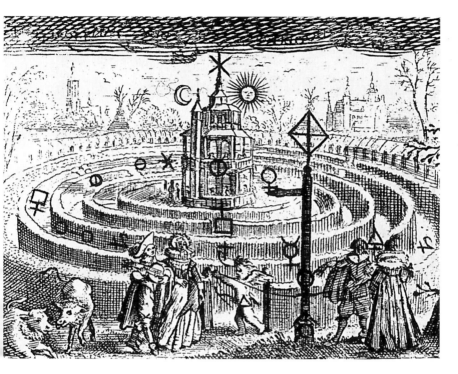

The outer fire △, in the form of a cherub, guides the alchemical couple sulphur and mercury into the labyrinth of material transformation. The central temple is the place of their transformation, which can only occur with the help of the secret salt-fire which opens up the metals. This is formed from ammoniac ✳, salt of tartar ⌀ and saltpetre ⊕, which is taken isolated from the divine dew.

The six-pointed star on the roof tells the wise men of the birth of their philosophical child.

G. van Vreeswyk, De Goude Leeuw, Amsterdam, 1676

In the cosmology of the gnostic Ophites, the sea-monster (*Leviathan*, Ouroboros) as the celestial, primordial water, forms the outermost circle of the world of creation, which is inaccessible to the experience of the senses, and shuts it off from the divine world of love and light.

The Cabala, which is strongly indebted to gnostic teachings, also places a veil between God and creation. Jacob Böhme called this celestial veil the "Upper Water", and in Blake's mythology man has dwelt in the sea of time and space since the Flood.

In the gnostic view, earthly existence is a sphere of grim exile, and for Paracelsus it is even the place to which Lucifer was banished: Hell itself.

At birth the light-soul descends the ladder of the seven spheres to earth, in the process coarsened by the planets, which are seen as humble creator-gods and demons (archonts), and coated in dirty layers of matter.

Each planet impresses a negative property upon the soul as it passes, dulling it in the process: Venus immodesty, Mercury miserliness, Mars wrath, Jupiter vanity, etc.

After death the earthly body remains behind as a shell in Tartarus, and the soul rises through the region of air (Beemoth) and back up to the archontes, although these attempt to obstruct the soul's passage. Hence, precise knowledge (gnosis) of the passwords and signs is required to open the way to sevenfold purification.

The passage through the final sphere is the most difficult. According to Ophitic doctrine, this sphere's master is Saturn, the demiurge, the "accursed" god who created time and space. He is the serpent guarding paradise.

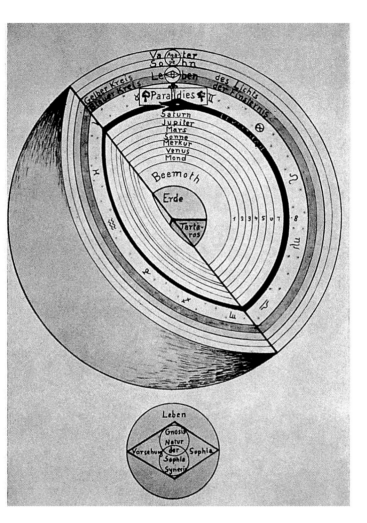

Reconstruction
of the gnostic
cosmology of the
"Ophites" (from
Gr. "ophis",
serpent).

*Hans Leisegang,
Die Gnosis,
Stuttgart, 1985*

The World

The writing of the Neoplatonist Pseudo-Dionysius Areopagita (c. A.D. 500) on the "celestial hierarchies" exerted a considerable influence on the structuring of the Christian cosmos through to the Renaissance. He distinguished between nine choirs of angels, each triad being assigned to a part of the trinity: the group of angels, archangels and virtues to the Holy Ghost; the powers, forces and dominions to the Son; the thrones, cherubim and seraphim to the Father.

III. top: Jacobus Publicus, Oratoriae artis epitome, 1482

III. bottom: Johannes Romberch, Congestorium artificiose memorie, 1533

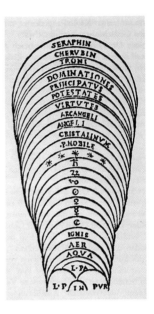

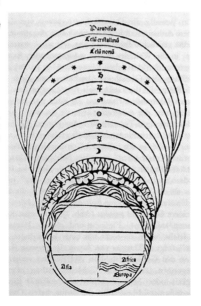

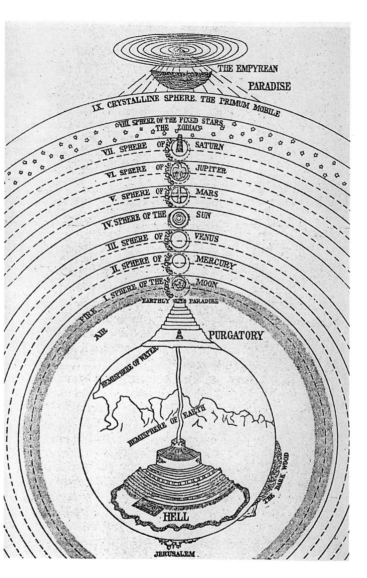

In Dante's *Divine Comedy* (1307–1321), the soul on its pilgrimage rises from the realm of Hell, which projects spherically into the earth, via the mountain of Purgatory and the nine spheres of the planets, the fixed stars and the crystalline sphere, all of which are kept in motion by angels, up to Paradise, where it finds its home in the white rose of heaven, illuminated by the divine light.

Michelangelo Cactani, La Materia della Divina Commedia di Dante Alighieri, 1855

The World

The enthroned Christ Pantocrator blesses the universe below him. The spheres of Jupiter and Saturn are inhabited by hierarchies of angels. At the centre is the map of the world with the T-shaped division into the three continents of Asia, Europe and Africa; a division familiar since classical antiquity, which depicted Asia as the same size as Europe and Africa put together. The vertical of the T is the Mediterranean, the horizontal is formed by the Don, the Black Sea and the Nile

Manuscript of Lambert of Saint-Omer, 1260, Paris

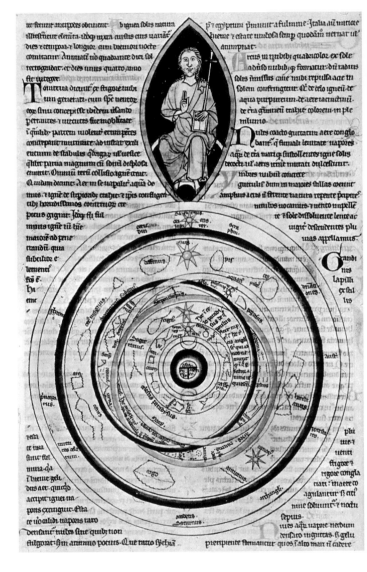

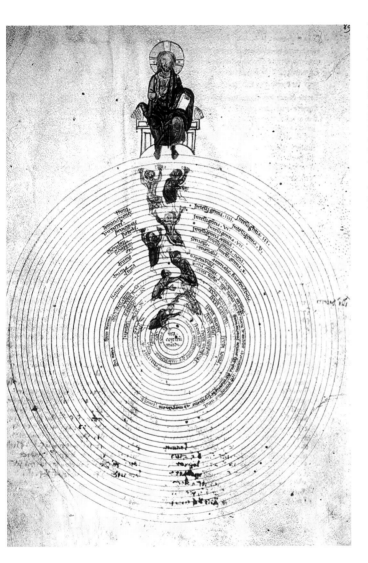

The souls ascend from the realm of the elements via the spheres of the planets, the four levels of the soul and the nine choirs of angels to the highest sphere of Platonic Ideals. Christ sits enthroned above them all.

Anonymous manuscript, 12th century

The World

The diagram shows the possible relationships and transformations of the four elements, both between each other and with respect to the four seasons and the temperaments. Earth – autumn – melancholic/ fire – summer – choleric/ air – spring – sanguine/ water – winter – phlegmatic.

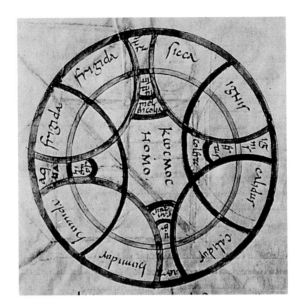

The year as a network of relationships between the seasons, the elements and the four points of the compass.

Isidore of Seville, De natura rerum, manuscript anthology, c. A.D. 800

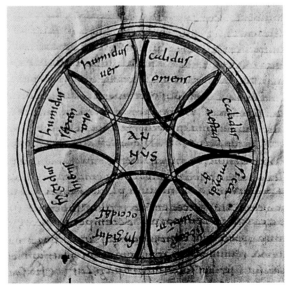

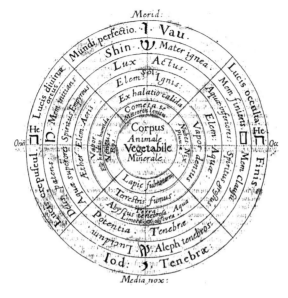

Fludd combined the diagrams of the Middle Ages, as handed down by the well-known encyclopaedic works of Isidore of Seville (A. D. 560–633), with the complex symbolism of the Cabala.

III. top: the components of the macrocosm

III. bottom: the components of the microcosm

R. Fludd, Utriusque Cosmi, Frankfurt, 1621

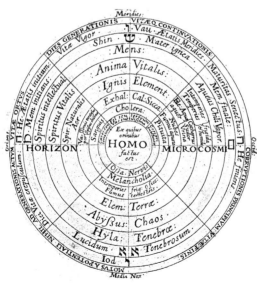

The World

Based on the work of the Florentine Pico della Mirandola (1463–1494), the systems of the so-called "Christian Cabala" link to neoplatonic and Christian elements with a knowledge of Jewish mysticism, that was often taken from corrupt sources. In this diagram Robert Fludd established a parallel between the levels of the Ptolemaic cosmos and the twenty-two letters of the Hebrew alphabet, from which God created the world.

R. Fludd, Utriusque Cosmi, Vol. I, Oppenheim, 1617

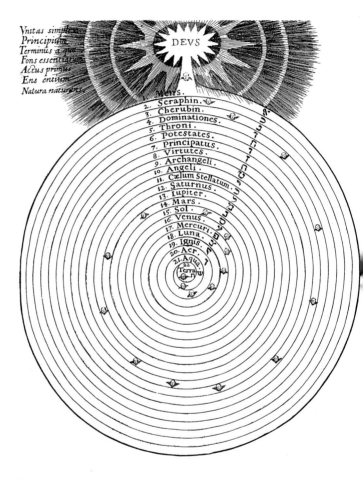

Vnitas simplicia
Principium
Terminus a quo
Fons essentiarum
Actus primus
Ens entium
Natura naturans

DEVS

1. Mens.
2. Seraphin.
3. Cherubin.
4. Dominationes.
5. Throni.
6. Potestates.
7. Principatus.
8. Virtutes.
9. Archangeli.
10. Angeli.
11. Cælum Stellatum.
12. Saturnus.
13. Iupiter.
14. Mars.
15. Sol.
16. Venus.
17. Mercuri.
18. Luna.
19. Ignis.
20. Aer.
21. Aqua.
22. Terra.

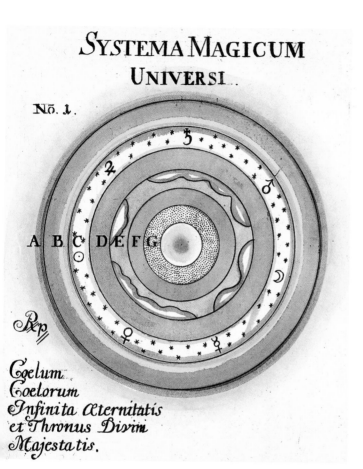

SYSTEMA MAGICUM
UNIVERSI

Nᵒ. 1.

A B C D E F G

Rp//

Coelum
Coelorum
Infinita Æternitatis
et Thronus Divini
Majestatis.

The geocentric concept of the world was still evident in 18th-century Freemasonry. The "Magical Outline of the World after Ptolemy" from Georg von Welling's *Opus mago-cabalisticum* is divided into five regions: A and B are the primal elements fire (Hebr. esh) and water (mayim), C = region of the stars, D = region of the air, where the two elements merge into "shamayim", the "fiery water of the spirit", which, as the seed of all things, reaches the surface of the earth (E) in the dew. F = virgin earth, G = subterranean air and the red, focal point of the central fire.

Gregorius Anglus Sallwigt (pseudonym of von Welling), Opus mago-cabalisticum, Frankfurt, 1719

Comparative depiction of cosmological systems

III. I: the Ptolemaic system (c. A.D. 100–160) with the earth at the centre, surrounded by the seven ethereal spheres of the moon, Mercury, Venus, the sun, Mars, Jupiter and Saturn, which all move in a circle around the earth. Above them is the static level of the fixed stars and the circles of the zodiac. This system, which contained the whole of the age's astronomical knowledge, continued to predominate for more than a millennium, until overturned by the Copernican revolution.

III. II: For Plato (427–347 B.C.), the cosmos was the image of the cosmic soul, rotating on its own axis. He placed the sun directly above the moon.

III. III: In the pseudo-Egyptian system adopted by Vitruvius, Mercury and Venus revolve around the sun, which in turn, like the other planets, revolves around the earth.

IIIs. IV + V: the system put forward by Tycho Brahe in 1580 emanates from two centres. The sun revolves around the earth, the static centre, and is at the same time at the centre of the five other planets: "When the sun comes along, all the planets go around with it."

III. VI: 1800 years after the Alexandrian astronomer Aristarchus, Copernicus put the sun back at the centre of the world in 1543. His cosmological system corresponded to the hermetic vision of the upward movement of matter from the outermost coarse state of Saturn-lead to the highest level of sublimation, Sun-gold. But much more far-reaching were the concepts of the Neoplatonist thinker Cardinal Nikolaus of Cusa, known as Cusanus: as early as 1445 he reached the conclusion that the earth, rotating on its own axis, circled the sun, and that the universe, which Copernicus still saw as bounded by a belt of fixed stars, must be infinite.

His student in spirit Giordano Bruno, who combined the discoveries of Cusanus with speculations on magic, wrote in 1591 of the infinity of worlds: "We are no *more* the centre than any other point in the universe". And, "All things are in the universe and the universe in all things".

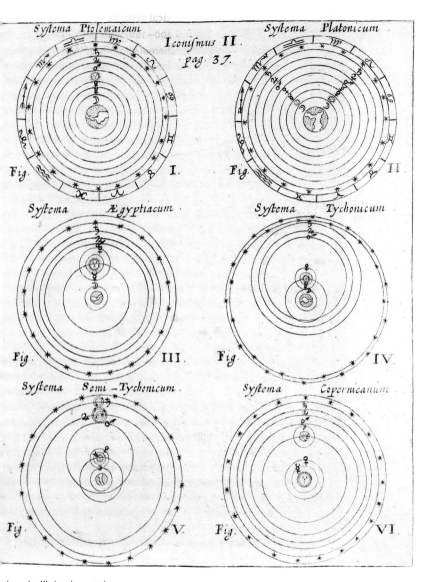

Athanasius Kircher, Iter extaticum,
Rome, 1671

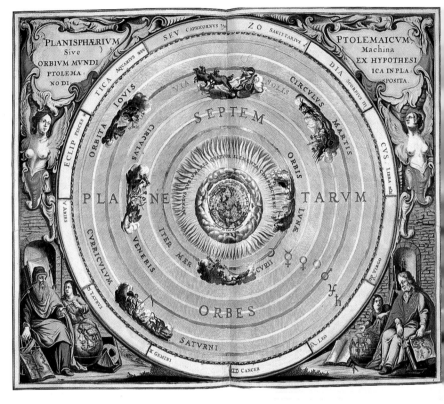

Planispheric depiction of the Ptolemaic system.

"The eye of man, who stands on the earth (...) organizes the structure of the entire universe in the sequence that he perceives, and in a sense places himself at the centre of the whole of space. Wherever he sends the rays of his gaze, he marvels at the work of the heavens, curved with admirable roundness (..) and believes that the globe is set at the centre of this great work." (Andreas Cellarius)

The illustration shows the Aristotelian stratification of the four elements in the sublunary region: the globe of the earth consists of the heaviest and most impure elements of earth and water, then comes air, and finally, adjacent to the sphere of the moon, is the lightest and purest element, fire.

A. Cellarius, Harmonia Macrocosmica, Amsterdam, 1660

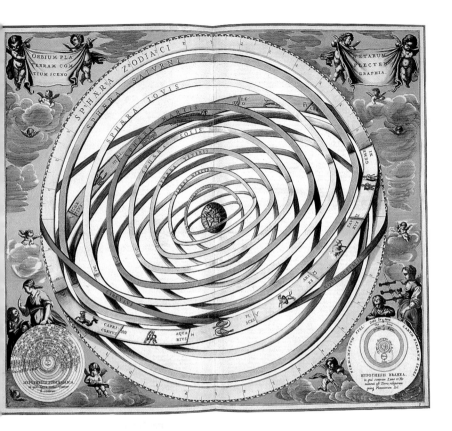

Spatial depiction of the Ptolemaic system

"Most ancient philosophers (...) believed that the superlunary world, i.e. the ethereal heavens, consisted of several circles or spheres, solid and diamond-hard, the larger of which contained the smaller. And that the stars, like nails set in the wall of a ship or some other movable object (...), were set in motion by them." (A. Cellarius)

The outermost, opaque sphere of the fixed stars was known as the *Primum Mobile*, the "first moved", because, driven by divine love, it caused the motion of all other spheres.

A. Cellarius, Harmonia Macrocosmica, Amsterdam, 1660

The World

Here, Kircher is receiving instruction from the angel Cosmiel, who is guiding him on an extended dream journey through the competing astronomical systems. He favoured the cosmology of Brahe, since he wanted to do justice to the fundamental experience of geocentricity, while at the same time wanting to give an appropriate status to the sun which, in the hermetic view, represents the divine in the cosmos.

A. Kircher, Iter extaticum (Ed. Caspar Schott), Würzburg, 1671

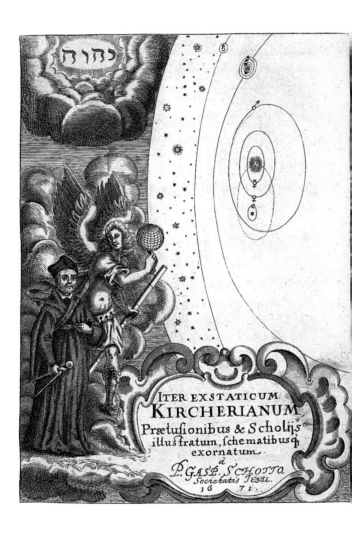

ITER EXSTATICUM
KIRCHERIANUM
Prælufionibus & Scholijs
illuſtratum, fchematibus q̃
exornatum
à
P. GASP. SCHOTTO,
Societatis Jesu.
16 71.

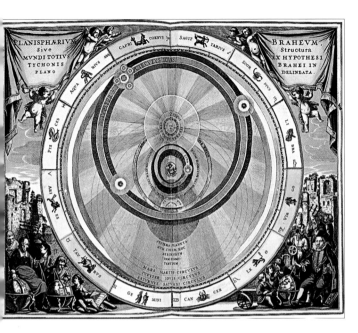

From the contradictory systems of Ptolemy and Copernicus, Tycho Brahe created a synthesis in which he attempted to "give greater credence to the geocentric structure of the world (...). He arranged the position of all the orbits as follows: around the earth, the centre of the entire universe, rotates the moon, which, like the sun, runs a course concentric to the earth. This in turn is the centre of the five other planets, Mercury, Venus, Mars, Jupiter and Saturn, which are concentric to the sun but eccentric to the earth. Venus and Mercury are the sole and constant satellites of the sun on its orbit around earth (...)" (A. Cellarius)

A. Cellarius, Harmonia Macrocosmica, Amsterdam, 1660

The World

That the earth cannot be regular in shape is already apparent in the different beginnings of day and night. And neither can it be hollow, because if it were, the sun would rise earlier in the west than in the east. As a rectangular shape is also impossible, only the spherical shape is conceivable.

Elementa Astronomica, Basle, 1655

Behind the Latinized name Sacrobosco stands the English cleric John of Holywood, whose astronomical textbook *Sphaera Mundi*, published in 1220, was one of the most widely read books of its day. In it he explains the Ptolemaic view of the world, and, along with numerous proofs for the spherical shape for the earth, he provides proof of the circular orbits of the planets and explanations for solar and lunar eclipses.

Johannes de Sacrobosco, Sphaera Mundi, Antwerp, 1573

"I remember (...) seeing an Atlas looking at a world whose hoops and rings had been broken by Copernicus, where Tycho Brahe placed his back beneath the globe, and a shouting Ptolemy tried to support the round lump, to stop it from falling into the void. In the meantime Copernicus was breaking many crystal spheres that were placed around the globe and was stamping out the little lights that flickered in the crystal jars." (de Hooghe, *Hieroglyphica*, Amsterdam, 1744)

"Sometimes the Earth will spin into the Abyss & sometimes stand at the Centre and sometimes it spreads flat into broad Space." (William Blake, *Jerusalem*, 1804)

Franciscus Aguilonius, Optica, 1611

Sun

For Fludd the sun is the heart of the macrocosm. It is at the precise point of intersection of the two pyramids of light and darkness, in the 'sphere of equilibrium' of form and matter. Within it dwells the life-giving cosmic soul.

R. Fludd, Utriusque Cosmi, Vol. I, Oppenheim, 1617

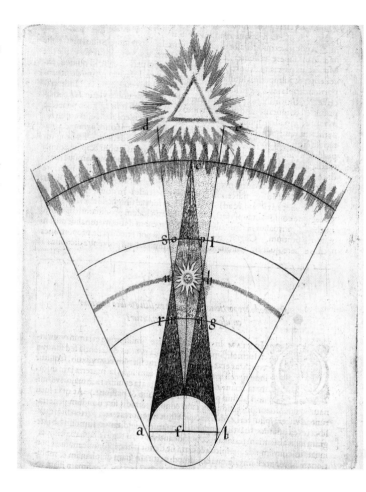

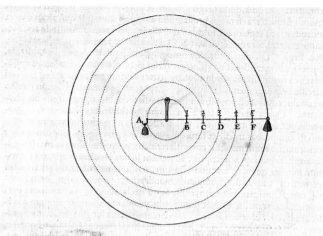

Demonſtratur hoc experimentum.lib.1.de motu cap.1.& 2.Reg.1.

Experimentum II.

Multò major vis requiritur ad motum alicujus rotæ à centro (quem motum à principio ſeu ab interiori appellant) *quàm ad motum à ſuperficie vel circumferentia ſeu ab exteriore,qui motus in fine dicitur.*

Here, Fludd is defending the geocentric concept of the world against the new theory of Copernicus, which he considered illogical on the grounds that it would be much simpler for the prime mover or God the creator to rotate the wheel of the spheres from the rim than for a sun to do so from the centre.

For Fludd, the mechanical centre of the universe remained the earth, while the spiritual centre was the sun.

R. Fludd, Utriusque Cosmi, Vol. I, Oppenheim, 1617

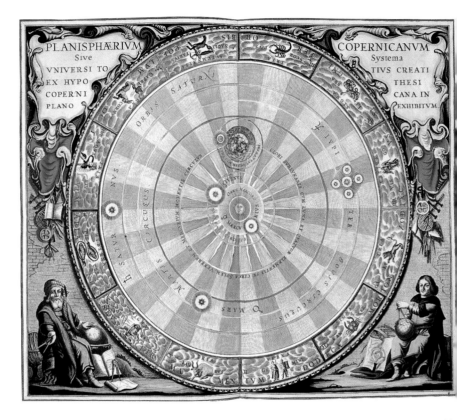

For the mystic and astronomer Kepler, the relationship of the seven spheres of the planets in the Copernican system to their centre, the sun, was identical to "that of the various discursive thought processes to simple intellectual insight" (*Harmonices Mundi*, Linz, 1619, Leipzig edition, 1925)

In 1507, through his investigations into the reasons for the imprecisions of the calendar of the time, Copernicus reached the conclusion that the calendar charts would be improved if they were produced on the basis of a heliocentric conception of the world. He was able to refer to a number of classical astronomers and philosophers, such as Aristarchos of Samos (c. 300 B.C.), Heraclides Ponticus, Nicetas of Syracuse and Ecpantus the Pythagorean.

A. Cellarius, Harmonia Macrocosmica, Amsterdam, 1660

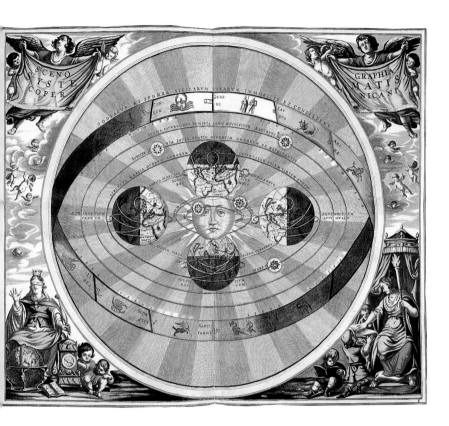

At the centre of all things resides the sun. Could we find a better place in this most beautiful of all temples, from whence this light illuminates all things at once? Rightly is it called the lamp, the spirit, the ruler of the universe. For Hermes Trismegistus it is the invisible god, Sophocles' Elektra calls it the all-seeing. Thus, the sun sits on its royal throne and guides its children, which circle it." (N. Copernicus, *De revolutionibus orbium caelestium*, 1543)

A. Cellarius, *Harmonia Macrocosmica*, Amsterdam, 1660

Sun

In the Renaissance, the translations by Marsilio Ficino (1433–1499) of the *Corpus Hermeticum* revived the cult of the sun based on the ancient Egyptian mysteries. For Ficino the sun embodied, in descending order, God, divine light, spiritual enlightenment and physical warmth. In this illustration, Fludd shows God placing his tabernacle in the sun at the beginning of creation, and thus illuminating and breathing life into the entire cosmos.

R. Fludd,
Philosophia sacra,
Frankfurt, 1626

Sun

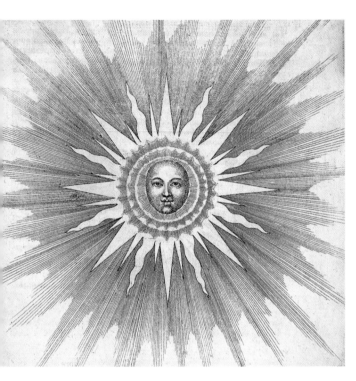

"The sublimity and perfection of the macrocosmic sun is clearly revealed when royal Pheobus sits at the very centre of the sky in his triumphal chariot, his golden hair fluttering. He is the only visible ruler, holding in his hands the royal sceptre and governing the whole world (...)". (Fludd, *Mosaicall Philosophy*, London, 1659)

R. Fludd, Utriusque Cosmi, Vol I, Oppenheim, 1617

Sun

In Masonic symbolism, the sun represents the imperishable spirit, immaterial gold. In many Masonic temples it is drawn in the east, from where the 'Master of the Lodge' directs proceedings.

A Freemason, formed from the materials of his lodge, engraving, 1754

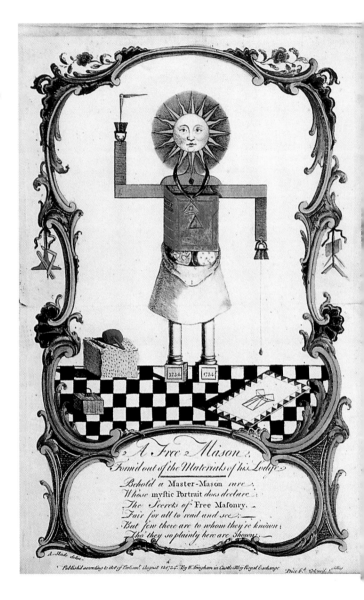

A Free Mason.
Formed out of the Materials of his Lodge.

Behold a Master-Mason rare,
Whose mystic Portrait does declare,
The Secrets of Free Masonry,
Fair for all to read and see;
But few there are to whom they're known,
Tho' they so plainly here are Shown.

Published according to the of Parliament. August 1st. 1754. By W. Tringham in Castle Alley Royal Exchange. Price 6.d.

Sun

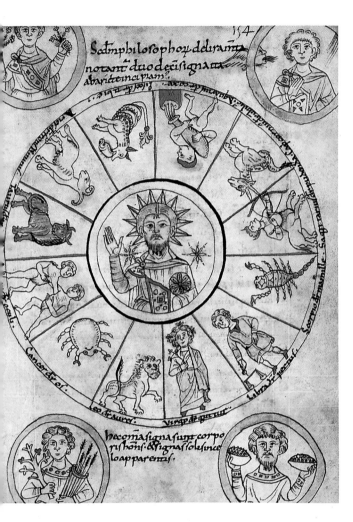

Christ-Apollo at the centre of the zodiac. The outer circles contain the four seasons.

Christ in the Zodiac, Northern Italy, 11th century

Sun

III. top: In Kircher's vision, the pagan heaven of the male gods represents different aspects of the sun, or the cosmic spirit: Apollo (Phoebus, Horus), for example, represents the warming power of the sun's rays, Chronos (Janus, Saturn) the time-generating power of the sun.

III. bottom: The pagan goddesses as emanations of the lunar powers: Ceres (Isis, Cybele) represents the lunar power that brings forth the the fruits of the earth, Persephone (Proserpina) the lunar power that promotes the growth of herbs and plants.

A. Kircher, Obeliscus Pamphilius, Rome, 1650

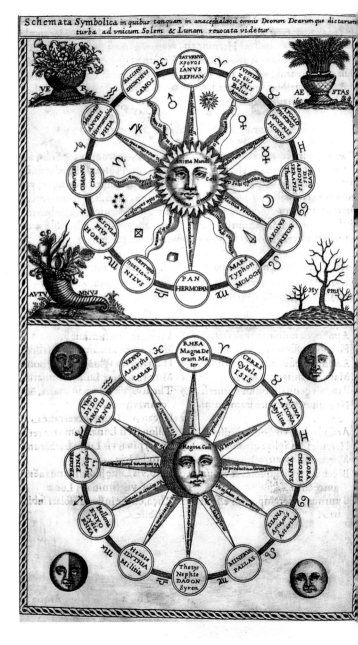

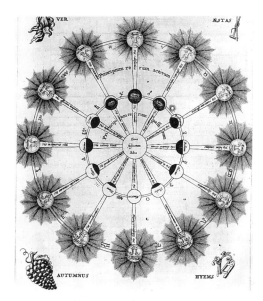

Kircher assumed that the whole polytheistic heaven of the gods, handed down from the Eygptians via the Greeks to the Romans, stemmed from the observation of the annual course of the sun through the zodiac and its position in relation to the phases of the moon.

A. Kircher, Turris Babel, Amsterdam, 1676

"The outer sun hungers for the inner one."
(J. Böhme, *De signatura rerum*)

Westphalian altar, c. 1370/80

Moon

According to its position in relation to the sun and the earth, the area of the moon lit by the sun appears in periodically changing forms: waxing from the invisible new moon through the first quarter (half moon) to the full moon (bottom), then waning through the final quarter back to the new moon (top).

A. Cellarius, Harmonia Macrocosmica, Amsterdam, 1660

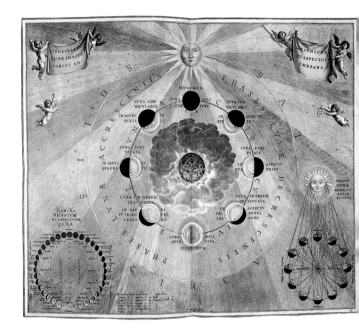

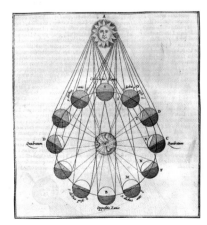

The views of the phases of the moon seen from the sun and the earth.

A. Kircher, Mundus Subterreaneus, Amsterdam, 1678

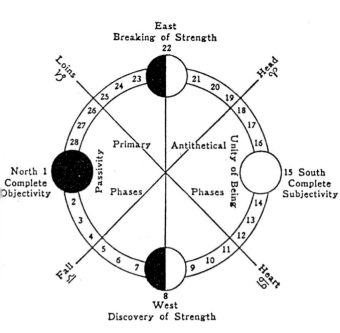

East
Breaking of Strength
22

Loins
Head

North 1
Complete
Objectivity

15 South
Complete
Subjectivity

Primary Antithetical

Unity of Being

Passivity

Phases Phases

Fall

Heart

West
Discovery of Strength

"As the moon passes through the whole of the zodiac in twenty-eight days, the most ancient astrologers assumed that there were twenty-eight stages (...) Within these twenty-eight stages lie many of the secrets of the ancients, miraculously affecting all things beneath the moon." (Agrippa of Nettesheim, *De occulta philosophia*, 1510)

From: W.B. Yeats, A Vision, London 1925

This wheel is every completed movement of thought or life, twenty-eight incarnations, a single incarnation, a single judgement or act of thought." (W.B. Yeats, *A Vision*, 1925)

Yeats' diagram, derived from Blake's theories of cycles and of the four essences (Zoas), also functions as a theory of types, in the manner of Gurdjieff's enneagram.

The Great Wheel, Speculum Angelorum et Hominum, in: W.B. Yeats, A Vision, London 1962

On the images of the head and tail of the moon dragon: "The ancients also made an image of the head and tail of the moon dragon, the figure of a serpent with a hawk's head between an airy and fiery circle, after the form of the Greek capital letter theta. They made this image when the head of Jupiter occupied the centre of the sky, and they attributed to it great influence on the success of petitions; they also intended it to designate the good and lucky demon which

they represented in the form of a serpent. The Egyptians and Phoenicians placed this creature above all others and saw its nature as divine because it has a sharper mind and a greater fire than the others. This is due both to its rapid movement without feet, hands or other tools, and the fact that it frequently renews its age with the sloughing of its skin, and rejuvenates itself. – They made a similar image of the dragon's tail when the moon had disappeared in the dragon's tail, or occupied an unfavourable position in relation to Saturn or Mars." (Agrippa of Nettesheim, *De occulta philosophia*, 1510)

Moon

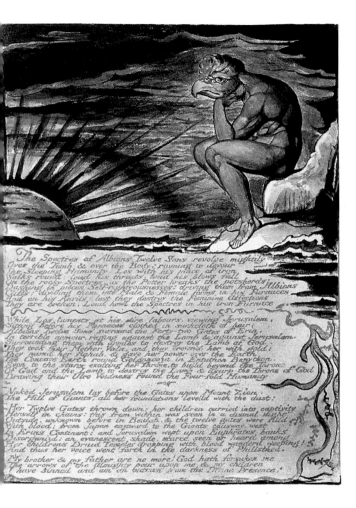

The Spectres of Albions Twelve Sons revolve mightily
Over the Tomb, & over the Body: running to devour
Her Sleeping Humanity: Los with his mace of iron,
Walks round: loud his threats loud his blows fall
On the rocky Spectres, as the Potter breaks the potsherds;
Dashing in pieces Self-righteousnesses: driving them from Albions
Cliffs: dividing them into Male & Female forms in his Furnaces
And on his Anvils: lest they destroy the Feminine Affections
They are broken. Loud howl the Spectres in his iron Furnace

While Los laments at his dire labours, viewing Jerusalem.
Sitting before his Furnaces clothed in sackcloth of hair;
Albions Twelve Sons surround the Forty-two Gates of Erin,
In terrible armour, raging against the Lamb & against Jerusalem,
Surrounding them with armies to destroy the Lamb of God.
They took their Mother Vala, and they crown'd her with gold:
They nam'd her Rahab, & gave her power over the Earth
The Concave Earth round Golgonooza in Entuthon Benython,
Even to the stars exalting her Throne, to build beyond the Throne
Of God and the Lamb, to destroy the Lamb & usurp the Throne of God
Drawing their Ulro Voidness round the Four-fold Humanity

Naked Jerusalem lay before the Gates upon Mount Zion,
The Hill of Giants, all her foundations levell'd with the dust:

Her Twelve Gates thrown down: her children carried into captivity
Herself in chains: this from within was seen in a dismal night
Outside, unknown before in Beulah, & the twelve gates were fill'd
With blood; from Japan eastward to the Giants causway, west
In Erins Continent: and Jerusalem wept upon Euphrates banks
Disorganizd; an evanescent shade, scarce seen or heard among
Her childrens Druid Temples dropping with blood wanderd weeping!
And thus her voice went forth in the darkness of Philisthea.

My brother & my father are no more! God hath forsaken me
The arrows of the Almighty pour upon me & my children
I have sinned and am an outcast from the Divine Presence!

A paraphrase of Dürer's "Melencolia". (cf. p. 203) The bird's head is possibly based on an illustration of the moon dragon from Agrippa's *De occulta philosophia*.

Blake had a special relationship towards the moon, as the ascendant in his horoscope was in the sign of Cancer, which is related to the moon. Thus 28, the number of the completed cycle of the moon, is of great importance in his mythology: it signifies the surmounting of traditional ideas through the act of free creation, when the muses of fantasy are illuminated by the sun of imagination.

*W. Blake,
Jerusalem,
1804–1820*

Moon

Chart for the calculation of the daily rising and setting of the moon and the degree of its waxing and waning. In the outer circle: the 28 phases of the moon.

A. Kircher, Ars magna lucis, Amsterdam, 1671

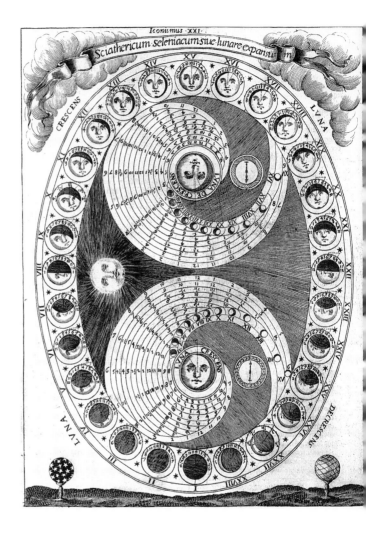

Apian's *Astronomicum Caesareum* is considered to be the last standard astronomical work based on the geocentric view of the universe. It consists of a series of concentric cardboard discs moved with threads, and from which the interested layman was able to read the arithmetical values and astronomical constellations as on the face of a clock.

Kepler mocked this "string-pulling": "Who will give me a spring of tears, that I may admire the lamentable industry of Apianus, who, relying upon Ptolemy, wasted so many hours representing a whole labyrinth of interlocking twists and turns."

Peter Apian, Astronomicum Caesareum, Ingolstadt, 1540

Moon

This disc from Apian's *Astronomicum Caesareum* enables the user to calculate the position of the ascending lunar node on a particular date.

The two points of intersection of the moon's orbit and the ecliptic are called lunar nodes or "dragon points". The ascending node is the head of the dragon, the descending one its tail. Both points play an important part in the calculation of the calendar, and were used in classical astronomy, chiefly for the calculation of solar and lunar eclipses.

P. Apian, Astronomicum Caesareum, Ingolstadt, 1540

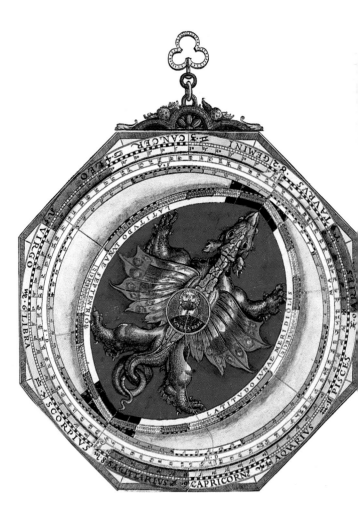

Chart for the calculation of solar and lunar eclipses. According to ancient legends, these were due to a dragon swallowing the heavenly bodies and spewing them out again.

A. Kircher, Ars magna lucis, Amsterdam, 1671

The eternal recurrence of the sevenfold division of the universe as a river of space and time.

Manuscript, Rajasthan, 19th century

Cosmic time

According to medieval calculations, one cosmic year equalled 15,000 sun years. "It is completed when all the stars find their way back to a particular place." In *Politicos* Plato calls it the "great year of the ancients": when its revolutions have passed through the appropriate length of time, it turns around again, i. e. time now runs in the opposite direction, rejuvenating itself on its path.

According to modern calculations, the duration of the "great" year is 25,868 years, the time the point of spring takes to cross the entire zodiac.

Lambert of St Omer, Liber Floridus, c. 1120

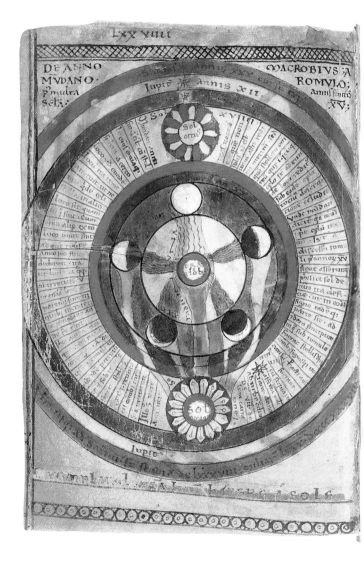

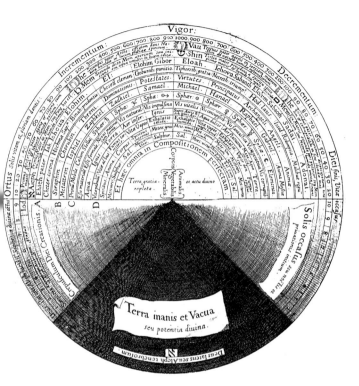

"Mirror of the causes of all things"

All of creation opens up like a fan from the night of the hidden, divine source. It pours from the outer, paternal circle, the Tetragrammaton, into the three Hebrew letters called 'mothers': Alef א air (avyr), mem מ water (mayim) and shin ש fire (esh). The other circles contain the ten divine names and aspects, followed by the Christian-

Platonic graded cosmos and, in the inner circle, are the *Tria Prima*, the three fundamental alchemistic principles of matter.

The whole plan of creation runs clockwise like a day from dawn to the "evening of the world".

R. Fludd, Integrum Morborum Mysterium, Frankfurt, 1631

Cosmic time

The personification of cosmic time, framed by the six cosmic ages familiar in the early Middle Ages. The five preceding cosmic ages from Adam to the birth of Christ were under the domination of Lucifer, the sixth and present age was the Kingdom of Christ.

Parallel to this: the division of the age of man falls into six sections from childhood to old age.

Lambert of St Omer, Liber Floridus, c. 1120

Cosmic time

The three cosmic ages of Joachim of Fiore (c. 1130–1202):

The first age is that of the Father (bottom), the age of the Old Testament and is formed by the Law and by the fear of God. The second age is that of the Son, of the Church and of faith in the Word. The third Age is that of the Holy ghost – which Joachim of Fiore saw drawing near – and is the time of jubilation and freedom. It brings with it a new intuitive and symbolic under-standing of the Scriptures, the end of the "walled church" and the foundation of new contemplative orders.

This spiritual age is the dawn that Jacob Böhme and the alchemists saw rising on the hori-zon, the general reformation of the Rosicrucians.

Joachim of Fiore, 12th century

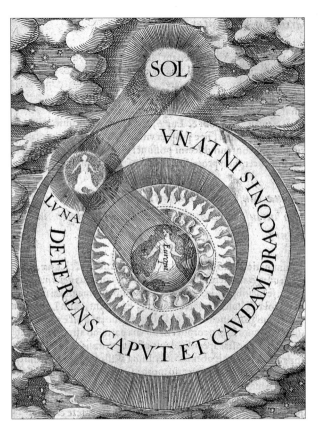

For the alchemical opus, the constellations of the sun and the moon were particularly important:

"Nowadays everyone knows that the light that the moon sends to us is nothing but a reflection of the sunlight, along with the light of the other stars. Therefore the moon is the collecting tank or (...) the well of its living water. So if you wish to transform the rays of the sun into water, choose the time when the moon conveys them to us in abundance, namely when it is full or close to fullness; in this way you will receive the fiery water from the rays of the sun and the moon in its greatest force (...).

In southern France the Work can begin in March and again in September, but in Paris and the rest of the Empire one cannot begin before April, and the second period there is so weak that it would be a waste of time to occupy oneself with it in the autumn". (Anonymous 19th-century hermetic treatise, quoted in: Canseliet, *Die Alchemie und ihr Stummes Buch*, Amsterdam edition, 1991)

M. Maier, Septimana Philosophica, Frankfurt, 1616

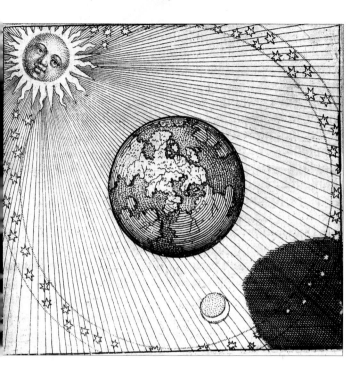

The sun and its shadow complete the work"

With its light and shadow the Philosoph-cal Sun produces an even day and a night which we may call the Latona or Magnesia. Democritus taught how its shadow might be extinguished and burned with a fiery medication."

Latona is a code name for the *prima materia* during the phase of putrefaction and blackening (nigredo). In the alchemical Work this blackness unites the body with the spirit.
Sulphur (Sol) and Mercurius (Luna) are also known as "the sun and its shadow".

M. Maier, Atalanta fugiens, Oppenheim, 1618

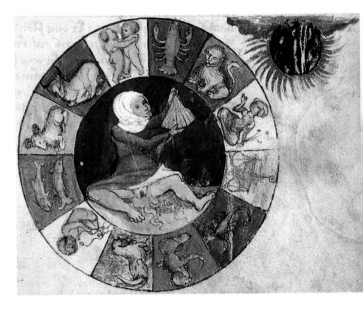

In the view of the alchemists, the metals represent the assembled forces of the planets, and hence they also referred to their art as the "lower astronomy". In accordance with the twelve divisions of the zodiac, the material must pass through twelve gates or stages, until it reaches its definitive fixity in reddening, when "the zodiac no longer has any power over it". (Nicolas Flamel)

The author of the *Aurora consurgens* compares this growth in the lapis with the nine-month development of the embryo in its mother's womb. According to George Ripley (1415–1490), the water that breaks at birth is symbolized by the white or luna tincture that precedes the solar reddening (above right).

Aurora consurgens, late 14th century

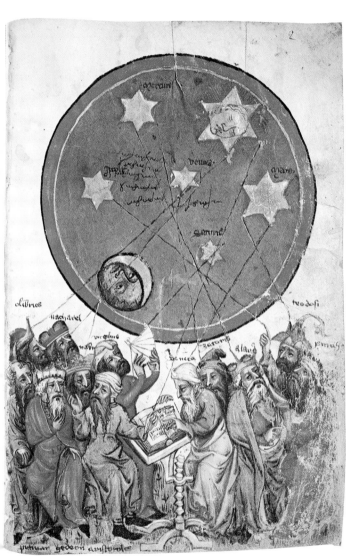

Twelve pagan astrologers (including the poet Virgil and the philosophers Seneca and Aristotle) immersed in the interpretation of the stars.

Book of oracles in rhyming couplets, Central Germany, 14th century

The horoscope (literally "hour-watch"), the record of the constellations at the moment of birth, is the expression of belief in man's entanglement in fate and predestination.

"The horoscope is that 'handwriting' of which it is said (Paul, Col. II, 14) that He (Christ) cancelled the bond (...) He set these cosmic powers and authorities to the side, nailing them to the cross." (C.G. Jung, *Mysterium coniunctionis*, Zurich, 1968

Daniel Cramer, Emblemata Sacra, 1617

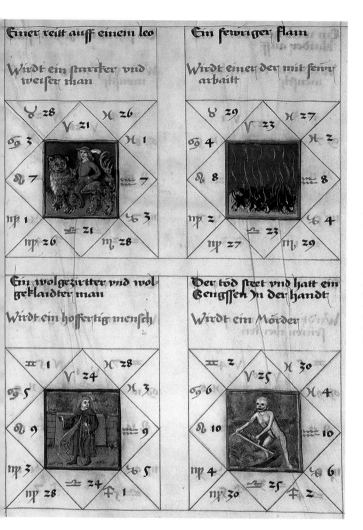

The horoscope pictures are taken from the so-called "Heidelberg Book of Fate" (end of 15th century), a German translation of the *Astrolabium planum* of Petrus of Abano (13th century).

Each of the twelve signs of the zodiac is divided into three decans and thirty degrees. The book also contained charts for determining the ascendant and the degree of the zodiac rising on the eastern horizon at the time of birth, the knowledge of which is the basis for drawing up the horoscope.

Stars

The court astronomer Terzysko, amidst the crisscrossing lines of astrological aspects. The term "horoscope" only became established in the Middle Ages. In classical antiquity there was a preference for speaking of the "theme" or the "genesis" (Latin "constellatio" and "genitura"). The establishment of the angle-relationships or aspects is derived from Pythagorean harmonics.

Astronomical manuscript of Wenceslas IV, Prague, 1400

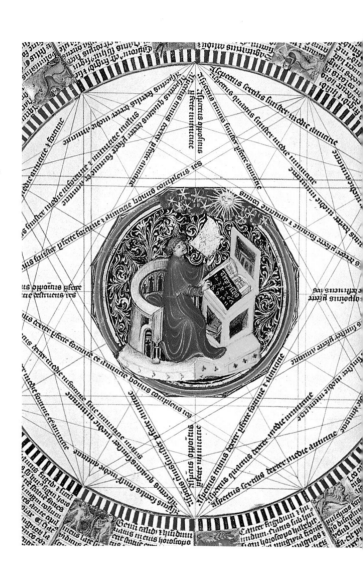

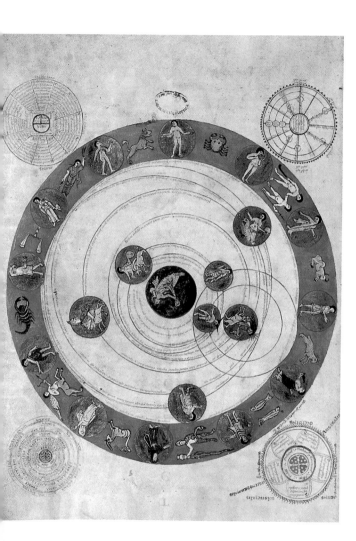

Planisphere with constellations and signs of the zodiac, manuscript, 16th century

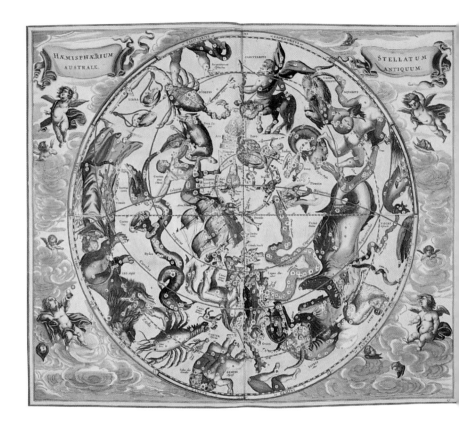

The "southern starry sky of the ancients" with the familiar constellations of Greek mythology.

In Giordano Bruno's satire *The Dethronement of the Beast*, published in 1584, Zeus personally orders that these heavenly images be replaced by virtues: "Obvious and naked to the eyes of men are our vices, and the heavens themselves bear witness to our misdeeds. Here are the fruits, the relics, the history of our adulteries, incest whoring, our passions, robberies and sins For to crown our error we have raised the triumphs of vice to heaven, and made it the home of lawlnessness."

A. Cellarius, Harmonia Macrocosmica, Amsterdam, 1660

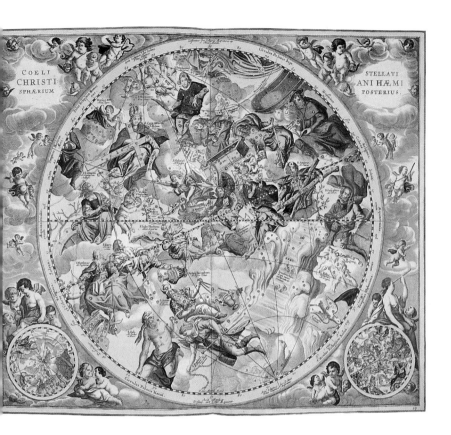

COELI CHRISTI SPHÆRIUM

STELLATI ANI HÆMI POSTERIUS.

nis depiction of a "Christian starry sky" based on an original by Julius Schiller ugsburg 1627), who considered it incom- atible with his faith "to assign to the ars the meanings of evil spirits, animals d sinful people", when the Bible has : "The wise leaders shall shine as the right vault of heaven, and those who have uided the people in the true path shall be like the stars for ever and ever." (Daniel 12, 3).

The "Little Bear" has become the Archangel Michael, the "Great Bear" the boat of St Peter, and the constellation "Andromeda" the tomb of Christ.

A. Cellarius, Harmonia Macrocosmica, Amsterdam, 1660

Stars

"The Jesuit Rheita relates his sweet ecstasy at finding Veronica's veil depicted in the sign of Leo, quite distinctly, brightly and clearly. The wonderful star-painting included more than 130 stars, concentrated in the middle like a swarm of bees. He compared the picture of Orion with Joseph's coat of many colours, which was splashed with many drops of blood." (Erasmus Franciscus, *Das eröffnete Lusthaus der Ober- und Niederwelt,* Nuremberg, 1676)

A. Kircher, Iter extaticum (Ed. C. Schott), Würzburg, 1671

In a dream, Scipio saw the heavenly firmament with its nine plan-
etary orbits. The outermost, the 'primum mobile', is God himself,
embracing all the others: "'What is that sound, so loud and sweet,
that fills my ears?' It is the sound which, connected at spaces which
are unequal but rationally divided in a particular ratio, is caused
by the vibration and motion of the spheres them-
selves, and, blending high notes with low, pro-
duces various harmonies; for such mighty motions
cannot speed on their way in silence, and it is
Nature's will that the outermost sphere on one
side sounds lowest, and that on the other side
sounds highest. Hence the uppermost path, bear-
ing the starry sphere of heaven, which rotates at
the greatest speed, moves with a high and excited
sound, while that of the moon and the nethermost
sphere has the lowest. For the Earth, the ninth of
the spheres and static, remains fixed to *one* spot at

the centre of the universe. But those eight spheres of which two pos-
sess the same power, produce seven different sounds, a number that
is the key to almost everything (…)" (Cicero, *De re publica*)

*J. Bornitus,
Emblematum
Sacorum, Heidel-
berg, 1559*

 "Nature-Music contains within itself the nature of all things /
(...) it is the great cosmos-music / the wonderful harmony of heaven /
of the elements and of all the creatures / and especially of human
music / what develops here is either in harmonic agreement of the
human body / or of all of the inner and outer senses" (Athanasius
Kircher, *Musurgia universalis*, 1662)

 "The shine of the stars makes the melody, Nature under the
moon dances to the laws governing this melody." (Johannes Kepler,
Harmonices Mundi, 1619)

Music of the spheres

The theory of the harmony of the spheres dates back to the Greek philosopher Pythagoras (570–496 B.C.).

According to a legend told by Iambilochos, when Pythagoras heard the different sound made by hammers in a forge, he realized that tones can be expressed in quantitative relationships, and hence in numerical values and geometrical measures. Using stringed instruments, he then discovered the connection between vibration frequencies and pitch. The whole world, according to Pythagoras' theory, consisted of harmony and number. Both the microcosmic soul and the macrocosmic universe were assembled according to ideal proportions, which can be expressed in a sequence of tones.

F. Gaffurio,
Theorica musica,
Milan, 1492

The pitches of the individual planetary tones of the celestial scale were derived from their orbital speeds, and the distances between them were placed in relationship to the musical intervals. Kepler complicated the system somewhat by assigning a whole sequence of tones to each planet. The series that he believed he had found for the earth (Mi Fa Mi) came to represent for him, shortly after the outbreak of the Thirty Years' War, the fact "that *Mi*sere and *Fa*mes (hunger) rule in our vale of tears.

According to Genesis 4, 21, Jubal (ill. top left), a descendant of Cain, was the father of all such as handle the harp and organ". For Kepler, this figure is none other than Apollo, and Kepler also believed that Pythagoras was Hermes Trismegistus.

Music of the spheres

In the bottom left-hand corner, Pythagoras is pointing to the smiths who had inspired him. Here they are at work inside an ear. Kircher goes into great detail about its 'wonderful anatomical preparation', with hammer and anvil.

According to the theorist of Neoplatonic music, Boethius, (5th century A.D.), terrestrial 'musica instrumentalis' is but a shade of the 'musica mundana', the music of the spheres represented by the sphere at the centre. This in turn is merely a faint echo of the divine music of the nine choirs of angels.

A. Kircher, Musurgia universalis, Rome, 1650

Music of the spheres

Diagram of the Ptolemaic cosmos giving the intervals meant to correspond to the distances between the heavenly bodies and their various speeds: Earth – Moon: a whole tone, Moon – Mercury – Venus: a semitone each, Venus – Sun: three semitones, Sun – Mars: a whole tone, Mars – Jupiter – Saturn: a semitone each, Saturn – fixed stars: three whole tones.

Astronomical manuscript anthology, Salzburg, c. A.D. 820

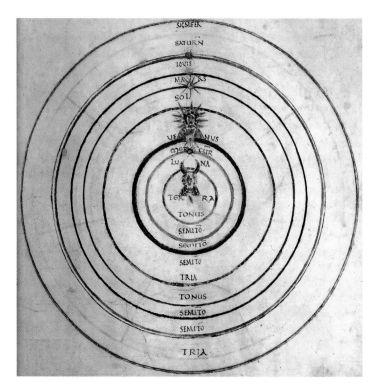

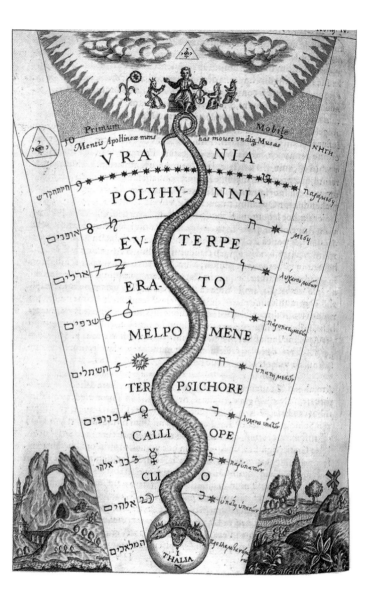

Music of the spheres

The assignment of the nine spheres to the nine Muses was the result of a harmonic vision by the Neo-Pythagorean, Martianus Capella (5th century A.D.). The scale covers a full octave.

The concord is conducted by Apollo, the Prime Mover. Flowing rhythmically through the spheres is the Egyptian serpent of the life-force. Its three heads represent the divine trinity in the three dimensions of space and the three aspects of time.

Tragedy is assigned to the sun, comedy to the earth.

A. Kircher, Ars magna lucis, Rome, 1665

Music of the spheres

In his *Musurgia universalis* (of the miraculous power and effect of consonances and dissonances) Kircher developed the idea of God as an organ-builder and organist, and compared the six-day labour of creation with the six registers of a cosmic organ.

Like Fludd, Kircher divided the various zones of Heaven and Earth into octaves. The organist's art appeared primarily in the accord of the four elements.

A. Kircher, Musurgia universalis, Rome, 1650

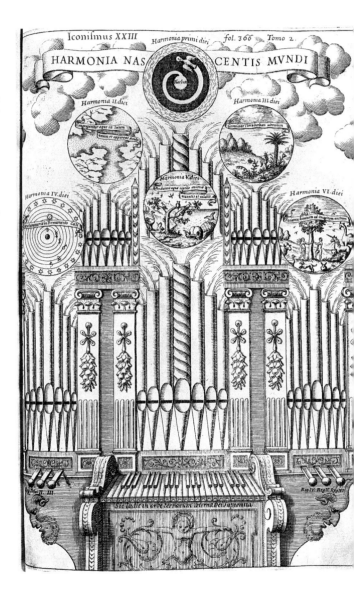

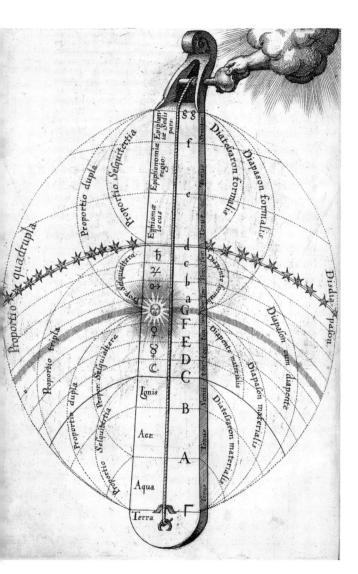

Music of the spheres

According to Fludd, "the monochord is the internal principle which, from the centre of the whole, brings about the harmony of all life in the cosmos."

By altering the tension of the strings, God, the "Great Chord", is able to determine the density of all materials between Empyreum and Earth.

The instrument is divided in half into an upper, ideal, active octave and a lower, material, passive octave, and these are in turn divided into fourths and fifths. On these intervals the upper, principle of light moves down into dark matter, and at their intersection the sun assumes the power of transformation.

R. Fludd, Utriusque Cosmi, Vol. I, Oppenheim, 1617

Music of
the spheres

"The ancient philosophers assumed that the world consisted of a perfect harmony, namely, from the earth to the starry heavens is a perfect octave." (A. Kircher, *Musurgia universalis*). The seven steps of the octave were seen as containing the world, for it is the number seven that links the divine trinity to the quadernity of the elements. In 1922 the Caucasian philosopher and dancing teacher G. Gurdjieff founded his famous "Institute for the Harmonic Education of Man" in Fontainebleau, based on the law of the octave.

"In every line of development there are two points where movement can go no further without external help. At two specific points an additional impulse from an external force is necessary. At these points everything needs an impulse, otherwise it can move no further. We find this "law of the seven" everywhere – in chemistry, in physics, etc.: the same law is at work in all things. The best example of this law is the structure of the scale. Let us clarify this with an octave."
(*Gurdjieff's Conversations*, Basle, 1982)

Trismegistus in Asclepius: "Music is nothing but knowing the order of all things."

For Kepler there was no doubt "that either Pythagoras speaks in a Hermetic way or Hermes in a Pythagorean way."
(*Harmonices Mundi*)

A. Kircher, Musurgia universalis, Rome, 1650

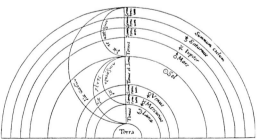

Reconstruction of the Pythagorean cosmos according to the plan of the octave.

Stanley, History of Philosophy

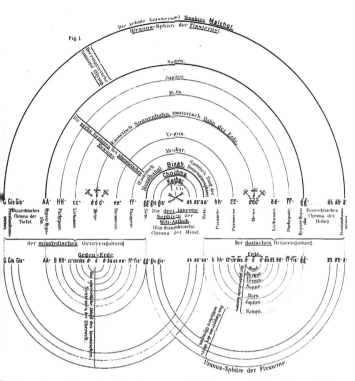

Fig. I.

The harmonic symbolism of antiquity by Albert Freiherr v. Thimus (1806–1878) is a large-scale attempt to reconstruct the Pythagorean foundations of music from Neoplatonic sources, and to establish harmonics as an autonomous science. He based his work on the untenable hypothesis that the Pythagorean concept of the world was based on the Cabalistic book of creation. The Sefer Yezirah is about the ten primal numbers, the Sephiroth, which are linked in the upper part of the diagram to the planetary orbits.

The Pythagorean Philolaos (c. 400 B.C.) referred to a counter-earth, which followed the same orbit as the earth, but was always on the opposite side and therefore invisible. Both bodies orbited around the central fire.

Albert Freiherr v. Thimus, Die harmonikale Symbolik des Altertums, Cologne, 1868

Genesis

According to Pythagoras, the structure of the world is based on the consonant intervals of the octave, the fifth and the fourth. The numbers of their proportions 2:1, 3:2 and 4:3 are the 'holy diversity' of the Pythagoreans, called the tetractys: 1+2+3+4=10. "Progress from oneness to the number four and the ten emerges, the mother of all things."

Within this formula lies the entire act of creation, from the splitting of the primal element into sexual duality, its propagation into the space-forming trinity, through to its completion in the four elements.

Robert Fludd, Philosophia Sacra, Frankfurt, 1626

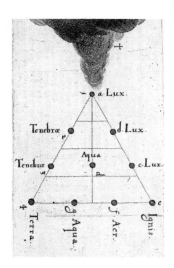

In the Cabala, the work of creation unfolds according to a similar pattern, in four steps starting with the letters of the tetragrammaton, the unpronounceable divine name: in alchemy too this fourfold step, the 'axiom of Maria Prophetissa', plays a leading part.

The tetragrammaton as a tetractys

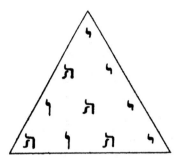

The tetractys also forms the basis of the image of the cosmic soul, to whose structure in the form of a Chi (X) Plato refers in the 'Timaeus'. In line with the law of the proportional division of the chord, the matrix of all earthly phenomena unfolds here as a network of coordinates of fractions and multiples.

The Pythagorean 'Chi'

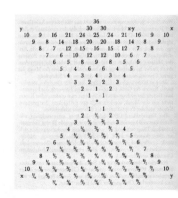

Genesis

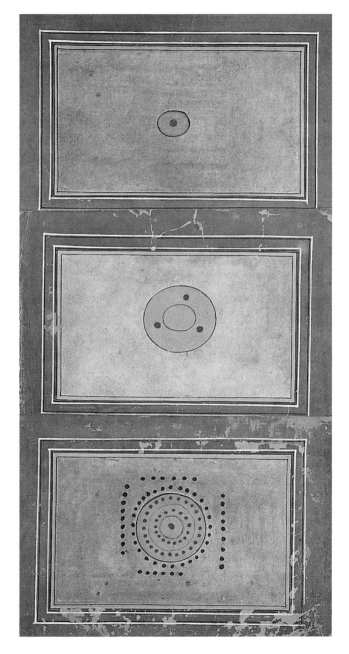

In the Tantric vision, an invisible power-point (bindu) produces the primal matter (prakriti), which consists of three qualities (gunas): sattva (essence, peace), rajas (energy, passion) and tamas (substance, inertia).

At the beginning of creation the three are in equilibrium; only their disharmony brings forth the world of diversity.

In *Finnegans Wake* Joyce draws a parallel between the gunas and Blake's four beings (Zoas, cf. pp. 652–653)

Painting, Rajasthan, c. 18th century

The tetragrammaton, the holy name of God with the four letters JHVH (Jehova), concentrates within itself all of the elemental strength and power from which creation arose. "The visible world, with its teeming creatures, is none other than the word transpired," wrote Böhme. All things arise out of combinations or rearrangements of these four letters.

Illustrating the magical meaning of the word in Hebrew, Gershom Scholem

quoted a rabbi's admonition to a Torah writer: "My son, be careful at your work for it is God's work; if you leave out but one letter or write but one letter too many, you destroy the whole world (...)". (G. Scholem, *On the Kabbalah and its Symbols*, New York, 1967)

Sephardi Bible, 1385

Successive utterances of the divine name produce the four worlds of Aziluth, Beriah, Yezirah and Assiya.

R. Fludd, Utriusque Cosmi, Vol. II, Frankfurt, 1621

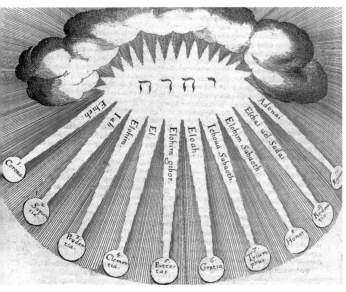

From the great tetragrammaton flow the ten "epithets" of God. These embody various aspects of the godhead, which in turn correspond to the ten primal numbers, the Sephiroth:

1. Crown
2. Wisdom
3. Prudence
4. Clemency
5. Power
6. Grace
7. Triumph
8. Honour (Fame)
9. Redemption
10. Kingdom.

R. Fludd, Philosophia Sacra, Frankfurt, 1626

Genesis

Three symbols of the Trinity

Ill. 1: Eye. The white: the Father, the iris: the Son, the pupil: the Holy Spirit

Ill. 2: Sun. The orb: the Father, the light: the Son, the heat: the Holy Spirit

Ill. 3: Storm. The consuming fire: the Father, the thunder: the Son, the lightning-flash: the Holy Spirit

Ill. 1 emphasizes the self-contained aspect of the divine Trinity as the original reflection of eternity, ill. 2 the life-giving aspect, ill. 3 the procreative aspect: the seed falls from the cloud.

R. Fludd, Utriusque Cosmi, Vol. II, Frankfurt, 1621

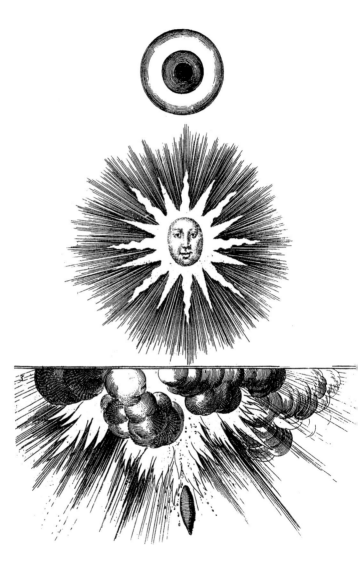

Yod as the crown (Kether) represents the hidden, original essence of God, *En-Sof*, is called the Infinite. *He* is the higher palace God's magnificent throneworld, *Vau*, is that which connects, the angelic world of forms. The lower *He* is equated with *Assiya*, the spiritual archetype of the material world.

For Jacob Böhme and other Christian Cabalists, the Tetragrammaton is an expression of the trinity: "The unity when the J. goes into itself into a threefold being (...) to an active life." (J. Böhme, *Quaestiones Theosophicae*)

R. Fludd, Utriusque Cosmi, Vol. II, Frankfurt, 1621

Genesis

And so on for ever

R. Fludd, Utriusque Cosmi, Vol. I, Oppenheim, 1617

For the Paracelsian Robert Fludd, the divine act of creation took on concrete and visible form as an alchemical process, in which God, as a spagyrist, divided primal, dark chaos, the *Prima Materia*, into the three divine, primary elements of light, darkness and spiritual waters. These waters, in turn, were the roots of the four Aristotelian elements, of which earth is the coarsest and the heaviest, comparable to the dark sediment, the "raven's head" that is left on the bottom of the retort in the process of distillation.

No wonder, wrote Fludd, that our planet i such a vale of tears, given that it has emerged from the sediment of creation, where the devil dwells.

"When the secret of secrets wished to reveal himself, he began to produce a point of light. Before that point of light broke through and became apparent, the infinite (en soph) was entirely hidden and radiated no light." (Zohar)

R. Fludd, Utriusque Cosmi, Vol. I, Oppenheim, 1617

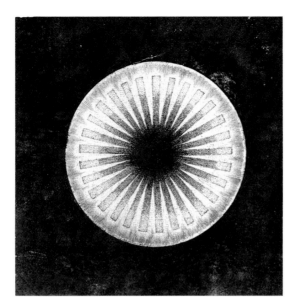

Light, the inexhaustible source of all things, appears in the darkness and with it the watery spirits that begin to divide into near (bright) and far (dark).

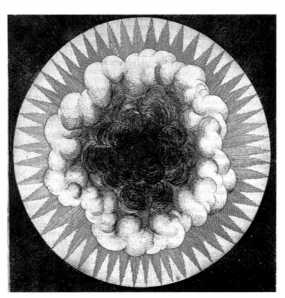

In the centre are the dark waters, far from the light, forming the source of matter; at the edge are the upper waters, from which the divine fiery heaven (Empyreum) will unfold. The bright cloud in between is a state "called variously the Earth-spirit, the Spirit of Mercury, the Ether and the Quintessence."

R. Fludd, Utriusque Cosmi, Vol. I, Oppenheim, 1617

Genesis

The chaos of the elements from the lower waters "is a confused and undigested mass in which the four elements fight against each other."

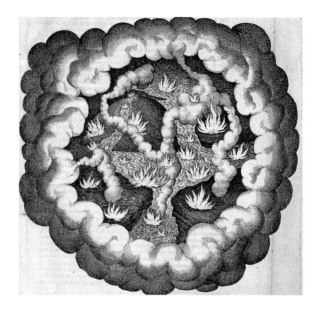

The ideal final state of material is achieved when the elements are arranged according to the degrees of their density: (from outside to inside) Earth, Water, Air and Fire. In the centre appears the Sun, gold.

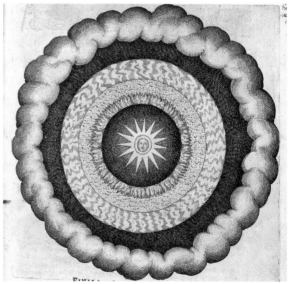

R. Fludd, Utriusque Cosmi, Vol. I, Oppenheim, 1617

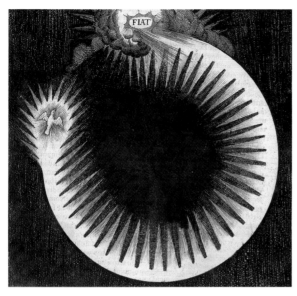

The first day of creation:

"Let there be light, said God; and forthwith Light/(…) Sprung from the deep; and from her native east/ To journey through the aery gloom began,/ Sphered in a radiant cloud, for yet the sun/ Was not (…)."
(John Milton, *Paradise Lost* 1667)

The dove is the spirit of God.

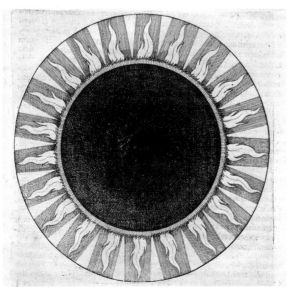

"The uncreated light of the spirit reflected in the sphere of the fiery firmament as in a mirror, and the reflections in their turn, are the first manifestations of created light."

R. Fludd, Utriusque Cosmi, Vol. I, Oppenheim, 1617

Genesis

The earth belongs to the lowest level of the elements, the sediment of creation.

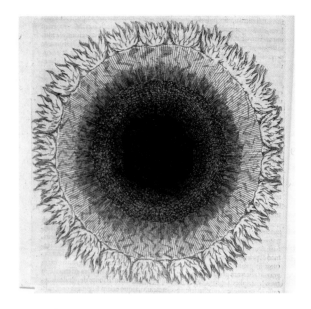

According to the proportions, the grossest element couples with the most subtle when the elements of air and water are produced.

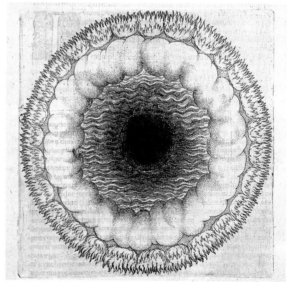

R. Fludd, Utriusque Cosmi, Vol. I, Oppenheim, 1617

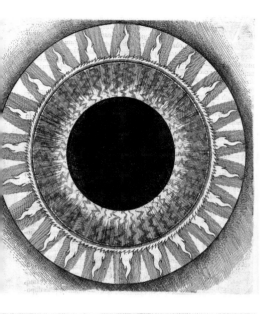

The second day

"And God said, Let there be a vault between the waters to separate water from water (...) And God called the vault Heaven." (Genesis 1, 6 and 8)

The ethereal sphere with the fixed stars and planets divides the upper waters (Empyreum) from the lower. In this sphere the upper heavenly quality (form) is in balance with the lower heavenly quality (material).

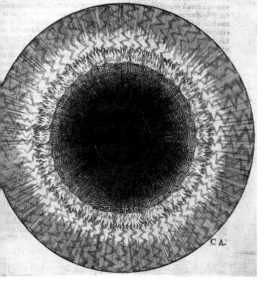

The third day

Fire arises as the first and most subtle element.

This is not, as Fludd stressed, the 'invisible fire' of the alchemists, but the material fire that Paracelsus called the 'dark' fire, which leads everything alive to destruction. Life in the Paracelsian sense is a process of destruction by fire.

R. Fludd, Utriusque Cosmi, Vol. I, Oppenheim, 1617

Genesis

The sequence by which the elements are ordered in an ascending degree of purity – earth, water, air and fire – is repeated in the structure of the entire cosmos from the sublunary, elemental heavens, the ethereal heaven to the empyrean.

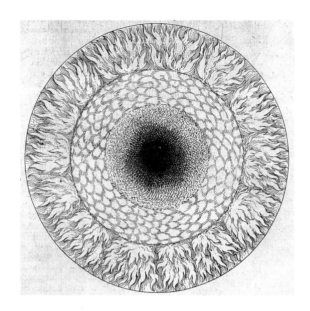

The stars on the outer edge of the ethereal sphere only became visible with the creation of the sun, for they store its light and after a space of time emit it again like phosphorous.

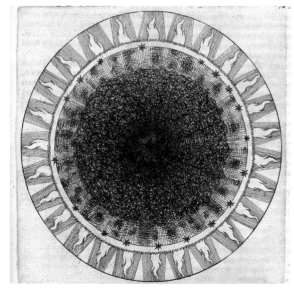

R. Fludd, Utriusque Cosmi, Vol. I, Oppenheim, 1617

Genesis

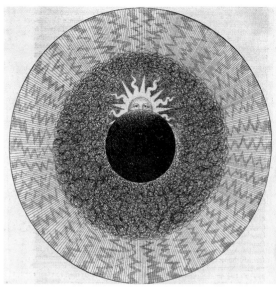

"The perturbations attendant on creation had caused some of the celestial light to be trapped in the cold mass of the central earth. Obeying the law of gravity, this celestial substance began to rise towards its rightful place in the heavens, and it was thus that our sun was formed."

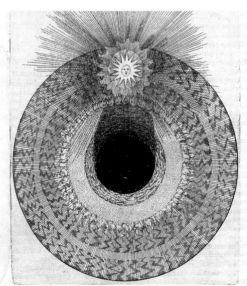

In the firmament the sun is the visible representative of the divine fire and of love. Its corresponding part in the human body is the heart, "which emits its vital rays (*the veins*) in a circle from the centre, and thus animates each individual limb". (Robert Fludd, *Philosophicall Key*, c. 1619)

R. Fludd, Utriusque Cosmi, Vol. I, Oppenheim, 1617

Genesis

When the sinking, hot rays of the sun encounter rising, watery steam, they condense and give rise to the planets.

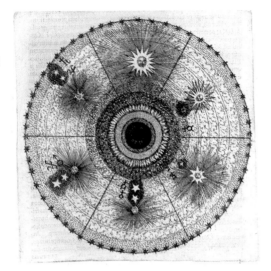

The spirit of God hovers as a dove above perfect creation, which is already menaced by the Fall. In the 'Tractatus apologeticus', Fludd emphasized that the chief goal of macrocosmic study must be to study the role of the divine spirit in creation, for without the light emanating from this spirit, life is not possible.

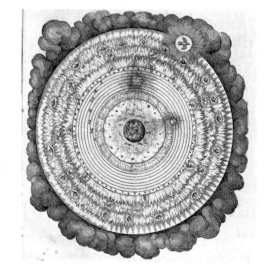

R. Fludd, Utriusque Cosmi, Vol. I, Oppenheim, 1617

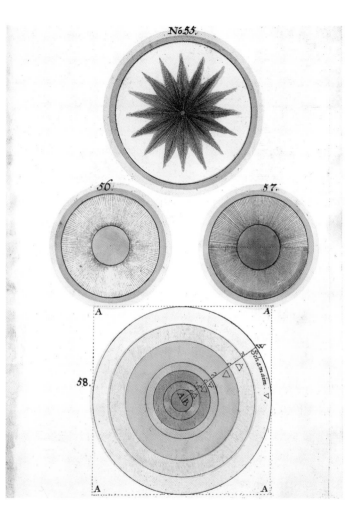

The emergence of the earthly world from the "dark and gloomy waters", from the chaos (No. 55) in which Lucifer-Saturn was imprisoned after his fall from the heavenly world of light. After the division of light and darkness (No. 56 + 57), God (Elohim) created the seven elementary regions of the universe from the outermost fiery waters of light (Shamayim) to the innermost central fire, the "grim mire", in which Lucifer dwells until the day of judgement.

Georg von Welling (pseudonym of Gregorius Anglus Sallwigt), Opus mago-cabalisticum, Frankfurt, 1719

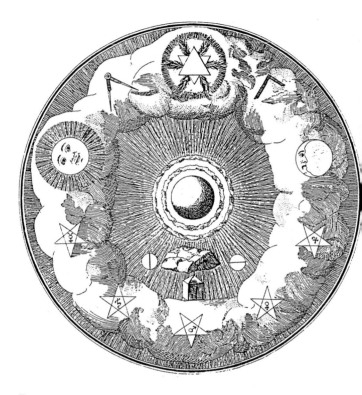

The underlying plan of this Masonic tapestry is the circle with a point at the centre, the sign of gold. The earth in the centre signifies the 'true lodge' which must be established, the sounding of the spiritual, inner space. The compass and the set-square stand for reason and conscientiousness at work. According to Kirchweger, the two signs ⊕ and ⊖, nitrum (saltpetre) and alkaline salt embody the dual principles of male and female, mind and spirit, active and passive. These are to be united via seven planetary stages of sublimation, thus transforming the 'red stone' (*Prima Materia*: apprentice) into the 'sculpted stone' (final state: lapis).

Die Theoretischen Brüder oder zweite Stufe der Rosenkreutzer..., Regensburg, 1785

osmological depiction of the alchemisti-
al Work in the form of an eyeball. From
e pupil, the macrocosmic chaos of four
ements, the spherical lapis emerges as
e renewed, smaller world. The arms that
ise it up are "the two major parts of the
Work, the dissolution of the body (solve)
nd the hardening of the spirit (coagula)".
ed and white water pours from the rebis,
e twofold aspect of material, to form
e viscose, vitreous body of the cosmic
ye, the sea of time and space.

The bird represents the phases of the
Work. It is composed of the raven (putre-
factio), the swan (albedo), the peacock
(phase of bright colours) and the phoenix
(rubedo).

In this instance the Pythagorean tetraktys
forms the optic nerve.

*H. Khunrath, Amphitheatrum
sapientiae aeterna, 1602*

Eye

In the medieval view, the eye consisted of three different forms of condensation of physical fluid. According to the theory of the Arabian scholar Avicenna (980–1037), an icy fluid forms the centre of the eye. In front of it is the watery area, behind it the crystalline area. It is clad in seven robes or skins (tunicas), to which the seven planetary spheres correspond in the macrocosm. The Cabalists connected this ten-part structure of the eye with the Sephiroth. The blind spot was a term applied to the highest Sephira "Kether", the crown, or the divine void in all things.

Gregor Reisch, Pretiosa Margarita, Freiburg, 1503; Basle, 1508

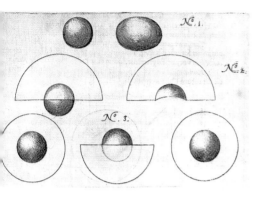

The composition of the eye according to Fludd:

1. The ice-like, lens-shaped area is transparent and of medium hardness.

2. The watery, whitish area surrounds the first as the egg-white surrounds the yolk.

3. The glass-like, gleaming area supplies the first two with nourishment from the blood.

R. Fludd, Utriusque Cosmi, Vol. II, Oppenheim, 1619

...) the eye of man (is) an image of the
world and all the colours in it are arranged
circles. The white of the eye corres-
nds to the ocean, which surrounds the
hole world on all sides; a second colour
the mainland, which the ocean sur-
unds, or which lies between the waters;
hird colour in the middle region:
rusalem, the centre of the world. But a
urth colour, the vision of the whole eye
elf (...) is Zion, the midpoint of every-
ing, and visible within it is the
pearance of the whole world." (Zohar)

*Fludd, Utriusque Cosmi, Vol. II,
penheim, 1619*

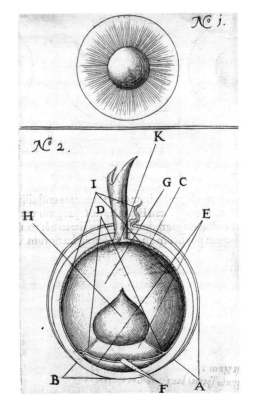

Eye

ADAM SPACE (ANATOMY OF EYE)
RETINA AS EDEN
LINES OF PERCEPTION AS VORTEX
CHAMBER OF VITREOUS-HUMOR AS BEULAH
CONVEXITY OF LENS AS ROCK OF AGES
IRIS AS ALLAMANDA (POLYPUS)
LENS AS GOLGONOOZA (CONCAVITY)
CHAMBER OF AQUEOUS HUMOR AS BOWLAHOOLA
LENS AS MUNDANE SHELL MICROCOSM
POINT OF FOCUS AS COUCH OF SATAN
UDAN-ADAN
ENTUTHON BENYTHON
ULRO
MUNDANE EGG
SATAN SPACE (PERCEIVED SPACE)
LINES OF PERCEPTION AS VORTEX

Large parts of William Blake's poetry are concerned with a detailed engagement with Isaac Newton's materialist view of the world, particularly his optics. In Blake's view the physical eye is dull and dim "like a black pebble in a churning sea", and the optic nerve, to which Newton pays homage, "builds stone bulwarks against the raging sea". (Blake, *Milton*, 1804) Blake instead turned to the work of Jacob Böhme, and attempted to develop an optics of the visionary.

According to the hypothesis of Easson an Easson, which fails to take into account many aspects of the poetry, every level of Blake's poem 'Milton' is based on an optical model, inscribed within the form of the cosmic egg.

K.P. Easson and R.R. Easson, A hypothetical model for the visionary geography in 'Milton', from: W. Blake, Milton, London, 1979

The astronomer and mathematician John Dee (1527–1608) used the egg as a glyph for the ethereal heavens, because the orbit of the planets within it forms an oval (Even Copernicus assumed that planetary orbits were circular.)

For Paracelsus "the sky is a shell which separates the world and God's heaven from one another, as does the shell the egg". "The yolk represents the lower sphere, the white the upper; the yolk: earth and water, the white: air and fire". (*Paragranum*, 1530)

John Dee, Monas Hieroglyphica, Antwerp, 1564

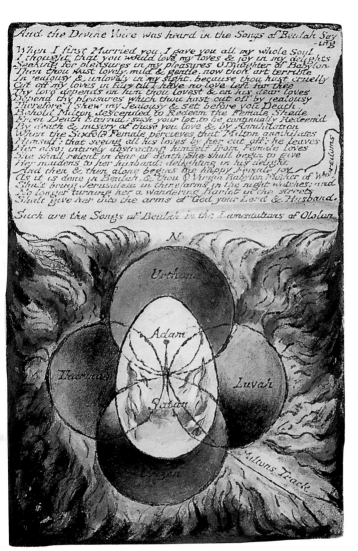

The four intersecting globes are inscribed with the names of the four *Zoas*, the apocalyptic creatures that represent the elemental forces of the universe. *Urthona/Los* is the imagination, *Luvah* passion, *Urizen* reason and *Tharmas* the body.

"The egg-shaped world of Los", which swells from the swirling centre of chaos, forms the illusory three-dimensional space defined by the two boundaries of opacity (Satan) and material condensation (Adam). They obstruct man's free vision of things as they really are according to Blake, namely eternal and infinite.

W. Blake, Milton, 1804–1808

Cosmic egg

Hildegard von Bingen's vision of the cosmos

"Then I saw a huge object, round and shadowy. Like an egg it was pointed at the top (...). Its surrounding, outer layer was bright fire (*Empyreum*). Beneath this lay a dark skin. In the bright fire hovered a reddish, sparkling fireball (the *Sun*)". Beneath the dark skin she saw the ethereal sphere with moon and stars, and beneath this a zone of mist which she called the 'white skin' or the 'upper water'.

Hildegard von Bingen, Scivias (Rupertsberg Codex), 12th century

SCHEMA GLOBI TERR=AQUA=AEREI

The genesis of the world of the elements between the celestial world of light and the chaotic underworld. Johann J. Becher (1635–1682) described the interplay of the elements as follows: "Earth thickens and contracts, water breaks down and purifies, air makes fluid and dries, fire divides and completes".

The engraving is inspired by illustrations from Kircher's *Mundus subterreaneus* (2 vols, 1665, 1678) (cf. p. 179). These show a subterranean central fire linked directly to volcanoes and underground waters which feed the superterrestrial seas.

J.J. Becher, Opuscula chymica, Nuremberg, 1719

Opus Magnum

In reference to the divine work of creation
and the plan of salvation within it, the alchemistic
process was called the 'Great Work'. In it,
a mysterious chaotic source material called
materia prima, containing opposites still
incompatible and in the most violent conflict, is
gradually guided towards a redeemed state of
perfect harmony, the healing 'Philosophers' Stone'
or lapis *philosophorum*: "First we bring together,
then we putrefy, we break down what has been
putrified, we purify the divided, we unite the
purified and harden it. In this way is One made from
man and woman."
(Büchlein vom Stein der Weisen, 1778)

Genesis
in the retort

"It ascends/ saith Hermes Trismegistus in his Emerald Tablet/ from Earth to Heaven: by which words the circulating distillation is most beautifully explained/ as also this/ that the Chymical Vessel/ is made or arranged in the same way as the natural Vessel. For we see/ or find/ that the whole Heavens/ and the Elementa are like a sphere round and sweet in nature/ in whose mid-point or innermost essence the heat of the subterranean Fire is very strong and powerful/ which drives the more subtle matter of the Elements upwards into the Air/ and at the same time rises upwards itself." (Conrad Horlacher, *Kern und Stern*, Frankfurt, 1707)

"Place this in the right oven of the philosophers/ and seal it in a constant and ever-changing prison/ which should be quite transparent/ light and clear like a crystal and round in shape like a celestial sphere. (...) But this heaven of yours must be kept safe with three bulwarks and walls (triple oven)/ so that not more than a single entrance/ is well-guarded: for the celestial city will be besieged by earthly enemies." (anonymous, *Nodus Sophicus Enodatus*, 1639)

"But it is necessary that the vessel be round in shape, so that the artist may transform the firmament and the top of the skull." (*Theatrum chemicum*, 1622)

"The (Philosophers') Stone is made in the image of the Creation of the World. For one must have its chaos and its prime matter, in which the elements float hither and thither, all mixed together, until they are separated by the fiery spirit. And when this has happened, the light is lifted up, while the heavy is brought downwards." (J. d'Espagnet, *Das Geheime Werk*, Nuremberg, 1730)

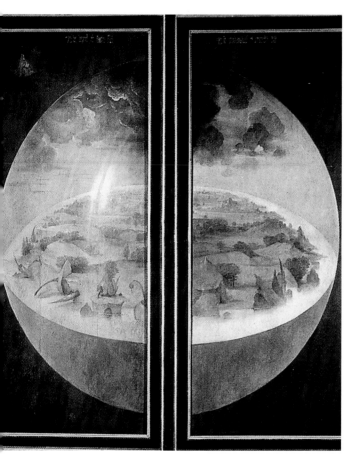

Genesis
in the retort

"The creation of
the world"

*Hieronymus Bosch,
outer wings of the
"Garden of De-
lights", c. 1510*

Genesis
in the retort

The following series of illustrations is taken from the *Elementa chemicae* of the Leiden chemistry professor J.C. Barchusen. He had them engraved from an old manuscript "to do a great favour to the adepts of gold-making". He was of the opinion that they described the production of the Philosopher's Stone "not only in better order, but also with a more correct emphasis" than anything else that he had seen hitherto.

In order to attain the lapis, the alchemist had to make a fundamental decision on which path to follow: a short "dry" path, in which the separation of the matter took place under the influence of external heat and the involvement of a secret "inner fire", and a "wet" path, which was much longer and only led to its goal through many distillations. The latter is illustrated here.

The main role in this process is played by the philosophical Mercury, not ordinary quicksilver, but a mysterious substance whose origins are entirely shrouded in darkness.

The material spirit is extracted from it. The legendary *Azoth* comes, as the agent of the Work, in the form of a dove. Like the doves that Noah sent forth to learn whether the waters had abated, it only ends its flight when the lapis is finally fixed.

Its twenty-seven-fold flight upwards and downwards here and in a related series of illustrations corresponds, in William Blake's mythology, to the flight of the twenty-seven larks, which act as bearers of conventional ideas. Only the twenty-eighth brings enlightenment and an escape from the retort's restricted field of vision. It is destroyed when the lapis is complete.

The commentaries on the individual illustrations follow the explanations provided by Barchusen.

He himself, by his own account, was never witness to a transmutation, and repeatedly declared that in all his instructions he had to rely entirely on speculation.

Genesis in the retort

The emblems of the lapis on the crescent moon. Normal gold (lion) must be twice driven by anti-mony (wolf) in order to lose its impurities. The dragon is philo-sophical quick-silver (Mercury).

2. The alchemist assures himself of God's presence in the Work.

3. Chaos.

4. The coat of arms of the lapis.

5. The four ele-ments.

*J.C. Barchusen,
Elementa chemi-cae, Leiden, 1718*

Genesis
in the retort

6. The chamois represent spirit and soul, which unite to form philosophical mercury.

7. The six planets embody the metals to which the bird mercury is related. The locked trunk says that the path to this quicksilver is hidden.

8. The inner circles are the four elements, which form the basic material of the seven metals (fixed stars).

9. Sulphur (sun) and mercury (moon), male and female.

J.C. Barchusen, Elementa chemicae, Leiden, 1718

Genesis in the retort

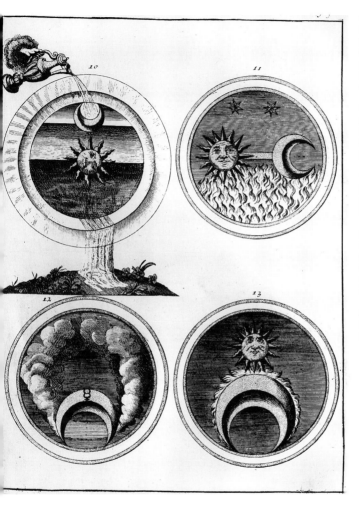

10. Through contact with the moon and the sun, philosophical mercury attains the power of fertilizing the earth.

11. Sulphur and mercury must be freed by fire from the material which contains them.

12. Purification of philosophical mercury by sublimation.

13. Philosophical mercury is joined once more to its sulphur, so that a homogenous liquid is produced.

J.C. Barchusen, Elementa chemicae, Leiden, 1718

Genesis
in the retort

14. Gold (lion) is purified by mixture with antimony (wolf).

15. and transformed by dissolution into philosophical sulphur

16. The oven.

17. The retort in which sulphur and mercury are united.

J.C. Barchusen, Elementa chemicae, Leiden, 1718

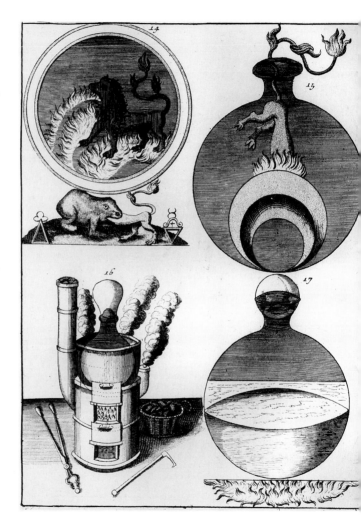

Genesis
in the retort

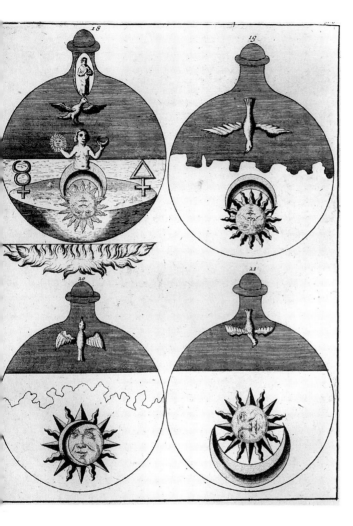

18. Philosophical quicksilver consists of liquid, mercurial components (Azoth) and solid sulphurous parts (Latona). The bird is the mercurial "spirit" that carries out the Work.

19–21. The state of putrefaction: here the four elements separate and the soul emerges from the body. The ascending bird represents the distillation of philosophical mercury. The descending bird indicates that the distillate must be repeatedly poured on to the physical residue.

J.C. Barchusen, Elementa chemicae, Leiden, 1718

Genesis in the retort

22.–23. The blackness of putrefaction (nigredo) is purified by Azoth, the living spirit, which is extracted from the quicksilver.

24.–25. Putrefaction is the gate to the *conjunctio*, and conception. It is the key to transmutation. The star indicates that the matter is self-enclosed, and that the seeds of the seven metals lie within it.

J.C. Barchusen, Elementa chemicae, Leiden, 1718

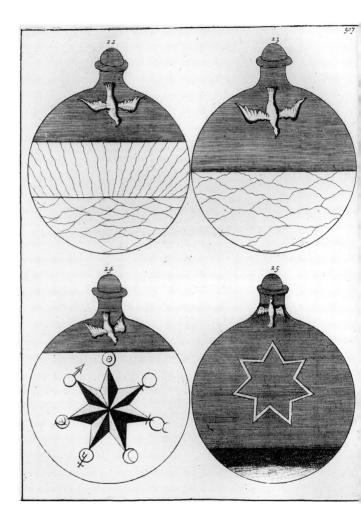

Genesis in the retort

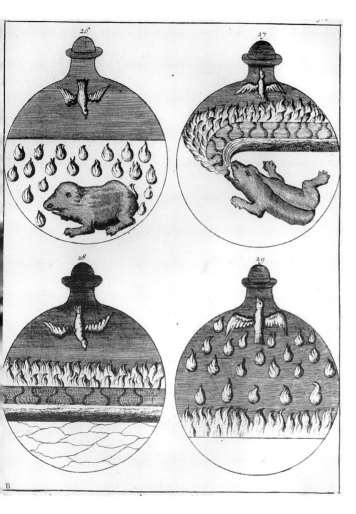

26.–27. The black material (toad) turns white if Azoth (dove) is poured on it again. With the application of great heat, it then yields all of its liquid components.

28.–29. Under the effects of heat the elements begin to restratify.

J.C. Barchusen, Elementa chemicae, Leiden, 1718

Genesis
in the retort

31.–33. The restratification of the elements in the glass occurs by repeatedly extracting the mercurial spirit and then pouring it back.

J.C. Barchusen, Elementa chemicae, Leiden, 1718

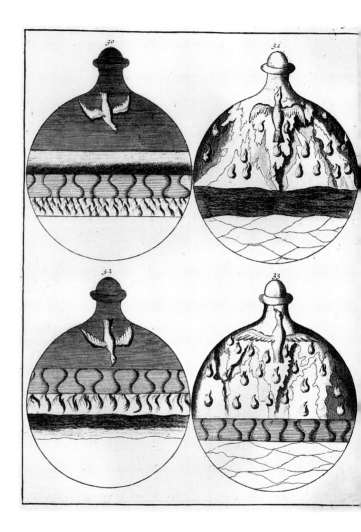

Genesis
in the retort

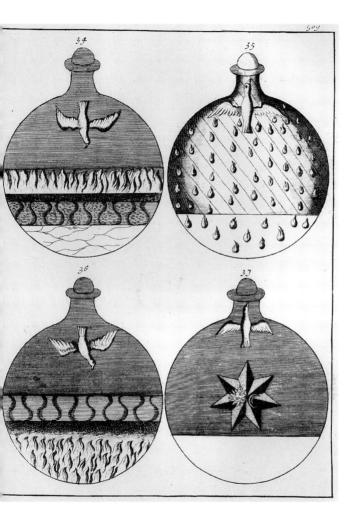

34.–36. In the seventh distillation the lapis attains its fiery nature.

37. The appearance of Apollo and Luna announces that the stone will soon have the capacity for transmutation.

J.C. Barchusen, Elementa chemicae, Leiden, 1718

Genesis
in the retort

38.–41. In the
ninth distillation
of philosophical
mercury the
watery matter,
followed by air,
strives upwards.

*J.C. Barchusen,
Elementa chemi-
cae, Leiden, 1718*

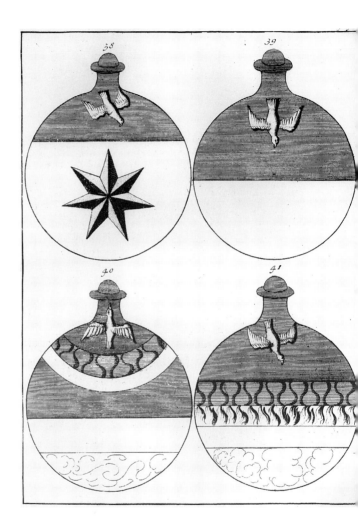

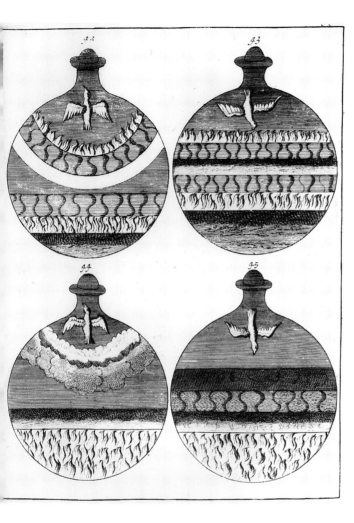

Genesis in the retort

42.–45. In the tenth distillation and the subsequent moistening the elements are divided in two.

The fiery nature of the lapis lowers itself to the ground. The water turns into clouds.

J.C. Barchusen, Elementa chemicae, Leiden, 1718

Genesis
in the retort

46. The final sublimation of the lapis. Here it is represented as a pelican, said to bring its dead young (the base metals) back to life with its own blood (tincture).

47. The final solidification (fixatio) of the lapis, which rises as a phoenix in the flames.

48.–49. The elements are united and the Work completed.

J.C. Barchusen, Elementa chemicae, Leiden, 1718

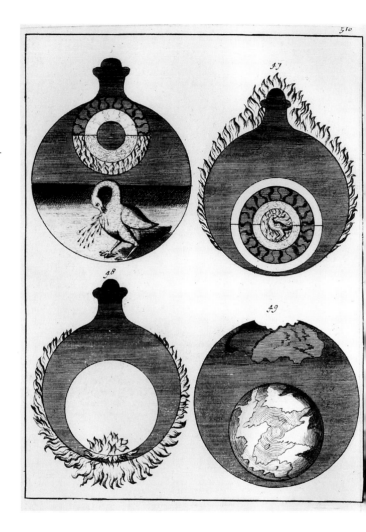

Genesis in the retort

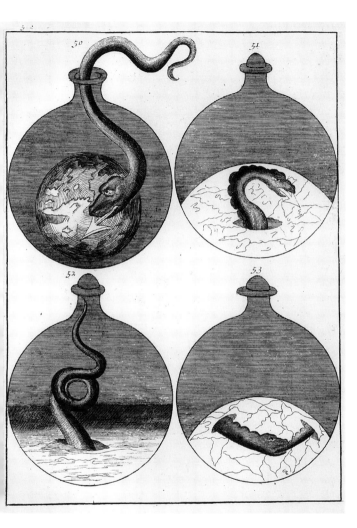

50.–53. The more transparent and subtle the consistency of the lapis, the higher its penetrative capacities and the greater its strength of colour. In order to intensify this, further sublimations occur: it is now fertilized with philosophical mercury (serpent), "until the serpent has swallowed its own tail" and the lapis is dissolved.

J.C. Barchusen, Elementa chemicae, Leiden, 1718

Genesis
in the retort

The dissolution of the lapis (54) and the repeated distillations or sublimations (55) and subsequent moistenings (56) lead to its final resolidification (57)

J.C. Barchusen, Elementa chemicae, Leiden, 1718

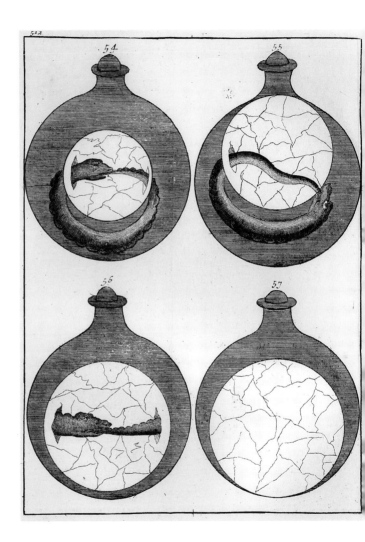

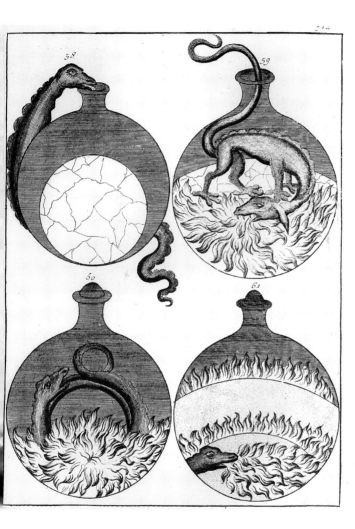

Genesis in the retort

Azoth is poured on once more (58), and the intensity of the fire is raised (59–60), for the soul must be "sweated out" (61).

J.C. Barchusen, Elementa chemicae, Leiden, 1718

Genesis
in the retort

62.–65. The lapis
must be burned
strongly and for a
long time.

*J.C. Barchusen,
Elementa chemi-
cae, Leiden, 1718*

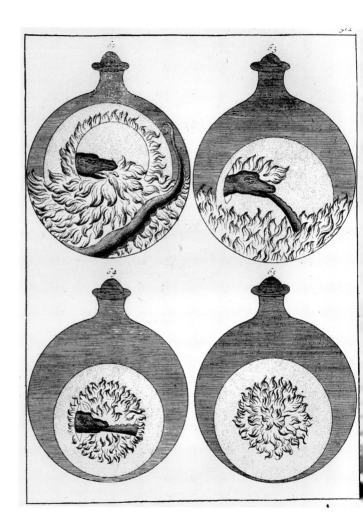

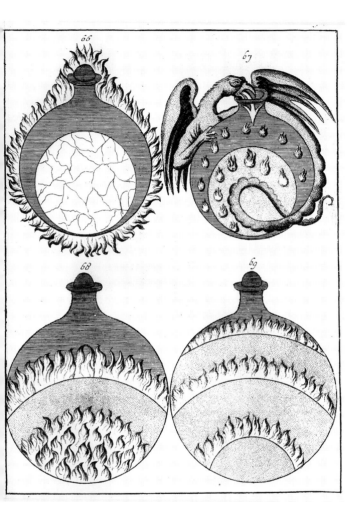

Genesis in the retort

67.–69. The mass is moistened again, because the more often the stone is distilled the greater is its capacity to penetrate and to colour (tincture).

J.C. Barchusen, Elementa chemicae, Leiden, 1718

Genesis
in the retort

70.–74. In a tor-
ture by fire lasting
several days,
the stone now
matures to its
perfection and
resurrection.

*J.C. Barchusen,
Elementa chemi-
cae, Leiden, 1718*

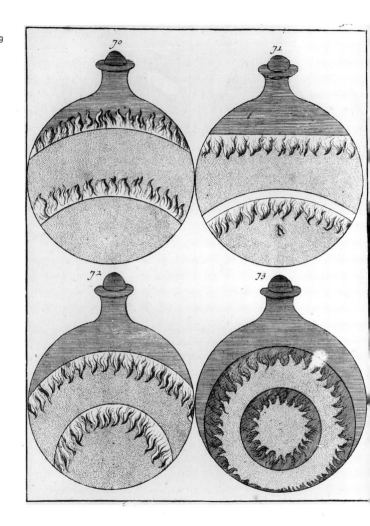

Genesis in the retort

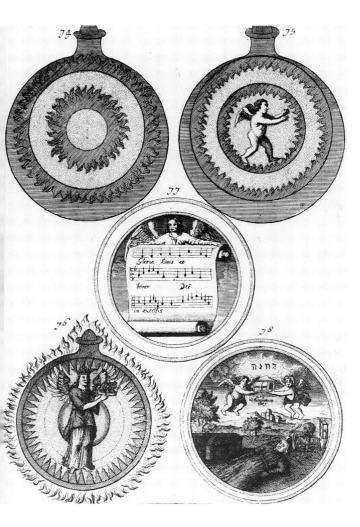

75.–78. "After much suffering and torment I was resurrected large, pure and immaculate."

Spirit and soul have now completely penetrated the body, father and son are united, transience and death have lost all their power.

J.C. Barchusen, Elementa chemicae, Leiden, 1718

The splendid illustrations with the seven glass retorts "hermetically" sealed are taken from the treatise *Splendor solis* (The sun's splendour") of Salomon Trismosin, a 16th century German alchemist, whose existence has not been historically proven.

In the anthology *Aureum vellus* (Rorschach, 1598), he tells of his travels, which led him to distant lands, where he encountered "cabbalistic and magic books" and the "whole treasure of the Egyptians", namely "the three powerful tinctures of the greatest pagan kings."

Just as unoriginal as this pseudo-biography is the way to the philosopher's stone that he indicated in 'Splendor solis'. This is only one of the countless compilations that were sold at the time, drawing on a limited fund of alchemistical legends, proverbs and doctrines. Goethe spoke in this context of the monotonous ringing of a bell, more likely to drive one into madness than to prayer.

The treatise is famous only for its illustrations, which exist in several versions. The earliest, from 1535, comes from Nikolaus Glockendon's Nuremberg book-painting workshop.

The following depictions of retorts refer only vaguely to passages in the text in which Trismosin speaks of the "governments of fire" which pass through the zodiac following the course of the sun. "When the Sun is in Aries, it shows the first degree" (weak heat); when it is in Leo, the heat rises to the zenith, and in Saturn it is restrained.

In the illustrations, the seven phases of the Work are also linked to astrological motifs, namely the depictions of the planet rulers and their children.

Life on earth was seen as the reflection or shadow of a celestial order. Every destiny, estate and profession came under the influence of a particular planet ruler. The school of Dürer further developed this canon of motifs of the children of the planets, which had been handed down from the Middle Ages.

Genesis in the retort

The sickle that Saturn holds in his hand indicates that he represents the restrictive sides of life. He is the portal of death (left), through which the raw material (earth, right) must pass. The incarnation of the solid principle also clutches the staff, or caduceus, of his adversary Mercury, showing that all opposites mysteriously cooperate in the Work.

In the retort, Mercurius fires up the "primaterial" dragon and gives it wings: that is, it begins to vaporize. The blood with which he feeds it is the universal spirit, the soul of all things.

S. Trismosin, Splendor solis, London, 16th century

...ild our dead dragon back up with blood, that it may live.

Genesis
in the retort

After the Satur-
nine restriction
Jupiter promises
good fortune and
wealth. His chil-
dren are the great
dignitaries of soci-
ety. The phase of
multiplication in
the Work is as-
signed to him. The
mass in the retort
is in a seething
transitional stage,
indicated by the
fighting birds,
clad in the three
colours of the
Work.

S. Trismosin,
Splendor solis,
London,
16th century

Genesis
in the retort

As the number of heads of the bird reveals, the matter has now been thrice sublimated, and is in a gaseous state. Bellicose Mars arrives. His attribute, the sword, and the warrior's lance are symbols of the fire that is now intensified so as to condense the material and "separate the pure from the impure and thus to renew the elixir."

*S. Trismosin,
Splendor solis,
London,
16th century*

ne dissolved bodies have now been brought back to the true spirit

Genesis
in the retort

The sun is the ruler of Leo, the sign of the zodiac, to whom, according to the inscription on the base, the matter should be thrown on the base as food. The green wings of the monster in Glockendon's original version support the thesis of Hartlaub (G.F. Hartlaub, "Signa Hermetis", in: *Zeitschrift des Deutschen Vereins für Kunstwissenschaft*, Berlin, 1937), that this is a representation of green vitriol, a highly corrosive sulphurous acid code-named "green lion". The phase of 'digestion' is assigned to the sun.

S. Trismosin,
Splendor solis,
London,
16th century

Give the wild lion to our living dragon to devour.

Genesis
in the retort

The arrival of
Venus in the sky
brings sensual
pleasure; a mag-
nificent play of
colours called the
"peacock's tail"
appears. Basil
Valentine said
that this phenom-
enon, like a rain-
bow, indicates
"that in future the
matter will come
from the moist
to the dry".
(*Philosophischer
Hauptschlüssel*,
Leipzig, 1718)

*S. Trismosin,
Splendor solis,
London,
16th century*

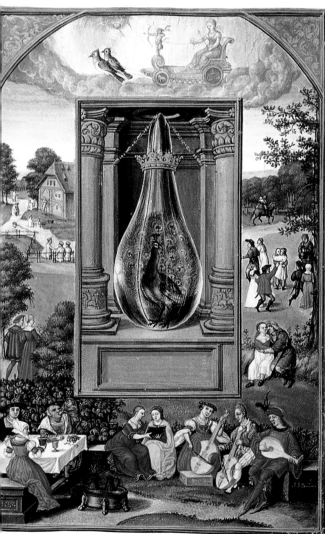

mpletion is nigh

Genesis
in the retort

Mercury arrives with two cocks, the heralds of the dawn. The pure virgin, embodying the phase of whitening (albedo), brings a happy message. Still subject to the moon and the night, she is already carrying the son of the Sun. The material, wrote Pernety in the *Dictionnaire mytho-hermétique* (1787), has now reached such a degree of solidity that no fire can destroy it.

S. Trismosin, Splendor solis, London, 16th century

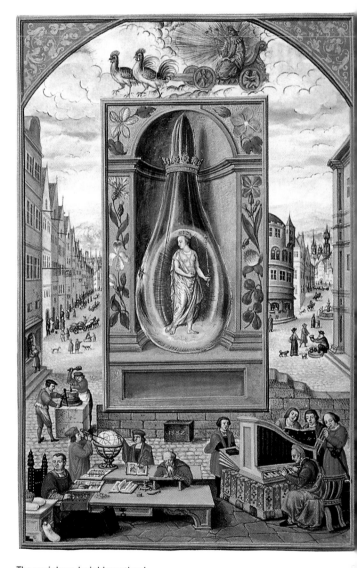

The son is born, he is bigger than I

Genesis in the retort

Luna, who governs all things moist, gives birth to the immaculate purple-robed king: red tincture, the universal medicine that can heal all afflictions. "Here the worker's efforts cease". A state has been attained which abolishes the passage of time. The power of the planetary demons is thus broken.

S. Trismosin, Splendor solis, London, 16th century

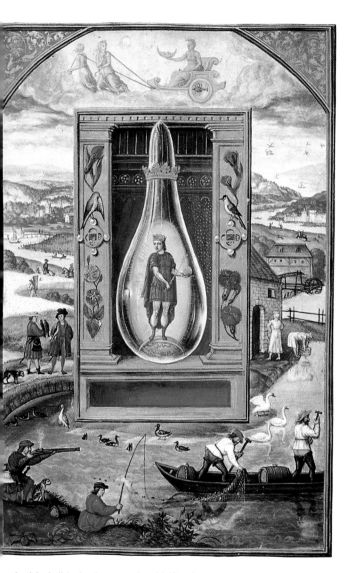

w death is abolished and our son rules with his redness

The alchemist Lambsprinck, with his three-towered *Athanor* (Arabic at-tannur, oven), the alchemists' oven, also known as "fourneau cosmique" or "Fauler Heinz". It had to be constructed in such a way that over a number of weeks it provided "a continuous although uneven fire". Also important was the "little glass window", so that the change of colours during the process could be observed. For this indicated the beginning and ending of the individual phases and thus also informed the alchemist about the "governments of fire".

Lambsprinck, De Lapide philosophico, Frankfurt, 1625

Purification

De fornace anatomica.

III. left: anthro-
pomorphic oven

*G. Dorn, Aurora,
Basle, 1577*

III. right:
the Athonor as a
matrix

*Andreas Libavius,
Alchimi, Frankfurt,
1606*

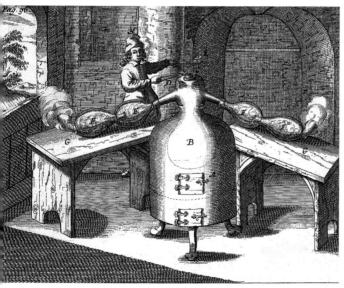

Distillation oven
with connecting
condensation
retort after
J.R. Glauber
(1604–1670).
Glauber was the
"Paracelsus of the
17th century",
famous for his
preparation of
sodium sulphate,
known as "Glauber
salt". In it he saw
the opening of
the great arcanum,
the "Elias Artista"
prophesied by
Paracelsus.

*J.R. Glauber,
Von den Dreyen
anfangen der
Metalle, 1666*

Purification

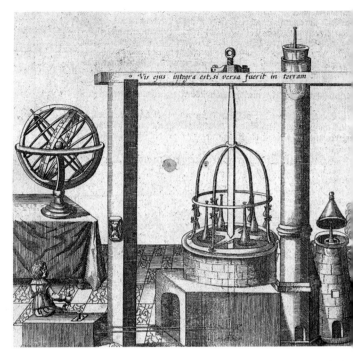

"It was a threefold large oven/ fitted inside with a number of glasses/ and each piece was in its proper place/ in each/ was a milling chaos or the sanctified gift of God/ like the whole, wide world/ and in the midst of the implements/ one could see an Earth/ with beautiful, clear water poured over it. From it sprouted forth/ many hills and salt-sand cliffs with their own fruits/ (…) the waters also crashed and roared/ in the middle/ like the big sea/ (…) The oven (…)/ was made after three perpendicular motions/ (…) a three fold/ yet a single oven/(…)."

Oswald Croll, Chymisch Kleinod, Frankfurt, 1647

The heat-giving Athanor was seen as the male element; the receptive, pot-bellied retort (Latin cucurbit, gourd) as the female elements. The "Chymical Wedding" occurs both outwardly and inwardly.

Cosmic oven, Annibal Barlet, La theotechnic ergocosmique, Paris, 1653

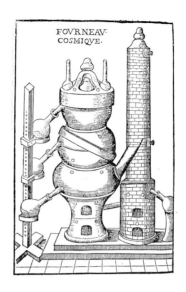

"If I have performed alchemy, then it was in the only way that is reliable today, namely unwittingly". (Marcel Duchamp; quoted by Robert Lebel, *Duchamp – Von der Erscheinung zur Konzeption*, Cologne, 1962)

Marcel Duchamp, Chocolate-grinder No. 2, 1914

Purification

A marks the flue area, and C the fireplace of the oven.

B is divided into an upper area where distillation occurs; the lower half holds the balnea, the water-baths for the retorts. It also holds an iron pan for the calcination (ashing) of the metals.

D is attached to the floor.

D.J. Faber, Die hell-scheinende Sonne, Nuremberg, 1705

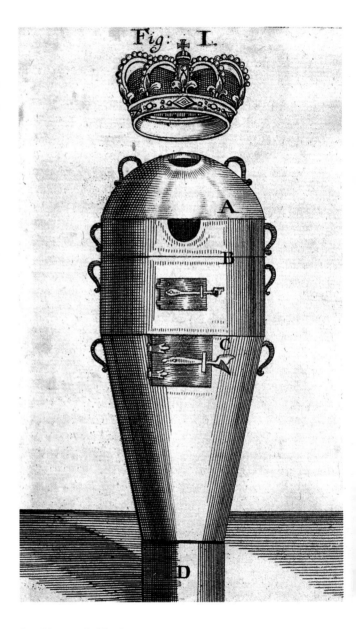

Fig: I.

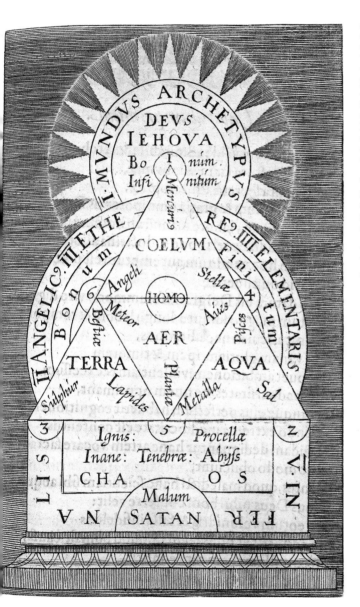

A diagram of the cosmos in the form of an oven from Thomas Norton's famous alchemistic poem "Ordinall of Alchemy" (1477), contained in Elias Ashmole's anthology *Theatrum chemicum Britannicum* (London, 1652).

The fireplace represents the sphere of hell, the abyss, chaos. Evil is waste, ash.

Thomas Norton, Tractatus chymicus, Frankfurt, 1616

Purification

"You must know, my son, that the course of nature is transformed, so that you (...) can see without great agitation the escaping spirits (...) condensed in the air in the form of various monstrous creatures or people moving hither and thither like clouds." (R. Lull, *Compendium in Bibliotheca chemica curiosa*, Vol. I, Geneva, 1702)

"But the philosophers have described this 'spirit' and this 'soul' as 'steam' (...), and as there is moisture and dryness in man, our work is nothing but steam and water." (*Turba philosophorum*, Berlin, 1931)

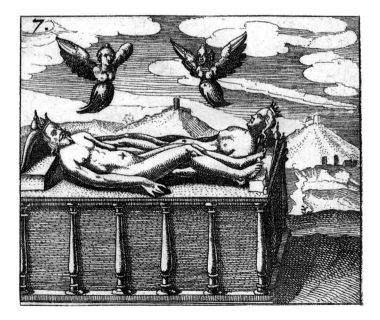

Ill. top: Aurora consurgens, early 16th century

D. Stolcius von Stolcenberg, Viridarium chymicum, Frankfurt, 1624

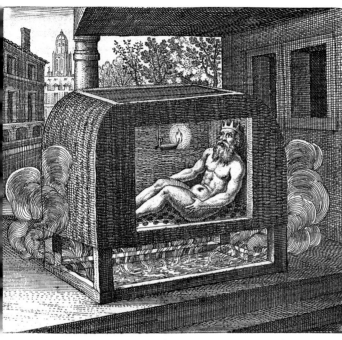

King Duenech (code name for the green vitriol of the philosophers: the raw material) is seen here in a vessel called a "balneum", which is being heated in the oven. He is taking a "sweat-bath", which is supposed to free him from the "black gall", the "Saturnine filth". The process lasts "until the skin breaks and a red colour appears".

M. Maier,
Atalanta fugiens,
Oppenheim, 1618

"Taking a sweat-bath with Saturn" meant seeing our passage through the earthly vale of tears as a process of purification, at the end of which lay the overcoming of the raw nature of the "old Adam".

W. Blake, Death Door, from: Gates of Paradise, 1793

Purification

"Then, as in a
furnace, the fire
draws out of
matter and divides
what is best,
spirit, mind, life
(...) leads it up-
wards, takes the
topmost by the
helmet, holds fast
to it and then
flows downwards
(...), the same as
God will do on the
Day of Judgment;
with a fire He will
separate every-
thing, and divide
the just from the
godless. The Chris-
tian and the just
will go to heaven
and dwell in it for
ever; but the god-
less and the
damned will stay
in hell as broth and
yeast." (Martin
Luther, *Tischreden*)

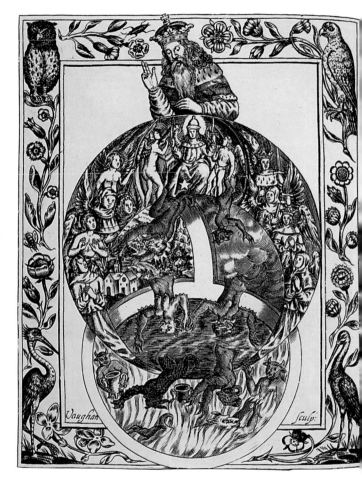

*Theatrum
chemicum Britan-
nicum, London,
1652*

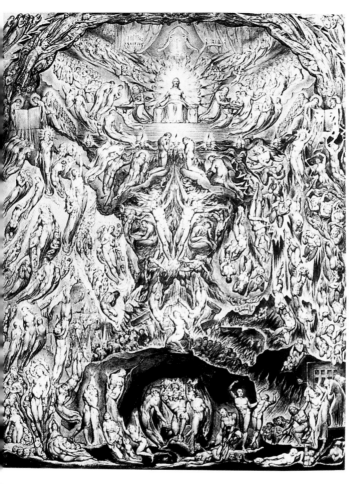

W. Blake, *Last Judgement, 1808*

"When Imagination, Art & Science go, all Intellectual Gifts, all the Gifts or the Holy Ghost, are look'd upon as of no use & only Contention remains to Man, then the Last Judgement begins." With these words Blake introduced a detailed commentary on the painting of the same name, in which he gives a precise explanation of the countless figures depicted in it. "If the Spectator could enter into these Images in his Imagination, approaching them on the Fiery Chariot of his Contemplative Thought (…) then would he arise from his Grave, then would he meet the Lord in the Air & then he would be happy." (William Blake, *A Vision of the Last Judgement*, 1810)

Fall of Adam

"The Father indig-
nant at the Fall –
the Saviour, while
the Evil Angels are
driven, gently con-
ducts our first par-
ents out of Eden
through a Guard of
weeping Angels –
Satan now awakes
Sin, Death & Hell,
to celebrate with
him the birth of
war and Misery,
while the lion
siezes the Bull,
Tyger, the Horse,
the Vulture and
the Eagle contend
for the lamb."
(Inscription on the
reverse of the
drawing, 1807)

*W. Blake, The Fall
of Man, 1807*

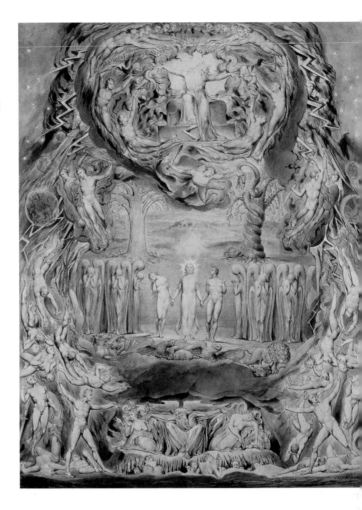

The celestial revolt of arrogant Lucifer, his subsequent banishment to the dark abyss and the fall of Adam, causally linked to it, form the starting point of Hermetic philosophy. For these two cosmic catastrophes produced the 'primaterial' chaos of the elements, which forms the starting material for the Work.

The artist faces the superhuman task of bringing this 'dark lump' back to its original paradisal state through complete sublimation. "It is clear that the Earth as originally made by God was quite complete and perfect and also like the nature and virtue of the philosopher's stone (...). When man fell, God grew angry and cursed the red earth (Adam derives from the Hebrew: Adamah, 'red earth'. This was seen as a reference to the red of the lapis), he destroyed its intrinsic proportions, turned the homogeneity into heterogeneity and changed it by taking the elements into an offensive conflation of material: from which follow corruption and death." (Julius Sperber, in: *Deutsches Theatrum Chemicum II*, Nuremberg, 1730)

According to the mystic Jacob Böhme, writing in the early 17th century, it was Lucifer who had lit the fire in nature through inciting God's wrath with his arrogance, and "sweet love, which arose in the thunderbolt of life (...) became a sting of death; clay became a hard knocking of stones, a house of misery". (Böhme, *Aurora, 1612*)

The fall of Adam drew with it the fall of man from an original, inner unity into the external world of opposites. According to Cabbalistic teachings, taken up by Paracelsus and Böhme, the Ur-Adam was androgynous: "he was a man and a woman at the same time (...) quite pure in breeding. He could give birth parthenogenically at will (...) and he had a body that could pass through trees and stones. The noble lapis philosophorum would have been as easy for him to find as a building stone." (Böhme, *Vom dreyfachen Leben, Amsterdam, 1682*)

The feminine that was essential in Adam, before it was separated from him in sleep, was his heavenly spouse Sophia (wisdom). Blake calls her "Emanation".

After Adam had "imagined" himself into the outside world in the Fall, thus forfeiting his astral light-body for the fleshly "larva",

his companion and matrix left him. Since then his existence has been shadowy and unreal, a ghost (spectre, the male side).

The high level of abstraction of Jacob Böhme's ideas and his hallucinatory linguistic form inspired several series of illustrations by the London-based Nuremberg theosophist Dionysos A. Freher (1649–1728), which Blake ranked with the pictorial discoveries of Michelangelo. The following emblems on the fall of Lucifer and the fall of Adam are part of the *Hieroglyphica Sacra* (or Divine Emblems), which were published in 1764 as an appendix to the four-volume English edition of Böhme's writings by William Law.

The starting situation shows the residence of the divine trinity including the flames of the heavenly host. They are divided into the hierarchies of the archangels Michael (M) and Uriel (U). The third and topmost is unoccupied, for its previous occupant, the representative of Jesus, has committed high treason by his wilfulness.

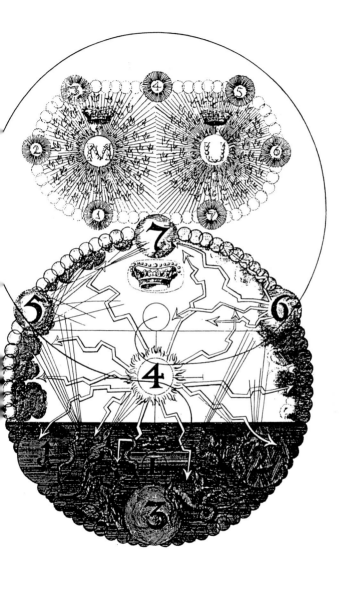

Fall of Adam

Lucifer ascends, driven upwards by his proud wilfulness, but Michael and Uriel cast him down through the fire (4).

The seven numbers refer to the seven source spirits of God. According to Böhme they embody the seven qualities of all things and the seven powers at work in every natural process. Here Freher shows how they divide, like a cell, into a dark sphere of wrath and a light sphere of love. The fourth spirit, fire, is the pivot and central point of this separation.

Fall of Adam

The symbol for the work of reunification ☿, which is known in India as the Sri-Yantra, meaning the complete interpenetration of the sexes, was seen by the pupils of Böhme as a symbol of Christ, since he, as a second Adam, restored Adam's primal androgyny. "For this reason, Christ became human in the woman's part and brings the man's part back into the holy matrix." (Böhme, *Mysterium Magnum*)

This enabled him to travel downwards, to break down the portals of hell, defeat death, rise up and thus fulfil the prophesy in Micah 2, 13: "So their leader breaks out before them ... and the Lord leads the way."

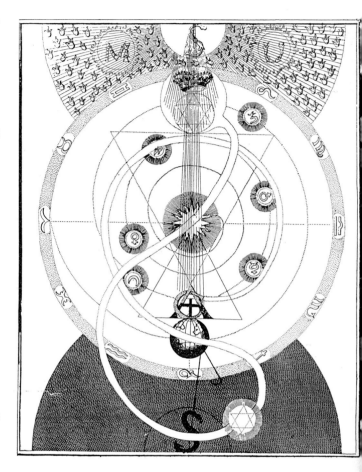

Fall of Adam

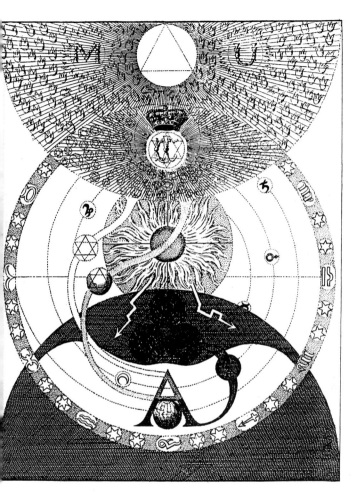

The "serpent-treader" is now enthroned in the third hierarchy, which has remained unoccupied since Satan's fall. He, himself the Moses serpent of healing, the true tincture, has broken the power of the cunning snake: the gates of Paradise are open once more, and according to the level of their perfection in life, the souls encounter more or less large obstacles on their crossing.

At the centre, the "salnitric fire" rises as a flash of recognition. It is the secret salt-fire of the alchemists.

Fall of Adam

With his rebellion, Lucifer had brought his new dwelling-place into such a chaotic state that God created the visible and tangible world from it in six days. But because of its provisional and temporal nature, it is unattractive to Lucifer and he leaves it. So, as a new governor, Adam is created as a "compendium of the whole universe". The seven spirits manifest themslves as planetary forces which form the "wheel of anguish" of outer nature".

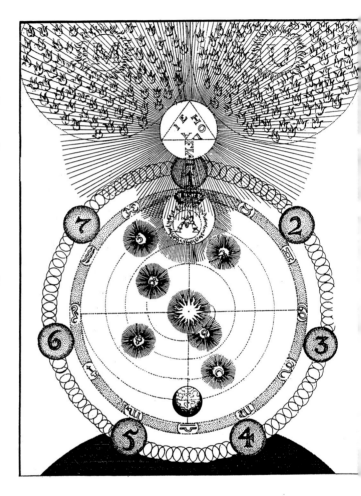

Fall of Adam

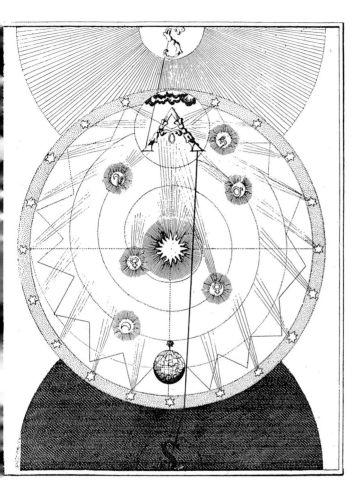

Adam, created in a state of purity and perfection, is at the point of intersection between the divine world of angels and the dark world of fire. Three creatures make claims on him: 1. Sophia (S), the companion of his youth, 2. Satan (S) below him and 3. the spirit of this world, depicted here by the astral influences. In order to force him to a decision, there follows the temptation at the Tree of Knowledge.

The two S's, Sophia and Satan, are the two contrary snakes of the staff of Mercury (Caduceus) and must be united.

Fall of Adam

"Here poor Adam has actually fallen and has lost everything that was good and worth striving for. He lies as though dead at the outermost boundaries of the spirit of this world." Sophia has left him, because he faithlessly left her in the lurch. "He is completely in gloom and lies more under the earth than ruling over it: all the stars fire their influences at him." This was his state after the transgression, before he heard the word of mercy, "that the seed of the woman will tread the head of the serpent".

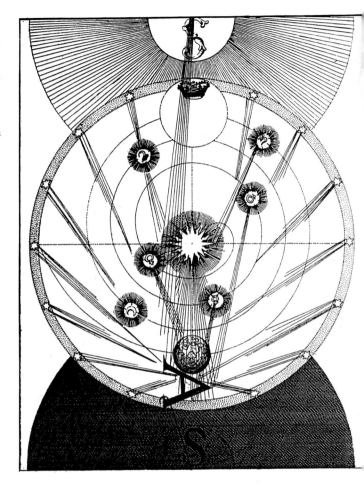

Fall of Adam

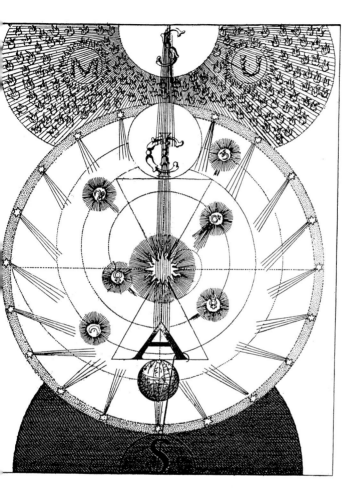

The word of mercy, whose name is JESUS, has brought him so far back up that he can stand on the base of a fiery triangle △ (his soul) on the terrestrial globe. Above him, the sign of the redeemer on the basis of a watery triangle ▽. When these two triangles have completely interpenetrated one another in the ✿, "the most meaningful sign in the entire universe", the work of rebirth and reunification with Sophia will be complete.

Chaos

From the gloomy scenario of the creation of the world in the *Book of Urizen:* like a placenta, the female parts are shown emerging from the head of the demiurge. "In pangs (…)/ Life in cataracts poured down his cliffs./ The void shrunk the lymph into nerves (…)/ And left a round globe of blood/ Trembling upon the void (…)/ branching out into roots,/ Fibrous, writing upon the winds:/ Fibres of blood, milk and tears (…)"

W. Blake, The Book of Urizen, Lambeth, 1794

Chaos

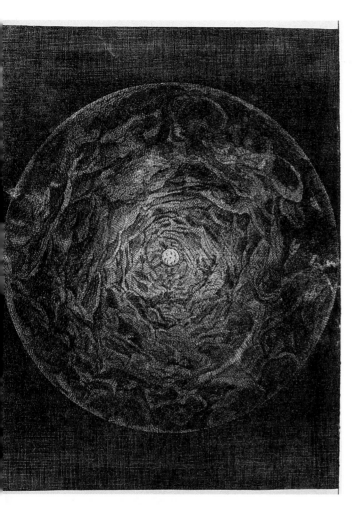

Chaos, formed from heat, moisture, frost, concealment and dryness.

"Outwardly it is the Jewish en-soph, and one with the Night of Orpheus: O Night you black wet-nurse of the golden stars! From this darkness all things that are in this world have come as from its spring or womb." (Philalethes, pseudonym of Thomas Vaughan, *Magia adamica* London, 1650)

"It has no name. Nevertheless, it is called Hyle, Matter, Chaos. Possibility or Being-able-to-develop or Underlying and other things (...)." (Nikolaus of Cusa, *Compendium*, Hamburg edition, 1970)

Coenders van Helpen, Escalier des sages, 1689

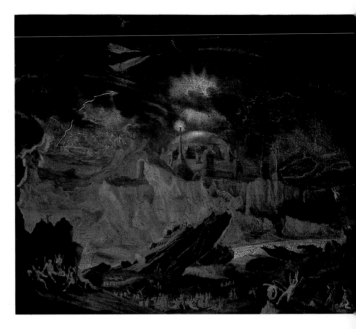

After his fall Satan finds himself back in the abyss of Chaos with a host of fallen angels on a burning lake. After a short time, the vast and magnificent palace Pandemonium rises on the model of the Greek Pantheon. In a great council assembly it is here decided that Satan should investigate the truth about the rumour that a new world, with a new kind of being, has been created.

John Martin, The fallen angels enter Pandemonium, 19th century

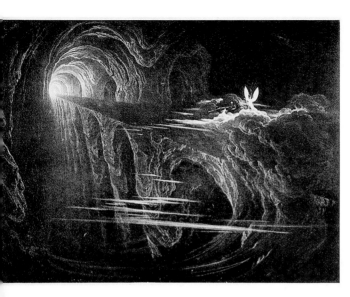

After the fall of man, Sin and Death, the two watchmen at the gates of Hell, follow the tempter earthwards and pave him "a broad and beaten way/ Over the dark abyss (...)" (John Milton, *Paradise Lost*, 1667)

J. Martin, On the edge of Chaos, 1825

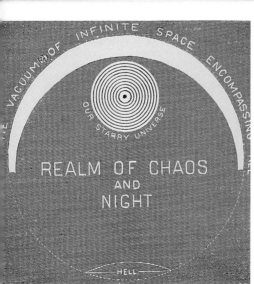

The cosmos of 'Paradise Lost':

God's "new world" is suspended as a self-enclosed sphere above the realm of darkness ruled by "Chaos and ancient Night". Its nethermost realm, bolted with a great gate, adjoins Hell. From there, the wide thoroughfare is built across Chaos to the new world, as a kind of negative Jacob's Ladder.

Homer B. Sprague, Milton's Cosmography, Boston, 1889

Chaos

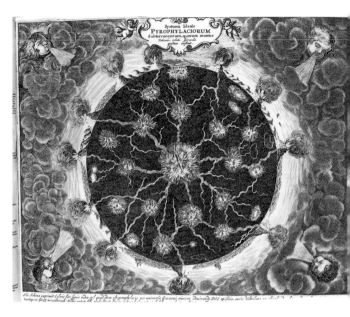

In 1638, in the course of a research expedition to Sicily, Pater Kircher was witness to a catastrophic volcanic eruption. Travelling on to Naples, he was then taken to the edge of the crater of Vesuvius, to examine whether it might not have an underground link with Etna. "There he was confronted with a terrible sight. The sinister crater was completely lit by fire, and emanated an unbearable smell of sulphur and pitch. Kircher seemed to have arrived at the dwelling-place of the underworld, the residence of the evil spirits (...). At dawn, he had himself lowered on a rope inside the crater, down to a large rock which gave a good view of the whole subterranean workshop (...). This wonderful natural spectacle greatly reinforced his opinion of the fiery, fluid state of the interior of the earth. Accordingly, he considered all volcanoes as merely the safety valves of the underground furnace." (K. Brischar, *P. Athanasius Kircher*, 1877)

A. Kircher, Mundus subterreaneus, Amsterdam, 1682

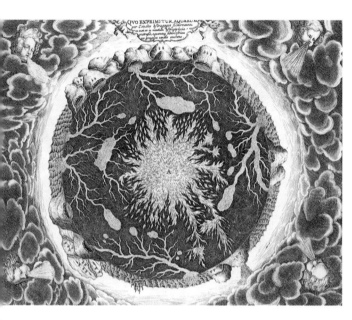

imagine the earth with its circle of
vapour as resembling a great living crea-
ture, constantly breathing in and out."
Goethe, *Conversations with Eckermann*,
1827) With this image, Goethe placed him-
elf in the Platonic-Hermetic tradition,
which understood the planets as physical
creatures with an internal pulse, from the
venous network of subterranean lava

canals leading from the central fire, which
acts as the heart-centre, and a water circu-
lation, whereby the sea-water reaches the
great mountains via large subterranean
tanks, from which it flows back along the
rivers to the sea.

*A. Kircher, Mundus subterreaneus, Amster-
dam, 1682*

Chaos

Here Kircher showed the metals being cooked in the terrestrial matrix. Although he did not believe in transmutation by chymical means, he absorbed some Paracelsian ideas, such as the theory of the creation of all material things from a universal seed, the "Chaos sulphureo-sale-mercurialis".

A. Kircher, Mundus subterreaneus, Amsterdam, 1682

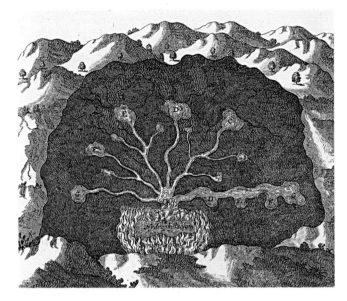

Here, the *Prima Materia*, the raw state of the lapis (pelican) is being dug from the earth by miners. Because of their small size, they became the model for Snow White's seven dwarfs (whose number also refers to the metals, which were held to be the "seven coagulated planetary forces").

Aurora consurgens, early 16th century

Chaos

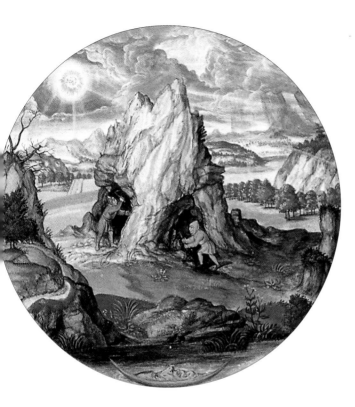

"And this *Prima Materia* is found in a mountain which contains a huge number of created things. Within this mountain all kinds of knowledge can be found which exist in the world. There is no science or knowledge, no dream or thought (...) that is not contained therein." (Abu'l-Qâsim, Kitâb al-'ilm, Ed. Holmyard, Paris, 1923)

The two miners are soul and mind, who, along with the mountain as the body, form the trinity in the Work. The moon in the water signifies the Mercurial "slimy fluid" in the subterranean distillation.

S. Trismosin, Splendor solis, London, 16th century

Chaos

"In one of the oldest (alchemical) texts, the manuscript of 'Comarius to Cleopatra', the metals (are) described as 'corpses' which lie around in Hades, confined and fettered in darkness and fog. The elixir of life, the 'blessed waters', penetrate down to them and rouse them from their sleep." (M.-L. von Franz, Aurora consurgens, in C.G. Jung, *Mysterium conjunctionis*, Zurich, 1957)

The Descent of Man into the Valley of Death, William Blake, 1805

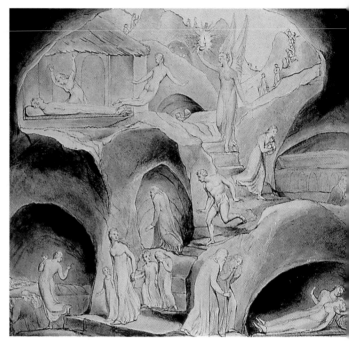

D. Stolcius v. Stolcenberg, Viridarium chymicum, Frankfurt, 1624

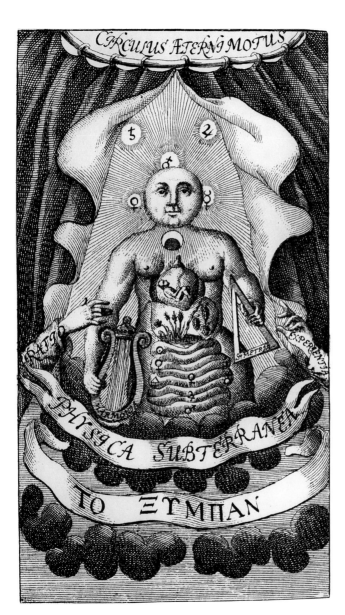

Sun and moon as givers of all super-terrestrial and subterranean life. In the bowels of Mother Earth, the base metals mature towards their perfection. "The mines or metal-pits are also seen as the womb: in place of it the philosophers use a wide glass (...) which is also called her 'egg'." (J.J. Becher, *Chymischer Rätseldeuter*)

J.J. Becher, Physica subterranea, 1703

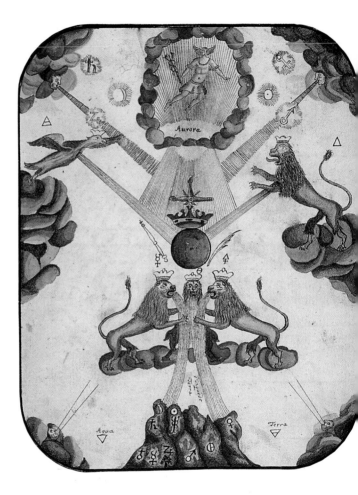

Heaven is a source and spring of life/ (...) for with its fiery rays of influence it strews its subtle seed in the air/ that mingles with the seed of the air/ and casts itself in the water; the water/ which is impregnated by the received seeds of both heaven and the air/ sinks/ with its own seed/ into the earth; the earth/ as a mother/ receives the seed of all three/ mixes her own among them/ as a strange grease/ and preserves them all. From this there now arises the universal balm and Mercurius of the world (...)" (J. de Monte Raphaim, 1727)

German manuscript, 18th century

Chaos

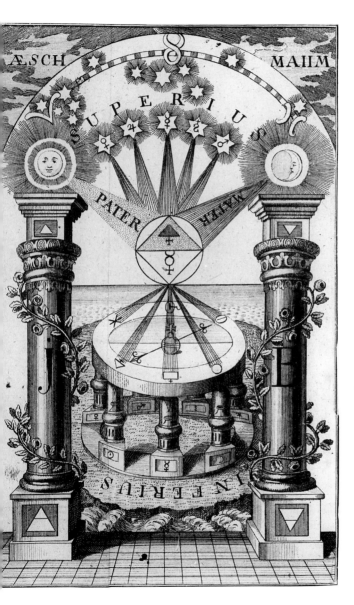

The "philosophers' compass" between the magnetic poles of the Work, symbolized here as the two Masonic columns of Solomon's temple. Joachin: male, upper fire (esh) and lower air, Boaz: feminine, upper water (Mayim) and lower earth. These produce the lapis. It joins the powers of the upper (the planets) and the lower. (The materials in the Work: tartar, sulphur, sal ammoniac, vitriol, saltpetre, alum and in the centre antimony, the saturnine source material, said to be the greatest poison and the supreme medicine. Its symbol is the imperial orb.)

Der Compaß der Weisen, Ketima Vere, Berlin, 1782

Chaos

The raw chaotic source material, the legacy of Satan's and Adam's fall, is shown here as a beast with horns and a crown, of which it is said in the Apocalypse: "(…) and his deadly wound was healed: and all the world wondered after the beast (…)". (Rev., 13, 3) Its exaltation occurs during the familiar phases of the Work, represented by the birds in the central retort. The upper six-sided star signalling perfection refers to Mercury, which is both beginning and end.

S. Michelspacher, Cabala, Augsburg, 1616

Chaos

An allegory of the Chaos of the elements and the need to harmonize them. The text states that one should pay attention to *Temperantia*, moderation, lest any of the elements in the Work assume predominance. Such disharmony is expressed here.

In the three-footedness of the creature Lennep sees a reference to the tripod, the stand in which the retort is exposed to fire. (J. van Lennep, *Alchimie*, Brussels, 1985)

*Aurora consurgens,
late 14th century*

Chaos

An collection of various illustrations with which the "ancient pagans" supposedly imagined Chaos: at the bottom the dark Demogorgon (Chronos), who dwells in the centre of the earth, enclosed by the Ouroboros serpent of eternity. To the right above him, the Egyptian Eneph (B). The egg in his mouth is supposed to signify the creative word. Next to him, Saturn (C) with the sickle. Pan (D) is the whole world, but also the spagyric fire that divides the "disordered lump". The four children in the cave (H) represent the four elements, L the spirit of God which floats above the darkness, and M the Hebrew word Bereshith: 'In the beginning'.

De Hooghe, Hieroglyphica oder Denkbilder der alten Völker, Amsterdam, 1744

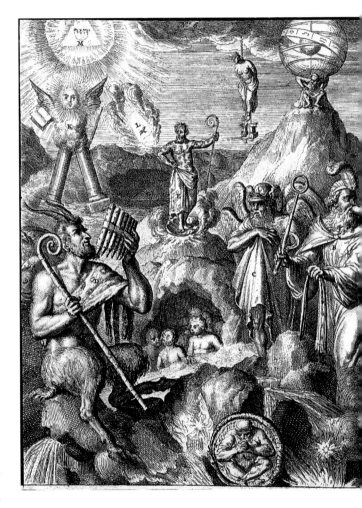

say to you that I am the thing itself, but you must not touch me; within me lies the seed of all animals, herbs and ores." (*Conversation between Saturn and a chemist*, Frankfurt, 1706)

Once Cronus-Saturn was the proud ruler in the eternally youthful "Golden Age", but since his son Jupiter overthrew him and he, according to the *Iliad* was, "put under the earth", he is in a pitiful condition: as Father Death, with his sickle in his hand, he now embodies the destructive aspect of time, and represents the original "gate of darkness" in the Work, through which material must pass "in order to be renewed in the light of paradise" (Aeyreneus Philalethes, *Ripley Revived*, London, 1677). The lowest and coarsest level, the sediment of the world edifice, is assigned to him: stones, earth and lead (antimony). Böhme called him "the cold, sharp and strict, astringent ruler" (Aurora), who created the material skeleton of the world. The influences of his planet were held responsible for all kinds of poverty and misery.

For the Neoplatonists, however, he rose "to become the most sublime figure in a philosophically interpreted pantheon" (Klibansky, Panofsky, Saxl, *Saturn und Melancholie*, Frankfurt, 1992). According to Plotinus (205–270), he symbolizes the pure spirit, and Agrippa von Nettesheim (1486–1535) referred to him as "a great, wise and understanding lord, the begetter of silent contemplation" and a "keeper and discoverer of mysteries" (*De occulta philosophia*, 1510). In this way, he rose to become the patron of the alchemists, their central role model.

D. Stolcius v. Stolcenberg, Viridiarum chymicum, Frankfurt, 1624

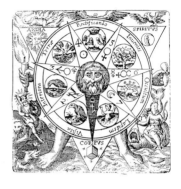

The inscription on the meditational image urges saturnine self-knowledge. "Visit the interior of the earth and through rectification (purification through repeated distillation) you will find the hidden stone." The number seven of the sublimations – Blake speaks of seven ovens of the soul – was assigned to Saturn as the seventh planet in the cosmological system.

Saturnine
night

"Behold, in Saturn a Gold lies enclosed (...). Just so man lies now, after his fall, in a great, formless, bestial, dead likeness (...) He is like the coarse stone in Saturn (...) the outer body is a stinking cadaver, because it still lives in poison." (Jacob Böhme, *De signatura rerum*)

"Therein lies the most evil poison of all (...) and an earthly treasure and an earthly God in whose hands lies the spiritual and earthly law, and who has the whole World in his hand."

J. Isaak Hollandus, Hand der Philosophen (1667), Vienna edition, 1746

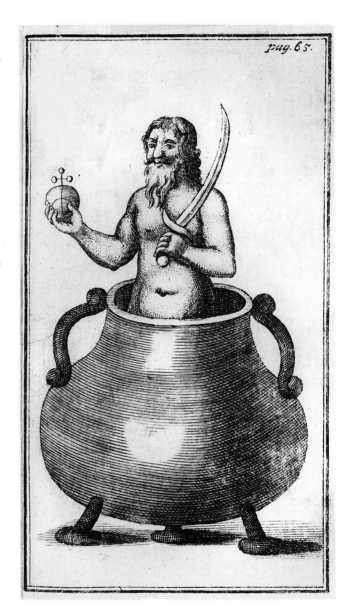

pag. 65.

Saturnine night

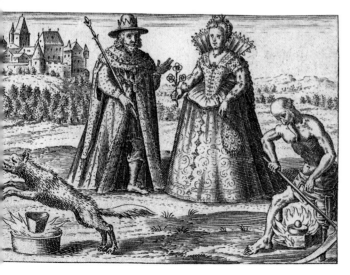

"Take the grey wolf, the child of Saturn (..) and throw him the body of the King. And when he has swallowed him, build a big fire and throw the Wolf into it, so that he burns up, and then the King will be liberated again." (Basil Valentine, *Twelve Keys*)

M. Maier, Atalanta fugiens, Oppenheim, 1618

For the purification of gold (king) the impurities were alloyed with antimony, which was added to the melt. As antimony attracted and swallowed impurities, it was called the "philosophers' magnet", the "wolf of metals", the "fiery dragon" or the "bath of the king".

D. Stolcius v. Stolcenberg, Viridarium chymicum, Frankfurt, 1624

Saturnine night

Blake's old creator God Urizen (from: "your reason" and "horizon") embodies what Novalis called the "petrifying intelligence". In the form of God the Father in the Old Testament, he created himself full of longing for "solidity", hard material as a protective wall against eternity, which Blake imagined as a free "fluctuation" of energies. Urizen is the saturnine "drier of all forces, from which loveliness is produced", and his world is "an enclosure of life". (J. Böhme, *Aurora*)

W. Blake, The Book of Urizen, Lambeth, 1794

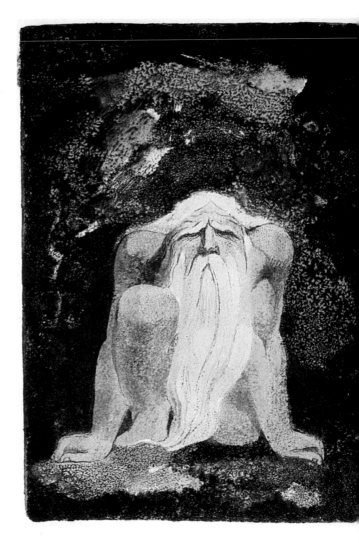

Saturnine night

> "The stone that Saturn devoured, spewed out, instead of Jupiter, his son, is placed on Mount Helicon as a reminder to Man."

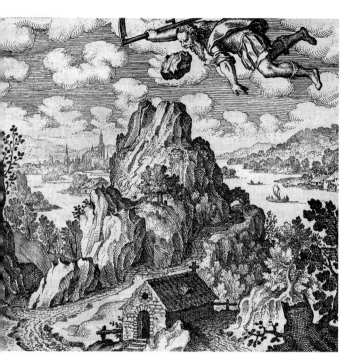

cording to the Greek myth, Cronus-
turn castrated his father Uranus with a
kle and thereafter became the ruler of
e Golden Age. But as it had been proph-
ed to him that one of his children would
throne him, he always devoured them
mediately after their birth. But his wife
ea hid his third son Jupiter from him,
d in his place gave him a stone which he
er vomited up after Jupiter had mixed
t and mustard with his drink.

That the stone was chymical, says Maier,
is clear enough. But it is not, as the begin-
ners have it, in the saturnine lead, but in
the black phase of putrefaction which
stands at the beginning of the Work and is
governed by Saturn.
Maier also established a genealogical con-
nection, for Saturn is the grandfather of
Apollo, the incarnation of the sun, gold.

*Michael Maier, Atalanta fugiens, Oppen-
heim, 1618*

Saturnine night

Here the metals are being "driven through Saturn" as little children. After the process of digestion, that is, the gloomy phases of the solutio and putrefactio, they are spewed out, brought back to life and purified in a bath of mercurial distillate produced by the heating (sword) of the *Prima Materia* (Saturn). Now they are ready for the "chymical wedding", and, with Latona (Leto, Leda), Jupiter will father Apollo, gold.

De Alchimia, Leyden, 1526

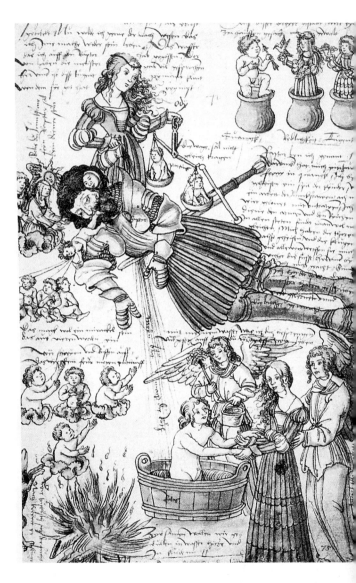

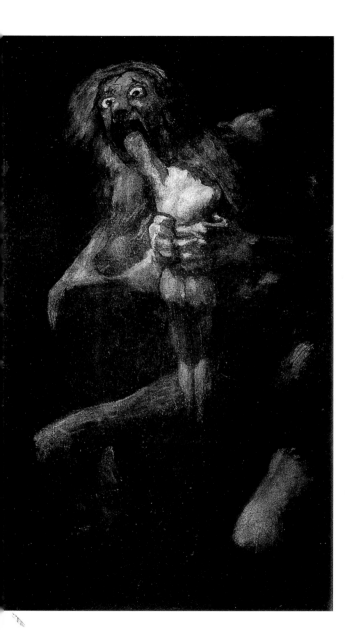

Saturnine night

"Towards midnight Saturnus turned, and a heavy vapour came from his ears, likewise a foulsmelling fog was emitted from his nose and mouth, wherefore there was a great darkness upon the world, and no life could be found in the world, until he opened his eyes, from which there came forth terrible, fiery flames mixed with strange, adventuresome colours." (Monte-Snyders, *Metamorphosis Palnetarum*, Vienna edition, 1774)

Francisco Goya, Saturn devouring his children, 1820–1823

Saturnine night

The saturnine "night of lead" in which the body falls prey to dissolution and putrefaction, is indicated here by the gaping mouth.

"Within lead there dwells a shameless demon who drives men to madness". (Olympiodoros, 5th century)

Goosen van Vreeswijk, De Goude Leeuw, Amsterdam, 1676

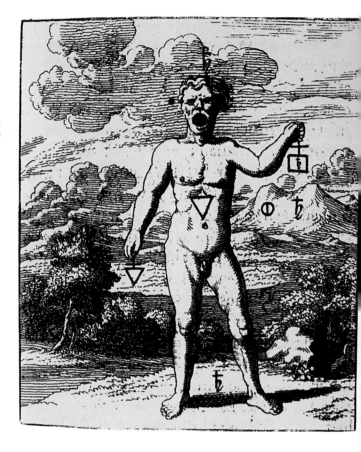

Saturnine night

Spirit and soul leave the old body which now, as indicated by the raven, enters the stage of blackness (nigredo) and putrefaction.

"If they now come and are properly conjoined with it: from these three Apollo will be born."

D. Stolcius von Stolcenberg, Viridarium chymicum, Frankfurt, 1624

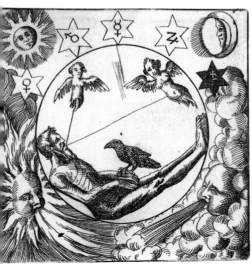

"My spirit wants to be with the soul above. So that none of the others fly, the grave is artificially closed (…). I am like a raven when two weeks have passed."

D. Stolcius von Stolcenberg, Viridarium chymicum, Frankfurt, 1624

Saturnine night

"Ovid (…) writes of an ancient sage who wished to rejuvenate himelf. He should cause himself to be divided up and boiled until completely cooked, then the limbs would reunite and rejuvenate most powerfully."
(S. Trismosin)

The dove is the spirit (the distillate) which reunites with the bodily remains after the putrefaction. "Just as this Saturn is baptized with his own water, the black raven flies off." (B. Gutwasser, 1728)

*S. Trismosin,
Splendor solis,
London,
16th century*

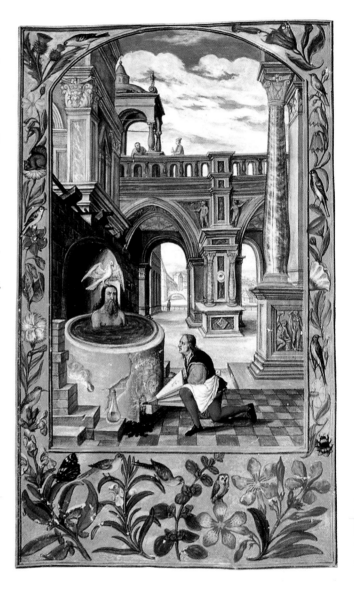

Saturnine night

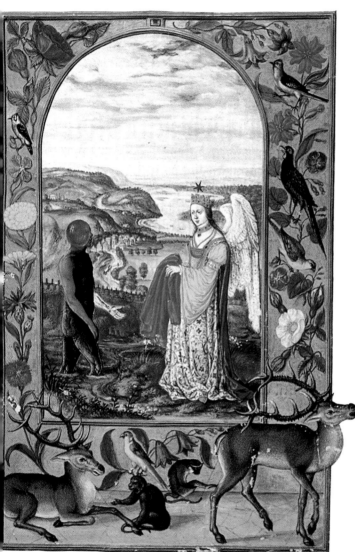

Trismosin tells of an angel (a code name for the mercurial components of the *Materia* which can be sublimated), which helps "a man, black as a Moor" out of an "unclean slime" (the putrefied sediment in the retort), clads him in crimson and leads him to heaven. This is an image which shows that spirit and soul "are freed from the body by being gently boiled" and later guided back to it, whereby the body becomes stable "in the power of the spirit".

S. Trismosin,
Splendor solis,
London,
16th century

Saturnine night

"I turn backwards to unholy, un-speakable, mysterious night. Far off lies the world – sunk within a deep grave – (...) In dewdrops I would sink and mingle with ashes." (Novalis, *Hymnen an die Nacht*)

"Looking from afar, I saw a great cloud that cast a black shadow over the whole earth, absorbing it, which covered my soul, and because the waters had reached it (*the soul*) they became rotten and corrupt from the vision of the lowest hell and of the shadow of death, for the Flood drowned me. Then the Ethiopians will fall down before me, and my enemies will lick my earth." (*Aurora consurgens*, 14th century)

Sapientia veterum philosophorum, manuscript, 18th century

Figura xxx.

PVRGATIO

Saturnine night

The "spectre of reason" and the "Satanic mills" of the Industrial Revolution cast their destructive shadow over Albion-England, and from there across the whole world. The creative energies in the form of the swan lie as if paralyzed in the "Egyptian waters" of materialism.

The swan is the symbol of whitening (albedo) in the Work. If it rises, "then life has vanquished death, then the king is resurrected". (J. Pernety, *Dictionnaire mythohermétique*, 1758)

W. Blake, Jerusalem, 1804–1820

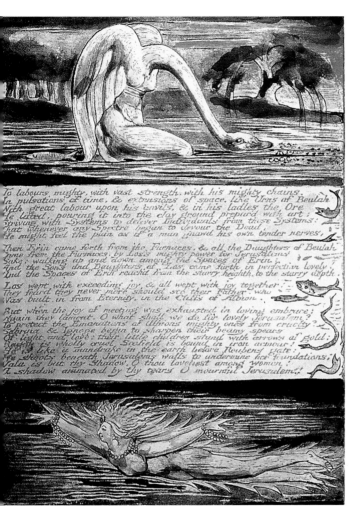

Saturnine
night

*Frontispiece to
W. Blake's "America:
A Prophecy", Lam-
beth, 1793*

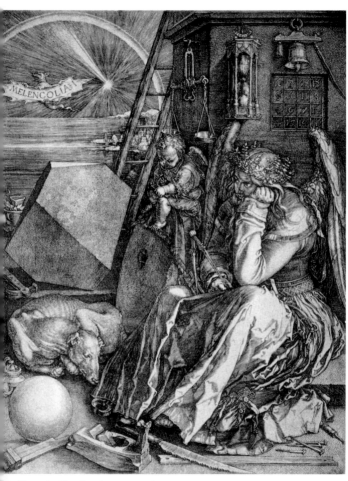

The Florentine Neoplatonists esteemed the "black gall" of the saturnine-melancholic humour as a state of mind that prompted flights of fancy of genius and profound self-knowledge. The crucible at the left-hand edge of the picture refers to a Christological path of purification, which, with the help of the trinity of the most subtle spirit (Ikosaeder: quintessence), pure body (lamb) and immaculate soul (white sphere), leads via the seven-stepped ladder of sublimation to success. The magic square above the angel is supposed to draw down the healing powers of Jupiter.

A. Dürer, Melancholia I, 1514

Saturnine night

"The whole process of the philosophical Work is nothing but that of dissolving and making hard again: Namely, dissolving the body and making hard the spirit." (J. d'Espagnet, *Das Geheime Werk*, Nuremberg Edition, 1730)

Saturn(e), whose name Fulcanelli reads as an anagram of "natures", is the fleshly principle, the root of the Work. He is pregnant with the golden fruit, but the "craftsman of this child is Mercurius". (Jacob Böhme, *De signatura rerum*)

J.C. von Vaanderbeeg, Manuductio Hermetico-Philosophia, Hof, 1739

N. 4

Mit diesem haue dem Python die Füße ab oder brenne sie ab mit dem △ auß dem grünen Drachen bereitet

Torment of the metals

In 1357 a mysterious parchment fell into the hands of the Parisian notary Nicolas Flamel. It contained hieroglyph figures, whose interpretation by a Jewish scholar finally enabled Flamel to perform several successful transmutations.

In Eleazar's interpretation, the dragon is prepared from the philosophers' vitriol and represents the dry path, while Saturn-Antimon represents the wet path. Finally, by achieving links to Mercurius, both lead to its fixing.

Abraham Eleazar, Uraltes chymisches Werk, Leipzig, 1760

Torment
of the metals

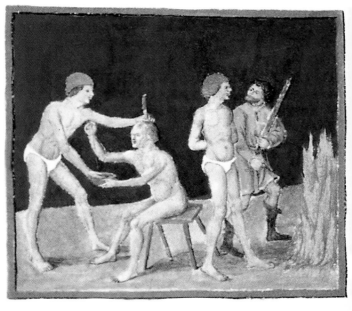

"The metals must be strongly calcinated into a pure, clear ash (…) think on't, sinful man, that you too with the best of wills must also suffer several deaths if you wish to be the pure red, golden stone and enter the pure Heaven." *(Book of the Holy Triplicity,* early 15th century)

"Calcination is transposition to a kind of white ash or earth or white chalk thanks to the spirits of our process; it occurs with our fire, with the water of our Mercury." *(Rosarium philosophorum,* 1550)

"No thing can be transformed into another nature unless it has previously been made into ash, lime or earth." (Anonymous, *Nodo Sophico Enodato,* 1639)

"In the ash that remains at the bottom of the grave, there lies the king's diadem." *(Livre de Arthéphius,* Bibliothèque des Philosophes chimiques, Paris, 1741)

Aurora consurgens, early 16th century

Torment
of the metals

"It is necessary to know that there are three calcinations: two of the body and one of the spirit. The first at the beginning of the Work is a theft of the cold moisture (*the lunar body*). In the second, the earthiness (*as chalk*) is removed (*the solar body*). "The third is nothing but "drawing the quintessence out of the elemental" (*the four flowers in the retort*).

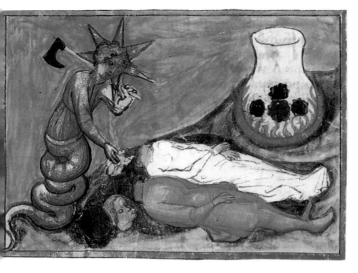

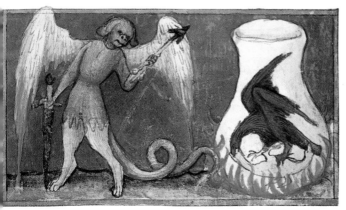

Aurora consurgens, early 15th century

...he fabulous winged being represents ...e initial pulverization, "philosophical ...newal". Sword and arrow mark the ...estructive use of inner and outer fire.

Dead matter is brought back to life with "Aquapermanens" (Mercurius), and distilled up to twelve times.

Torment
of the metals

The *Book of the Holy Trinity* (1415–1419), attributed to a wandering Franciscan monk by the name of Ulmannus, is one of the earliest and most important testimonies to a way of thinking that combines the representation of the chymical process with Christian mysticism and iconography. Numerous different levels intermingle in the text, much of which remains mysterious even today: "Here there are many artful meanings: natural, infinite, supernatural, divine human". The network of correspondences that Ulmannus developed with a suggestive language of cyphers shows many striking similarities to Jacob Böhme's system.

Buch der Heiligen Dreifaltigkeit, early 15th century

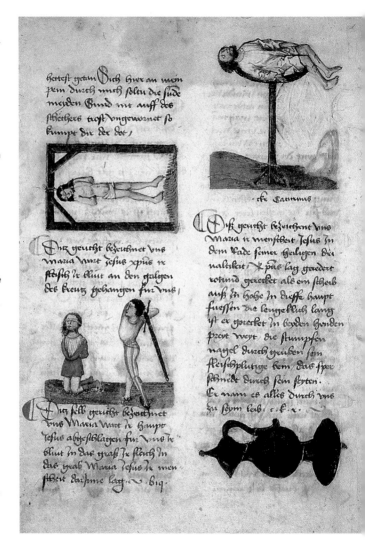

Torment of the metals

In the representation of the scene of the Fall showing Adam (silver) and Eve (gold), the author reminds us that it was unchaste behaviour that put the metals into a state of impurity. The lance signifies purification through fire. The gallows show the martyrdom of iron (Mars), copper (Venus) is beheaded, the breaking on the wheel is saturnine (Böhme's "wheel of anguish"!). The Jupiterine pewter pot contains saturnine "gall-drink", and the Mercurial cubes refer to the play of the soldiers beneath the cross.

Buch der Heiligen Dreifaltigkeit, early 15th century

Torment
of the metals

"Take his soul and return it to him, for the corruption and destruction of the one thing is the birth of the other. This means: rob him of the destructive moisture and augment it with his natural moisture, which will be his completion and his life." (*Aurora consurgens*, after a 16th-century translation)

Aurora consurgens, early 16h century

Torment of the metals

The Greek alchemist Zosimo (4th century) tells of a transformation of the body into pure spirits by ritual dismemberment. Here, he tells of the chopped-up limbs, which are "as white as salt". (The philosophers say that salt in the calcinated ashes is the key to success.) But the head is golden. The cruel slayer with the black face holds in his right hand the double-edged sword of the two fires "and a piece of paper in his left". On it was written: I have killed you so that you may have overflowing life (…). But your head I will hide, that the world shall not see you (…)".

*S. Trismosin,
Splendor solis,
London,
16th century*

Torment
of the metals

A parable on the "preparation of the destructive moistures" (putrefaction, Saturn), and "renewal with the essential moisture", Mercurial water: "The ancients saw (...) a mist draw over the earth and water it (Genesis 2, 6), and the impetuosities of the sea (...) and of the earth, which grew rotten and stinking in the darkness, and they saw the king of Earth sinking and heard him cry: Whoever saves me will (...) govern in my clarity on my royal throne (...) The next day they saw what seemed to be a morning star arise over the king and the light of day (...) He was crowned with three precious crowns of iron, silver and gold (...)".

S. Trismosin,
Splendor solis,
16th century

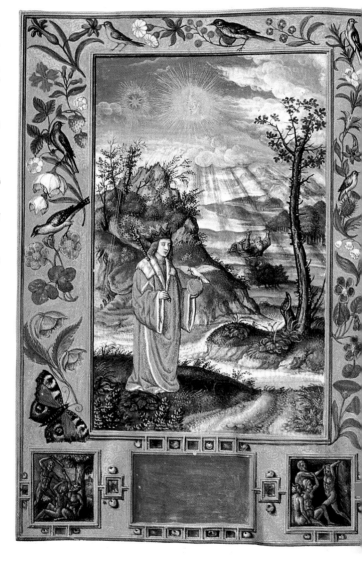

Torment of the metals

King Urizen sinks into the "sulphureous fluid (of) his fantasies", from which he created the "old body", the realm of matter as the "upper water of nature". (Jacob Böhme)

W. Blake, The Book of Urizen, Lambeth, 1794

work upwards into the future"

Torment
of the metals

If one fetches the king from the red sea (Mercurial water), says Maier, one should be careful that he does not lose his crown, for with its stones one could heal illnesses. Afterwards one should place him in a steam-bath, so that he loses the water that he has swallowed, and then marry him, so that he produces a royal son.

M. Maier,
Atalanta fugiens,
Oppenheim, 1618

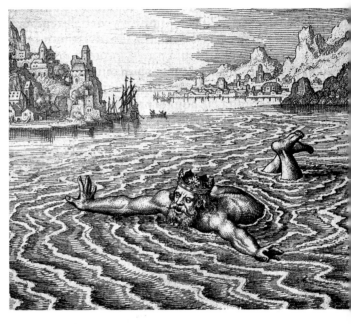

HELP! HELP!

W. Blake, The Gates
of Paradise, 1793

"The king in the sea swims and cries with a loud voice: Whoever catches and rescues me, to him will I give a great reward."

"Osiris is under-
handedly mur-
dered by Typhon
(*Seth*), who after-
wards scatters his
limbs, but Isis
gathers them up
and puts them
together to make
a body. But the
male member has
broken off, lost
in the water. For
sulphur perishes,
thus is sulphur
born."

…he married couple, the siblings Isis and
…siris, represent the relationship of Luna-
…ercurius and Sol-Sulphur, which consti-
…tes the lapis. Here Typhon-Seth is given
…e saturnine role of the separator.

"…now, my son, that this our stone (…) is
…mposed of four elements. It must be di-
…ded and its limbs taken apart (…) and
…en transformed into the nature that is
…thin it." *(Rosarium philosophorum)*

The absence of the king's male member
after he is reassembled is a reference to
the idea that the matter is now the unified
material which the philosophers call
"rebis" or "hermaphrodite".

*M. Maier, Atalanta fugiens, Oppenheim,
1618*

Resurrection

"First prepare the glorious water of life, purify it and carefully pick it up. Think not, however, that this juice is not the clear and bright moisture of Bacchus *(spirit of wine, alcohol)."*

Son and servants ask the king for power over the realm (oro, Latin: I request; ro: anagram of French or: gold, and Hebrew: light).

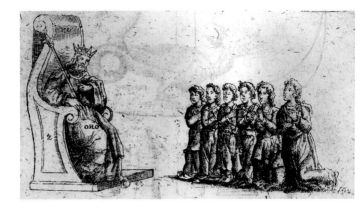

The son (Azoth) kills the father

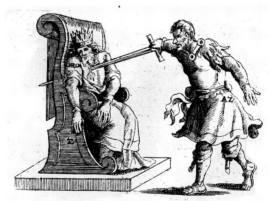

and collects his blood.

Janus Lacinius, *Pretiosa Margarita, Venice, 1546; Leipzig edition, 1714*

The grave (oven) is prepared.

"Both fall through art into the grave." (QUADR: four-elemental.)

The son tries to escape, but a third comes, who has sprung from both, and holds him back.
(\mathcal{X} is the alembicus, the still head.)

*J. Lacinius,
Pretiosa Margarita,
Leipzig, 1714*

Resurrection

In the grave "comes putrefaction in ashes or a very warm bath". (QUA: Aqua.)

After cooling down, the result of putrefaction can be seen. (LAS : anagram of Sal.)

The bones are taken out

J. Lacinius, Pretiosa Margarita, Leipzig, 1714

The dissolved matter is cooked until black, sprinkled with the water of life and once again cooked, until it is white. An angel comes and throws the bones (salt) onto the white earth, which is then cooked again.

The servants ask God for the return of the king.

Gradually the angels bring the rest of the bones, until the earth is completely fixed and red like a ruby. (Ro from Lat. 'ros': dew, sweat; Lat. 'rosa', the rose, a code name for tartar.)

*J. Lacinius,
Pretiosa Margarita,
Leipzig, 1714*

Resurrection

The king is now entirely spiritual

and has the power to turn all the servants into kings. The son is missing. He has conjoined with the father.

In this phase of "projectio" (transference), the dusty lapis is added as an enzyme to the base metals.

J. Lacinius,
Pretiosa Margarita,
Leipzig, 1714

The alchemists "also possessed a second type of alcohol (...) the 'secret spirits of wine of the adepts', which, because of certain properties that it shares with alcohol, to mask them, is also spoken of as 'spirits of wine'. Its chemical formula is well known, but the iatro-chemists have by degrees and with many cohibations and processes of digestion intensified this and transformed this product, and thus, finally, by sharpening it with acids and mineral salts, preserved its menstrua mineralis, by means of which they were able not only to dissolve the metals but also to make them volatile (...)". (Alexander von Bernus, *Alchemie und Heilkunst*, Nuremberg edition, 1969)

e depiction of the Great Work through regicide, decay and resur-
ction lives on in the higher degrees of Freemasonry. In its cere-
onies, the murder of the legendary architect of Solomon's temple,
ram Abif, is ritually carried out.

Hiram was murdered with the three tools of Masonry – the mea-
re, the set-square and the hammer – by three apprentices who
anted to force the master-word from him. For later recognition, the
urderers placed an acacia branch on the spot where they buried
m. As the old master-word was now lost (it was supposedly
ehova: the central fire"), the new master-word became "Mack-
nach" or "Mach-benak", which was exclaimed by a man on discov-
ing Hiram's decayed corpse.

This new master-word has been interpreted as: "The flesh is
ming away from the bones", "He lives in the Son", "Son of decay",
Mason has been killed" or "Mach: decay! Benach: apparently!"

The meaning of the ceremony lies in the unification of each new
aster with Hiram and in the continuation of the endless chain of
ath and rebirth.

Joyce's cryptically infinite work is about the death and resurrec-
on of a mason of the other kind. His name is Tim Finnegan, also
own as "Finnagain (...) of the Stuttering Hand", a "freemen's mau-
r" who dies when he falls drunk from the scaffolding and is put in
s coffin. The guests at his cheerful wake (funferal) experience his
surrection when the loud uncorking of a whisky bottle awakens
w life in him. The whisky is the elixir, the "wise key", the key to the
ork: the lost master-word of Hiram Abif and the lost member of
siris. Finding this member means bringing together the beginning
d end of the 'end-negating' (fin negans) book, completing the
uroboros. The member is a syllable, and it is found among the
nes that the angels bring (cf. p. 634–635).

Resurrection

The lodge at the admission of a master:

A position of the Grand Master in the East

B Altar with Bible and hammer

G The old master-word on the coffin

K Tears of grief over Hiram's death

LM The burial mound with the acacia branch

O The positions of the leading officials of the lodge.

X The new recruit in the West

This form of ceremonial representation, called the "carpet" (tapis), was developed from symbolic drawings made with chalk and charcoal on the floor of the inns, where the oldest Masonic lodges met.

L'ordre des Francs-Maçons trahi...,
Amsterdam, 1745

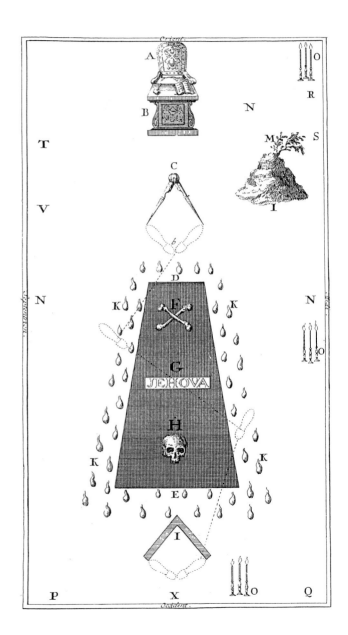

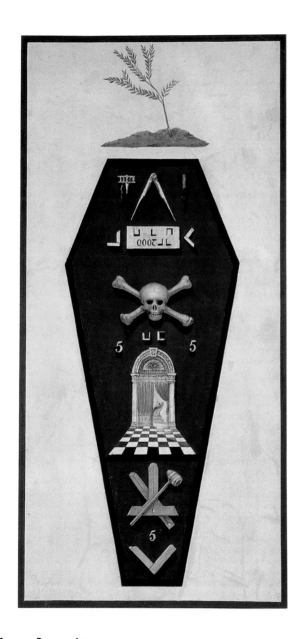

In the language of the Gold- and Rosicrucians, this type of depiction was meant to "indicate the corrupt fermentation, in the general mystical sense, through which the smallest parts of the body are dissolved, and the fire locked within it is liberated". (*Signatstern,* Stuttgart, 1866)

The "mosaic floor" of black and white tiles refers to the bipolar nature of earthly existence: the chimera of light and darkness, agens and patiens, form and matter. It leads to the holiest of holies containing the eternal spirit-fire of Jehovah, which no mortal can see.

Work-table for the 3rd degree (master), England, c. 1780

Resurrection

Our Chymical science, taken as a whole, is like a farmer working the land, preparing his field and scattering seed in it."

Both, alchemist and farmer, must precisely obey the laws of the seasons if they are to achieve good yields.

M. Maier,
Atalanta fugiens,
Oppenheim, 1618

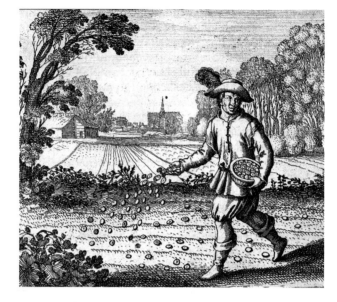

Alchemy is "celestial agriculture". Here Gold (Sol) and Silver (Luna) are added to matter as fermenting agents, to increase it. "If you throw the two pieces on our land: this living flame will give off its forces."

D. Stolcius von
Stolcenberg, Viridarium chymicum,
Frankfurt, 1624

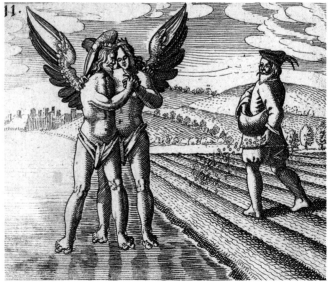

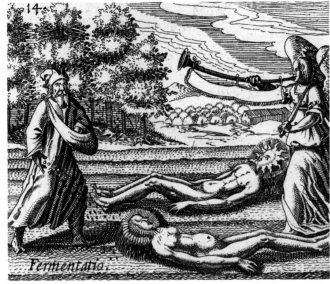

The "fermentation" of the metals:

"How foolish! The seed you sow does not come to life unless it has first died (...). What is sown in the earth as a perishable thing is raised imperishable (...). Sown as an animal body, it is raised as a spiritual body." (1 Corinthians 15, 36–44)

D. Stolcius von Stolcenberg, Viridarium chymicum, Frankfurt, 1624

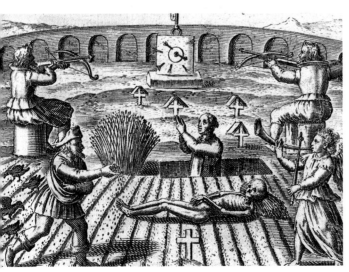

The cross and rectangle of the tomb form the glyphs of the *Sal Tartari* ♜, "whose spirit (...) causes all metals to evaporate (...)" (Basil Valentine). The crosses in the background ♁ refer to the fermentation of mercury with its own sulphur. Then the goal ☉, "our gold", is achieved.

D. Stolcius von Stolcenberg, Viridarium chymicum, Frankfurt, 1624

Resurrection

Sol and Luna still lie side by side as "two different things" in the glass coffin of the retort (Snow White!). After putrefaction they will be resurrected as "one thing from two" (Rebis).

D. Stolcius von Stolcenberg, Viridarium chymicum, Frankfurt, 1624

Without death by burning (candle) no resurrection can occur, for in ashes lies the "salt of glory" (cross and cube: salt of tartar), which brings new life (blossoming tree-trunk). The peacock on the church tower signals the next, brightly coloured phase.

D. Stolcius von Stolcenberg, Viridarium chymicum, Frankfurt, 1624

The "dark material fire" of the black sun divides spirit and soul from the putrefied body. "You should know that the head of art is the raven. If someone cuts off its head, it loses its blackness and will attract the wisest colour of all.

D. Stolcius von Stolcenberg, Viridarium chymicum, Frankfurt, 1624

"Decay is a wonderful smith", who transfers one element to the other: "It makes such changes without respite, until heaven and earth melt together into a glassy clump". (A. Kirchweger, *Aurea Catena, Homeri,* 1781)

D. Stolcius von Stolcenberg, Viridarium chymicum, Frankfurt, 1624

Resurrection

"O unhappy man!
Condemned to
draw thy breath in
this gruesome
body of Death."

*Pia Desideria,
Hermann Hugo,
Antwerp, 1659*

Resurrection

"In stony sleep" Urizen has separated from Eternity and will be hatched as the body of the world: "Ages on ages rolled over him! (...) In a horrible dreamful slumber, / Like the linked infernal chain, / A vast spine writhed in torment / upon the winds, shooting pained / Ribs, like a bending cavern, / And bones of solidness froze / Over all his nerves of joy (...)." (W. Blake)

"Just as in man the skull is a cover and encloser of the brain (...), saturnine force is also a cover, drier and container of all fleshliness and comprehensibility." (J. Böhme, *Aurora*)

W. Blake, *The Book of Urizen*, Lambeth, 1794

Aurora

Blake integrated the Paracelsian concept of the "inner volcano" (Archeus) into the figure of Los, the prophet of the imagination, whom he referred to as the "fabricator and workman of all things". He is the mysterious fire which, in inner nature, transforms the divine spirit into matter.

The Paracelsian Sendivogius referred to him as "the central sun, the heart of the world" (Los, anagram of sol, or soul). Urizen's satanic separation from eternity drags him into the abyss to which he must henceforward impart form and shape.

W. Blake, The Book of Urizen, Lambeth, 1794

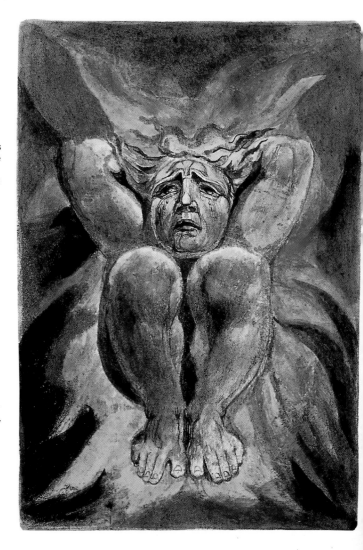

Aurora

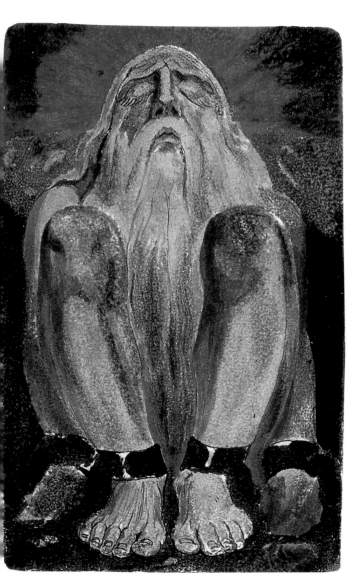

Urizen, master of the material sun, once possessed eternal youth, and embodied "trust and certainty" before his separation from Eternity. He then became the incarnation of destructive doubt and calculating reason.

However stark the oppositions of Urizen and Los "in the world of procreation" – in Eternity they were identical twins. "(...) in anguish Urizen was rent from his (Los') side"

W. Blake, The Book of Urizen, Lambeth, 1794

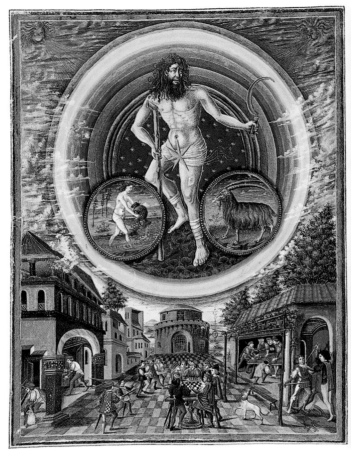

Saturn as ruler of the two signs of the zodiac, Aquarius and Capricorn. His children included the needy and the poor, peasants bound to the soil, lonely hermits, prisoners and murderers, but also the representatives of geometrical and astronomical scholarship. "The ancient pagans saw Saturn not only as time, but also as the Prima Materia of all metal things, under whose natural-alchymistic rule lay the truly golden age." (Heinrich Khunrath, *Vom hylealischen Chaos,* Frankfurt edition, 1708)

De Sphaera, Italian manuscript, 15th century

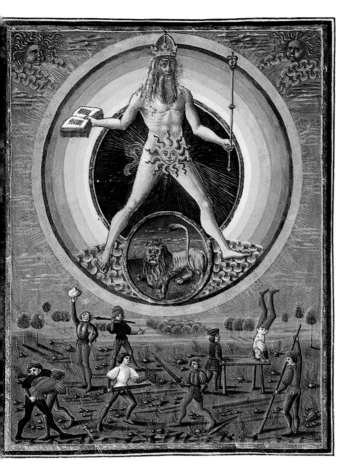

ing sun rules the zodiac sign of Leo.
ay and competition express the proud
hysicality of his children. While Saturn
epresents the immature, poisonous initial
:age of matter, Sol signifies its final ma-
urity after it has passed through all seven
pheres.

For Julius Sperber the circumference (Saturn as the outermost planet) is nothing but the unfolded centre (Sol) and vice versa.

De Sphaera, Italian manuscript, 15th century

Aurora

The black sun is the outer sun, whose "dark, consuming fire" brings everything to decay. After Adam's fall, tainted by Original Sin, man is made "from the black sun's fire", according to the *Book of the Holy Trinity*. In Arabic alchemy, "the blackness or the shadow of the sun" is also a code name for the impurities of common gold, which must be washed away.

S. Trismosin,
Splendor solis,
London,
16th century

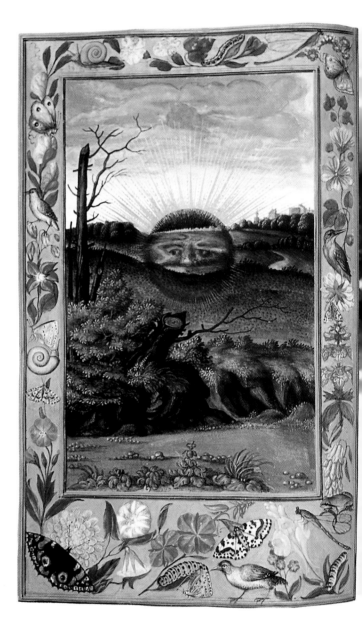

Aurora

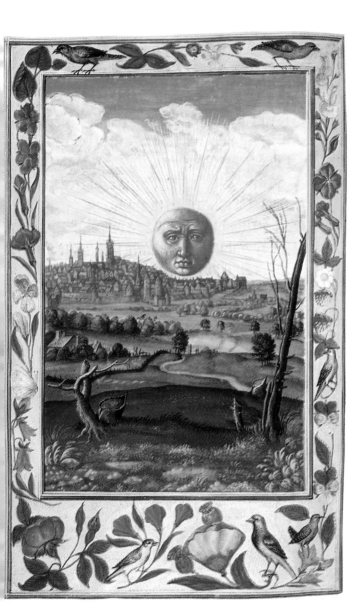

The inner sun as an image of the lapis, the red-winged lion: "He tears man from this vale of tears and releases him, that is: from the despondency of poverty, of illness, and lifts him with his wings with praise and honour from the stinking Egyptian waters, which are the daily thoughts of mortal man (…)". (Nicolas Flamel, *Chymische Wercke,* Hamburg edition, 1681)

S. Trismosin, Splendor solis, London, 16th century

Aurora

Stefan Fuchs, Untitled, tar and granules on carpet, 240 x 340 cm, 1984

Stefan Fuchs, Great Morning, concrete and wood on carpet, 300 x 400 cm, 1989

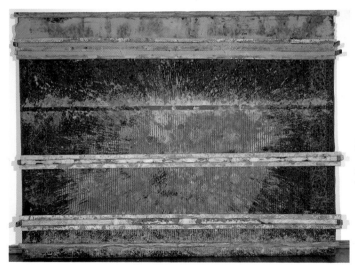

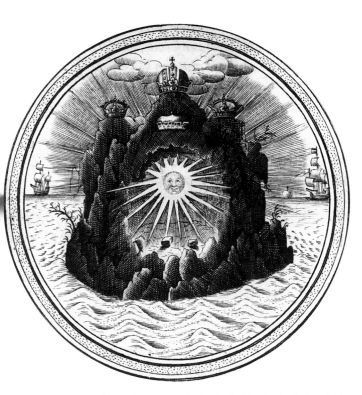

'It darkles, (tinct, tint) all this our funnam-
nal world (...). We are circumveiloped by
obscuritads. Man and belves frieren (...).
The time of lying together will come and
the wildering of the night till cockeedoo-
dle aubens Aurore." (J. Joyce, *Finnegans
Wake*)

"And as the Occidens is a beginning of this
practica, and midnight a complete means
of inward change: just so is the Oriens a
beginning of clarity, and through its pas-
sage soon makes an end towards midday
in the Work." (George Ripley, *Chymical
Writings*, Vienna, 1756)

Jacob a Bruck, *Emblemata Politica,*
Cologne, 1618

Aurora

The first part of the 'Aurora consurgens' (the rising dawn) is a hymn to wisdom (Sophia), interspersed with chymically interpreted passages from the Song of Solomon.

The upper illustration depicts Sophia as Aurora, as the "golden hour" (aurea hora), signifying the end of the night of unknowing and destructive material corruption. Here she suckles the philosophers with her "virgin milk", the Mercurial water. With the royal crown "of the rays of twelve, shining stars" on her head, and the final reddening in her face, she embodies the "*solar* celestial Sophia", while the black figure below represents the *lunar* Sophia, who has descended into matter and become caught in it. In the text she is compared with the Queen of Sheba, who says in the Song of Solomon that she is as black as the daughters of Cedar: "Look not upon me, because I am black, because the sun has looked upon me". Now she calls for help from the depths of matter: "The black depths have covered my face and the earth is corrupt and sullied in my works, and darkness has fallen upon it, as I am sunk in the mire of the depths and my substance has not been opened". (In: C.G. Jung, *Mysterium conjunctionis*, Zurich, 1957)

According to Fulcanelli, "in hermetic symbolism the black Madonnas represent the virgin earth, which the artist must choose as the subject of his work. It is the Prima Materia in its mineral state, and it comes from the ore-bearing seams buried deep beneath the masses of stone." (Fulcanelli, *Le Mystère des Cathédrales,* Paris, 1964)

Sophia (cf. p. 500 ff.) in Gnosticism and in the Cabala bears both the features of a virgin bride and those of the womb, the *mater materiae*. The seed that falls into it, according to the *Aurora consurgens*, produces a threefold fruit. And this fruit in her body is the tripartite Caduceus, the Christ-Mercury, the healing serpent, the curing water that flows into Hades to awaken the dead bodies of the metals and free his mother-bride. This is the beginning stage of the "whitening": her clothes are now "purer than the snow", and to her husband she will gives wings like those of a dove, to fly away with him in the sky.

Aurora

"(…) Thus the Dawn at the peak of reddening is the end of all darkness and the banishment of night, that wintry time that one will knock against if one wanders into it and does not take care."

"Turn to me with your whole heart and do not despise me because I am black and dark, for the sun has burned me so, and the black depths have covered my face."

Here, Sophia is standing on the full moon, whose silver pigment is oxydized over time.

Aurora consurgens, late 14th century

Aurora

The dark background is the innermost hidden aspect of God. In a free translation of the Cabalistic *En-Sof* (the infinite), Böhme referred to him as the "unground". In the virgin mirror of wisdom, the divine will recognizes itself and "imagines from the unground in itself (...) and impregnates itself with imagination from wisdom (...) as a mother without childbirth" (cf. p. 478).

"Around the red dawn, day separates from night/ and each is recognized in his nature and strength: for without opposition nothing is revealed/ no image appears in the clear glass/ so no page is darkened (...)". (G. Gichtel)

J. Böhme, Theosophical Works, Amsterdam, 1682

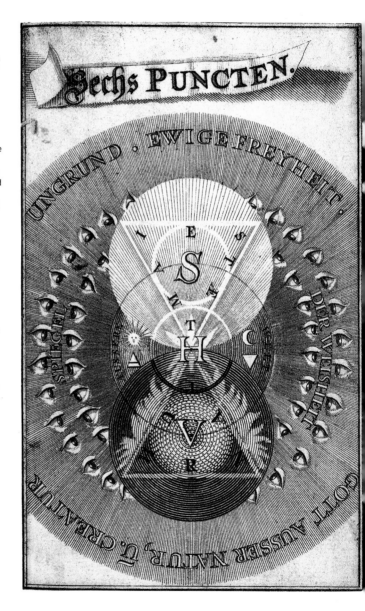

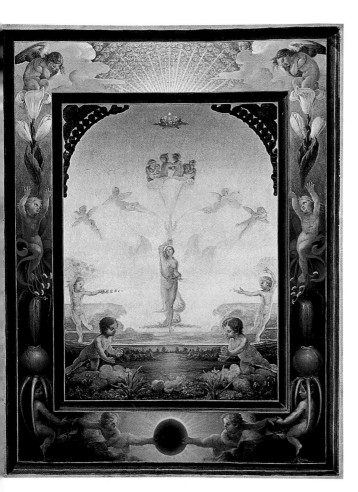

Runge planned the painting as part of a cycle on the four seasons as the "four dimensions of the created spirit". Morning represents "the boundless enlightenment of the universe", night (the black sun on the lower edge of the painting) "the boundless destruction of existence in the origin of the universe". Light is symbolized in the lily, and the three groups of children "relate to the trinity".

Lily and dawn symbolize the rise of the age of the Holy Spirit. "A lily blossoms, over mountain and vale, at all ends of the earth." (J. Böhme, *De signatura rerum*)

Ph. O. Runge, *Der kleine Morgen,* Hamburg, 1808

Dawn as a sign of a Protestant "spiritual reformation of the whole world", which the Rosicrucians urged in their 'Confessio Fraternitatis' in 1605. "After the world has almost reached its end", one should "joyfully approach the new rising sun with open heart (...)"

Ph. O. Runge, 1801

The divine unground as 'Eternity's eye of wonder' reveals itself in the mirror of wisdom (Sophia). "It is like an eye that sees and yet guides nothing in seeing that it may see, for the seeing is without being (...) Its seeing is in itself." (J. Böhme)

18th-century edition of Böhme

"Here, two eyes
have once more
become one (…).
By its changing
gaze all things are
nourished (…). If
this eye closed for
a moment, noth-
ing could exist any
more. For this
reason it is called
opened eye, upper
eye, sacred eye,
surveying eye, an
eye that sleeps not
nor slumbers, an
eye that is the
guard of all things,
the continuous
existence of all
things." (Zohar,
Cologne edition,
1982)

"The eye in which
I see God is the
same eye in which
God sees me; my
eye and God's eye,
that is *one* eye and
one seeing and *one*
recognizing and
one loving."
(Meister Eckhart,
*Deutsche Predigten
und Traktate*,
Munich edition,
1963)

*Little flower garden
of the Seraphim,
from the works
of Böhme, 18th
century*

Aurora

"The soul is an eye of fire, or a mirror of fire, wherein the Godhead has revealed itself (...). It is a hungry fire, and must have being, otherwise it becomes a dark and hungry valley." The darkness is hidden at the centre of light, and anyone who wishes arrogantly to go beyond God, like Lucifer, is left with only darkness. Thus it is best for the soul to linger in a "calm" middle region between spiritual heights and deep humility.

J. Böhme, Theosophische Wercke, Amsterdam, 1682

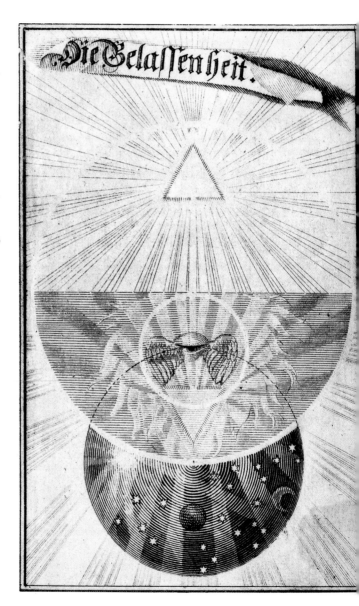

Aurora

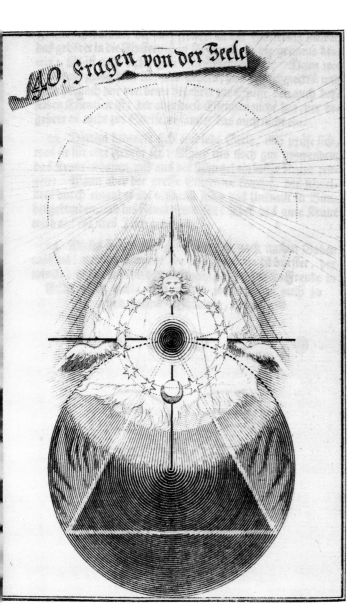

"Thus we understand the soul; that it is an awakened life from God's eye; its primal state is in fire, and fire is its life: but if it does not go from the fire with its will and imagination into the light, as if through grim death into the other Principium, into the Love-Fire, it remains in its own original fire, and has nothing (…) but bitter fury, a desire in the fire, a consuming and a hunger; and yet an eternal quest which is eternal fear."

J. Böhme, Theosophische Wercke, Amsterdam, 1682

Aurora

"This world stands in the confused life of time between light and darkness as an effective reflection of both." It is the third principle, and its form "has been in God's nature for ever, but invisible and immaterial". It was uttered by the spirit of God into the matrix of his wisdom (Sophia), where it can now be discerned in the light of God as his creation. And as this world is threefold and was enfolded in the divine trinity, "the human spirit (...) also has all three principia, as The Realm of God, the Realm of Hell and this Realm of the World within itself".

*J. Böhme,
Dreyfaches Leben,
Amsterdam, 1682*

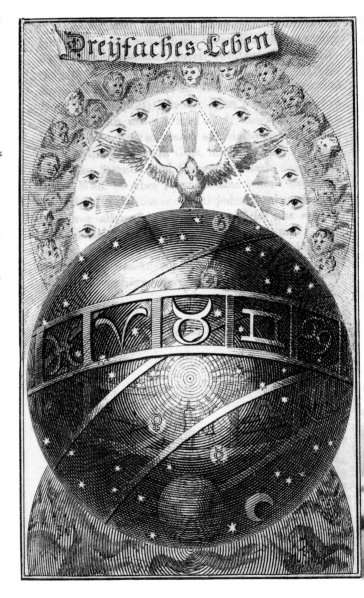

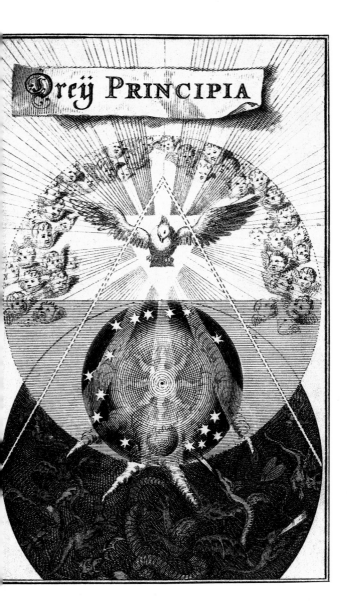

The visible world of the elements, the third principle, is a monstrous product of the world of darkness as the manifestation of the raging God-the-Father and the world of light as the principle of the Son "who is his Father's Heart and Love".

We must imagine these two worlds as the interaction of two wheels, each of them consisting of the three qualities of salt, sulphur and mercury. These are expressed in the dark root principle as the astringent, the bitter and the fire of fear. Friction produces a flash of fire from them, the "fire-crack". When it comes into its mother, "astringency", it becomes the source of the second principle of light, "impenetrable love".

J. Böhme,
Drey Principia,
Amsterdam, 1682

Light & Darkness

"All things originated from the fire-root as a twofold birth" in light (Wohl = good) and darkness (Wehe = ill).

"In this world, love and anger are inside one another, in all creatures, and man has both centres within himself."

"Each man is free and is like his own God, in this life he may turn himself into anger or into light."

J. Böhme, Theosophische Wercke, Amsterdam, 1682

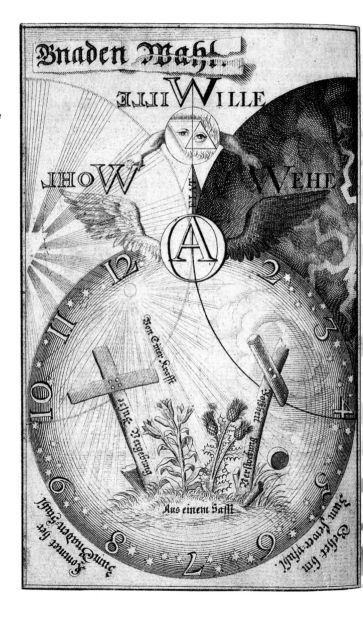

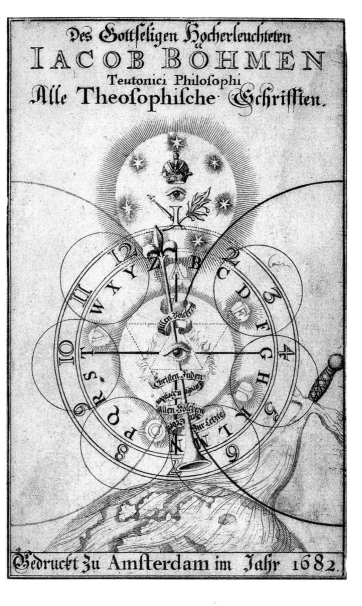

Des Gottseligen Hocherleuchteten
IACOB BÖHMEN
Teutonici Philosophi
Alle Theosophische Schrifften.

Gedruckt zu Amsterdam im Jahr 1682.

At the intersection of light and the world of darkness, the human and the divine eye meet and merge in a visionary "looking-through", which emerges "as a flash in the centre".

The trumpet and the lily, the two ends of the pointer, herald the coming of the end of the world and the beginning of the age of the Holy Ghost. The seven circles are the qualities of nature, the days of the Creation and the spirits of God. The inner alphabet signifies "the revealed natural language", which names all things "sensually", i.e., directly, according to their innermost quality. It was lost through Adam's Fall from number 1, the divine unity.

*J. Böhme,
Theosophische
Wercke,
Amsterdam, 1682*

Light & Darkness

Adaptation of Gichtel's Three-Worlds diagram in the *Geheime Figuren der Rosenkreuzer*, Altona, 1785.

The two dualistic principles are equated here with the 'upper and lower waters', familiar from the Cabala and the works of Fludd. According to the Zohar, these correspond to the two H's in the Tetragrammaton.

There are also references to the two outer columns of the Sephiroth tree. The left-hand column, with the aspect of the punitive power of God, is the emanation of the world of darkness, the right-hand column the mercy of God, the emanation of the world of light.

Geheime Figuren der Rosenkreuzer, Altona, 1785

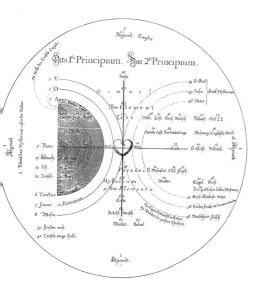

On the left, the world of darkness, "when the eye of wonder enters nature", on the right, the world of light, "when the Divine Mystery has passed through the fire and dwells in majestic light." The cruciform reflective axes mark the sphere of the magic fire "from which both the angels and the soul of man originate".

"Everything that wishes to have divine light must go through the dying, magic fire and exist in it, just as the heart on the cross must exist in the fire of God." If the soul does not pass the threshold of the cross, it remains in the realm of the dark fire of fear.

J. Böhme, Wunderauge der Ewigkeit

The fourth of the seven properties is "the fire-crack or salnitric ground". It corresponds to the sun, which is divided into a dark exterior and a bright interior. Here, the unground of eternal freedom opens into the world of darkness "and breaks the strong, attractive power of darkness". (Freher)

D. A. Freher, in: Works of J. Behmen, Law Edition, 1764

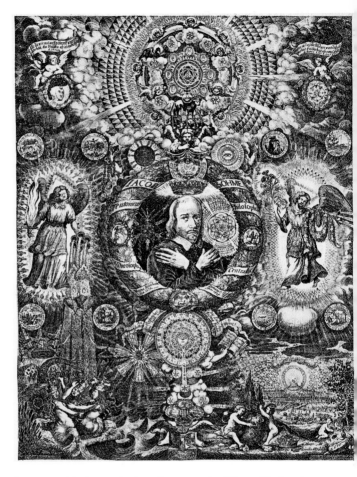

The two angels in the apocalyptic setting symbolize the hermetic fundamental forces of dissolution (solve: mercury) and binding (coagula: sulphur). Böhme referred to them as "the yes and no in all things".

In the exaggerated idealization of Böhme as a "Philosophus Teutonicus", or the "Hans Sachs of German philosophy", bestowed upon him because of his great influence on Romanticism and the philosophy of German idealism, there was a tendency to ignore his deep affinity to the ideas of the Jewish Cabala, which was "noted by his earliest adversaries but, strange to say, has been forgotten by more recent writers". (Gershom Scholem, *On the Kabbalah and its Symbols*, New York 1967)

Engraving, 1675, in: Jacob Böhme und Görlitz, Ein Bildwerk, Görlitz, 1924

In 1600, at the age of twenty-five, according to the testimony of his pupil and biographer Abraham von Frankenberg, the shoemaker Jacob Böhme was "seized by the divine light (...) and at the sudden sight of a pewter vessel (the sweet, jovial gleam) led to the innermost ground or centre of secret nature".

By Böhme's own account, he had broken through the portals of Hell for the duration of a quarter of an hour. "I recognized and saw in myself all three worlds (...) and recognized the whole of Being in Evil and Good, the way one originates in the other (...). I saw through as into a chaos with everything in it, but I could not undo it." He recognized "that all things consist of Yes and No", and these "are not two things side by side, but only one thing (...). Were it not for these two, which are in constant conflict, all things would be Nothing, and would stand still and motionless."

Only in the constant conflict of the seven properties of nature, in the turning of the "wheel of anguish", is nature revealed. "Böhme was the first to understand cosmic life as a passionate struggle, a movement, a process, an eternal genesis. It was only such a direct knowledge of cosmic life that made 'Faust' possible, made Darwin possible, Marx, Nietzsche." (Nicolas Berclyaev, *Underground and Freedom,* 1958).

Like his precursor, the Lutheran minister Valentin Weigel (1533–1588), Böhme is in a tradition of "visionary optics", leading from Augustine and Boethius to Hugo de St Victoire (1096–1141). It distinguished between three ascending levels of vision: the eye of the flesh, of reason and of mystical contemplation. For Böhme, no knowledge can be gained "with the corporeal eyes", "but with the eyes in which life gives birth to itself in me". He referred to it as "seeing through to the ground", "above and outside of nature".

It is characteristic of Böhme's great influence on the most diverse trends that he was able both to provide arguments for staunch critics of Newton's materalist conception of the world, such as Goethe and Blake, but also inspire Newton himself to formulate his theories of gravity and the composition of light. Also present in Böhme's work, even before Kepler, is the visionary insight into the elliptical orbits of the planets, produced by the polarity of two focuses or centres.

A summary of Böhme's system:

The outermost circle "is the great Mystery of the Abyss, as the divine being in the mirror of wisdom (Sophia) gives birth to itself in the Byss". This divine procreation through the self-reflection of the original Nothing is the basic dialectical threefold step of creation.

The name of God, ADONAI (top sphere) "indicates the opening or self-propulsion of the unground, eternal unity". Within it lie six intersecting seed-forces. In the central letter S lies the mystery of divine androgynity: it stands both for Sophia and for the virgin Son.

In the divine in- and exhalation of the three syllables of the tetragrammaton JE-HO-VA as the eternal exchange of diastole and systole, solve et coagula, the involving principle of the wrathful father emerges as the first counterbirth: the dark world. It consists of three properties:

1. The self-centred attracting force (Saturn). From it spring astringency, hardness and cold.

2. The repellent force of "stinging bitterness", also called the "sting of sensitivity". From it emerge mercurial mobility and sensual life.

3. From the opposition of attraction and repulsion (1+2) results the rotating "wheel of anxiety" (Mars).

4. Through friction and rotation, a flash or "Schrack" (fire-crack) is produced in the fourth property, the twofold fire of light and darkness. Finally, the third principle emerges from this, bipolar, four-elemental nature and all created life. The second exhaling principle of the son, which rises in the bright spirit-fire, consists of the properties:

5. Light or love, the true spirit (Venus).

6. Sound, tone: the joyful flow of the five senses (Jupiter).

7. The essentiality, "the Great Mystery", or the actual substance of the visible world (Luna-Sophia).

Light & Darkness

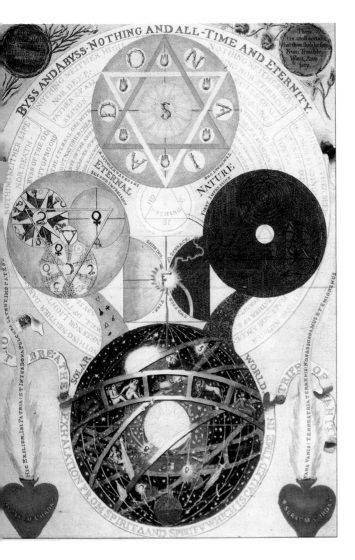

According to Böhme, the ancient sages had named the planets after these seven properties of nature, "but in this they understood much more, not only the seven stars, but also the seven kinds of properties in the procreation of all beings. There is nothing in the being of all beings that does not contain seven properties; for they are the wheel of the centre, the causes of sulphur, in which Mercury makes the liquid for the torment of fear". All seven "are born simultaneously and within each other, and none is the first, none the last".

D. A. Freher, in:
Works of
J. Behmen, Law
Edition, 1764

Light & Darkness

"The figure of God is twofold. He has a head of light and a head of darkness, a white and a black, an upper and a lower", according to the Sefer ha-Zohar, the *Book of Splendour*. It was written in 13th-century Spain, and after 1500 its influence was unparalleled, extending far beyond Jewish circles.

Fludd referred to the light and the dark aspect in a single God, his wanting (voluntas) and not-wanting (noluntas). "God is good, whether he wants or does not want, for in God there is no evil." In the work of Böhme, too, the severity or anger of God is not in itself a negative aspect. Only when Lucifer incited this anger did it become "a grim sting of death and a bitter poison".

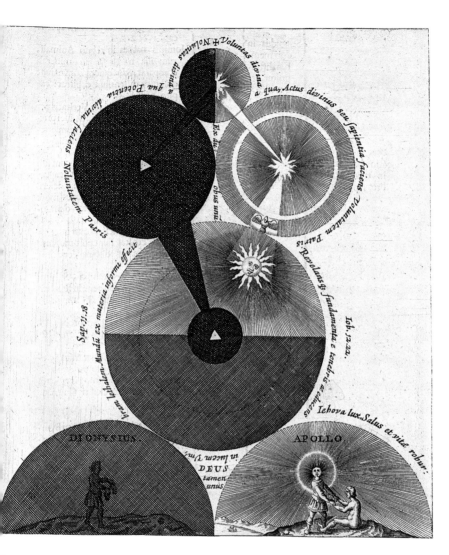

The primaterial dark chaos (left) is the centripetal principle in God, "where his rays are aimed at his own centre". But deep within it lies "the cornerstone of light". The creative centrifugal principle of light (right) is embodied by Apollo. Seven times by day it recreates the man dismembered at night by his alter ego Dionysus.

R. Fludd, Philosophia Moysaica,
Gouda, 1638

Light & Darkness

"In the picture man stands at the centre, as between the realms of God and Hell, as between love and anger; whichever spirit it makes its own, to that spirit it belongs (...)".

"We have the Centrum Naturae in ourselves; If we make an angel out of ourselves, that is what we are; if we make a devil out of ourselves, that too is what we are; we are all at work, creating, we are standing in the field."
(J. Böhme)

D. A. Freher, Paradoxa Emblemata, Manuscript, 18th century

This One is capable both of this and of that.

Choose, and what thou choosest shall be thine

In 1790, as an advocate of revolutionary ideals of freedom, and an opponent of all moral and state subordination, Blake wrote *The Marriage of Heaven and Hell*, a spirited polemic against the traditional identification of good and evil as soul and body. "But the following (...) are true: (...) Man has no body distinct from his soul, for that called body is a portion of soul discerned by the five senses (...). Energy is the only life and is from the body; and reason is the (...) outward circumference of energy". According to one Cabalistic idea, the lower worlds were produced by the reflection of the upper lights, and accordingly all earthly values and moral ideas are reflected. Blake likens this problem of re-evaluation to the problem of mirror reversal in the printing process.

The illustration above refers to a vision of Böhme, in which heaven and hell are within one another, "and yet neither is apparent to the other".

The divine, fertile angels "are in the gentle water's matrix", and the hellish and infertile "are enclosed in the hard fire of anger". (Böhme)

W. Blake, The good and evil angels, c. 1793–1794

"So we must seek light; but it is so thin and spiritual that we cannot touch it with our hand: so we must seek its dwelling-place, the celestial, ethereal, oily substance." It was in these terms that the English Rosicrucian Thomas Vaughan (writing under the pseudonym of Philalethes) postulated his theory of light, a few years before his compatriot Newton performed experiments in which he put light, which in his view consisted of a stream of hard corpuscles, "on the rack". (Goethe)

However, it was not the victorious, mechanistic, corpuscular theory which prevailed in the 17th century, but the old, alchemical idea of the "cohesive quality of oiliness" as a sulphurous condensing principle based on the theory of gravity and electrical attraction. (Gad Freudenthal, Die elektrische Anziehung im 17. Jh. (...) in: *Die Alchemie in der europäischen Kultur- and Wissenschaftsgeschichte*, Wiesbaden, 1986)

In his hermetic treatise 'Siris', Bishop George Berkley put forward his conviction that gold could be produced by condensing light and by allowing it "into the pores of quicksilver". Newton also worked from the premise that light could be converted into matter and vice versa. This connection has not yet been shown to be untenable. On the contrary: the discoveries of 20th-century physics all lead to the conclusion that matter is condensed light.

The Paracelsian concept of the "light of nature" running through all visible and invisible levels of nature is connected to the gnostic idea of the inner light or the divine spark, which is enclosed within the darkness of matter, illuminating it from the centre.

J.A. Siebmacher's *Wasserstein der Weisen* (1618) is among the chymical-Christological works in which the curative effect of the mercurial lapis is compared to the "celestial cornerstone".

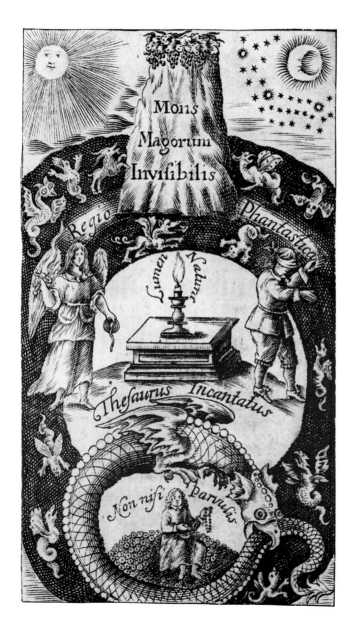

Mons
Magorum
Invisibilis

Regio

Phantastica

Lumen Naturæ

Thesaurus Incantatus

Non nisi Parvulis

Here, the English Rosicrucian Thomas Vaughan (1622–1666) tells of his encounter with Thalia, the personification of blossoming nature. After a violent lament at her rape by the laboratory chymists she leads him to the philosophical, lunar mountains of salt, from which the Nile of the spermatic *prima materia* springs. The darkness of the region represents the incorrect Aristotelian doctrines, in which one wanders around, until one discovers the invisible, divine "light of nature" in the *Sal Alkali*. The green dragon is the "philosopher's mercury", whose treasure can only be found by those who are as pure as children.

Eugenius Philalethes (T. Vaughan), Lumen de Lumine, Hamburg, 1693

Light & Darkness

By the beginning of the 17th century, the reception of the Cartesian corpuscular theory showed that the transition was under way from an organic understanding of nature to one that was mathematical and mechanical. Laboratory chymists and followers of traditional alchemy, now mocked as "Paracelsian fanatics", were increasingly irreconcilable adversaries, as can be seen here in the title engraving for Johann Kunckel's 'Ars vitraria': on the left, the *Experimentia*, whose "light of nature" is ignited by the Sun of Truth in the burning glass of Reason; on the right is "Unreason" and lunatic "Fantasy", both of which wander in the darkness of foolishness.

Johann Kunckel, Ars vitraria experimentalis, Nuremberg, 1744

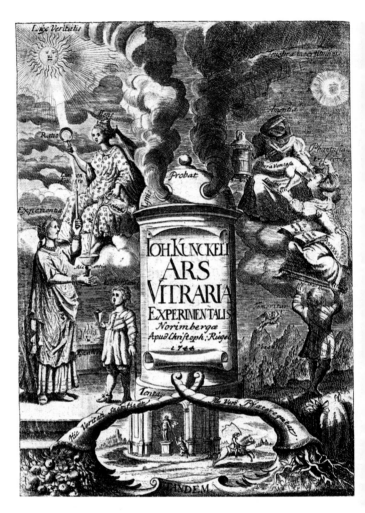

Light & Darkness

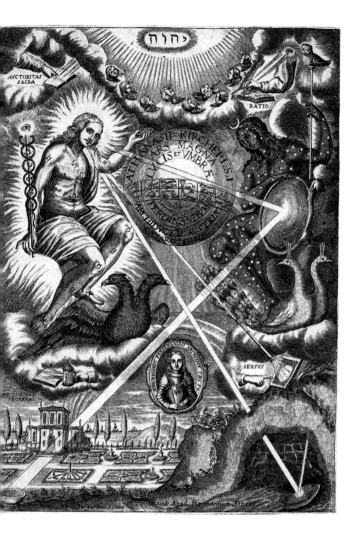

Of Kircher's *Ars magna lucis et umbrae*, Goethe writes in his *History of Colour Theory:* "Here for the first time it is clearly suggested that light, shade and colour should be considered as the elements of seeing; although the colours are represented as the monstrous product of the first two."

Here, light and shade, as the Habsburg double-headed eagle, are assigned to the Sun (Apollo), and the colours, as a peacock, to the Moon (Diana). The beams of light represent degrees of knowledge, in which the sensorily perceptible in the Platonic sense, only achieves the status of a faint reflection of the divine light in the dark cave of the body.

A. Kircher, Ars magna lucis, Rome, 1665

Light & Darkness

The conjunction of sun and moon as an allegory of the marriage of macro- and microcosm by astronomy and alchemy: in the Cabalistic and hermetic view, the upper, empyrean waters are male, the lower, atmospheric waters are female. The reflecting water in the tub symbolizes the astronomer's telescopic lens.

Erasmus Franciscus, Das eröffnete Lust-Haus der Ober- und Niederwelt, Nuremberg, 1676

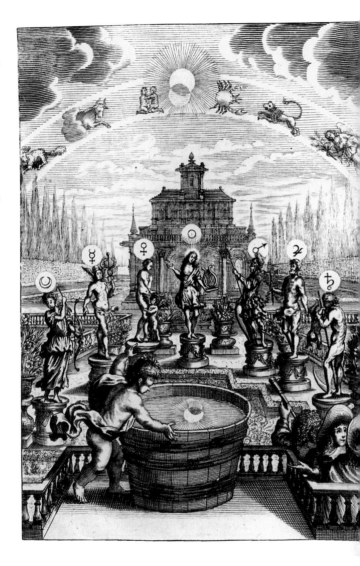

Light & Darkness

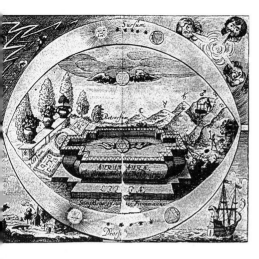

Here, against the background of the four elements, the basic directions in hermetic philosophy are captured by the eye of the imagination.

Upwards (sursum) and downwards (deorsum), fire △ and water ▽, sun and moon merge in the mercurial world-soul, whose mirror image is the lapis in the retort stream. The process runs backwards (retrorsum), since it begins with the old Saturn and ends with the young Sol. To the right, he divides matter into two components and then reunites them (on the left) in the trinity of body, soul and spirit (flower vases).

C.A. Baldinus, Aurum Hermeticum, Amsterdam, 1675

Chymischer Mondenschein, Frankfurt, Leipzig, 1739

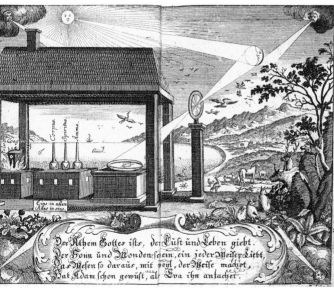

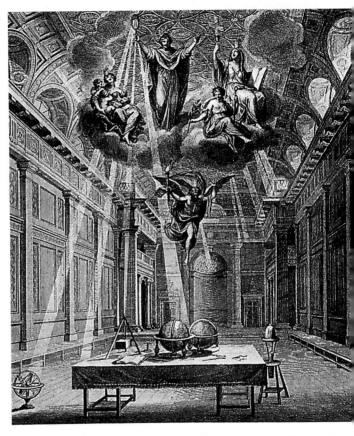

The Masonic lodges of the late Enlighten-
ment were nuclei for the transmission of
democratic and humanitarian ideals. They
played a great role in the movement for
American independence and in the incuba-
tion of the French Revolution.

Here, an assembly room, flooded with the
light of truth, stands under the patronage
of Faith, Hope and Charity.

*Masonic Allegory, Book of Constitutions,
1784*

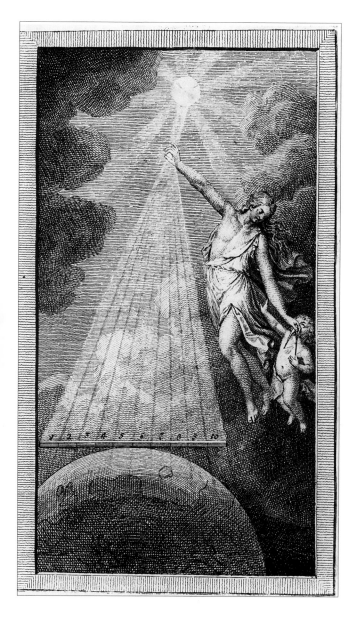

Light & Darkness

From the sun of unity the ten primal numbers (the *Sephiroth*) fall into the space of creation, forming the measure of all things. "To the side is a genius with a child; the genius is stretching his right arm towards the sun – emblematic of the necessity of approaching unity; with the compass in his left hand he is measuring the child's heart – a symbol suggesting that simplicity and power must unite to ascend to the unity, which is the source of all things."

Von Eckhartshausen, Zahlenlehre der Natur, Leipzig, 1794

Light & Darkness

In his *Ars magna lucis* Kircher provided the first descriptions of a *Laterna Magica*, thus making it popular. This apparatus for the projection of pictures painted on glass was a direct predecessor of the slide and film projector. Much of its development was due to the optical experiments of Giambattista della Porta (1535–1615), who can in many respects be seen as Kircher's precursor.

A. Kircher,
Ars magna lucis,
Amsterdam, 1671

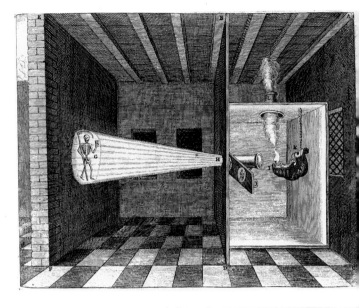

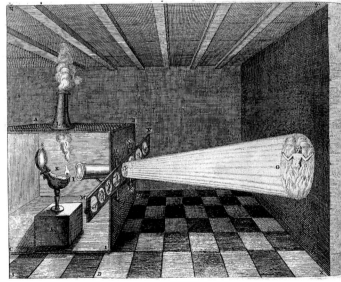

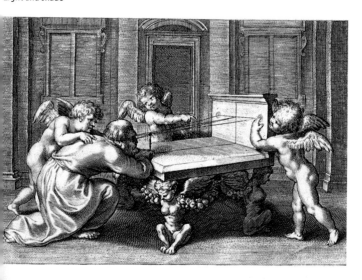

Light & Darkness

"Visible world. To construct it from light and darkness. Or break it down into light and darkness. That is the task, for the visible world, which we take to be a unity, is most agreeably constructed from those two beginnings." (Goethe, *Lectures on Physics*, 1806)

Franciscus Aguilonius, Optica, 1611

Light and shade

Optical illusions

Light & Darkness

No. 1. Form and matter, spiritual and physical principle as a light and dark comb.

No. 2. The combs can be depicted as two hemispheres, "the upper one corresponding to the male, generative nature, and the other to the female, receptive to the seed of light. This material hemisphere is like wax which is formed by the seal of the spirit".

R. Fludd,
Utriusque Cosmi,
Oppenheim, 1619

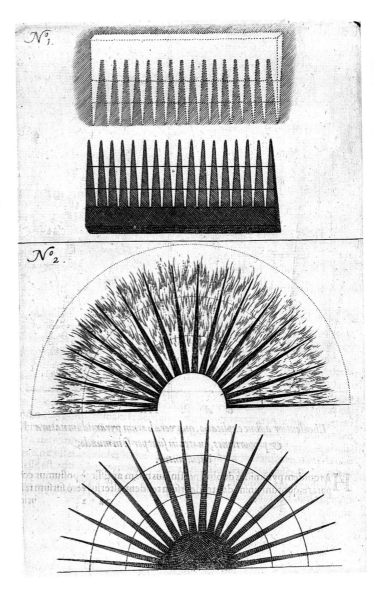

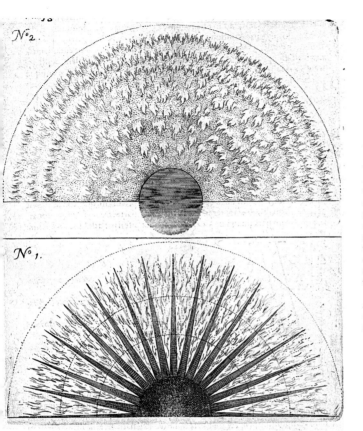

Light & Darkness

The great sex act of heaven and earth:

"The actual product of this mixture can be seen in No. 2, in which the spiritual fire declines by degrees as it approaches the earth."

The divine spermatic influx is the famous dew of the alchemists, which should only be collected on spring nights, when the sky is completely clear and the temperature is mild.

R. Fludd,
Utriusque Cosmi,
Oppenheim, 1619

Light & Darkness

From the central earth, two balanced lines of force pull the sixty-three layers of the upper and lower worlds of the Hindu cosmos. The red background represents the endless spatial mass consisting of atomic particles.

Gouache on paper, Rajasthan, c. 1800

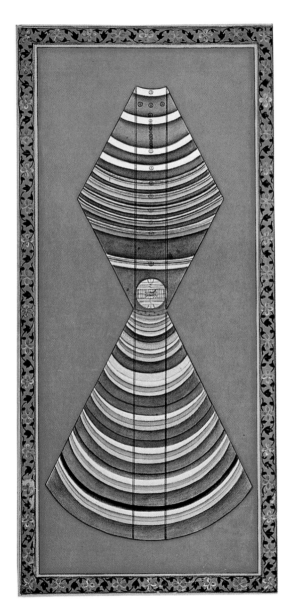

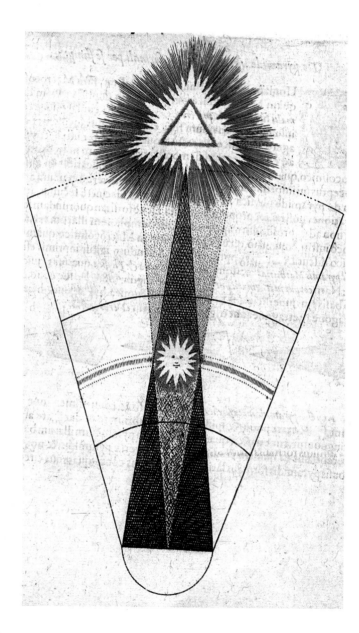

"I confess before my God that I could say so much about the possible uses of these two pyramids that I could easily fill a huge volume." (Fludd, *Philosophical Key*, c. 1619)

The upper third is the region of the divine, fiery heaven (Empyran), the lower of the elemental heaven. The central sphere, which consists of equal parts of upper light and lower matter, Fludd assigned to the ether, the "fiery air". The path of the sun runs straight through the intersections, "which Platonists therefore referred to as the sphere of the soul (sol)."

R. Fludd, Utriusque Cosmi, Oppenheim, 1619

Light & Darkness

No other medieval thinker so crucially influenced the hermetic and theosophical systems of the 16th and 17th centuries as the Neoplatonic universal scholar Nikolaus of Cusa, or Cusanus (1401–1464). His concept of the coincidence of all opposites in God and consequent speculations about the infinity of the universe and human existence helped to colour the views of

Marsilio Ficino and Pico della Mirandola and influenced Giordano Bruno. In his most important theorems Fludd builds upon this concept, and through the influence of Valentin Weigel some aspects of Cusanus' epistemology flowed into the works of Jacob Böhme.

In his text 'On conjecture' (*De coniecturis*, c. 1440) Cusanus uses two diagrams to explain his theory of the four levels of knowledge in which man participates.

The 'Figura Paradigmatica' (P) shows the universe in the interpenetration of two pyramids, whose two bases he calls unity (unitas) and otherness (alteritas). In these two, all other opposites are contained: God and the Void, Light and Darkness, Possibility and Reality, Universal and Particular, Male and Female.

Rise and fall, evolution and involution are one and the same. The progress of the one is the retreat of the other. "God is in the world" is just as valid as "the world is in God."

Nikolaus of Cusa, Mutmaßungen, Hamburg edition, 1988

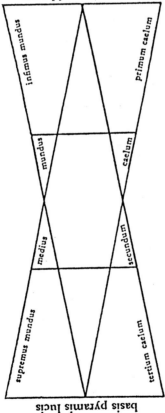

basis pyramis tenebrae

basis pyramis lucis

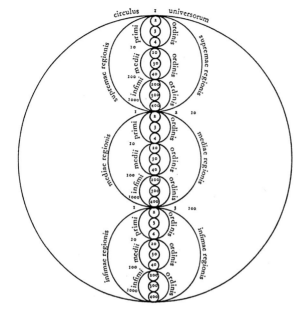

In Cusanus' second diagram, which he entitled 'Figura universi' (U), within the outer boundaries of the universe there are three interlocking worlds: the world of God, the world of intelligence and the world of the rational soul, whose outer crusts are the senses. In this lower region, contradictions cannot be reconciled, in the middle region they are abolished and then ascend in complete affirmation in the upper world of God.

Nikolaus of Cusa, Mutmaßungen, Hamburg edition, 1988

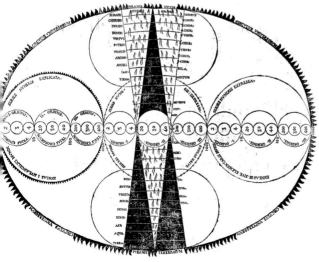

In Kircher's modification of the figure U the chain of worlds, following the theory of the pseudo-Areopagite, is also divided into nine choirs, the lowest sphere of a choir coinciding with the topmost of the next choir.

A. Kircher, Musurgia Universalis, Rome, 1650

Ladder

"Through a golden chain which from our corrupt nature is let down on to the earth from above, our character or rational soul climbs by divine assistance through the orders of creatures from the lowest (...) to the craftsman and architect of all things." (Oswald Croll, *Tractatus de signaturis internis rerum*, 1647)

"Everything is connected with everything, right through to the nethermost end of all the links of the chain, and the true essence of God is both above and below, in the heavens and on earth, and nothing exists apart from it." (Zohar)

Geheime Figuren der Rosenkreuzer, Altona, 1785

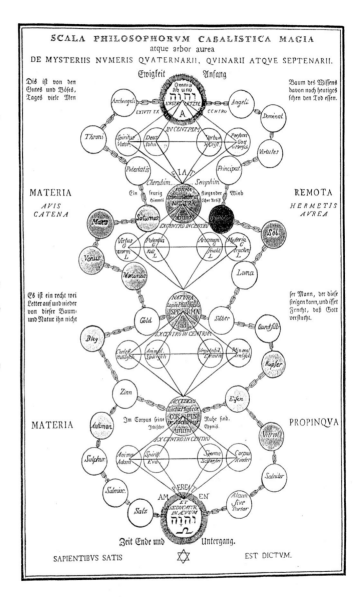

Inscription: "The world is linked by invisible knots"

"From very hidden properties the beasts, the plants of the earth and almost all kinds of natural body have a certain motion towards one another, which one might liken to a passion; partly sympathy, partly antipathy (...), we see, as it were, a large rope drawn from heaven down into the depths, through which everything is linked together and becomes as one piece and this band can be compared with the links of a chain and pull hither the rings of Plato and the golden chain of Homer." (Giambattista della Porta, *Magia Naturalis*, Nuremberg edition, 1715)

A. Kircher, Magneticum naturae regnum, Rome, 1667

Ladder

The author of the three-volume *Aurea catena Homeri* (1723), said to be an Austrian doctor by the name of Kirchweger, gives a detailed description of the cycle of nature as an eternal outflow and return of the world spirit ☉. As dew or rain it reaches the earth, where it condenses into solid male saltpetre ① and fluid female salt alkali ⊖. These two produce acidic alkaline salt ⊕.

Everything elemental consists of these three things, and after death and decay it forms itself back into dew and rain.

When Goethe was intensely involved with alchemy in 1768/69, he was particularly attracted by this book, because in it nature "albeit perhaps in a fantasic way, is depicted as a lovely association". It not only inspired him to write verses: "As all things weave into a whole / one in the other works and lives! As the powers of heaven rise and fall/ and give each other the golden pail" *(Faust),* but also stimulated his own laboratory work. In *Dichtung und Wahrheit* he wrote that these experiments required alkalis "which, when they disperse in the air, connect with superterrestrial things and are supposed to produce mysterious, median salt".

A.J. Kirchweger, Annulus Platonis (Aurea Catena Homeri), 1781, Berlin reprint, 1921

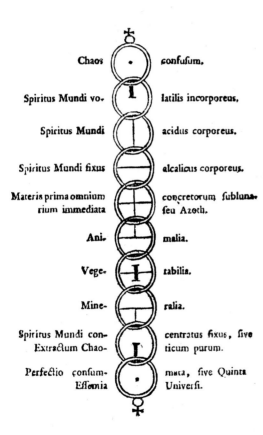

Chaos	confufum.
Spiritus Mundi vo-	latilis incorporeus,
Spiritus Mundi	acidus corporeus.
Spiritus Mundi fixus	alcalicus corporeus.
Materia prima omnium rium immediata	concretorum fubluna- feu Azoth.
Ani-	malia.
Vege-	tabilia.
Mine-	ralia.
Spiritus Mundi con- Extractum Chao-	centratus fixus, five ticum purum.
Perfectio confum- Effentia	mata, five Quinta Univerfi.

"A fourfold sphere of fire governs this Work."

e bottom is of Vulcanus, the next shows
rcurius, the third is the Moon's, into
top the sun rises, which is the fire of
ure. Let this chain be your commander,
t it may guide your hands in art." The
er, elemental fire, whose regulation is
alpha and omega of the work, penet-
es all the others and magnetically holds
chain together. Each fire has its own
tre and its own movement in the Work,
one affects the other. The lunar and
mercurial fire are *menstrua*, strong
ents. He calls them dragons, which

devour, spur on and transform the serpents
of their own sex.

The upper, solar fire is the great arcanum,
which Paracelsus called the bright "essen-
tial fire", in contrast to the dark, elemental
fire. This fire is the creative agent in the
Work. Alexander von Bernus noted the
close kinship of the Latin names Sol and
Sal.

*Michael Maier, Atalanta fugiens, Oppen-
heim, 1618*

Ladder

From a series about the creation of the universe out of the creative, the preserving and the dissolving forces. The interpenetrating energy circles emanate from a single source.

Painting, Western India, c. 18th century

The tree of the soul is rooted in the dark world of divine anger, and grows in two directions: to the right is self-will, influenced by the oppressing "sidereal spirit of this world" and the astral influences of the lower fiery heaven. On the left is selflessness, illuminated by the light of the holy spirit. This trunk alone leads upwards through the four Cabalistic worlds or layers of the soul.

D.A. Freher, in: Works of J. Behmen, Law Edition, 1764

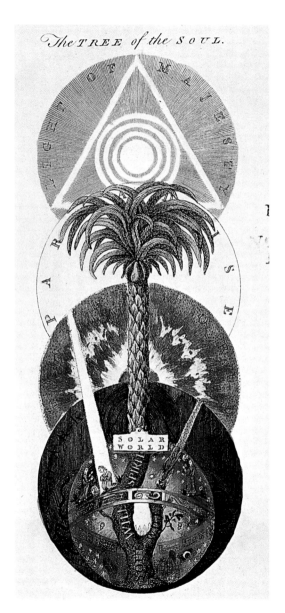

Ladder

On the left-hand track the soul rises via the nine steps of the empyrean and the ethereal heavens and then falls into the elemental realm. On the right, it descends again. Ascending and descending, said Cusanus, are one and the same. The "art of conjecture" lies in connecting the two with a keen intelligence.

Fludd took the division of the steps from the depictions of the Pythagorean lambda, put forward by the Franciscan Francesco Giorgio, a man interested in numerical speculations, as presented in his work *De Harmonia Mundi* (1525).

R. Fludd,
Philosophia sacra,
Frankfurt, 1626

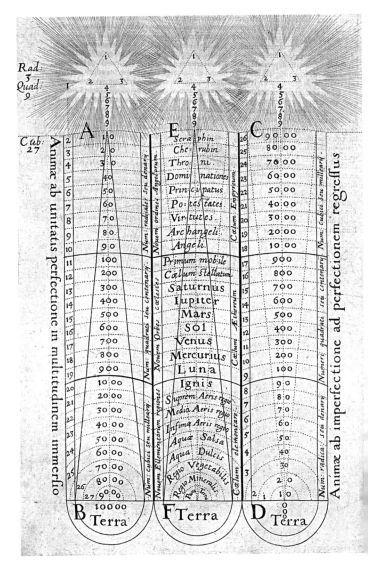

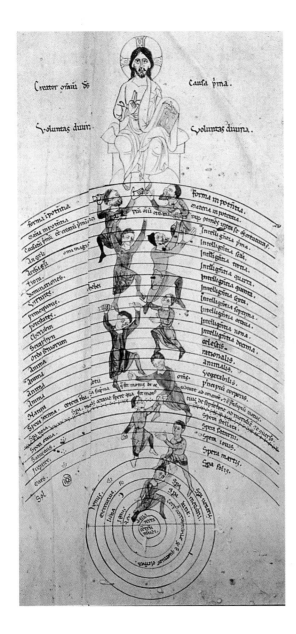

Ladder

"Just as the triune creator descended through the three-times-three orders of angels to us men, so should we rise through the same, as if on Jacob's Ladder, to God." (A. Kircher, *Musurgia universalis*, 1662 edition)

The division of the upper regions of the cosmos into the nine choirs of angels is taken from the work, *On the heavenly hierarchs* by the Alexandrian Pseudo-Dionysius (c. A.D. 500). In the 9th century, it was translated into Latin by the Irishman John Scotus Erugiena, whose own major work, *Of the division of nature* described the world as an emanation from God, to whom it must inevitably return.

Manuscript, 12th century

Ladder

Passage from "The ladder of the number ten"

"Through natural things we achieve natural forces, through abstract, mathematical and celestial things, celestial forces" wrote Agrippa von Nettesheim (1486–1535) in his standard work on magic *De occulta philosophia*, a compilation of Neoplatonic ideas, astral magic texts of Arab origin and Cabalistic teachings mostly taken from the writings of Pico della Mirandola.

The ladder is divided horizontally into six steps from the underworld, via the world of the elements, to the archetypal world, with the ten names of God and the Sephiroth. When the magician meditated on these ladders and memorized them, he wanted "not only to use the forces already available in the more noble, natural objects, but also to draw new ones down to himself from above."

Agrippa von Nettesheim, De occulta philosophia, 1510

In Archety-po.	יהוהיה וי הי Nomen quadriliterum collectum decem literarum.		יוד האואי הא Nomen quadriliterū extensum decem literarum.	
	אהיה Ebeie	יהוה Iod tetta grammmaton	אל El	אלרה Eloha
			יהוה Tetrag. Elohim	גיבר אדחים Elohim Gibor
	כתר Keth	הכמה Hochma	בינה Binah חסר Hæfed	גבודח Gebu-rah תפארת Tiphe-reth
In mundo intelligibili.	Sera phim Haioth haKa- dos Metat tron	Cheru bim Ophanim Iophiel	Throni Aralim Za lh- Kie	Domi-natiões Haima- lim ZadKiel potesta- tes Sera- phim Camael Virtu- tes Mala- chim Rapha- el
In mundo cœlefti.	Reichit hagal- lalim Primū mobile	Masloch Sphæra zodiaci	Sabba-i thai Sphæra Saturni Zedech Sphæra Iouis	Madim Sphæra Martis Sche- mes Sphæra Solis.
In mundo ele- métali.	Colum- ba.	Pardus	Draco Aquila	Equus Leo
In mi- nori mundo	Spiritus	Cerebrum	Splen Hepar	Fel Cor
In mundo infer nali.	feudo thei	Spiritus mendacij	Vafa ini quitatis Vltores fcelerū	Præftigi atores Aereæ potefta- tes

284 OPUS MAGNUM: Ladder

man, various faculties of knowledge – sensory perception, the imagination, reason and deep insight – correspond to the tiered arrangement of the macrocosm. The last rung is the direct comprehension of the divine word in meditation. The ladder extends no further, because God himself cannot be comprehended.

R. Fludd, Utriusque Cosmi, Vol. II, Oppenheim, 1619

Ladder

Here, the intellect stands at the foot of the ladder of creation, which leads upwards from the mineral realm via the levels of plant, animal, man and angel up to God, where Sophia, wisdom, has built her house. The figure symbolizing the intellect holds the instrument that is to enable him to climb up and down, a disc of the *ars generalis* of the Catalan philosopher and Christian mystic Ramon Lull (1235–1316). He developed this "universal knowledge" to convert the two world religions in competition with Christianity, Judaism and Islam, by proving to them the superiority of the Christian doctrines.

Ramon Lull, De nova logica, 1512

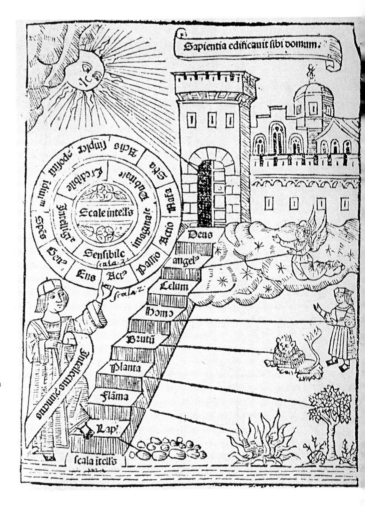

mon Lull took as absolutely fundamental principles for his work a
ries of nine properties or names of God such as goodness, great-
ss, power, upon which both Jewish and Islamic mystics meditated.
these divine attributes he assigned the letters B-K. The first letter
s not used, as it was reserved for the secret aspect of God, the *En-*
oh. Furthermore, nine relative predicates, cardinal questions, sub-
ts, virtues and vices were assigned to the main algebraic key. By
ating the discs, on which the series of letters was printed on dif-
ent rings, one could obtain all possible combinations of these con-
ots, mechanically answer all possible questions and even invent
w ones.

*Ramon Lull, Ars
Brevis, Opera,
Strasbourg, 1617*

The "Ars Raymundi" exerted a great influence because with his
ation Lull gave a new dynamics to thought, freeing it from the
traints of the hierarchial structures of medieval concepts. The
cepts were now understood relative to one another, in relation-
ps that were open because they could be reversed.

Cusanus called this disc-art "circular theology". The develop-
nt of his own theory of the coincidence of opposites and the
undlessness of all things was only made possible by Lull's break-
ough.

*G. Bruno, Opera,
Naples edition,
1886*

Lull Leibniz, the inventor of the German calculator, praised Lull
the godfather of mathematically, formalized logic. "Lull's arith-
tic dream," according to Ernst Bloch, had now become "a whole
lustry of ideas, with speed as witchcraft". (*Das Prinzip Hoffnung*,
nkfurt/Main, 1974)

The Christian Cabalists posthumously declared him one of their
n, and from Agrippa von Nettesheim to Giordano Bruno his
mbinatory art was charged with astro-magical ideas. The rotating
eel was always the prototype for all developmental processes,
d could therefore depend on the sympathy of the alchemists, who
voted a huge amount of hermetic writing to it.

Athanasius Kircher used Lull's combinatory art as a general method enabling him to link all his individual research into an enormous network. Kircher shared the Cabalistic view that creation is a combinatory act, a process of multiplication by endless permutation of the nine, revealed, divine, attributes or *Sephiroth*. In this view the whole universe is nothing but a construction of structural analogies and correspondences that follows the laws of logic and harmonic proportions.

In his *Ars magna sciendi* (1669), Kircher constructed a large baroque system of signs on the basis of Lull's work, generally replacing the terms with "hieroglyphs". He understood them as having symbolic meanings which went far beyond what could be grasped by the senses.

Figure A of Lull's 'Ars'. The network of relationships is designed to underline the trinitary relationships between the nine, divine attributes. The system is related to Gurdjieff's theory of the enneagram. Both are taken from the source of Sufism, the Islamic branch of mysticism with Neoplatonic and Pythagorean influences.

A. Kircher, Ars magna sciendi, Amsterdam, 1669

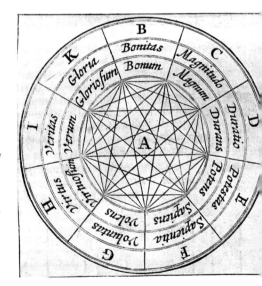

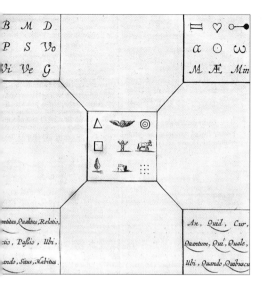

Combinatory chart, with the universal subjects in the middle (upper row: God, angel, heaven), top left: the absolute principles, the attributes of God (upper row: goodness, greatness, duration), top right: the relative principles (top row: difference, agreement, opposition), bottom left: nine statements, bottom right: nine questions.

A. Kircher, Ars magna sciendi, Amsterdam, 1669

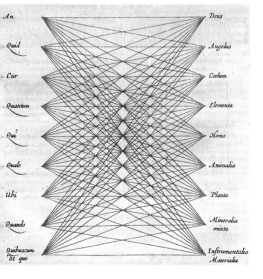

"Universal diagram for the formation of questions about every possible question."

A. Kircher, Ars magna sciendi, Amsterdam, 1669

Ladder

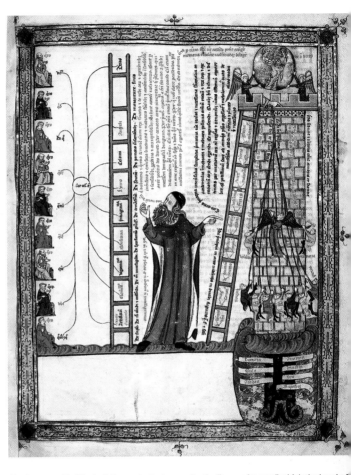

On the second ladder Lull demonstrated the nine absolute and relative principles: "(...) these rules guide the willing reason according to certain principles, from the tower of trust, away from the doubts of your questions, for they embrace the causes of everything in existence." But the "Ars" ends at the tower. Its summit and the haloed trinity can now be reached by the "rope of mercy" which the hand of God is lowering. At the top of this hangs the intellect, followed by memory, the wi and the seven virtues. The seven vices roast in Hell. (Translated inscriptions: W. Büchel/T. Pindl-Büchel, in: Lullus-le Myésier, *Electorium parvum seu Breviculum* Wiesbaden, 1988.)

Ladder

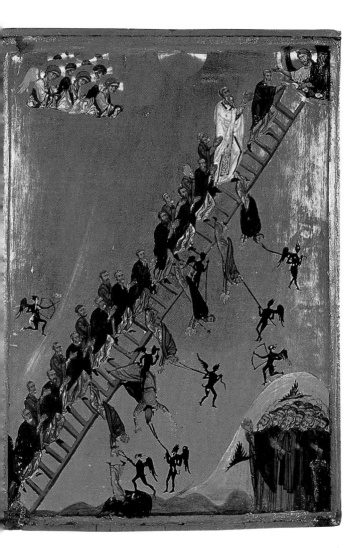

The thirty rungs of the ladder represent the thirty virtues recited by John Klimakos, an abbot at St Catherine's Monastery in Sinai towards the end of the 6th century, in a treatise for the moral fortitude of monks. They face the same number of vices, here embodied by devils. On the topmost rungs, most virtuous of all, marches the abbot himself.

The 'ladder of heaven' of John Klimakos, 12th Century

Ladder

From a Jesuit devotional book: "Consider what you intend to do in this **A** hour and (...) **B** direct your works and your steps (...) towards the glory of God, **C** with an ardent heart; and you can be sure that without **D** God's mercy you can do nothing. (...) Arrange your works equally according to **E** weight, number and measure, just as if **F** you were facing death **G** and angels and **H** devils were watching all your deeds attentively. But do **I** good works, just as if **K** your grave was already being dug (...); complete your works **L** according to the example of Christ and the saints; **M** the angels bring them *(your works)* before God. But above all (...) always bear in mind **N** that God and the heavenly host are always watching you."

A. Sucquet, Via Vitae Aeternae, Antwerp, 1625

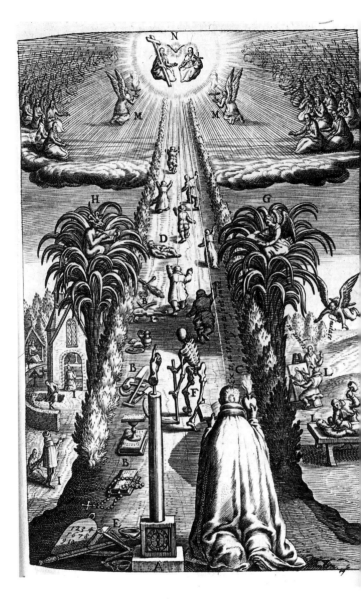

Ladder

The ascent into the mysteries of Freemasonry is based on the three "Great Lights": Bible, compass and square. The glyph ⊙ defines the Freemason's task by placing him, as a point at the centre, in relation to the infinite, circular horizon. The two verticals are the two Johns, the Baptist and the Evangelist, who stand by him. The Jacob's Ladder represents the process that is supposed to transform the raw stone (apprentice, *Prima Materia*) into the cubic stone (lapis).

The female figures: Faith, Hope and Charity. The columns: Strength (S), Wisdom (W) and Beauty (B). The board shows that the apprentice level is still caught up in antinomian thinking.

J. Bowring, First Degree Board, 1819

Ladder

While the ascent on the apprentice board leads straight up a ladder – as an expression of the original will, following a projection – at the more advanced level of the journeyman, what we now have is a curved path in the form of a seven-step spiral staircase, in which it is no longer clear where the beginning and end are. This expresses the slow and organic course of the process of spiritual maturity. One image of this is the ear of corn growing beside the endless river of life.

J. Bowring, Second Degree Board, 1819

Ladder

The two columns of Jachin and Boas indicate that we are now inside the temple of Solomon. The seven steps symbolize the seven phases of the process, the seven levels of consciousness and the seven liberal arts.

Here, everything still occurs in the side chambers of the temple: the holy of holies at the centre only discloses itself "when One has come of Two" and the portal of death and corruption has been crossed. (cf. p. 223)

F. Curtis, Work Chart for the 2nd Level, 1801

Ladder

"Improvement
makes straight
roads; but the
crooked roads
without improve-
ment are the roads
of Genius."
(W. Blake,
*Marriage of Heaven
and Hell,* 1793)

*Ph. O. Runge,
Perspektivische
Konstruction einer
Wendeltreppe*

"I want! I want!"

*W. Blake, The Gates
of Paradise, 1793*

Ladder

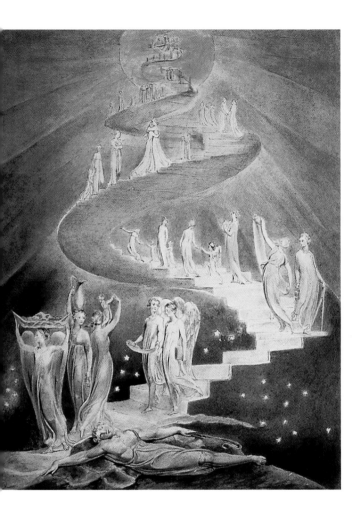

A ladder appeared to Jacob in a dream, "and the top of it reached to heaven: and the angels of God were going up and down on it". (Genesis 28, 12)

For Blake, the image of Jacob's Ladder as a gate to heaven was closely allied to the anatomy of the ear, whose passages he calls "the endlessly twisting spiral ascents to the Heaven of Heavens (...)." According to Swedenborg, with whose writings Blake was familiar, the "opening of the inner ear" is the precondition for making contact with the higher worlds.

W. Blake, Jacob's Ladder, c. 1800

Ladder

L'ordre des Francs-Maçons trahi…, Amsterdam, 1745

Ladder

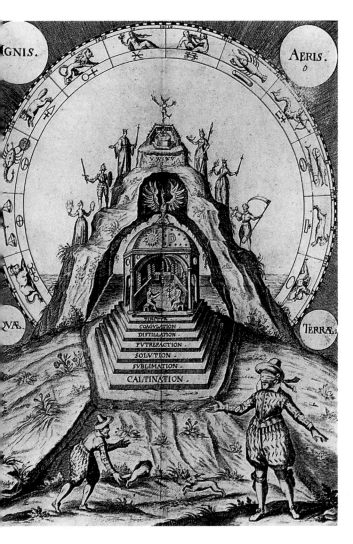

The alchemist is led astray until the fleeting mercurial hare indicates the correct source material, behind whose rough facade, via the seven steps of the process, a palace is revealed. Here, the principles of Sol and Luna unite to form the lapis, the "philosophical mercury", which crowns the dome in the form of a phoenix.

The zodiac indicates that the Work begins in May, in the sign of Taurus. Each sign of the zodiac corresponds to a chemical substance.

S. Michelspacher, Cabala, Augsburg, 1616

Ladder

The *Alchymia* of Andreas Libavius (1540–1616) is considered to be the first systematic textbook of chemistry, inspired by the attempt to impose a structure of clearly defined concepts upon a diffuse, alchemistic nomenclature.

With his tireless attacks on Paracelsian fanatics, whom he accused of blasphemy and black magic, he prompted Robert Fludd to write his first apologia for the Rosicrucians in 1616.

The double-headed green lion in the foreground is spewing out the solvents on which the Work is based. The seven steps symbolize the alternating phases of dissolution (left) and coagulation (right). At the top sit King Sulphur and Queen Mercury in the chymical bath, from which grows the tree with the golden apples of the Hesperides. Above them are the six stars of the multiplicatio.

A. Libavius, Alchymia, Frankfurt, 1606

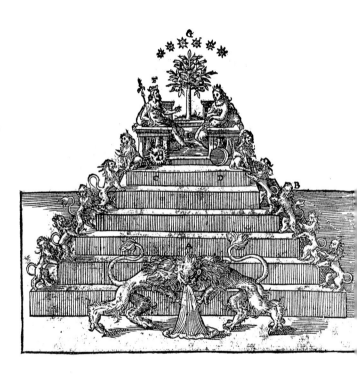

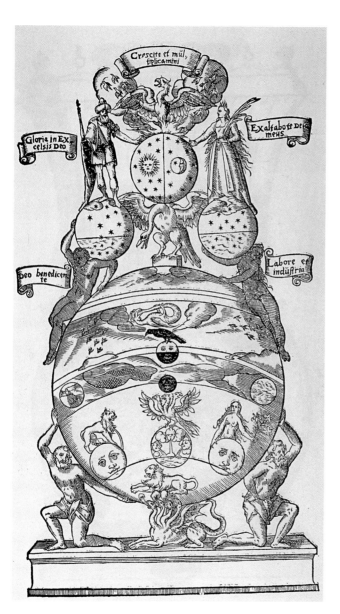

The structure of the *Opus Magnum* is divided into three storeys:

In the first Work (the bottom sphere), the *prima materia* is completely cleansed by a series of distillations, and passes through the unifying gate of putrefaction.

In the second (the three upper spheres), it is permanently fixed. The swan symbolizes the lunar tincture, the white elixir.

The third Work, beginning with the royal wedding, brings the birth of the phoenix: the solar tincture or the red elixir.

A. Libavius, Alchymia, Frankfurt, 1606

Libavius provides a detailed description of the illustration, a slightly abbreviated version of which is presented here:

C Four-headed dragon as the four degrees of the fire of the first operation.

D Mercury with the green lion (E) and a dragon (F) on a leash. These two signify the same mercurial fluid, the prima materia of the lapis.

G Three-headed eagle spews a white fluid into the sea from one of its heads (H). It is called "the eagle's blaze", a rubbery, binding agent. The wind (I) blows upon it.

K The blood of the red lion also flows into it.

M A mountain rising out of the black water of putrefaction. It is black at the bottom, and at the top, from which there flows a silver spring, white. The heads of the ravens rise from the black sea (N).

O Silver rain (Azoth) feeds Latona (M) and washes away its blackness.

Q The Ouroboros is the symbol of the second fixing after the second putrefaction.

R The Ethiopians, supporting the spheres at the sides, signify the blackness of the second operation in the second putrefaction.

T The swan is the white elixir, the arsenic of the philosophers. It spews a milky fluid into the pure silver sea (S), the mercurial fluid which acts as an agent to unite the tinctures.

X When the sun dips into the mercurial sea into which the elixir is also to flow, the true solar eclipse occurs (V), with the rainbow (peacock's tail) on either side. It is the sign of the fixing.

Y Lunar eclipse as a symbol of the white fermentation.

a King in crimson with golden lion and red lily.

b Queen with silver eagle and white lily.

c Phoenix burning on the sphere; from the ashes a large number of silver and gold birds fly up as a sign of multiplication.

Ladder

A. Libavius,
Alchymia, Frank-
furt, 1606

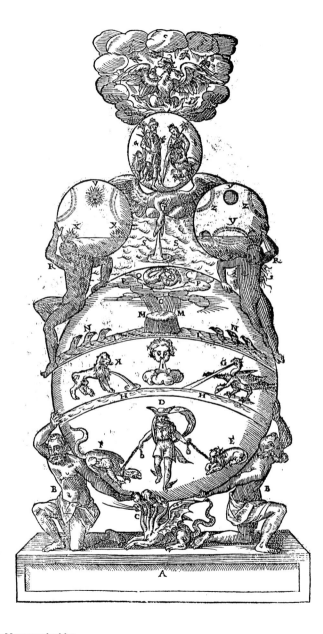

Philosophical tree

This depiction of the Sephiroth tree is indebted to the *Opus Magnum*.

The dissolving and binding powers sit opposite one another on the branches: on the bottom left is volatile Mercury with the winged shoes, and to his right is the fire-spitting Sulphur. Above them, diagonally reversed, are their forms in a sublimated and crowned state. On the top level, the third Work, the two unite as the lunar tincture. From this there finally emerges the solid sulphur, the son of the sun. He wears the crowns of the three realms, vegetable, animal and mineral.

*J.D. Mylius,
Anatomia auri,
Frankfurt, 1628*

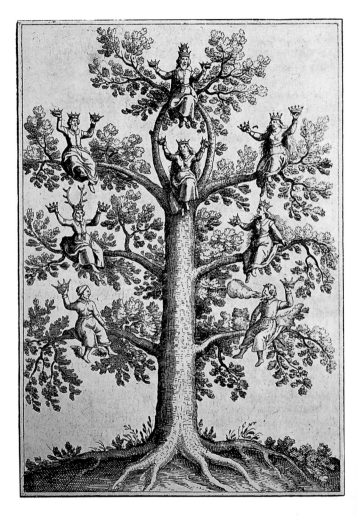

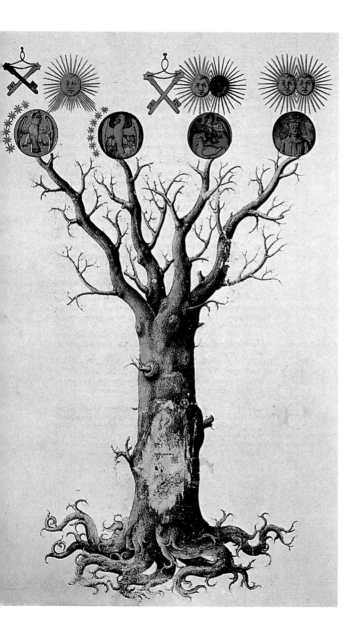

Philosophical tree

The Alexander novel, popular in the Middle Ages, tells of the oracular trees of the sun and moon. Observations of the appearance of tree-like crystallizations in the retort must also have contributed to the dissemination of this symbolism:

"They grow in the glasses in the form of trees, and by continued circulations the trees are dissolved again into new mercury (...). The gold begins to swell, to blow itself up, and to putrefy, and also to spring forth into sprouts and branches (...) which every day impresses me anew." (Isaac Newton, quoted in: Betty Dobbs, *The Foundations of Newton's Alchemy*, Cambridge, 1975)

Pseudo-Lull, Alchemical Treatise, c. 1470

Philosophical tree

"We have painted the composition of the trees of the forest together on one sheet." The ribbons indicate their compatibility in the process.

J. Lacinius, Pretiosa Margarita, Venice, 1546, Leipzig edition, 1714

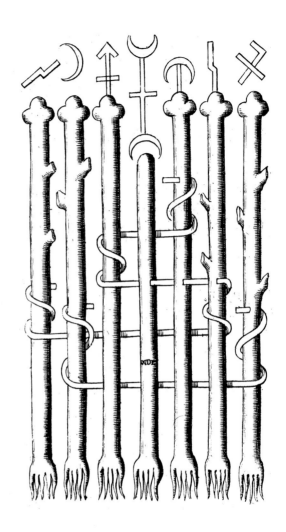

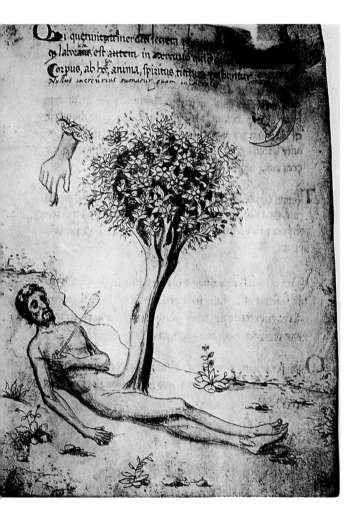

Philosophical tree

From the dead body succumbing to decay at the bottom of the retort, "the mercurial soul, the spirit, the tincture is extracted". According to Gerard Dorneus, mercury is "the mineral root of the tree that nature has planted in the middle of her womb". All metals emerge from it and its branches, are spread over the whole surface of the world, like the veins in the body. (Gerardus Dorneus, "De genealogia mineralium", 1568, in: *Theatrum chemicum,* 1602)

Miscellanea d'Alchimia, Italy, 15th century

Philosophical tree

The term 'Azoth' is an arcane Paracelsian name for mercury, a combination of the first and last letters of the Latin, the Greek and the Hebrew alphabets. The tree here is being used to demonstrate that Azoth refers to both the beginning of the Work, the mercurial root-powers, and also the upmost point, the philosophers' mercury, the all-healing elixir.

Basilius Valentius, Azoth, Paris, 1659

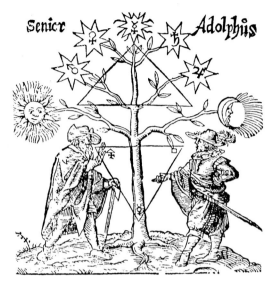

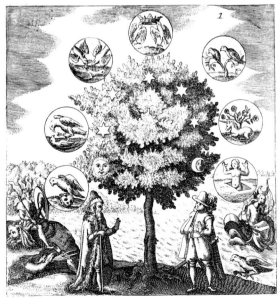

Surrounded by the symbols of the four elements, for the purposes of meditatio the tree shows the seven phases of the Work as an inner development, beginnir with putrefaction (left: old man – Saturn and ending with rebirth (right: young ma – lapis). The unicorn symbolizes the pen timate phase of whitening, from which sprout the red roses of definitive fixing.

Musaeum Hermeticum, Frankfurt edition, 1749

Philosophical tree

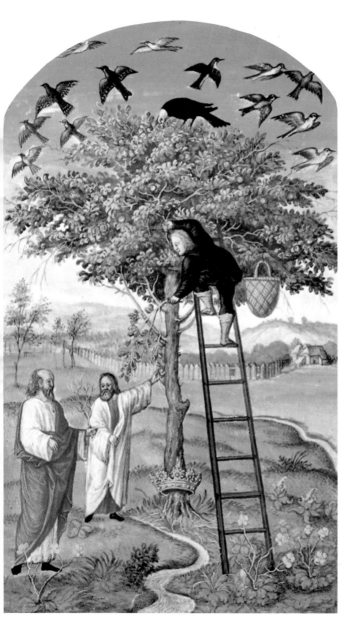

"Plant this tree on the lapis (...) that the birds of the sky come and reproduce on its branches; it is from there that wisdom rises." *(Theatrum chemicum)*

Aeneas, draped in majestic red, receives from his son Silvius a branch of the tree of life, to protect him on his journey through decay and the purifying fires of the underworld. The good end is in sight, for according to Trismosin the raven's head has turned white.

*S. Trismosin,
Splendor solis,
London,
16th century*

Sephiroth

The Sephiroth tree is at the core of the Cabala, its most influential and multi-layered symbol. The Sephiroth are the ten, primal numbers which, in combination with the twenty-two letters of the Hebrew alphabet, represent the plan of creation of all upper and lower things. They are the ten names, attributes or powers of God, and form a pulsating organism called the "mystical face of God" or the "body of the universe". It stands on the three pillars of mercy (right) severity (left) and central balance. The central pillar forms the spine through which the divine dew flows down into the lower womb. In creation only the effects of the seven lower Sephiroth are visible, the upper triad works outside time and beyond understanding. In the system of the four worlds it corresponds to the divine light-world (aziluth), which is separated by a veil from the two lower triads of the throne-world (beriah) and the world of angels (yezirah). The lowest Sephira, Malchut, is identified with Assia, the spiritual prototype of the material world.

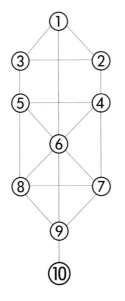

1	Kether	supreme crown, initial will
2	Chochma	wisdom, seed of all things
3	Bina	intelligence, upper matrix
4	Chessed	love, mercy, goodness
5	Gebura	severity, punitive power
6	Tiphereth	generosity, splendour, beauty
7	Nezach	constant endurance, victory
8	Hod	magnificence, majesty
9	Jesod	ground of all procreative powers
10	Malkuth	kingdom, the dwelling of God in creation

Sephiroth

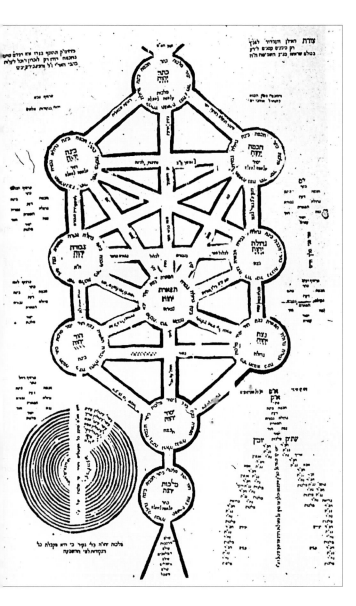

After the expulsion of the Jews from Spain in 1492, the charismatic Isaac Luria founded a new influential centre of Cabalistic exegesis at Safed in Upper Galilee. His mysticism was characterized by the queston of the origin of evil. According to one doctrine of the Zohar, evil arose from an eruption of the Sephira of "severity" (5), when it was separated by a blockage of the intermediary channel from the mitigating influence of divine love (4). For Luria, this was caused by a cosmic fracture and by the fall of the lower Sephiroth, unable to bear the penetration of the upper stream of light in primal times. The spiritual light is now scattered in matter and can only be led back to the desolate divine organism by good deeds on the part of the individual.

Sephiroth tree after Isaac Luria, Amsterdam, 1708

Sephiroth

The Sephiroth are also imagined as ten shells or casings around the innermost core of En Soph, the formless and ineffable centre of all being.

The Cabbalists called meditation on this Nothing-in-Everything, extrapolating from a verse in the Song of Solomon (6, 11), "going down into the garden of nuts". Shakespeare refers to this when he has Hamlet say, "O God! I could be bounded in a nutshell, and count myself a king of infinite space". And Joyce in *Finnegans Wake*: "Mark Time's Finist Joke. Putting Allspace in a Notshall".

Sephiroth scroll, Poland, 19th century

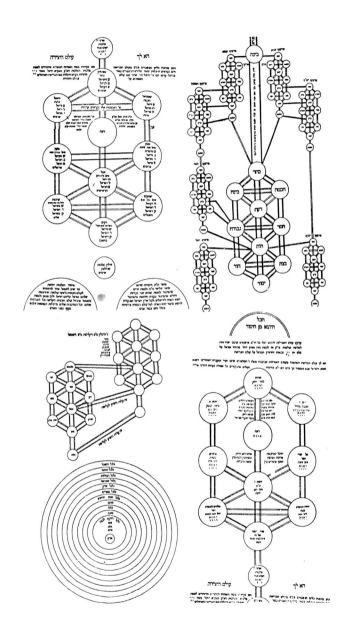

Sephiroth

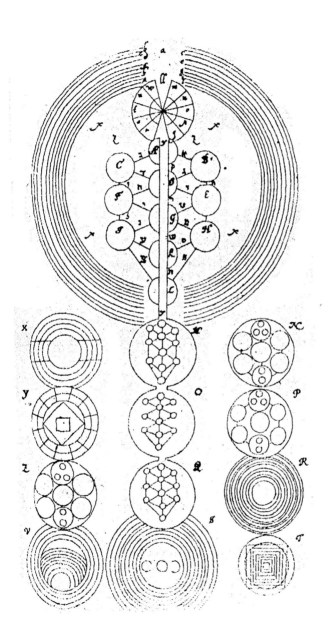

The Sephiroth form a holistic system in which the whole propagates and reflects itself infinitely into its tiniest particles.

In the *Kabbala denudata* of the Christian theologian and poet Christian Knorr von Rosenroth (1636–1689) published in Sulzbach, Germany, in 1677, a broader, non-Jewish public had its first access to a collecton of uncorrupted Cabalistic texts. It contains, amongst other things, a partial Latin translation of the Zohar and a text by Luria. Rosenroth was in close contact with the English acolytes of Böhme and the Amsterdam circle around Gichtel.

C. Knorr von Rosenroth, Kabbala denudata, Sulzbach, 1684

Sephiroth

The honeycomb-like links depicted here represent new formations and restructurings of the tree after the fracture of the lower Sephiroth. Luria called the configurations "Parzufim", faces of the deity.

At the very top (No. 52), "the forbearing one" (Kether), thrones above "Father" (Chochma, 55–65) and "Mother" (Bina, 66–77). The lower Sephiroth are assembled into the form of the "impatient one". 138–149 is his mystical bride Rachel, the renewed Sephira Malchut.

C. Knorr von Rosen-roth, Kabbala denudata, Sulzbach, 1684

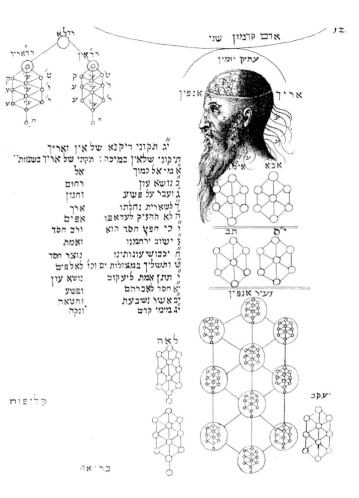

The ten Sephiroth not only form the cosmic body of the first man, Adam Cadmon, with the three upper brain-chambers and the seven limbs, but, according to the teaching of Isaac Luria, the individual Sephiroth are also reflections of his mystical face, each stressing a particular aspect. The uppermost Sephira, Kether, is called "the forbearing one" or "sainted old age" or "star of the universe". On him depends the life of all things, according to the Zohar, and from the curve of his skull, dew flows incessantly down onto the lower heaven: the nectar of the Rosicrucians, the philosophers' mercury.

C. Knorr von Rosenroth, Kabbala denudata, Sulzbach, 1684

Sephiroth

According to the law of the Pythagorean Tetractys, the four seeds of the arcane name of God unfold on ten levels. "The world was created in ten words" (Zohar). In combination with the twenty-two letters, the channels through which the divine power circulates, the diagram of the Sephiroth encompasses all possibilities and all combinations of the world of elements.

Manuscript, Salonica

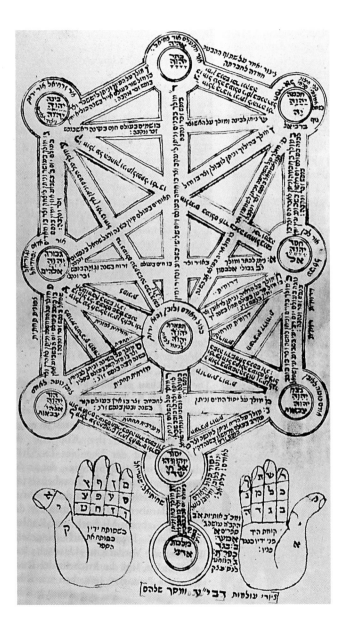

Sephiroth

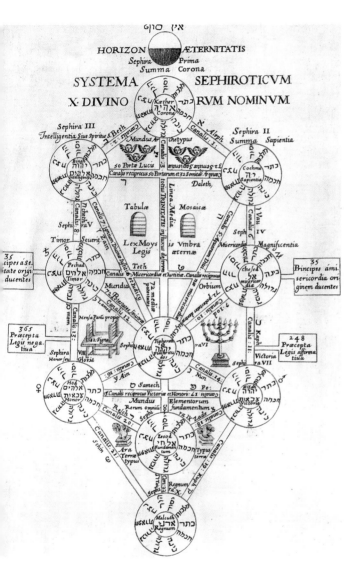

The Sephiroth diagram as a ground plan of the Temple of Solomon, with *Malchut* as the entrance and two altars for sacrifice by fire in the forecourt. *Tiphereth* is the position of the devotional altar in the sanctuary, in which, on the left, are the table with the twelve loaves (the twelve tribes of Israel, as an earthly illustration of the Zodiac) and on the right, the seven-branched candelabra. Behind it, closed off by a curtain: the holy of holies with the Ark of the Covenant and the two tablets with the Law. Above it sits the *Shechina*, the glory of God in the world. Kircher assigned to the seven lower Sephiroth the sequence of planets from Saturn-Gebura (Pechad) to Moon-Malkuth.

A. Kircher, Oedipus Aegyptiacus, Rome, 1653

Sephiroth

René Zuber tells of the preparation for a Russian Christmas party in the Paris apartment of M. Gurdjieff:

"I had almost completed my task when Gurdjieff came in (…) and, approaching the tree, gave me a sign to indicate that the pine-tree had to be fastened to the ceiling of the room (…) 'But (…) Monsieur (…), on the hook up there? With the tip pointing downwards and the roots upwards?' That was exactly what he wanted. There was nothing for me to do but to relieve the pine tree of its decorations, climb on a stool and fasten it after a fashion to the ceiling with its roots pointing upwards."
(*Wer sind Sie, Herr Gurdjieff?*, Basle, 1981)

R. Fludd, Utriusque Cosmi, Vol. II, Frankfurt, 1621

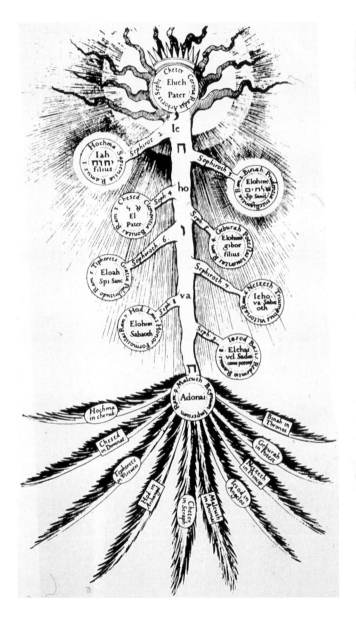

Sephiroth

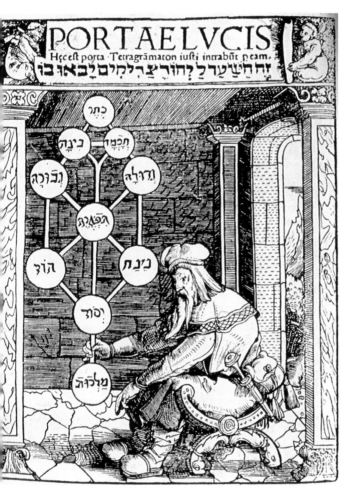

Title picture for the *Portae Lucis* (Gates of Light), a partial translation, published in Augsburg in 1516, of the 'Shaare ora' of Joseph Gikatilla, a Spanish Cabbalist of the late 13th century. Scholem believed that his work had an influence on the author of the Zohar, Moses de Leon.

According to Gikatilla, the Fall of Adam destroyed the smooth relationship between the upper and the lower Sephiroth, and thus destroyed the unity of heaven and earth.

*Paulus Ricius,
Portae Lucis,
Augsburg, 1516*

Sephiroth

"That which comes from the tree of knowledge," the Zohar has it, "bears duality within itself". The fruits of love and anger, of light and darkness, of eternity and time.

Although Adam decided in favour of the dark fruit of mortality, he has the freedom to choose, for the world of elements consists of both root-forces, of the light and the dark.

The seven hands are Böhme's "source spirits", the lower aspects of the Sephiroth tree. The central sun is Böhme's dividing fire, and corresponds to the Sephira Tiphereth, identified by the Christian interpreters of the Cabbala with Christ as the "heart of heaven".

V. Weigel, Studium universale, Frankfurt, 1698

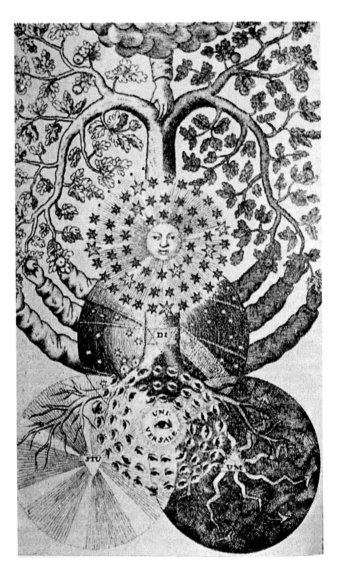

Sephiroth

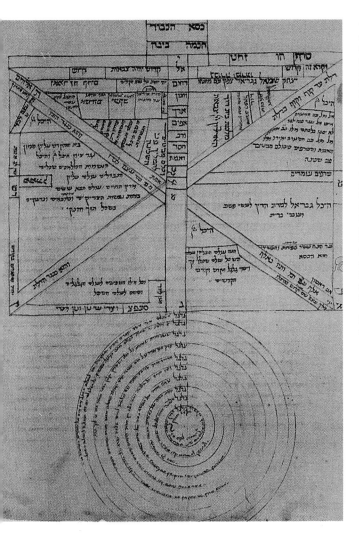

The Sephiroth system in correspondence to the geocentric shell model of the universe and the levels of the angels.

Kether was linked to the *primum mobile*, *Chochma* to the heaven of the fixed stars, *Bina* to Saturn, *Chessed* to Jupiter, *Gebura* to Mars, *Tiphereth* to the sun, *Nezach* to Venus, *Hod* to Mercury, *Yesod* to the Moon and *Malkuth* to the sublunary, elemental region.

Manuscript, Italy, c. 1400

The *Opus mago-cabalisticum* of the director of a mine, Georg von Welling (1655–1725), who was later employed as an alchemist at the court in Karlsruhe, enjoyed great popularity in the circles of the late 18th-century Rosicrucians, and even influenced the Russian Freemasons. For Welling, the true Cabala was "a spiritual, Christian science". But the Jewish Cabala was nothing but a misuse of divine names. "It was from this work ... that Goethe acquired his empty and vague concept of the Cabala, which he then passed on", wrote Scholem. (Gershom Scholem, *Alchemie und Kabbala*, Frankfurt, 1994)

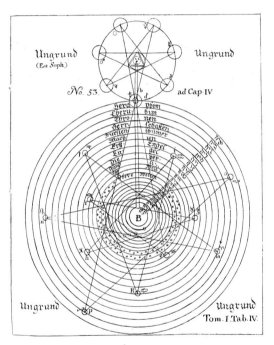

During his hermetic phase, the poet devoted a great deal of effort to an understanding of Welling's book, marking the "obscure references, where the author points from one place to the other" with marginal notes. "But even then the book remained obscure and incomprehensible enough." (Goethe, *Dichtung und Wahrheit*)

A few years after reading this book, Goethe reconstructed Welling's imagined world as a Lucifer-Gnosis of his own in his unfinished drama, *Prometheus* (1773). Later, this would be taken up by Rudolf Steiner and anthroposophy.

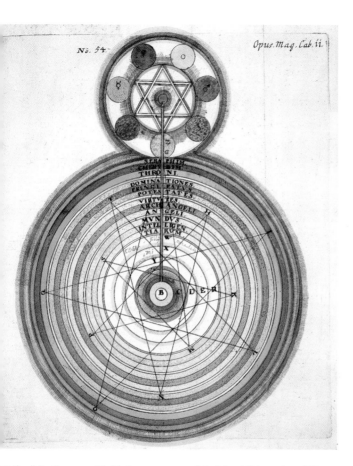

No. 54. Opus. Mag. Cab. ii.

m the divine throne-world with the
even Great Spirits of Revelation" the di-
e light pours through Sachariel, the
rit of Jupiter, creating the spirit world
he archetype of "our solar system in its
st perfect state".

CDE is the world of the son of the red
wn (Lucifer) (...) to which shone all the
rays of the light of divine majesty." The
third world consists of the 12 choirs of the
angelic hosts. Through his arrogance, Luci-
fer causes "the confusion of his wonderful
spirit-world with the earthly one".

*Gregorius Anglus Sallwigt (pseudonym of von
Welling), Opus mago-cabalisticum, Frankfurt,
1719*

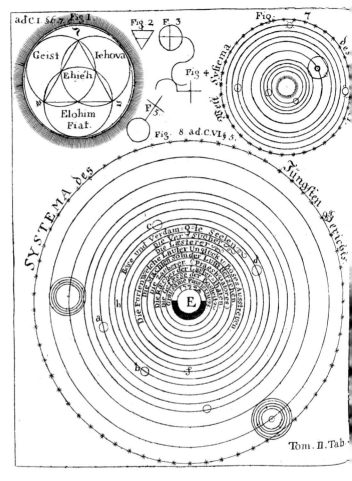

Like Paracelsus, Welling distinguished between a dark and a light fire, and like Böhme he believed in a celestial and an earthly sulphur. Earthly sulphur is a reversal of the upper light. He derived the sign of lovely sulphur, the "light of joy", from the triangle of the trinity (Fig. 1) and the cross of the "miraculous salt". The inverted sign of the grim sulphur of "slimy saltiness" was a combination of the signs for earth (Fig. 2) and vitriol (Fig. 3).

The Copernican system (Fig. 7) is modifie in the course of the Apocalypse, when Heaven and the elements will be destroyed by fire. The earth will fall into th centre E, and be divided into the dark "fiery mire" and the "sweet light of joy"

Georg von Welling, Opus mago-cabalisticum, Frankfurt, and Leipzig, 1760

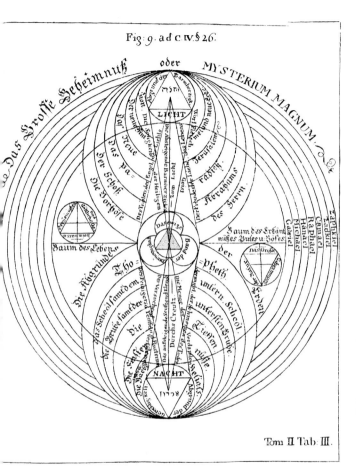

Fig: 9. ad c. IV. § 26.

Tom II Tab: III.

Welling, influenced by Paracelsus, Agrippa and Böhme, called the imagination a "radiation of the emotions" which grasps the substance of visible and invisible objects and incorporates them within the soul. "Every one of us is drawn by the rays of his imagination, as by a powerful magnet, towards his own death, the way to which he has imagined during his life." Between the two poles of light and night, as lines of magnetic fields, lie the "squadrons of joy and grief" in which the soul dwells after death.

Georg von Welling, Opus mago-cabalisticum, Frankfurt, and Leipzig, 1760

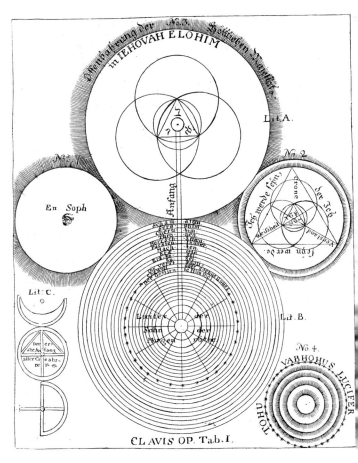

The main key to the 'Opus-mago': the incomprehensible unground (No. 1) emerges from itself and reveals itself in the trinity (No. 2). "In praise of his incomprehensible majesty" (Lit. A) he creates the spirit-world (Lit. B). The first emanation from the Void is the fiery water "Eshmayim", whose glyph is a combination of the signs of the Tria Prima (Lit. C). Lucifer was the centre of the spirit-world. This was created from fiery water, which, after his Fall, became a thick salty, sulphurous water, the *Tohuwabohu* (No. 4). As an act of "divine generosity" our solar system was separated from this dark chaos.

Georg von Welling, Opus mago-cabalisticum, Frankfurt, and Leipzig, 1760

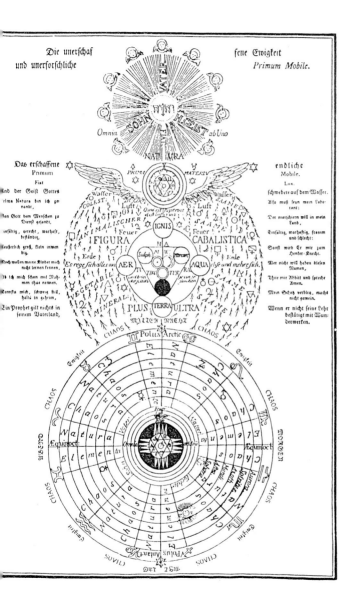

Diagram of the Gold- and Rosicrucians:

The wheel of nature, which stems from the seeds of all planets and metals, the mobile and temporal reflection of the eternal *primum mobile* of the divine trinity. From this emerged Jacob Böhme's elemental 'wheel of anguish', bounded on the outside by the Zodiac.

Geheime Figuren der Rosenkreuzer, Altona, 1785.

Sephiroth

The Sephiroth diagram was adapted by the 18th-century Gold and Rosicrucians, to represent the *Opus Magnum* in a universal context.

A precise interpretation of this figure will only occur when "2,800 parts are described in a corn of wheat" and Elias Artista reveals himself.

Geheime Figuren der Rosenkreuzer, Altona, 1785

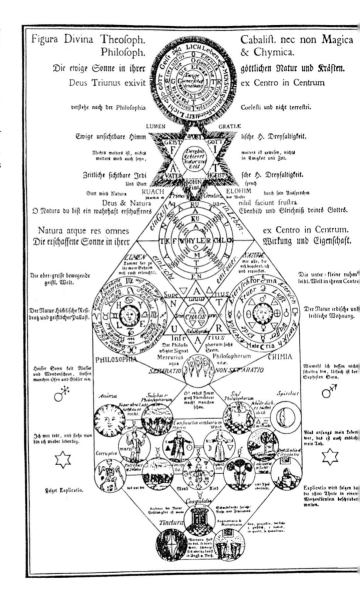

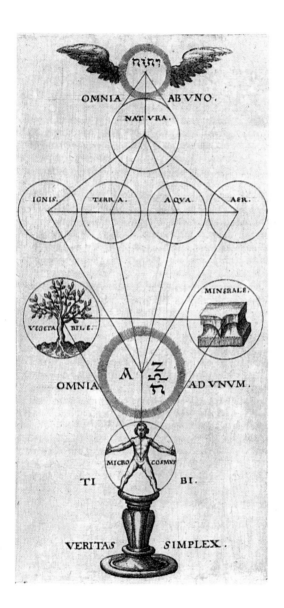

"The four elements yield up (…) a sperm or semen (Azoth: quintessence), which is cast into the centre of the earth, where it is transformed (…)".

The "Tree of Pansophia" was the name that the Rosicrucian Daniel Mögling from Constance (alias Theophilus Schweighart) gave to his diagram, in which the harmonic connection of microcosm and macrocosm is to be contemplated: *Omnia ab uno* (Everything from the One), *Omnia ad unum* (Everything to the One): "Seriously contemplate nature, and then the elements (…) therein you will finally rediscover yourself, from which you then ascend to God Almighty".

Theophilius Schweighart, Speculum sophicum Rhodostauroticum, 1604

Ab uno

⊙ "The circle and the point: the circle is the symbol of eternity. The point is the symbol of the concentration of time in the moment. Sun = gold = connection between circle (eternity) and point (concentration), is time in eternity, is the symbol of the unity of macro- and microcosm." (From the *Tabula Chaeremonis*, 18th century)

Philotheus, Symbola Christiana, Frankfurt, 1677

"The circumcircle is in the point, in the seed lies the fruit, God in the world; the intelligent one will seek him within it." (Daniel von Czepko, writing under the name of Angelus Silesius, 1605–1660)

Ein schön nützlich Büchlein und Underweisung der Kunst des Messens, Nuremberg, 16th century

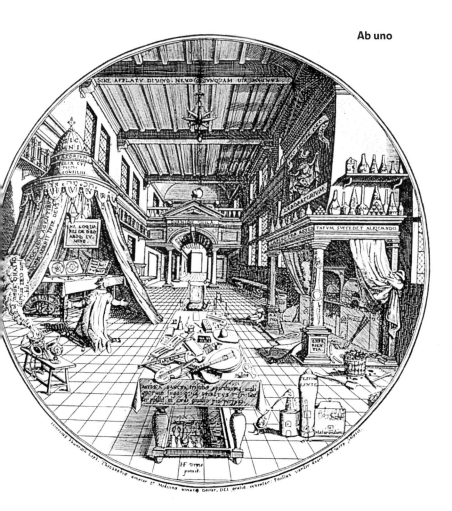

einrich Khunrath's "Whole circle-round
.) stage of eternal wisdom" is filled with
e spiritual salt of wisdom, the "Tartarus
undi" or "central salt-point of the great
uilding of the whole world" into which all
e spatial lines of Hans Vredeman de
ies' perspectival construction vanish.

wake in sleep" stands above the en-
ance, for "We are the stuff that dreams
e made on" (Shakespeare, *The Tempest*).
e can awake from this state through

constant prayer in the oratorium (left), and
through unstinting work in the laborat-
orium (right), which rests on the two
pillars of experience and reason. The oven
in the foreground admonishes us to
patience ('Hasten slowly'), and the gifts
on the table remind us that sacred music
and harmony are supposed to accompany
and define the Work.

Heinrich Khunrath, Amphitheatrum
sapientiae aeternae, 1602

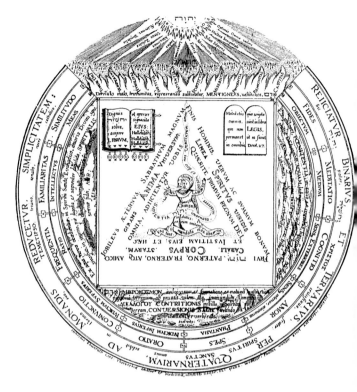

For the Paracelsian doctor Heinrich Khunrath (1560–1605) the correct knowledge of art is "a breath from God" by communication with the heavenly hierarchies. Thus, his works, which were highly respected in Rosicrucian circles, consisted largely of grandiose conjurations and curses. Khunrath is supposed to have practised at the court of Rudolf II in Prague with Oswald Croll and Michael Maier, and he was also in contact with the English astrologer John Dee. The influence of Dee's *Monas Hieroglyphica* (1564), an interpretation of the Pythagorean Tetractys seen from the perspective of magic is apparent in the illustration above. The son of the great world, the lapis, is likened to Christ as the son of the microcosm. Both arise after torture and death in an indestructible heavenly body, which now has the power to release all other bodies from their transitory, elemental quadrinity. The perfect harmony of the trinity of body-soul-spirit brings sexual duality (the Rebis in the centre) into primal unity, the Monas. How that is to be achieved is written on the two arms of the Rebis: Ora et labora.

Heinrich Khunrath, Amphitheatrum sapientiae aeternae, 1602

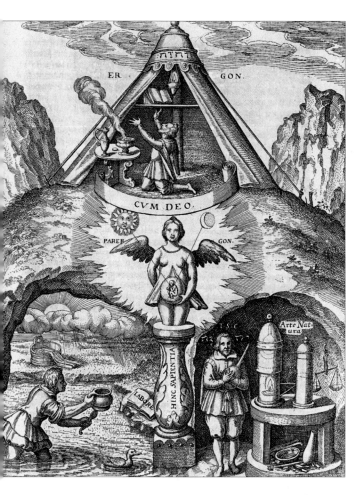

The Holy Scriptures and prayer are the source for and the foundation of the Brotherhood of the Rosicrucians. These are the actual Work (Ergon). In comparison, the preparation of the lapis, which is maturing here in the womb-retort of Natura, can only be considered as a subsidiary Work (Parergon). Anyone who thinks otherwise, according to Schweighart, would be better off hanging a millstone around his neck and sinking into the depths of the sea.

Theophilius Schweighart, Speculum sophicum Rhodostauroticum, 1604

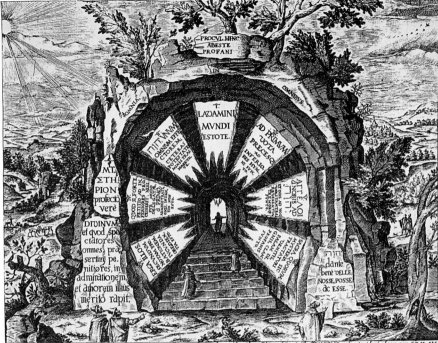

Heinrich Khunrath, *Amphitheatrum sapientiae aeternae*, 1602

Like bees attracted by the scent of the rose, the lovers of Theo-Sophia stream by from all directions to climb the seven steps of the "mystic ladder," through "the gate of eternal wisdom". This gate, narrow (angustus) but sublime (augustus) is the *sephira chochma*, the Cabalistic source. It is "the force of light" and "the eternal centre of life", which, according to Böhme, is open everywhere in the darkness of this world as "a little seed". The passage contains seven pieces of advice on dealing with the celestial powers, and consists of the combs of light and darkness. (cf. p. 271)

Heinrich Khunrath, Amphitheatrum sapientiae aeternae, 1602

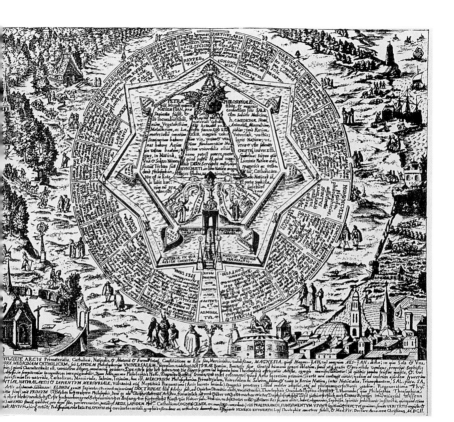

venty-one paths lead to the alchemistic
rtress but only on one, the enthusiastic
th of the fear of God and of prayer, can
be entered. This path alone brings the
owledge of the correct source material.
e other paths represent false concepts
godless "argchymists". The seven cor-
r-points of the fortress are the seven
ases which lead to the central rock of

the lapis. Here is the throne of "our Mer-
cury", the dragon, "who marries himself
and impregnates himself, who gives birth
on one day and with his poison kills all
living creatures". (*Rosarium philosophorum*,
Ed. J. Telle, Weinheim, 1992)

*Heinrich Khunrath, Amphitheatrum
sapientiae aeternae, 1602*

Fortress

Inscription above the emblem: "God is the fortress of all who believe in him"

Inscription beneath the emblem: "We trust in God when the flood begins"

M.J. Ebermeier, Sinnbilder von der Hoffnung, Tübingen, 1653

On the art of warfare and the planning of fortifications.

R. Fludd, Utriusque Cosmi, Vol. II, Oppenheim, 1619

Fortress

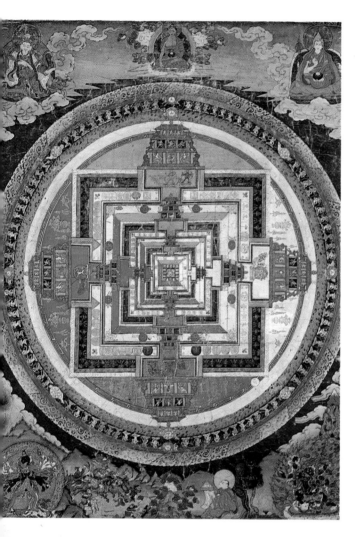

On the lower levels of the five elements, at the centre of the world on Mount Meru, sits the Mandala Palace. This precious palace is divided, analogous to man as the divine measure of all things, into the three levels of body, language and spirit, to which, in this *Mandala of the Time-Wheel*, precisely 722 Tibetan deities are assigned.

Kalachakra Mandala, gouache, Tibet, 18th century

Fortress

"For in brain and heart and loins/ Gates open behind Satan's seat to the city of Golgonooza/ Which is the spiritual four-fold London in the loins of Albion." Such are the topographical directions in William Blake's poems. Golgonooza, a combination of "Golgotha" (place of the skull", "ooze", "nous" and "noose") is the city of art and of crafts. In its eastern gate is a nest of larks. They are the messengers of Los, the personification of creative en-ergy. At the centre are his smithy and his forges, beside them his wife's spinning-wheel and the gate of Luban, symbols of the womb and the vagina. The city must constantly be recreated by Los as a bulwark against the shadowy three-dimensional world, called "Ulro" or "land of eternal death". The four-dimensional Golgonooza is modelled on Jerusalem, the place of complete fulfilment and freedom.

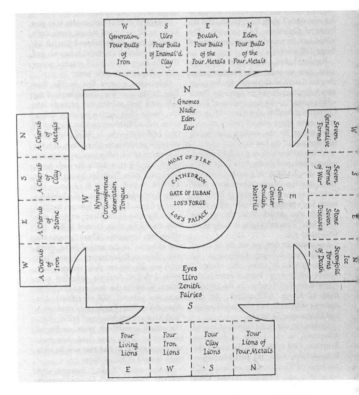

Each gate opens into all the other gates towards the four compass points, so that all are contained in each.

S. Foster Damon, Map of Golgonooza, A Blake Dictionary, 1965

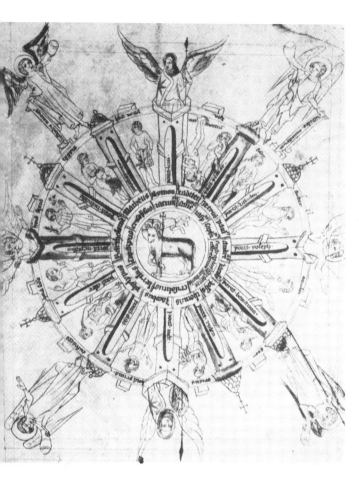

Vision of the celestial Jerusalem: "(...) and her light was like unto a stone most precious, even like a jasper stone, clear as crystal, and she had a wall, great and high, and twelve gates, at which were twelve angels, and on the gates were inscribed the names of the twelve tribes of Israel. And the wall of the city had twelve foundation-stones, and on them the names of the twelve apostles of the Lamb. (...) I saw no temple in the city; for its temple was the sovereign Lord God and the Lambs. And the city had no need of the sun, neither of the moon, to shine upon it: for the glory of God gave it light, and its lamp was the Lamb." (Revelation 21, 11–12, 14, 22–23)

Welislaw Bible, Prague, 14th century

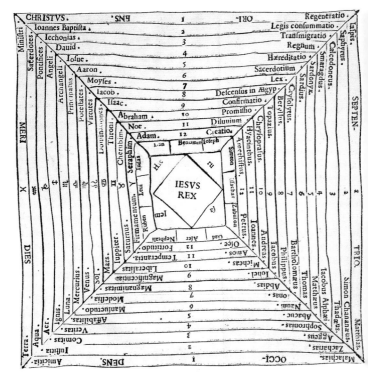

The illustration in Athanasius Kircher's *Arithmologia* (Rome, 1665) is a copy of the map of Jerusalem by Carolus Bovillus (*Opera*, Paris, 1510). The emphasis on the number twelve in the description of the Celestial City in the book of Revelation has often led to comparisons with the Zodiac.

For the famous 15th-century alchemist George Ripley, Jerusalem was an image of the Opus Magnum, whose twelve gates must be passed through analogous to the twelve phases of the work.

A. Kircher, Arithmologia, Rome, 1665

s in Blake's poems, in the writings of his contemporary, Richard Brothers, democratic convictions mingle with Biblical tradition and the author's own visionary experience. He identified the fallen Jerusalem with the London of his own time and prophesied its destruction, if the war of the monarchist alliance against republican France was successful. The new Jerusalem would not originate in Heaven, but would arise in contemporary Palestine. Brothers based his detailed map of the city on the descriptions of the prophet Ezekiel.

Engraving by Wilson Lowry, in:
R. Brothers, A Description of Jerusalem,
1801

In his treatise 'circulus quadratus' (1616), Michael Maier compared the Celestial Jerusalem with the lapis as a golden fortress, a circle divided into the pairs of opposites of the Aristotelian elements and qualities. These were often, and in the most diverse ways, linked to the four points of the compass. The lapis, which connects them all, thus also symbolizes the 'omphalos', the navel of the world.

Michael Maier, De circulo physico Quadrato, Oppenheim, 1616

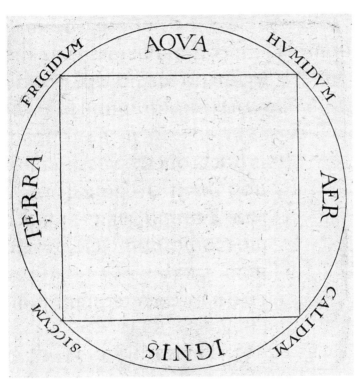

Diagram by Böhme's pupil Abraham von Franckenberg (1593–1652):

In the fire of the Last Judgment (1) the night divides the night of Babel from the light of Jerusalem.

Abraham von Franckenberg, Raphael oder Arzt-Engel, 1639

"The Celestial Jerusalem is an eternally clarified, subtle, penetrating, fixed corpse that can penetrate and perfect all other bodies." (*Nodus sophicus enodatus,* Frankfurt, 1639)

"The new Jerusalem will forever remain a red-golden transparent antimony glass, like stone: this is the new heaven and the new earth, in which we will all live together."

(Valentin Weigel, *Azoth & Ignis,* Amsterdam edition, 1787)

In Welling's interpretation of "Revelations", after the Day of Judgment Christ will "return this whole solar system to its original form, as it was before the Fall of Lucifer". He will bring forth a new world with the New Jerusalem "in the counter-image of the archetypal City of God". It was created in the circle of the globe after the measure of man as made in the image of God.

"Look upon Fig. 10 not with fleshly but with spiritual, emotional eyes." Along the edges of the cubic surface are the names of the twelve tribes of Israel. It is made of miraculously delicate, gold-glass, and is radiated by the pure light of God.

Georg von Welling, Opus mago-cabalisticum, Frankfurt, and Leipzig, 1760

A shipwrecked man in search of the 'Land of Peace' lands on the island of Caphar Salama, on which there rises the ideal city of Christianopolis, which is laid out in the shape of a star around the innermost temple, on the model of Campanella's 'Civitas solis' (1612). Life and education here are aimed, according to Rosicrucian ideals, at the harmonic connection of Christian tradition and universal knowledge. In school the Cabala is taught as the highest form of geometry, theosophy as the highest form of the humanities, as well as Pythagorean harmonic theory and astrology. The Swabian theologian Valentin Andreae (1586–1654) is also thought to be co-author of the pamphlets of the Rosicrucian Brotherhood published a few years earlier, although he was quick to distance himself from these, probably for fear of coming under suspicion of heresy. After the Thirty Years' War, he put into effect the ideals of the Brotherhood: active brotherly love and the reform of church, state and society, as reorganizer of the Württemberg educational system and the regional Lutheran church.

J. Valentin Andreae, Rei publicae Christianopolitanae descriptio, Strasbourg, 1619

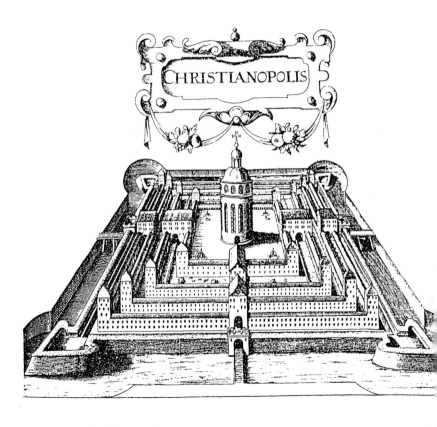

th his description of the floating island Laputa, driven by a group of lunatic scitists with a time-wheel magnetism, aathan Swift, in his 1726 novel *Gulliver's vels* parodied the Royal Society. This lest British academy for the sponsorship science was founded in 1660 on the

Rosicrucian idea of an "invisible college" encouraging the highest educational ideals.

Jonathan Swift, Gulliver's Travels, Leipzig edition, c. 1910

Fortress

Beginning in 1895, Hugo Hoeppner (1868–1948) designed a number of theosophical devotional temples in which Wagnerian drama is combined with the Masonic cult of initiation. "Our future temples will be wonderful representations of unified emotional experiences", he wrote in a 1912 essay. Hoeppner was well-known, under the name of Fidus, for his *Jugendstil* drawings, in which he evoked the Nordic light-man and nudism. In 1932 he joined the Nazi party, pleased that his ideas had fallen on fertile ground there.

Fidus, Tempel der Erde, 1895, in: K. Jellinek, Das Weltengeheimnis, Stuttgart, 1921

Fortress

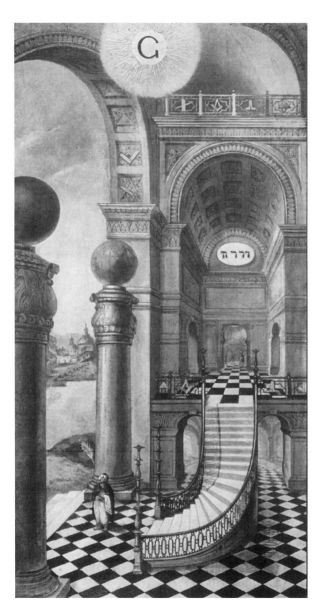

Solomon had two large copper pillars built in front of the entrance hall of his temple. The right-hand pillar he called Jachin, the left Boas (1 Kings 7, 15–23). They represent two dual principles in the Great Work and are the fundamental pillars of humanity.

According to 1 Kings 6, 5–8, one climbed a winding stair to the temple, containing the choir and the Ark of the Covenant.

The ripe ear of corn, the symbol of the journeyman degree, is hidden behind the column.

Masonic Second Degree Board, England, c. 1780

Fortress

The temple is said to have been "built upon the words of the Bible from hewn stone in such a way that no disturbing sound, no tool of iron could be heard. The stones (the developed personalities) are supposed to intersect in such a way that they hold without further connection (...). Solomon's temple is the model which allows all other symbols to evolve from it, to reassemble them in a unit. For this reason the Freemason calls his activity construction-work. The final goal is the temple of humanity in honour of the omnipotent architect of all the worlds (...)". (Lennhoff and Posner, *Internationales Freimaurerlexikon*, Graz, 1965)

18th-century work-carpet, engraving

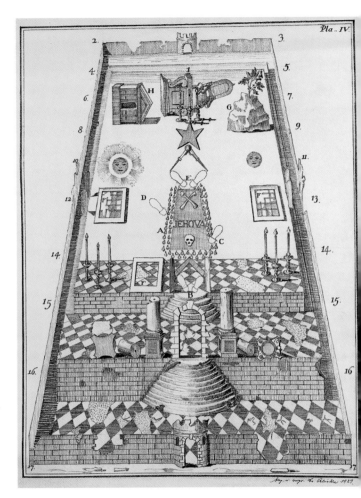

fore the three journeymen can deal him
e final death-blow, the temple architect
nages to throw the golden triangle with
e watchword, which he always wore on
chest, into a deep shaft.

e candidates of the 'Royal Arch', the
st important high-degree system of the
glo-Saxon countries, are prepared in
ges in search of this triangle with the
pronounceable name of God. It is hid-
den beside the temple plans in the rubble
of the subterranean vault raised on nine
arches, which rise so high that they are not
immersed by the waters of the flood.
A cubical stone is embedded in the ninth
arch, as a symbol of the highest moral
power. It alone can provide access to the
subterranean holiness.

*High-degree illustration: 'Le Royalle Arches',
c. 1775*

Fortress

"By the fruits shall ye know the roots."

"In the leaves of gardens of this kind, a golden crown grows for those that merit it (...). Because the door is closed, no-one can enter the house unless he has the key, while God guides the star."

Hermetischer Philosophus oder Hauptschlüssel, Vienna, 1709

The Arabic alchemist Umail at-Tamimi (c. 900–960), known as Senior Zadith, entering the "Treasure-house of Wisdom" the lapis. The four gates of the four elements must all simultaneously "be opene with four keys until the whole house is filled with light".

Aurora consurgens, late 14th century

"Whosoever wishes to enter the Philosophical Rose-Garden without the key is like a man who wishes to walk without feet."

e gate is bolted three times according the three sections of the Work. The ɔints on the arch indicate that three fferent fires must rule within. They are ɛrsonified in the lower Muses, sitting at e top right on Parnassus: "In vain you ɣ to walk upon this high mountain, ˥en you can barely stand on one leg on a ∨el path". To get the elixirs of the white and red roses, what is required above all is the right source material. This rose wears a green dress, says Maier. The wise man plucks it without being pricked, while thieves "have nothing but pain from it".

Michael Maier, Atalanta fugiens, Oppenheim, 1618

Fortress

Access to the "mountain of the philosophers" is blocked by a wall of false, sophistical doctrines. The old man at the entrance is the saturnine Antimon, here called "the father of metals". The alchemists identified this "old protector" with the Bethlehem landlord Boas, David's great-grandfather. Above him, the Arab alchemist Senior Zadith plants the sun and moon tree, from which the lapis emerges. In the 'Aurora consurgens' there is also a passage leading back to Senior Zadith, in which the lapis is compared with a house built on a strong rock. Whoever opens it will find within the source of eternal youth.

Geheime Figuren der Rosenkreuzer, Altona, 1785

e *Fama Fraternitatis* is the first pamphlet
an invisible brotherhood of the Rosy
oss published in 1614 by the circle of
bingen students around Valentin An-
eae. Their "youthful pranks and fool-
y", as Andreae later called them, had un-
pected consequences. Shady charlatans
erywhere declared their desire to join
is wonderful college. Scholars like René
scartes and Robert Fludd tried to make
ntact, but in vain. "Our building (…)

shall remain inaccessible to the godless
world," as the *Fama* has it.

Schweighart advises the searcher to watch
patiently like Noah's doves, to hope
quietly in God and to pray tirelessly. Then
a brother will announce himself, for they
are able to read thoughts.

*T. Schweighart, Speculum sophicum
Rhodo-stauroticum, 1604*

Fortress

Shortly after he wrote his *Aurora* in 1613, Böhme was denounced as a fanatic by dogmatic Lutherans, and after a brief spell in prison he was placed under a writing prohibition by the magistrate of the town of Görlitz. His assembled adversaries, devotees of the "historic, literal faith" and the "walled church" are shown here on the title page of his *Schutzreden* as the Beast of the Apocalypse, destroyed, like the basilisk, by its own reflection.

J. Böhme, Theosophische Wercke, Amsterdam, 1682

Noah's dove with
the olive branch, a
messenger pigeon
and above them
the dove of the
Holy Ghost "with
twenty-four
pentecostal
flames or fiery
tongues of the
spirits of the let-
ter. Three doves,
then, indicating
the threefold
spirit 1. of God
2. of nature 3, of
art". (G. Gichtel)

*J. Böhme,
Theosophische
Wercke,
Amsterdam, 1682*

Animal riddles Even the ancient Egyptians "commonly dealt with the Chymical Mysteries through the figures of the animals: thus the red Lion means: the sun, gold; the toad, the raven: putrefaction; the dove, the eagle, the snake, the green lion: the Luna philosophorum, their Mercury; with the wolf antimony, with the dragon saltpetre, with the snake arsenic and the like are meant. In the understanding of the meanings of the animals, the specific properties of the animals in question should be considered. Poisonous and volatile things indicate material; fixed, earthly things show form. In this way the following riddles can thus be understood; the red lion fights with the grey wolf, and having defeated him, he will become a magnificent victorious prince.

Afterwards, enclose him in a transparent prison, with ten or twelve virgin eagles, and entrust the key of the prison to Vulcan; thus the eagles will begin to dispute, and to vanquish the lion, and to rip it to shreds which, when it rots, the eagles will try to fly away, and escape the stink, and ask Vulcan to open up, and examine all the crannies of the prison; but when Vulcan refuses, and all ends of the prison are entirely closed, then by the stink from the lion's carrion the eagles too will be corrupted, infected and rotted. Hence, a terrible putrefaction. But while the one's corruption is the other's creation, thus many things arise from this twofold carrion: first there emerges a Raven, which, while it rots again, vanishes: from which a peacock emerges (...): when this perishes, there emerges a Dove, which, because the Raven could find no dry place, finds one such, but a new one because the previous Earth was corrupted by the Flood, but this is the virgin Chalk of the Philosophers. This Dove, not yet past all corruption, is slowly transformed into a Phoenix, which Vulcan burns, in the Prison itself. Hence, from its ashes there arises a new, incorruptible and immortal fruit, by which all sublunary things are refreshed.

You will interpret the significant riddle of these animals in this way: purify the gold with Spiessglas (antimony), place it in a glass with 10 or 12 parts of the Mercurii Philosophorum, or of the Mercurii water of its metals: place the glass in a reasonable heat: thus the form of the gold will be defeated by the Mercurial matter, and rot: From which a blackness and all manner of colours will be seen. When finally, the putrefaction is over, the Matter will first pass through a

tage of taking or a greyish colour, and will then tend towards a
vhiteness; if one puts a great heat to it, it will be tinged with a
emon-colour, and finally with a red colour, and thus pass from fluid
o its fixity." (Johann J. Becher, *Oedipus chimicus*, 1664)

M. Maier,
Viatorium,
Oppenheim, 1618

Animal riddles

"The philosophers generally say that two fish should be in our sea." The sea is the body, the two fish spirit and soul. "Decoct these three together, to produce the greatest sea."

*Lambsprinck,
De Lapide philosophico, Frankfurt,
1625*

"A deer and a unicorn are hidden in the forest." The forest is the body, the unicorn the spirit (Sulphur, male), the deer is the soul (Mercury, female). "Blessed can we call the man who artfully can capture and tame them"

*Lambsprinck,
De Lapide philosophico, Frankfurt,
1625*

"A beautiful forest in India is found, wherein two birds together are bound. One is snow-white (Mercury), the other red (Sulphur). They bite each other until both are dead." After they have entirely devoured one another, they turn first into a dove (whitening), then into a phoenix (reddening).

D. Stolcius von Stolcenberg, Viridarium chymicum, Frankfurt, 1624

The two opposite natures of the work are brought together by lengthy coction. "Have but patience, your labour will not be in vain: The lovely tree will in time yield fruits."

D. Stolcius von Stolcenberg, Viridarium chymicum, Frankfurt, 1624

Animal riddles

On the top of the mountain where the *prima materia* is found ,the 'philosophers' vulture' (their Mercury) sits screaming incessantly: "I am the Black of the White and the Red of the White and the Yellow of the Red; I am the herald of the Truth and no liar".

Maier took this speech from the 'Rosarium philosophorum', a 14th-century anthology of alchemistic theories. The passage continues: "And know this, that the summit of art is the raven, who flies without wings in the blackness of night and the holiness of the day" (*Rosarium philosophorum*, Ed. J. Telle, Weinheim, 1992). This refers to the phase of nigredo, in which the solid components of the matter succumb to putrefaction.

Michael Maier, Atalanta fugiens, Oppenheim, 1618

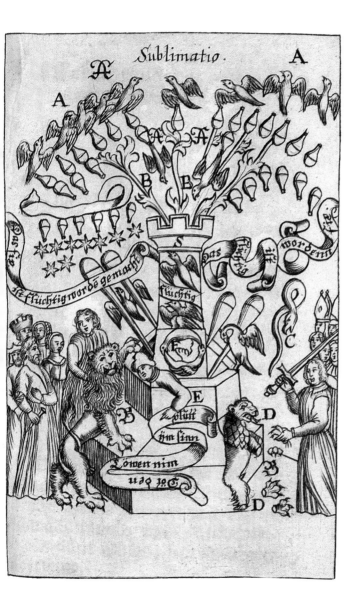

AA The ascent

BB The descent

C Mercury

DD The solid body is dissolved

E The salt becomes water

FS The Salt Body is made volatile / and ascends

Hieronymus Reussner, Pandora (die edelste Gabe Gottes), Basle, 1582

Animal riddles

"I came to an underground house (…) and on its roof I saw pictures of nine eagles", writes the Arabic alchemist Senior Zadith (c. 900–960), who is often quoted in the *Aurora consurgens*. The eagles refer to the nine processes of sublimation. The bow and arrow represent the subsequent phases of fixation.

The depiction is closely linked to Arab legends of the discovery of the Emerald Tablets of Hermes Trismegistus, which the old man is holding on his lap. On them, the hermetic axioms are represented hieroglyphically.

Aurora consurgens, early 16th century

The fire gives form and makes everything perfect, as it is written: He blew into his face the breath of life (...) the fire makes subtle all earthly things that serve matter."

No thing that is heavy can be made light without help of the light thing. And the light things cannot be pressed down without the presence of the heavy thing. The 'Turba' speaks thus: Make the body spiritual and what is fixed make volatile."

Aurora consurgens, early 16th century

Animal riddles

"Two birds in the wood are named and only one is understood", according to Lambsprinck. The two young of the bird Hermeti signify the volatile and solid components of quicksilver, which are united by repeated sublimations.

Lambsprinck,
De Lapide philosophico, Frankfurt,
1625

An eagle has two young. One is fledged, but the other, which is featherless, prevents it from flying. "Add the head of one to the other, and you will have it", advises Maier. That is: solidify the volatile and volatilize the solid.

M. Maier,
Atalanta fugiens,
1618

Spirit and soul should be added to the body and taken away *(solve et coagula)*. "It may be a great wonder that two lions turn into one."

Lambsprinck, De Lapide philosophico, Frankfurt, 1625

"Add to the lion a winged lion, so that both may live in the air. But it stops firmly and stands on the earth. This picture of nature shows you the way through which it rules." Maier advises sublimating the two natures (Sulphur and Mercury) until they are inseparable.

M. Maier, Atalanta fugiens, 1618

Animal riddles

Apart from the snow-white steam that settles as "burning water" or "unnatural fire", and belongs to the "sulphurous, stinking waters", the "green lion" is among the "Three things that are sufficient for mastery". Here it is described as a saliva-like extract of raw Duenech (antimony).

*M. Maier,
Atalanta fugiens,
1618*

The 'blood of the green lion', which also goes under the code name of the 'philosophers' vitriol', is the universal solvent that swallows the seven metals and gold. Basil Valentine said that the solid blood of the red lion (the lapis, the sun) comes from the volatile blood of the green lion.

D. Stolcius von Stolcenberg, Viridarium chymicum, Frankfurt, 1624

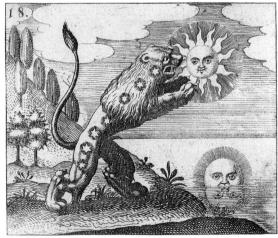

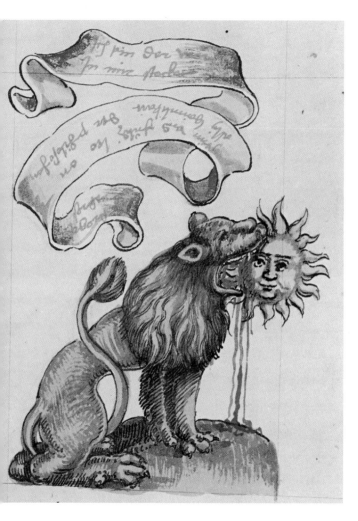

"I am he who was the green and golden lion without cares, within me lie all the mysteries of the philosophers."

"The green lion that swallows Sol" is, according to the *Rosarium*, "our Mercury. It alone works deep into each body and lifts him up. So if it is mixed with a body, it enlivens and relieves it and transforms it from one consistency into another." (*Rosarium philosophorum*, Ed. J. Telle, Weinheim, 1992)

Heinrich Khunrath called it "the natural quickly comprehensible, Catholic Everything and Everything in Nature, Natural and Naturally-artificial Conquering". (*Vom hylealischen Chaos,* Frankfurt edition, 1708)

Rosarium philosophorum, 16th century

Animal riddles

"This is the philosophers' pot, with which they deal so secretly in their books and parables, so that nobody can understand them (...) I advise all those who wish to fry, poach or boil the philosophers' egg, to be careful that the shell does not break, for then (...) all the poison would come out, and would kill everyone nearby (...), for within it is the most evil poison in the whole world."

J. Isaac Hollandus, Hand der Philosophen (1667), Vienna edition, 1746

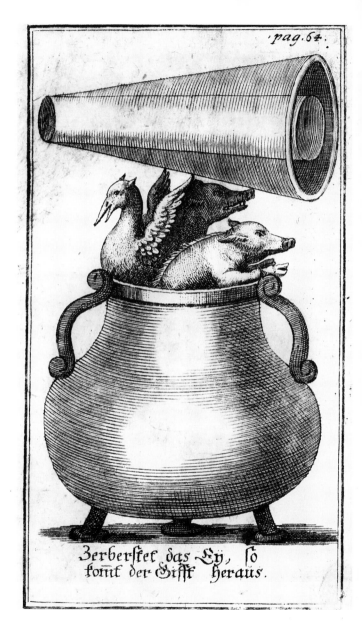

pag. 64.

Zerberstet das Ey, so komt der Gifft heraus.

The 'basilisk' is a poisonous mixture of cock and toad. Its eye fixes and kills everything at once, like a strong solvent or the projection powder that transmutes the metals. If you hold up a mirror to it, it kills itself. "From its ashes, arise wonderful things."

Aurora consurgens, early 16th century

"On the rock also combine the eagle (sal ammoniac) with dragon's smoke (salt-petre)." The 'Third Key' of Basilius Valentius says it is a matter of "extracting the sulphur or soul from the King or gold". This sulphur is the fox which has fixed the mer-curial hen and which is now, in turn, pursued and devoured by the cock.

D. Stolcius v. Stolcenberg, Viri-darium chymicum, Frankfurt, 1624

Animal riddles

A 'serious joke' (Lusus serius) was the title that Michael Maier gave his treatise, published in Oppenheim in 1618, in which Mercury is given precedence over all other creatures by human judgment. The cow, the sheep, the oyster, the bee, the silkworm and the flax-plant have their merits, but Mercury is "the king of all worldly things".

When lion/sun and serpent/moon are fully united, the lapis is complete. But so that it may have the power to increase, and Mercury ☿ can bear fruits, it must be heated and fermented in a melting-pot with three parts purified gold.

Ill. top/bottom: D. Stolcius von Stolcenberg, Viridarium chymicum, Frankfurt, 1624

Oedipus chimicus

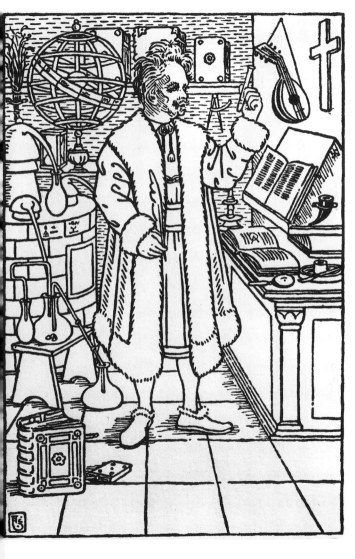

"The world has no more mysteries. This arrogant lie had already irritated me around 1880, and during the fifteen years that followed I had undertaken a revision of the natural sciences (…) In the meantime, I went even further, erasing the boundary between spirit and matter. So in 1894, in the *Antibarbarus*, I had discussed the psychology of sulphur."

"The intertwined letters F and S remind me of the first letters of the name of my wife. – She still loves me! – The next second the chemical signs of Ferrum and Sulphur strike me like lightning; and before my eyes the secret of gold lies revealed." (August Strindberg, *Inferno*, Berlin, 1898)

August Strindberg, Antibarbarus, Stockholm, 1906

Oedipus chimicus

"So that the truths found therein (…) may penetrate deeper into the soul", the ancients had "so great a delight in the Egyptian images, riddles and edifying fables." These have been used by the chemists "to make their art very obscure" (J.F. Buddeus, *Untersuchung von der Alchemie*).

The lament was also often heard concerning the "ambiguous expression and the contrary style" of the alchemists. It was with a view to resolving this crisis that the Speyer doctor and alchemist J.J. Becher 1664 wrote his *Oedipus chimicus*.

With the help of mercurial inspiration, the figure of Greek mythology solves all the chemical riddles put before him, whereupon the sphinx falls from a rock to its death.

J.J. Becher, Oedipus chimicus, 1664

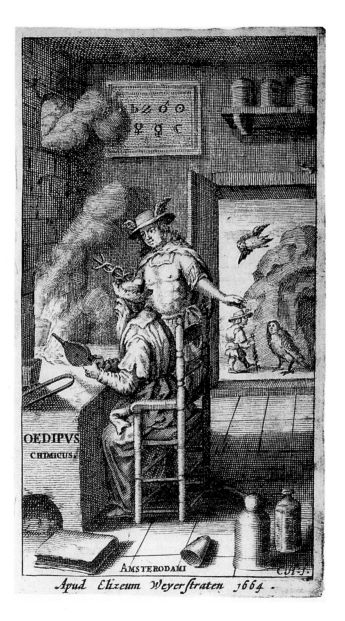

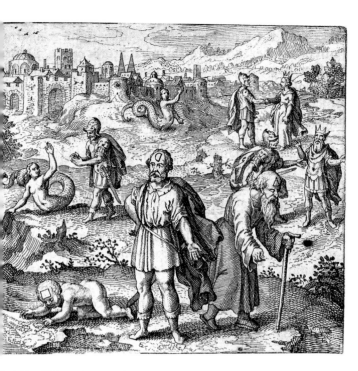

or Michael Maier, as for many other al-
chemists of the Baroque, all the myths of
classical antiquity had a hidden, chymical
ackground. Thus Oedipus' answer to the
ddle of the Sphinx – What walks on four
gs in the morning, on two feet at noon
nd on three feet in the evening? – was
ot, as tradition has it, man, but the lapis.
t the beginning, the lapis is "in its quality
nd force an (elemental) rectangle", at
oon a half-moon consisting of two lines,
amely the white lunar stone. But in the
vening it is the substantive triangle of
body, spirit and soul, namely the solar
lapis with the power to tincture and to
heal.

Oedipus' patricide and incest were also
chymical parables, for in the Work too
the first cause (Father Saturnus) is
removed by the Agent (Mercury), to unite
again "whereby the sun is married to his
wife".

M. Maier, Atalanta fugiens, Oppenheim, 1618

Dew

"The Greeks testify that from gold there fell a fertile rain as the sun lay in the passion of love with Venus. And from Jupiter's brain as Pallas did arise, so gold must also appear like rain in your vessel."

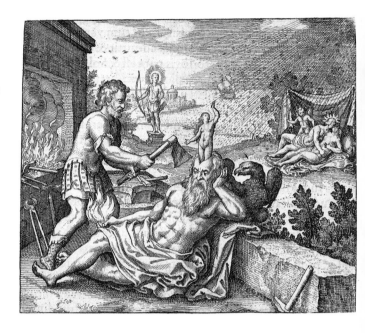

Vulcan, seeking to free Jupiter from his headaches with an axe, releases Pallas Athene, the goddess of wisdom, from his skull. This birth, Maier wrote, is celebrated annually on the island of Rhodes by the festival of the "golden rain", in which golden coins are scattered.

Johann Glauber (1604–1670) related how he demonstrated another classical, gold rain in an experiment: "I placed a pointed glass retort (...) on a table, poured King

Akrisio's beautiful daughter Danaè through the narrow opening the glass (...) Afterwards, following the advice and actions of Jupiter, I made a golden rain and let it fall through the tiles of the roof, which is to say the narrow hole of the retort, down on Danaè's lap (...)".
(J. R. Glauber, *Von den Dreyen anfangen der Metallen,* 1666)

M. Maier, Atalanta fugiens, Oppenheim, 1618

Dew

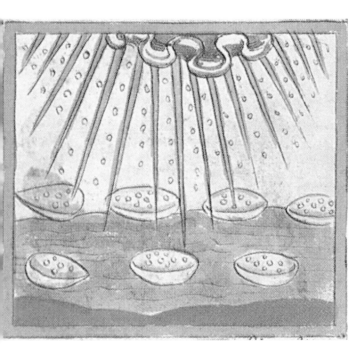

"Blessed of the Lord be his land, for the precious things of heaven, for the dew (...)". (Deuteronomy 33, 13)

"This dew is the manna on which the souls of the just nourish themselves. The chosen hunger for it and collect it with full hands in the fields of heaven." (Zohar)

"Our dew, our matter, is celestial, spermatic, dewish, electric, virginal, universal." (From the writing of Count Marsciano, 1744)

De alchimia, Leyden, 1526

Hardly any published work of alchemical history was more talked about than the *Mute Book* (Mutus Liber) which, like a rebus, hides its messages in a sequence of 15 plates. The first edition was published in 1677 in La Rochelle, while the present version in colour comes from a late 18th-century French manuscript. The author has been identified as one Jacobus Sulat, anagrammatically concealed behind the pseudonym Altus (Latin: high) in Plate 1, and in the expression "Oculatus abis" (as a sighted man you leave) in Plate 15. On many points the captions follow the detailed interpretations of Eugène Canseliet (1899–1982), the pupil and editor of the works of the legendary alchemist Fulcanelli (Altus, *Die Alchemie und ihr Stummes Buch*, Amsterdam edition, 1991). His annotated edition of the *Mutus liber*, Canseliet writes, was written out of gratitude that he had succeeded, solely with the help of this hieroglyphic picture-book, in isolating the extraordinarily volatile salt of the dew.

The representation of the preparatory attainment of salt on the wet path occupies a great deal of space within the sequence of pictures, while the following central preparation of the lapis on the dry path, with the help of the secret salt fire, is only faintly hinted at. The dew contains a very fine saltpetre, which is capable of refining the other salt. Its glyph ☉ forms the basic compositional structure of the first plate and that of sal ammoniac ⊖ the last. This is not ordinary sal ammoniac however, but a crystalline salt with the power of harmony. Canseliet calls it harmoniac. Together, saltpetre and harmoniac work, as in Kirchweger's *Aurea Catena Homeri,* as the agens and patiens of the Work (cf. p. 278). In changing figurations they appear as the dual fundamental principles of the work in *Mutus liber*: as an alchemistic pair or as Taurus and Leo, Apollo and Diana.

The author has placed one major barrier in the way of the comprehension of the work by switching the correct sequence of the plates. We present the original sequence, putting Canseliet's suggested amendments in brackets.

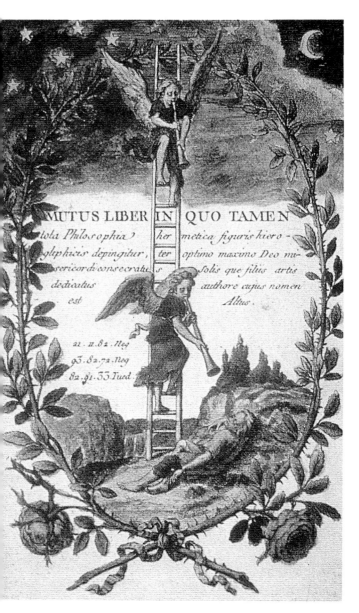

Plate 1

Stimulated by the raw stone *(prima materia)*, Jacob dreams his dream of the ladder to heaven, or of the exchange of spirit and matter. The ten stars signify the ten sublimations in the Work. The three sequences of numbers, read backwards, refer to the various passages in the Bible dealing with the blessings of the celestial dew. The roses also refer to it (Dew: French 'rosée', Latin 'ros').

Dew

Plate 2
(before plate 8)

In the phial, Neptune, in the middle phase of the work leads his disciples, Apollo and Diana, to their marriage. Chaotic night has withdrawn, and the light of the spiritual sun now illuminates the Work.

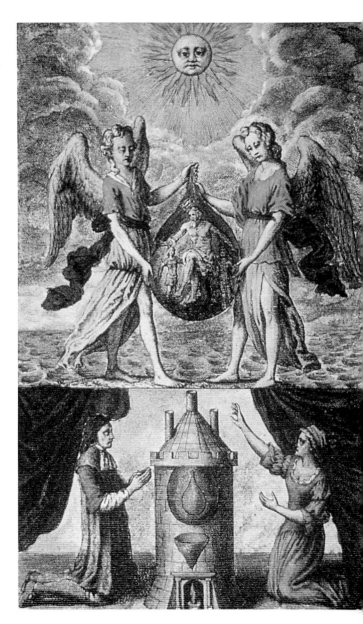

Dew

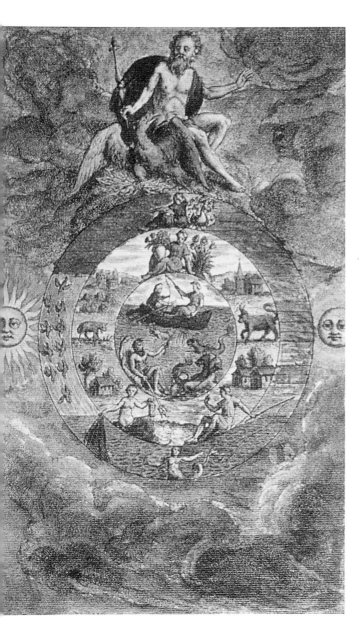

Plate 3

Jupiter, the first gleam of light to penetrate the saturnine night is enthroned on the three rings symbolizing the rotations in the three sections of the work with their reversals of inside and outside. Beneath him, his wife Juno, as representative of the brightly-coloured phase (peacock), beside him the birds of the sublimations. The scenes of fishing symbolize the interconnection of coagulation and sublimation of the two fundamental components, shown here as Aries and Taurus.

Dew

Plate 4

The alchemical couple as the lower correspondence to the sun and moon in the harvesting of the dew, which must occur in the months of April (Aries) and May (Taurus), when the green world-spirit of which Khunrath often spoke is at its strongest. The hermetic dew is also called "the philosophers' vitriol" or "green lion". Its glyph 🜖 can be seen on the top of the church-tower on the right.

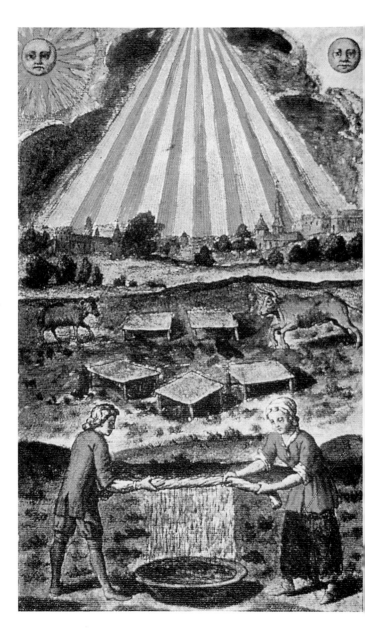

Plate 5

After distillation, the woman takes four coagulated particles from the retort and gives them to the "Lunar Vulcan". He symbolizes the "secret fire" formed from the two salts of the dew. This vulcanic fire will later revivify the dead child at his breast. At the bottom, the dew is entrusted to the digestive apparatus.

Dew

Plate 6

The result of the forty-day digestion and a second distillation is the appearance of a fixed sulphurous blossom called the "philosophers' gold". The man gives this extract to Apollo, who appears in martial armour. Beside him the content of the flask previously entrusted to the secret vulcan fire is poured into a cooking vessel.

Plate 7

The result of the distillations is conjoined with the extract that has been concentrated by the secret, lunar fire. Then everything is heated in the water-bath and the salt of Universal Harmony with the sign ✳ removed from it. At the bottom, Antimony-Saturn devours the child or the "philosophers' sulphur". After being purified, it is brought to whitening (Diana).

Dew

Plate 8

In the phial carried by the two angels, the philosophical Mercury appears. He is the product of the marriage of sun/Apollo and moon/Diana, brought together by Neptune in Plate 2. The ten birds of the sublimation correspond to the serpents of the Caduceus. Two of the birds bear branches with the signs of the two fundamental saline substances of the "secret fire", tartar salt and sal ammoniac.

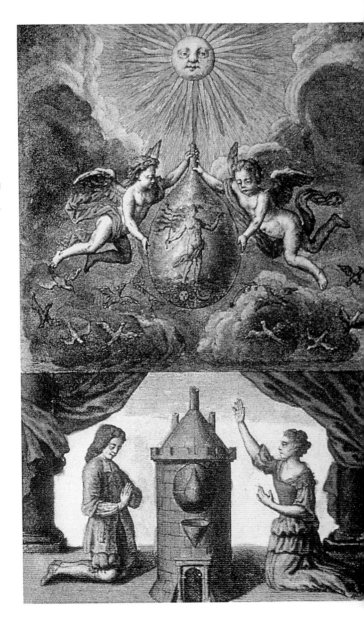

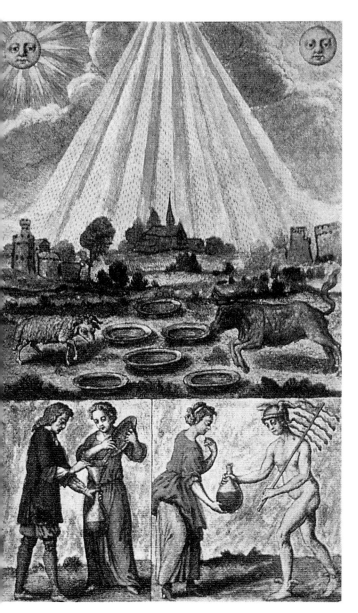

Plate 9
(after Plate 4)

Poured into six plates arranged in the form of a fiery triangle, the dew is now exposed to the cosmic fluid, further to enrich its force (Greek 'rosis'). The involvement of this energy, according to Canseliet, is precisely what distinguishes alchemy from profane chemistry.

Dew

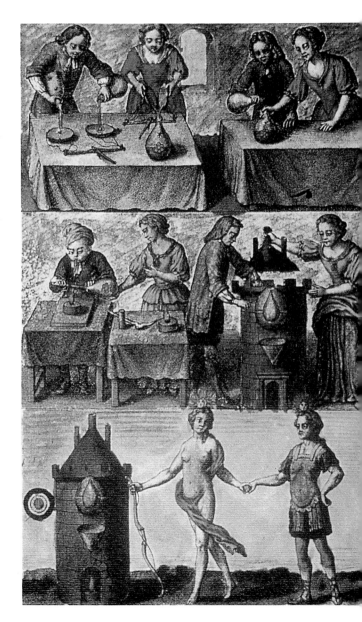

Plate 10

Here the "philo-
sophical egg" or
mercurial "vessel
of nature" is pre-
pared and sealed.
But the bowl and
its contents do
not yet consist, as
it would appear, of
glass and fluid,
but of the two
salts, within which
lies the sulphurous
blossom or the
"spiritual gold".
In Athanor the two
principles conjoin
into the definitive
redness, the
centre of the
target.

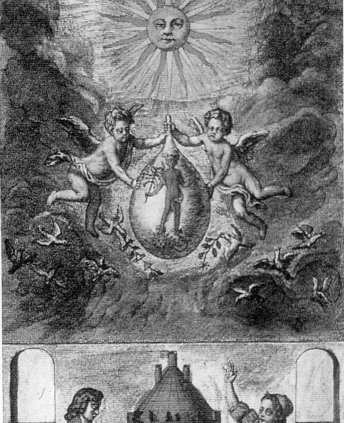

Plate 11

In comparison to Plate 8, the content of the phial has now become transparent, and transformed "into the deepest depth of a bottomless light". The philosophical Mercury now appears elevated to purple redness, and the sign of the sulphurous tartar salt has been given the glyph of sublimation. At the bottom, the darkening curtains have vanished from the windows.

Dew

Plate 12

Filled with inner dynamism, the sulphur-bull bucks and the dew in the bowls vibrates, sated with the nitric heavenly spirit, pure salt-petre. It is eagerly collected by the philosophical Mercury, who needs it for the crystallization of his inner, sulphurous germ of "spiritual gold".

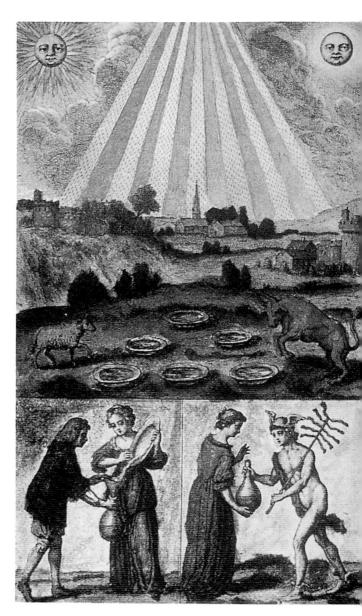

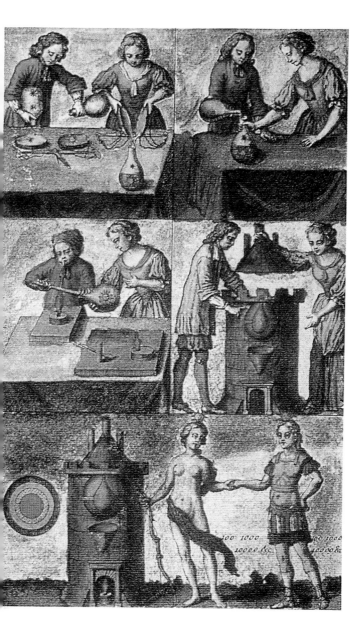

Plate 13

The sulphurous blossom in Plate 10 has turned into a small sun, which has the power to take the philosophical Mercury to its highest stage of consistency. (The target with the reddening at its centre has now grown.) The numbers in the two united principles indicate the phase of multiplication, which advances towards infinity in powers of ten.

Dew

Plate 14

The three ovens signify the three different fires in the work: the inner spiritual fire, the secret, salt fire and the dark, material fire that stimulates the other two. This final phase is called "women's work and child's play", being concerned with constant cooking. It must last for three days ☿ until the philosophical silver has been attained (left), and three more, through to the philosophical gold, the son of the sun (right). "Pray, read, read, read again and you will find," the couple advise the man clinging to the heels of Mercury.

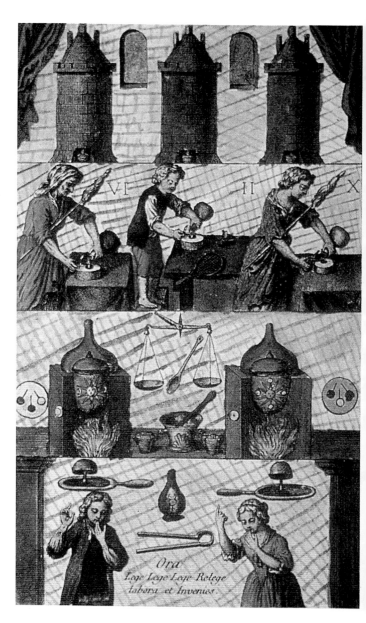

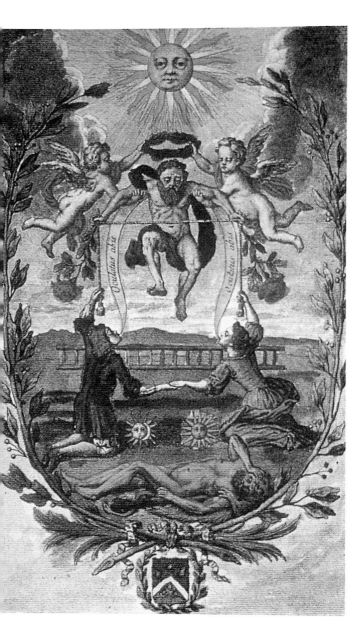

Plate 15

The night of the first plate has made way, in this closing plate, for the rising red sky of morning. The pagan Hercules has completed the deeds of the Work, and remains as a physical residue on the floor, while, thanks to the dew (the roses), his incorruptible spirit body rises into the air as the true cornerstone, uniting male and female. The surrounding branches (this is more easily seen in the first edition) form an X, the Greek Chi, the sign of Christ or the revealed light.

Dew

Here, the French alchemist Armand Barbault (1906–1974) is shown wringing out the dew-drenched canvases. Barbault added these liquids, whose quality depends strongly on the species of plant from which they are collected, to a plant extract, the "blood of the green lion", his *prima materia*.
As such, he took a piece of "virgin earth", which had to be untouched by chemical fertilizers, and composted it for three years, along with the additives until it was completely black.

Armand Barbault, L'or du millième matin, Paris, 1979

Women's work & child's play

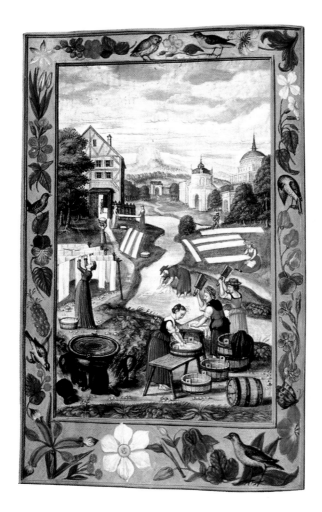

The "whitening" of the black matter after the phase of nigredo, shown as "women's work".

Joyce was familiar with the illustrations of the *Splendor solis,* and variously worked motifs from them into his work: "Wring out the clothes! Wring in the dew! (After Tennyson: "Ring out the old, ring in the new") (...) Spread! it's churning *(churn: centrifuge)* chill *(depression, nigredo)* Der went ist rising. I'll lay a few stones on the hostel sheets. A man and his bride embraced between them." *(The rebis of Sol and Luna).* (J. Joyce, *Finnegans Wake,* p. 213)

S. Trismosin, Splendor solis, London, 16th century

Women's work
& child's play

"Look at a woman and learn how she washes her linen, pours warm water thereon and mixes with ashes. Copy her, and everything will go well, for the body, so black, will be washed clean by the water." This water is the "philosophical fire" that penetrates the centre of the raw matter and and takes from it all its impurities.

M. Maier, Atalanta fugiens, Oppenheim, 1618

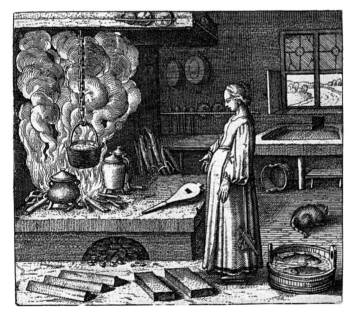

"Just as a woman softens, simmers and cooks fish in their own water (...) the artist also treats his subject in his own water, which is stronger than the strongest vinegar. He destroys it, makes it soft, dissolves it and coagulates it, and all in the well-sealed glass of Hermes."

M. Maier, Atalanta fugiens, Oppenheim, 1618

Women's work & child's play

'Women's work' and 'child's play', generally mentioned in a single breath, refer to an advanced phase of the Opus, in which, apart from the maintenance of a constant fire for coction, there is nothing to do but pass the time. According to Salomon Trismosin, however, this picture of playing children is also a parable of the fixation of the quicksilver by the sulphur, because as in "child's play", what was previously above (Mercury) is now below.

The group in the foreground is reminiscent of the "Hülsenbeck Children" by Ph.O. Runge (1805)

S. Trismosin, Splendor solis, London, 16th century

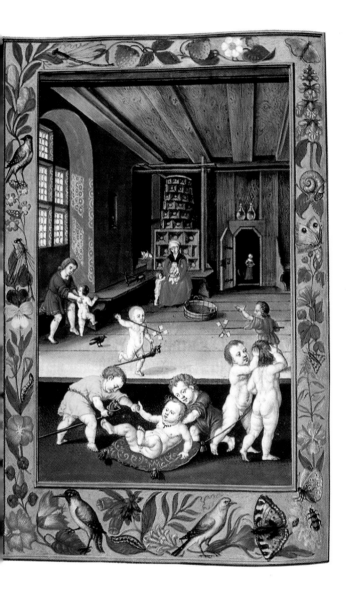

Vegetable chemistry

"Sow the gold in the white, foliate earth which is the third earth that serves the gold, it tinges the elixir and the elixir tinges it in turn."

'Tingeing' means colouring, and is used in the sense of a penetrating transfer of power. Here the last two phases of the 'multiplicatio' and the 'projectio' are addressed.

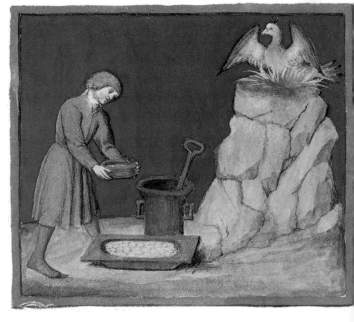

Aurora consurgens, early 16th century

"Nature brings to light nothing that is perfect, but man must perfect it. This perfection is called alchimia. An alchemist is the baker when he bakes bread, the viniculturist when he makes wine, the weaver when he makes cloth." (Paracelsus, *Paragranum*, 1530)

Sourdough is a favourite image of the ferment used in the process to raise the matter.

Aurora consurgens, late 14th century

Even before Paracelsus (1493–1541), who has gone down in history as the founder of pharmaceutical iatrochemistry (Greek 'iatros', doctor), healing was a major aim of alchemy. As the alchemical process is geared towards organic growth, Newton described alchemy, in contrast to mechanical laboratory chemistry, as 'vegetable chemistry'.

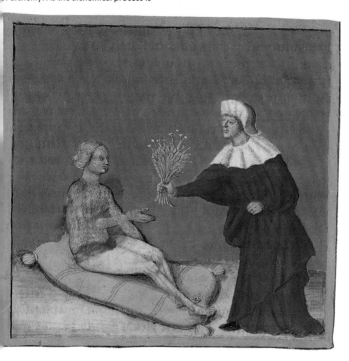

Here the "most learned philosopher" is handing "Mother Alchemy" a bunch of herbs to heal her sick body. While her golden head and her silver breast (painted over by a censor, in this instance), are already complete, her lower body is still in an impure, poisonous state. Her thighs are swollen by dropsy, and her calves and feet afflicted with gout.

Aurora consurgens, early 16th century

Vegetable chemistry

"Good, pure, oleous and mild soil, necessary moisture for putrefaction and nourishment for growth, also the warmth of the sun for growth and fecundity; seeds need all these things. And likewise in the art. First, prepare your seed in the matter; you should clean this (...) and the pure fire and water spirit will bless your fruit." (M. Barcius, "Gloria Mundi", in: *Hermetisches ABC,* Berlin, 1778)

D. Stolcius von Stolcenberg, Viridarium chymicum, Frankfurt, 1624

Vegetable chemistry

Pseudo-Eleazar, an 18th-century alchemist hiding behind the name of Flamel's legendary teacher, considered this fifth page of the codex to be of special importance. "Should you lose all writings, just copy these figures or paint them for your children, and they will easily understand them." The old oak tree is "our black and heavy lump, our Albaon", a codename for antimony. From it grow the red roses as "the blood of the Ancients or our secret gold" and "the moon-white water", called "our python" (a code name for Mercurius vivus).

Abraham Eleazer, Uraltes chymisches Werk, Leipzig, 1760

Serpent

"Here you see, flowing from a desert, a lunar, white water which is from the old progenitor of all things, spread on two paths." This is the dangerous dry path "that goes from the oiliness of the earth, from the primordial chaos. The other (wet path) from our black, heavy and white lump; but that the snakes creep in the grass, the Python (Mercury) is in the dry path, for this is very poisonous, but if it must climb the mountains (head of the still) a number of times, it becomes a flower, and almost medicinal."

A. Eleazar, Uraltes chymisches Werk, Leipzig, 1760

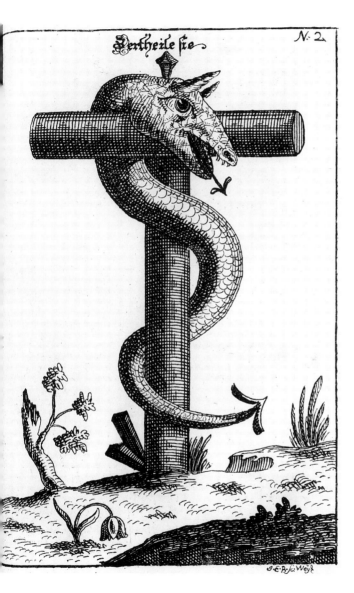

The second illustration in Flamel's codex showed "a cross, where a snake was fastened and crucified".

The serpent that Moses nailed to the cross "that it might be seen before all the people and they might recover from the plague they had endured", is a symbol of the healing power of the Mercurial elixir, the crucified Christ (John 3, 14). Pseudo-Eleazar calls this snake the "powerful king of nature" who heals the whole world, a salt-balm. But before it can become effective, the pri-material poisonous body must be dismembered and the volatile spirit fixed with a golden nail.

A. Eleazar, Uraltes chymisches Werk, Leipzig, 1760

Serpent

"The first illustration in Flamel's codex showed "a rod and two serpents devouring one another". They embody the repeated circulation of distillation and condensation. "The winged snake," Pseudo-Eleazar explains, "signifies the universal world-spirit, (...) which is sucked from the dew and with which we prepare our salt. But the lowest snake signifies our matter, (...) the virgin earth (...) found beneath the vegetable roots." This is the "philosophers' turf" that Armand Barbault dug on the nights of the new moon. On many points, Barbault precisely followed the instructions of Pseudo-Eleazar. (cf. p. 392)

A. Eleazar, Uraltes chymisches Werk, Leipzig, 1760

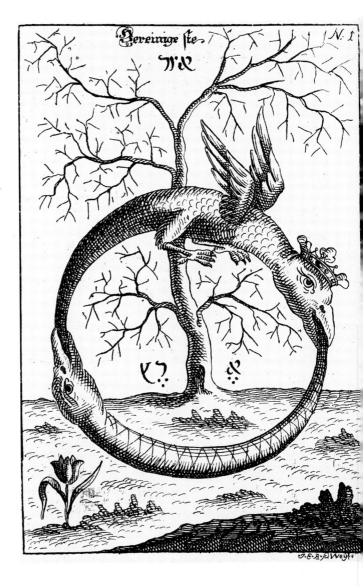

Serpent

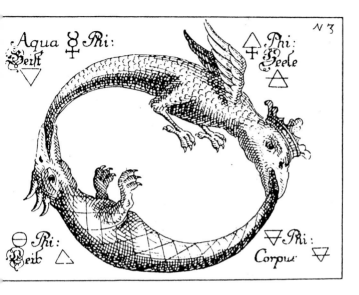

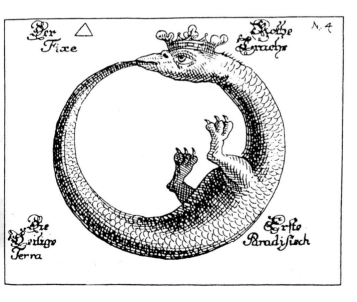

"The top snake (No. 3) is the cosmic spirit which brings everything to life, which also kills everything and takes all the figures of nature. To summarize: he is everything, and also nothing." Through the art of separation one makes the One into Two, "which have the Third and Fourth within themselves. It is the most volatile and also the most fixed, it is a fire that consumes everything, and opens and closes everything (…). Cook this fire with fire until it stops, and you have the most fixed thing that penetrates all things, and one worm has eaten the other, and this figure (No. 4) comes out."

It is called *Ouroboros*. In Coptic *Ouro* means king, and in Hebrew *ob* means a snake.

A. Eleazar, Donum Dei, Erfurt, 1735

Serpent

"Make of man and woman a circle; when you add the head to the tail, you have the whole tincture." (Hermetic saying)

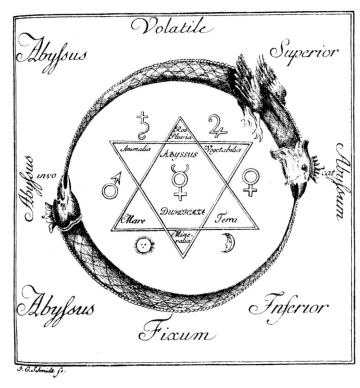

"Consider these two dragons, for they are the true beginnings of philosophy which the sages were not permitted to show their children. The one at the bottom is called the fixed and constant or the man. But the upper snake is the volatile or black, dark woman. The first is called sulphur or the warm and dry. The other is called quicksilver or the cold and moist (...).

If they are brought together and then returned to the quintessence, they overcome all dense, hard and strong metallic things." (Nicolas Flamel, *Chymische Werke*, Hamburg edition, 1681)

A.J. Kirchweger, Annulus Platonis (Aurea Catena Homeri), 1781; reprinted Berlin, 1921

A number of versions exist of the famous emblem scroll which gave a sympathetic depiction of the poetic, bizarre visions of Sir George Ripley (16th century). The twelve signs of the zodiac, in which the hermaphroditic matter of "Sunne and Moone" circulates, refer to Ripley's well-known work, *The Compound of Alchymie,* in which the preparation of the "drinkable gold" is described as a repeated passage through the twelve gates of the process.

Ripley's writings were circulated by the *Theatrum chemicum Britannicum* published by Elias Ashmole in 1652 (Reprint: New York, London, 1967). Ashmole was one of the founders of the Royal Society and one of the first "speculative Masons" to be accepted into the London guild of "work-masons".

Ripley Scroll, 16th century

Serpent

"These are the two snakes fastened around Mercury's staff, with which he demonstrates his great power and changes into whichever forms he wishes (...). When these two are placed together in the vessel of the Dead Tomb, they bite one another cruelly (...). Through putrefaction they lose their first natural forms to take on a new, nobler form (...). The reason why I make you draw these two (male and female) seeds in the form of a dragon is because their stink is very great, and their poison (...)". (Nicolas Flamel, *Chymische Werke*, Hamburg edition, 1681)

Livre des figures hieroglyphiques, Paris, 17th century

Serpent

The two snakes which, in this tantric depiction, symbolize cosmic energy, are wound around an invisible *lingam* (phallus). In Sanskrit, the microcosmic form of this universal energy is called *kundalini*. The vital stream of the awakened *kundalini* ascends along the spine via the central, subtle channel, the *susumn*, to the centre of the brain. To the left, is the lunar channel, *ida*, to the right the solar channel, *pingala*. The three channels come together again in the area around the eyebrows.

Bosohli, c. 1700

Serpent

"In India the spine is called the staff of Brahma. Illustration 4 also shows the archetype of the Caduceus, whose two serpents symbolize the Kundalini or the serpent fire (...) while the wings signify the power of conscious flight through the higher worlds brought about by the unfolding of this fire."
(C.W. Leadbeater, *The Chakras,* 1927)

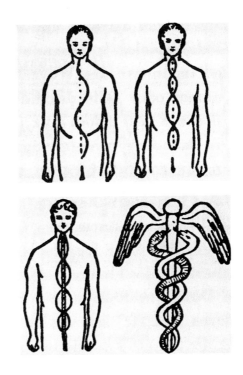

Ripley's "Serpent of Arabia" speaks: "Azoth is truly my sister, and Kibrick (Arabic kibrit, sulphur) is indeed my brother". Ripley advises: divide it in Three, make from it One and you have the lapis.

Theatrum chemicum Britannicum, London, 1652

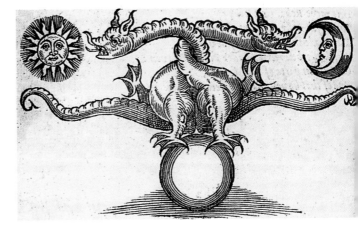

In the Second Key of Basil Valentine, a purifying bath "of two fighters (ie. of two conflicting materials)" is prepared for the bridegroom, gold. The one on the right with the eagle on his sword is sal ammoniac, the one on the left is saltpetre. The philosophical Mercury in the middle symbolizes the distillate of the two, the mineral bath in which the bridegroom is dissolved for the marriage.

D. Stolcius von Stolcenberg, Viridarium chymicum, Frankfurt, 1624

As well as having practical capacities for chymical laboratory work, being well-read and intelligent, the artist must try above all by living religiously and virtuously to share in the mercy of God, shown here elevating the bipolar, mercurial matter, with the Holy Ghost, into the trinity of the lapis.

Theatrum chemicum Britannicum, London, 1652

Seal of the spagyric laboratory 'Soluna', founded in 1921 by the poet and shadow player Alexander von Bernus at Stift Neuburg near Heidelberg, and continued a few years later in Stuttgart. According to Bernus, iatrochemical spagyrics, which date back to Paracelsus, refers to "that type of healing which includes both complex homeopathy and biochemistry and goes beyond itself; for on the one hand it encompasses the whole fund of medicines of both, on the other it gives the disabled organism the indicated ingredients in (…)" an 'open' and thus assimilable state, particularly the metals, half-metals and minerals."

These medicines, according to Bernus, have their effect through the invisible "fluid body" or "ethereal body" of man and are thus capable "of summoning up the healing forces without burdening the organism with poisonous substances and doing it lasting damage, so that it may reorganize itself". (Von Bernus, *Alchymie und Heilkunst,* Stuttgart, 1936)

Serpent

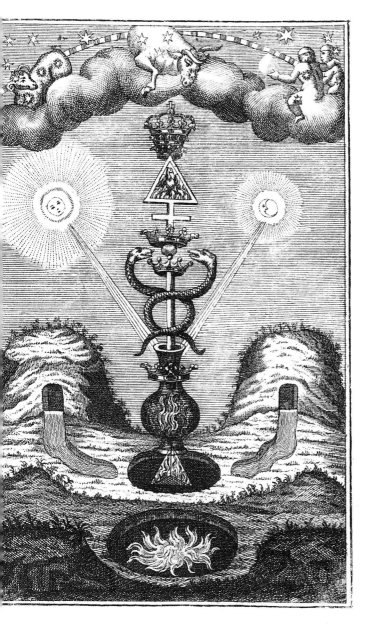

The illustration shows "two parabolic streams (...) which together yield the mysterious triangular stone" and "a mysterious and natural fire whose spirit penetrates the stone and sublimates it into vapours which thicken in the vessel". It should also be observed "that art gives this divine fluid a double crown of perfection by reversing the elements and purifying the beginnings, from which it becomes Mercury's Caduceus" and "that this very ☿ like a Phoenix (...) attains the final perfecton of the fixed philosophers' sulphur."

A.T. de Limojon de Saint-Didier, Le Triomphe hermétique, 1689, German edition Frankfurt, 1765

Serpent

Mercury received a staff from Apollo. When he came to Arcadia with it, "he found two serpents biting one another; he threw the rod between them, and they became one once more, hence the rod (...) is a sign of peace (...)". (G.A. Böckler, *Ars Heraldica*, Nuremberg, 1688/Graz, 1971)

Der Compaß der Weisen, Ketima Vere, Berlin, 1782

"The cold, moist vividness of Mercury reaches the Elemental Mixture through celestial impression." (L. Thurneisser)

"The inner Mercury is the life of the deity and all Divine Creatures. The outer Mercury is the life of the outer world, and all outer corporeality (...) in growing and procreative things." (Böhme, *De signatura rerum*)

Leonhard Thurneisser, Magna Alchymia, Berlin, 1583

Serpent

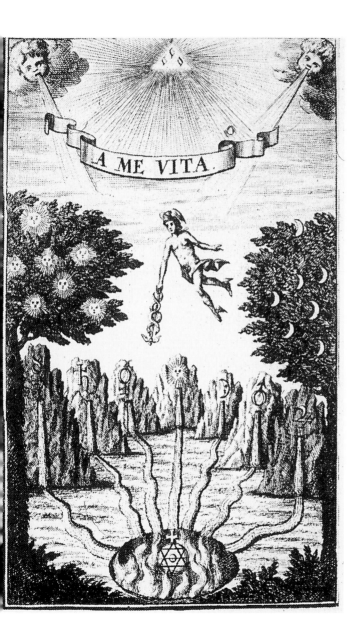

A ME VITA.

"The painted, winged Mercury is volatile by nature (…). His staff wound about with snakes points to his power (…) with which he opens heaven and earth, gives death and life and, with this powerful nature both ascends towards the sky and descends to earth, thus attaining the powers of the upper and lower things." ("Aus des Herrn de Nuysement's Tractat vom allgemeinen Geist der Welt", in: *Hermetisches ABC*, Berlin, 1778)

Famae alchymiae, Leipzig, 1717

Serpent

This illustration is inspired by a section from the Ripley Scroll, various copies of which were in circulation in the 15th and 16th centuries.

Adam (Hebrew: red earth) is sulphur, Eve mercury. According to Fulcanelli, the snakes of the Caduceus represent the "sharp and dissolving nature of mercury, which greedily absorbs the metallic sulphur (the golden staff)".
(*Le Mystère des Cathédrales,* Paris, 1964)

Figuarum Aegyptiorum Secretarum, 18th century

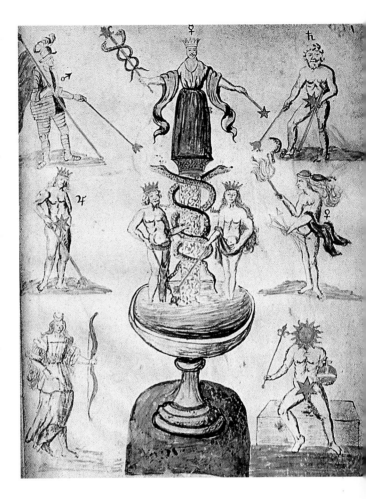

Serpent

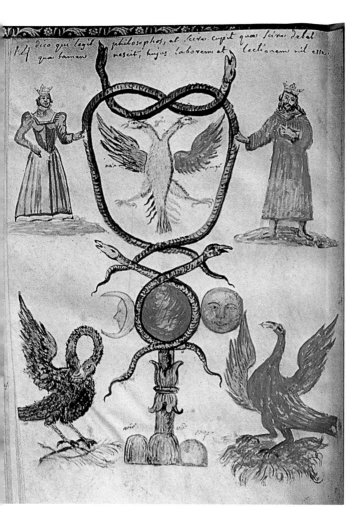

Allegory of the marriage of the dual principles in the work: on the left the female, mercurial side with the pelican as a symbolic animal, feeding its young with its blood, and on the right, the male, sulphur side with the firebird, the Phoenix.

Figuarum Aegyptiorum Secretarum, 18th century

Serpent

For Hieronymus Reussner (*Pandora*, Basle, 1582), the dragon that grows from the "philosophers' tree" is "our Mercury" or the "water of life" from whch God created all things. United in it, are the powers of the six planets and metals. The double-headed eagle of the Habsburgs symbolizes the fixed and volatile components of matter.

Hieronymus Reussner, Pandora, Basle, 1582

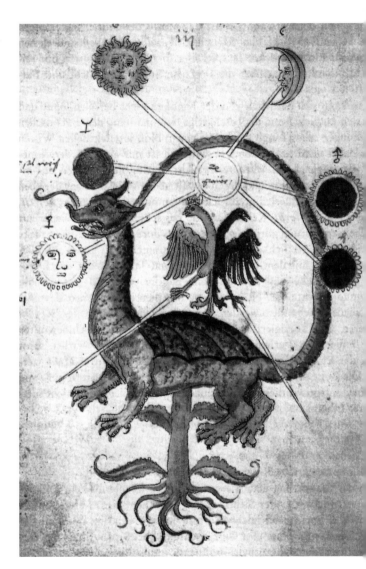

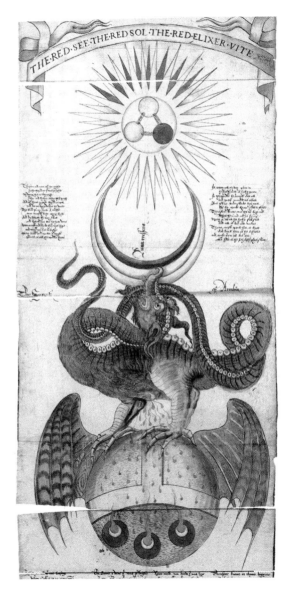

The "Red Sea" in the caption above this detail from the Ripley Scroll was a well-known code name for the divine mercurial water and its tincturing power. Here it is depicted as the blood pouring from the heart of the "Serpent of Arabia". It brings happiness to whomsoever finds it, and flows, round as a ball, to every place in the world, Ripley writes.

The comparison of the little red blood-corpuscles and the lapis reappears as a *leit-motif* in William Blake's relative theory of space and time, which he developed in his late poem *Milton* as a response to the concepts of Newton (cf. p. 530).

Ripley Scroll, manuscript, 16th century

Serpent

"The dragon has killed the woman and she him, and both are poured over with blood."

The dragon that dwells in the narrow crevasses embodies the elements of earth and fire, the woman water and air, according to Maier. Earth refers on the one hand to the physical sediment of distillation, and on the other to the "virgin earth" of the philosophers, at the centre of which is hidden the great dragon blaze, the secret fire. Here the two, of which "one is white (Mercury) and the other red (Sulphur)", nestle united in a deep grave, the putrefaction.

This final image from Maier's *Atalanta fugiens* was taken up by Blake, who was well versed in Hermetic symbolism. He interpreted the woman as *Jerusalem* or the spiritual emanation of the fallen England/Albion, which lay in the strangling grip of materialistic powers.

M. Maier, Atalanta fugiens, Oppenheim, 161

From the python (Mercurius vivus) a "heavy, greasy water" is prepared. "In this water you can dissolve the king *(gold)*, his whole body, and then hand it to Vulcan, who cooks both in the supreme medicine. Thus, with this greasy python one can fecundate the king and the queen, so that they will conceive incredible numbers of children."

A. Eleazar, Donum Dei, Erfurt, 1735

Serpent

The "Mercurial tail-eater" is "our subject". "From this one root will sprout roses, the supreme good." The white rose signifies the lunar "Philosophical Tincture", the red rose the solar "Metallic Tincture". The mysterious "blue rose" in the middle is called the "flower of wisdom".

Blue is not given any autonomous significance in alchemical colour theories. It generally signifies a moist state of matter, and is treated as a modification of saturnine black, the sign of high spirituality and arcane knowledge.

H. Reussner, Pandora, Basle, 1582

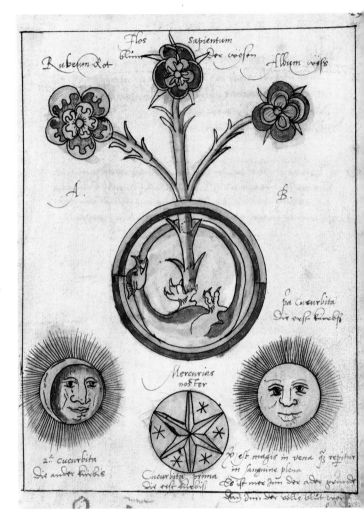

Serpent

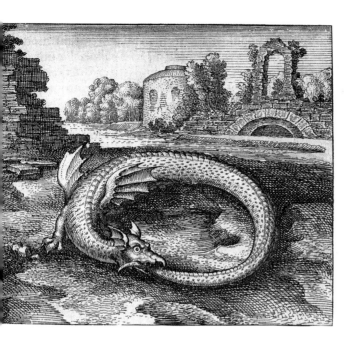

"Not without reason do the ancient philosophers compare quicksilver with a snake (...) because it pulls a tail behind it and its weight drags it hither and thither."

e ancients, Maier writes, saw the
ıroboros ring both as "the change and
turn of the year" and as the beginning
the Work in which the poisonous, moist
agon's tail is consumed. When the
agon has completely sloughed its skin,
e the snake, the supreme medicine has
en from its poison.

Goethe's hermetic *Märchen* (1795), the
ıroboros plays an important part: "(...)

sweet Lily stood motionless, staring
rigidly at the soulless corpse (...) In her
mute despair she sought not help, for she
knew of no help. The snake moved all the
more assiduously against it (...) With its
lithe body it drew a broad circle around
the corpse and grasped the end of its tail
with its teeth and lay there peacefully."

M. Maier, Atalanta fugiens, Oppenheim, 1618

Serpent

This sheet from an 11th-century Greek anthology illustrates a treatise about 'gold-making' *(Chrysopeia)* by an alchemist named Cleopatra in 4th-century Alexandria.

At this time, alchemists were persecuted by the state and the Church, since there was supposedly a biblical curse upon their work. The caption is said to have been whispered to mankind by the fallen angels. The inscriptions and symbols on the sheet indicate that at this time chemistry was a subsidiary part of magic.

The circles on the top left read: "One is all, of him is everything, for him is everything, in him is everything. The snake is the one; it has two symbols, good and evil".

Abraxas gems and zodiac man

The snake was the central, symbolic animal of many late Classical sects. It was worshiped by the *Naassenians** (Hebrew, 'Naas', snake) as a demiurge, by the *Ophites* (Greek 'Ophis', snake), it was worshipped as the redeeming son of God. As the serpent of Moses it represents the basis of all magical powers or, as Ophiomorphos, the spirit of evil.

Talismans of the gnostic God Abraxas, shown as, amongst other things, a snake-footed hybrid, were widely disseminated. His magical name, with the numeric value 365, encompasses the universe, which, according to the gnostic Basilide (c. A.D. 130), consists of as many heavens as there are days in the year.

Erasmus Franciscus, Das eröffnete Lust-Haus der Ober- und Niederwelt, Nuremberg, 1676

Serpent

The magical inscriptions on the Abraxas gemstones were often surrounded by the Ouroboros. He is Eon, the entirety of time and space, and also Okeanos, the water-belt in the gnostic cosmology, which separates the upper sphere of the Pneuma from the lower, dark waters.

Heinrich Khunrath calls "our Mercury" Proteus, the eternally wandering watery, old man from Greek mythology, "who has the keys to the sea (...) and power over everything, the son of Oceanus (...) who reforms and returns in diverse forms". (*Vom hylealischen Chaos*, Frankfurt, 1708)

Whoever manages to grasp and preserve him will achieve great and wonderful things.

Johannes Macarius, Abraxas en Apistopistus, Antwerp, 1657

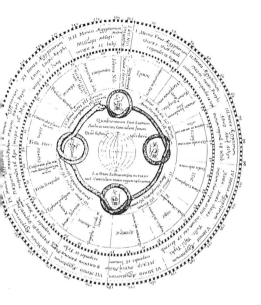

In the outer ring of this Egyptian time-wheel, an attempt is made to harmonize the 360 degrees of the zodiac with the 365 days of the calendar. Among the Egyptians, the extra five days were devoted to the birth of the gods and the new year. The twelve months follow in the central ring, and within that the snake of eternity connects the four gods Sothis (=Sirius), Isis, Osiris and Horus. Each of them is the ruler of a "great year" consisting of 365 earthly years. All told, they produce 1461 years, the amount of time between the moments when the year's first rise of Sirius coincides with the sunrise.

According to more recent discoveries, the directional shaft in the queen's chamber in the pyramid of Cheops is said to be aimed precisely at this fixed star, which was held to be the star of Isis.

e earliest interpretations of hieroglyph
ve been handed down to us in the Greek
guage by Horapollo, an Egyptian of the
century A.D.. "If they wish to repre-
t the universe, they draw a snake scat-
ed with bright scales, swallowing its
n tail: the flakes indicate the stars of
e universe (...) Each year it divests itself
ts skin, the old time (...) And the con-
mption of its own body indicates that all
ngs in the world which may be pro-
ced by divine providence in the world,
o succumb to decay."

top/bottom: A. Kircher,
eliscus aegyptiacus, Rome, 1666

Serpent

To the poor soul who wants to turn away from God, the Devil shows his own image as the cycle of nature, "in the form of a snake: the fire-wheel of essence". He speaks: "You too are such a fiery Mercury, as you introduce your desire into this art. But you must eat from a fruit in which each of the four elements reacts within itself to the other, with which it is in conflict.'"

When the soul has eaten of it, "Vulcan lights the fire-wheel of essence, and all the qualities of nature awakened in the soul, and guided it into its own pleasure and desire". (J. Böhme, *Gespräch einer erleuchteten und unerleuchteten Seele*)

J. Böhme, Theosophische Werke, Amsterdam, 1682

Serpent

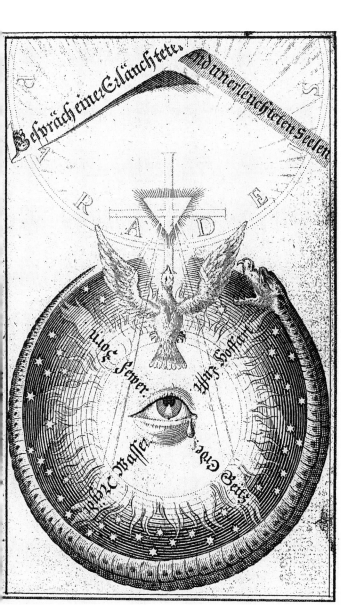

Since Vulcan lit the mercurial wheel of anguish into which the soul had imagined itself, "its meaning only stands after the multiplicity of natural things". It is entirely subject to the changeable play of the passions.

The illuminated soul counsels the poor soul to break the bonds of the monstrous snakehusk by introducing it to Christ, the spirit of love, who, by becoming flesh, had burst the gates of Hell and thus reopened the way to Paradise.

J. Böhme,
Theosophische
Wercke,
Amsterdam, 1682

Serpent

Joel 2, 13: "Rend your heart, and not your garments, and turn unto the Lord, your God."

The fiery soul has entered a false shelter with fire, and must break out again with fire and violence, or the diabolical serpent or the astral world spirit will keep it in its prison. There is no escape route downwards; "only upwards – above all the senses – does one draw breath and strengthen life". Here the celestial Sophia awaits her soul-bridegroom.

J. Böhme, Weg zu Christo, 1730 edition

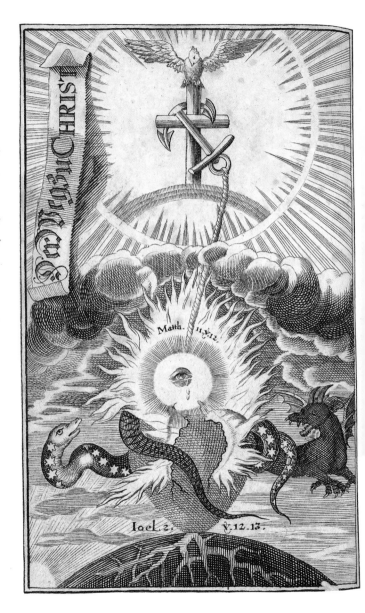

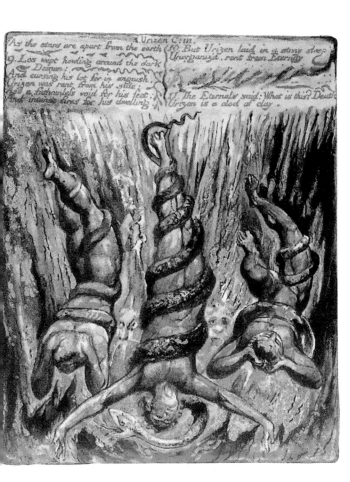

Serpent

Here, three divine figures are falling into the yawning abyss of the material world (Ulro), which the abstract demon Urizen (your reason) created by dividing the eternal world into light and darkness.

In an 1818 engraving, Blake interpreted the Greek Laocoon group (he believed it to be the copy of a Hebrew original) as Jehovah being strangled by the snakes of good and evil with his two sons Satan and Adam. "Art is the tree of life, science is the tree of death".

W. Blake, The Book of Urizen, Lambeth, 1794

Return

In the emblem of the Theosophical Society, a combination of the western Ouroboros, the eastern Swastika, the Jewish Star of David and the ancient Egyptian Ankh, its syncretic programme is very directly expressed.

The society was founded in New York in 1875 by the Russian emigrant Helena P. Blavatsky (1831–1891), described by W.B. Yeats as a "primeval peasant". In Joyce's *Finnegans Wake,* she appears as a hen scratching a mysterious piece of writing from a dung-heap. This is her 'Secret Doctrine', published in three volumes in 1888, a mythical pot-pourri such as is found, for example, in paintings by Max Beckmann, imbued with the spirit of *fin-de-siècle* salon spiritualism.

In 1879 the society moved its main seat to Adyar in India. The

mixture of Eastern spirituality and Western occultism made a decisive contribution to the development of abstract painting. Wassily Kandinsky and Piet Mondrian were among the society's devotees.

Her programme of "science, religion and philosophy", which she sought to promulgate with a keen sense of dramatic effect, also makes Madame Blavatsky a herald of the New Age movement of the late 20th century.

According to her theory, the whole cosmos consists of a seven-stage process of evolution and involution. The goal of humanity is the upward development from the sexual, material body to the ethereal, light body. This path leads from the currently dominant Aryan mother-race to a sublimated race of people that she saw emerging in the America of her own time. It is clear that such doctrines, which were easily compatible with the inhuman racial doctrines of Guido von List and Lanz-Liebenfels, could become esoteric supports for the formation of Nazi ideology.

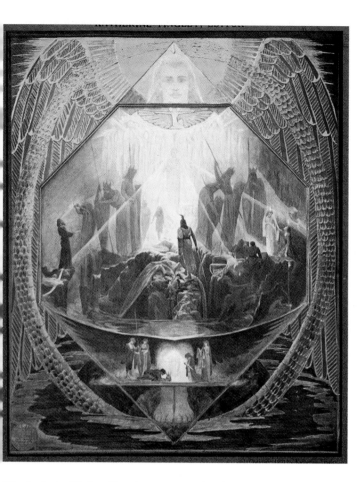

After the death of Madame Blavatsky, there was a break in 1895 between the Indian headquarters of the Theosophical Society and its original seat in the USA, which was run by Katherine Tingley. Christian and Nordic motifs predominate in her painting of the eternal cycle of global ascents and descents.

When the leaders of the society in India sought to impose upon its European members a Hindu boy called Krishnamurti as a new Messiah, in 1913, under the direction of Rudolf Steiner, the German section broke away to form itself as the Anthroposophical Society.

The Theosophical Path, Ed. Katherine Tingley, Point Loma, California, USA, 1926

Return

"Since the matter and substance of things are indestructible, all its parts are subject to all forms, so that Each and Everything becomes Everything and Each, if not at one and the same time and in a single minute, then at various times and various moments, in sequence and in alternation." (Giordano Bruno, *Ash Wednesday*, 1584)

Cycle of rebirth, Bhaktivedanta Book Trust, 1993

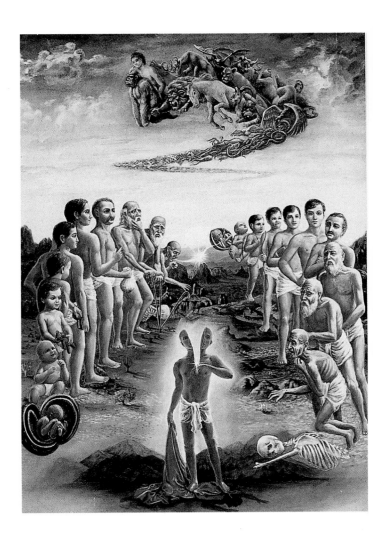

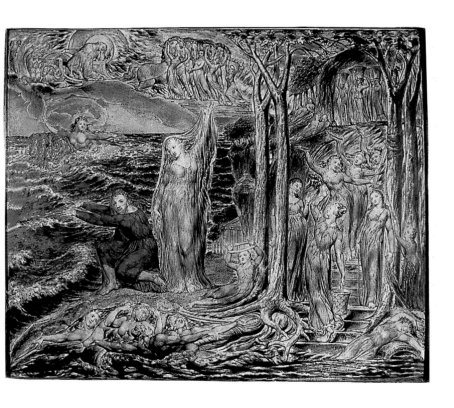

At the top left of the picture, we see the cause of the great cosmic disorder: when Urizen, reason, falls asleep, drunk at the wheel of the sun-chariot, Luvah, passion, takes control of the vehicle. The result of this reversal is the dark "sea of time and space" with the cycle of incarnations.

In the *Politeia,* Plato speaks of the "thousand-year wandering of the soul", defined by the "spindle of necessity", and by the three Fates who decide on birth, life and death (bottom left). At the right, with a bucket of water from the source of life in his hand, the soul rises into the vegetable hollow of the body, which is woven by women at the "womb-spinning-wheels of generation".

The figure in the red robe at the left may be Odysseus, "who symbolizes man on his way via the dark and stormy sea of the Generatio". (Thomas Taylor, *Plotinus, Concerning the Beautiful,* London, 1787)

W. Blake, *The Arlington Court Picture, 1821*

Return

"All the works that the good God has created go around in a circle and are perfect, returning from whence they have come." (John Dastin, "Rosario vom Stein der Weisen", 14th century, in: *Hermetisches ABC,* Berlin, 1778)

D. A. Freher, Para-doxa Emblemata, manuscript, 18th century

Neither Beginning nor End

23

The End is swallowed up by the Beginning.

Return

"Just as there was only one at the beginning, so too in this work everything comes from One and returns to One. This is what is meant by the reverse transformation of the elements." (Synesios, 4th-century Greek alchemist)

Principio Fabrice, Delle allusioni, imprese et embleme, 17th century

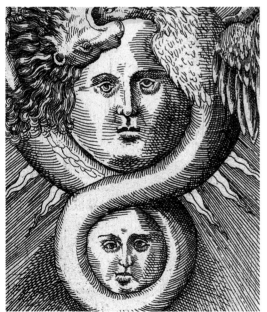

The eternal war between the 'eagle's blazing' (binding agent) and the 'lion's blood' (solvent).

D. Stolcius von Stolcenberg, Viridarium chymicum, Frankfurt, 1624

Return

Ph.O. Runge, Zwei Kinder in Rosen-blüten, durch den Schlangenring der Ewigkeit getrennt, 1803. (Two children in rose-flowers, separated by the snake-ring of eternity.)

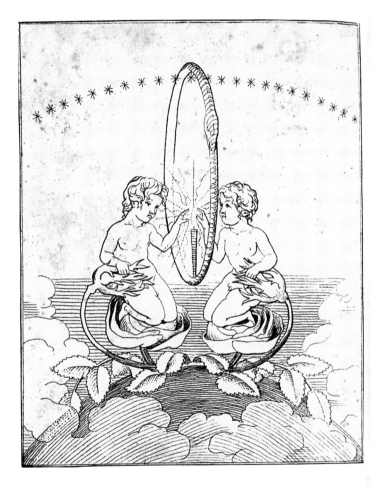

"The Sun's light
when he unfolds it

Depends on the
Organ that
beholds it."

*William Blake,
For the sexes: The
Gates of Paradise,
1793 and 1818*

What is Man?

"Hermes writes: The dragon only dies when he is killed by his brother and sister at once. Not by one alone, but by both at once, namely by sun and moon (...) That means that one must fix and unite it with Luna or Sol. The dragon is the living quicksilver drawn from or out of the bodies that have a body, soul and spirit. Hence, it is also said that the dragon does not die without his brother and his sister (...)." (*Rosarium philosophorum,* Ed. J. Telle, Weinheim, 1992)

"The dragon always represents Mercury, whether it is fixed or volatile," writes Maier. Within it is Saturn, who eats his own tail and, because of his poison and hi· sharp teeth, is a watchful and faithful servant of the philosophers, who is not easily vanquished.

M. Maier, Atalanta fugiens, Oppenheim, 16⚡

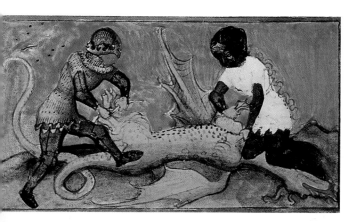

"Our Mercurial dragon" can only be conquered by Sol and Luna together, that is, in order to kill him one must remove his sulphur and lunar moisture at the same time.

Aurora consurgens, early 16th century

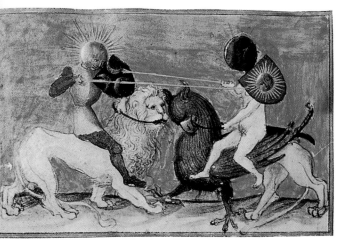

t is said: Woman dissolves man, and he akes her solid. That is: The spirit dis-lves the body and makes it soft, and the dy fixes the spirit."

"Senior says: I am a hot and dry Sol and you Luna are cold and moist. When we couple and come together (...) I will with flattery take your soul from you". *(Aurora consurgens)*

Aurora consurgens, early 16th century

Conjunctio

The king, Gabricius, and his sister, Beya, want to embrace "to conceive a son whose like is unknown to the world".

The feet of the gryphon or dragon in the rock indicate that both are from the same poisonous parental house of prime matter. In the *Rosarium philosophorum* it also says: "The intercourse of Gabricius with Beya leads to his immediate death. For Beya rises above Gabricius, and encloses him in her womb, so that nothing can be seen of him. So great is her love that she has absorbed him entire into her nature and divided him into indivisible parts".

*J. D. Mylius,
Anatomia auri,
Frankfurt, 1628*

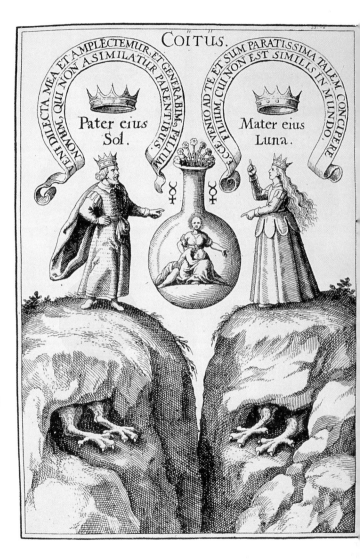

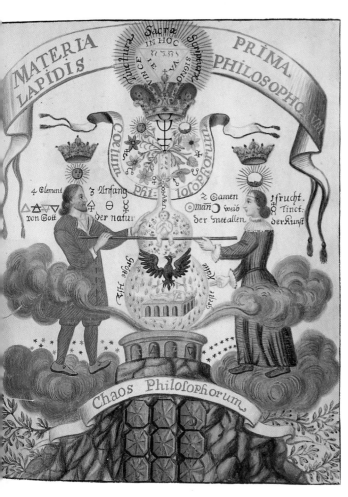

the green mountain of *prima materia*
e signs of the relevant materials are
signed to Saturn's magic square of num-
rs. At the top, sun and moon lift their
nperial son' (the mercurial tincture) from
baptism in the retort.

The manuscript, from the circle of the Gold
and Rosicrucians, contains parallels with
Kirchweger's *Aurea Catena a Homeri* (1781).

*Materia Prima Lapidis Philosophorum,
manuscript, early 18th century*

Conjunctio

The 'Donum Dei', first contained in 15th-century manuscripts, is one of the most widespread alchemical collections of quotations. Here, the stages of the work are illustrated in twelve pictures.

The royal pair seeks to unite to give birth to a son, a king "his head red, his eyes black, his feet white: this is mastery".

"We want to go and seek the nature of the four elements which the alchemists draw from the belly of the earth./ Here begins the dissolution of the wise (solutio), and from it comes our quicksilver."

Donum Dei,
17th century

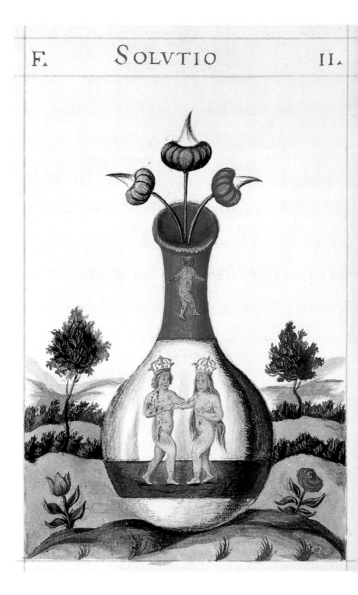

F. SOLVTIO II.

Conjunctio

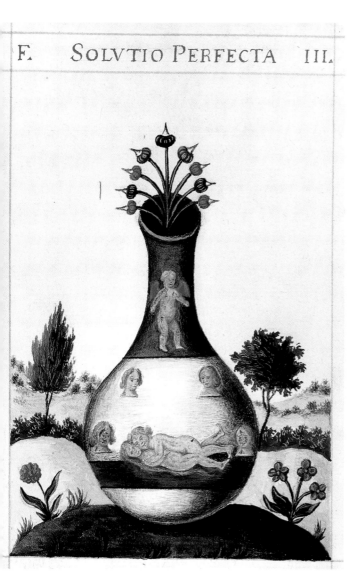

"The stone is prepared from four elements brought together./ Here, the bodies dissolve entirely in our living quicksilver, that is, in the water of our mercury, and from it emerges a permanently persistent water."

"Return the nature of the four elements, and soon you will find what you seek, but to return nature means making corpses into spirits in our mastery."

Donum Dei,
17th century

Conjunctio

"Putrefaction of the wise their raven-head/ (...) when you see the blackness delight, for it is the beginning of your work."

This phase lasts for a long time, so one should be patient, "for where our mastery is concerned, haste comes from the devil".

The following pictures describe the formation of a black, stinking earth, its dissolution into the mercurial "philosophers' oil", the first whitening and the appearance of many colours.

Donum Dei, 17th century

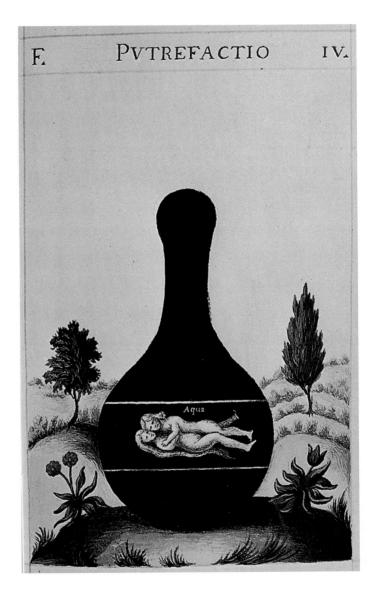

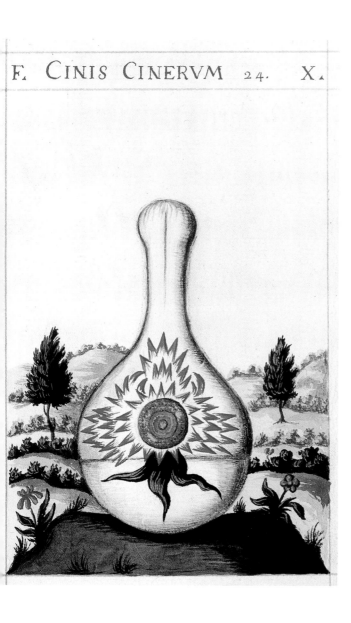

F. CINIS CINERVM 24. X.

Conjunctio

"An ash of ashes/ The black fogs have settled on her body, from where they started, and there has arisen a unity between the earth and the water and there has arisen an ash." This ash should not be underestimated, for in it, according to the legendary alchemist Morienus, is the diadem of the king.

In similar illustrations, the tree that grows from the ashes grows a grape-like fruit or the three stars of the work.

Donum Dei, 17th century

Conjunctio

"The white rose. I am the elixir of Whiteness, turning all imperfect metals into the purest silver."

The Catalan physician Arnald of Villanova (ca. 1240–1311) quotes: "Whosoever has made me white also makes me red. Both white and red spring from a single root". Whiteness is only transformed into redness by dry coction (Calcinatio), just as white urine is coloured yellow by continuous digestion in the body.

Donum Dei, 17th century

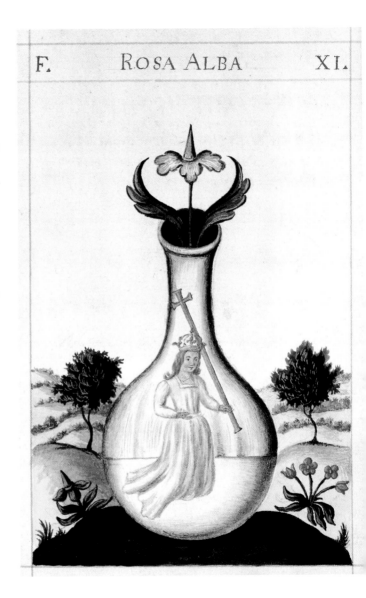

F. ROSA ALBA XI.

Conjunctio

"The red rose. I am the elixir of Redness, turning all imperfect bodies into the purest and truest gold."

The red king shines like the sun, "clear as the carbuncle, impetuously fluid like a wax, resistant to fire, penetrating and containing living quicksilver. He combines absolute sulphurous solidity with ultimate mercurial flexibility.

According to the Christian doctrine of transubstantiation, the purple colour of blood is the supreme form of spirituality.

Donum Dei,
17th century

F. ROSA RVBEA XII.

Conjunctio

"my goldrush gainst her silvernetss" (J. Joyce, *Finnegans Wake*)

S. Trismosin, Splendor solis, London, 16th century

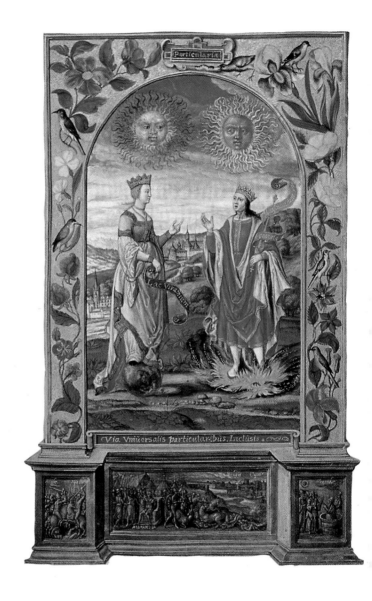

he *Sol and Luna* poem, a slightly abbreviated version of which is produced on the following pages, has circulated since 1400. It appeared in an illustrated version in 1550, in the first publication of the *osarium philosophorum* and as, since then, been one f the most popular and idespread alchemical picure-books. The alchemical holar, Joachim Telle, who as devoted an in-depth udy to the work (J. Telle, *ol und Luna,* Hürtgenwald, 80), laments the interretative trend of psychoalyst C.G. Jung that has redominated in the 20th entury. In the sequence of ictures Jung saw principally notation of psychic and nconscious 'projections' a 'symbolic drama'. y making the pictures ontemporary in this way, elle writes, one risks losing e historical singularity of e picture-poem. "Spiritual nd psychological interpretions ignore above all the fact that the picture-poem is connected ith scientific texts (...) Over the centuries, it was seen as an educaonal aid teaching about processes in the material world." The roots f this picture-alchemy lie in Arabic alchemy; we know too little bout its complex teachings.

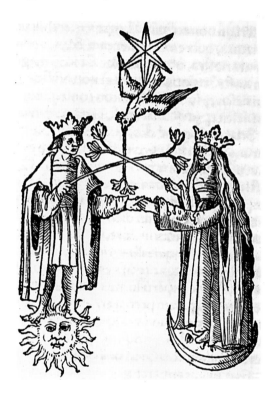

Conjunctio

UNIFICATION OR COPULATION

"O Luna, surrounded by me/and sweet one mine/

You become fine/strong/and powerful as I am

O Sol/you are recognizable above all others/

You need me as the cock needs the hens."

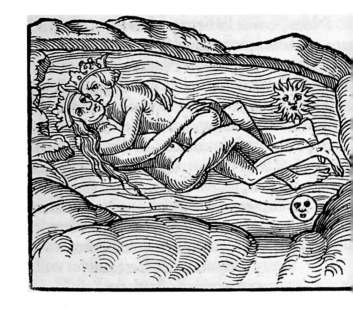

EXTRACTION OF THE SOUL OR IM-PREGNATION

"Here, king and queen lie dead/

The soul departs in great haste.

Here, the four elements separate/

And from the body the soul departs apace."

WASHING OR PURIFICATION

"Here, the dew falls from the sky/

And washes the black body in the grave."

JUBILATION OF THE SOUL OR BIRTH OR SUBLIMATION

"Here, the soul floats down/

And refreshes the purified corpse."

All illustrations: Rosarium philosophorum, 1550

Conjunctio

"Here is born the noble empress rich/

The masters say she is like her daughter.

She multiplies/ producing children numberless/

They are immortally pure/and without nourishment.

(…)

I became a mother/ and yet remain a maid/

And was in my essence lain with.

That my son became my father/

As God has decreed in essential way.

The Mother who gave birth to me/

Through me will be born on earth."

Rosarium philosophorum, 1550

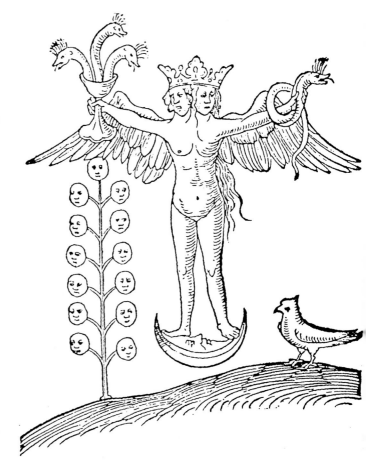

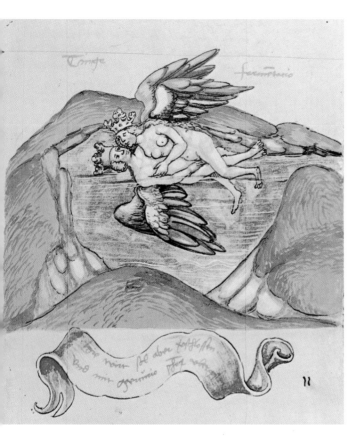

But here Sol is enclosed and poured over
with 'Mercurio philosophorum'."

Rosarium philosophorum, 1550

Conjunctio

FIXING

"Here Luna's life is
not at an end/

The spirit rises
high apace.

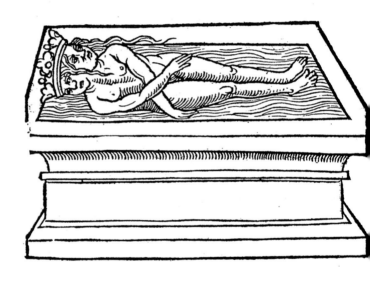

MULTIPLICATION

"Here, the water sinks/

And gives the earth its water to drink again."

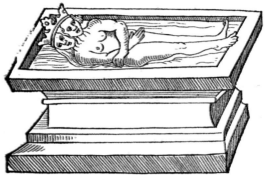

REVIVAL

"Here the soul comes from the sky, fine and clear.

And resurrects the philosopher's daughter."

All illustrations: Rosarium philosophorum, 1550

Androgyny

"Here is born the
richly honoured
king/

No higher may be
born,

With art or
through nature/

Of any living crea-
ture.

ANSWER OF
QUEEN LUNA

Here is born the
noble empress
rich/

All philosophers
say she and her
daughter are one.

She multiplies and
gives birth to
countless children

Who are immortal/
and without nour-
ishment."

*Rosarium
philosophorum,
manuscript,
16th century*

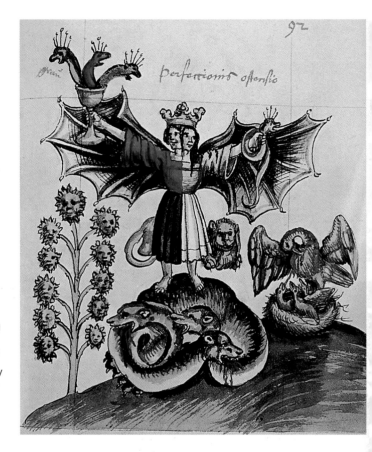

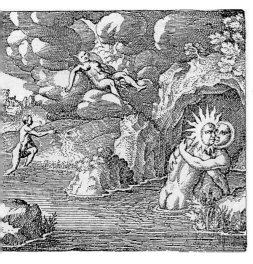

"He is conceived in the bath and born in air, but when he has turned red he leaves the water."

Sexual coupling occurs in the putrefaction on the bottom of the retort, when "man acts inside the woman, that is, Azoth inside the earth". But birth occurs above, in the steams of the still head."

M. Maier, Atalanta fugiens, Oppenheim, 1618

"The hermaphrodite is born from two mountains, of Mercury *(Hermes)* and Venus *(Aphrodite)*."

Like his father's Caduceus, it is a double thing (rebis) that unites the two opposites: "the he and the she and the his of it". (J. Joyce, *Finnegans Wake*)

M. Maier, Atalanta fugiens, Oppenheim, 1618

Androgyny

The extensive picture series from the *Philosophia reformata* of J.D. Mylius (1622) was clearly influenced by the 'Sol and Luna' picture poem. After purification by fire and the dissolution of their bodies in the mercurial bath, the royal brother and sister are united. The ravens indicate the stage of putrefaction.

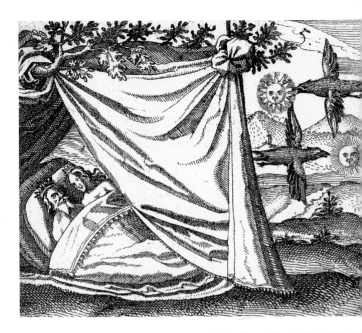

The pair arise as a rebis from the grave of putrefaction, and are cleaned of their blackness by the dew of heaven.

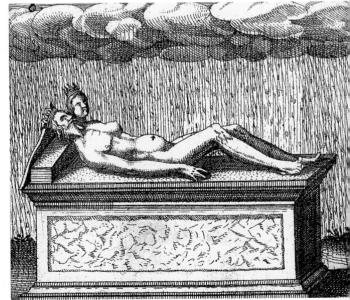

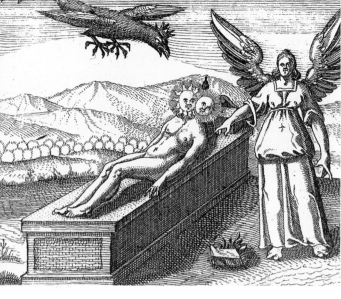

Philosophical gold and silver appear on the faces of the rebis. The presence of the two winged creatures indicates the final processes of sublimation.

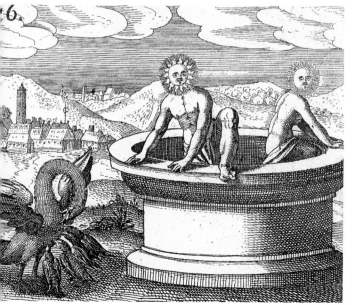

The pelican, feeding its young with its blood, symbolizes the final phase of the Multiplicatio. Given definitive strength and fixity, the red and white lapis arise from the mercurial spring.

All illustrations: D. Stolcius von Stolcenberg, Viridarium chymicum, Frankfurt, 1624

Androgyny

The philosophers call the cold and moist matter, woman (moon), the hot and dry, man (sun). The androgynous being is all four qualities at once. With fire one can remove the excess of moisture and form "the idea in the philosophical work, which is tincture".

*M. Maier,
Atalanta fugiens,
Oppenheim, 1618*

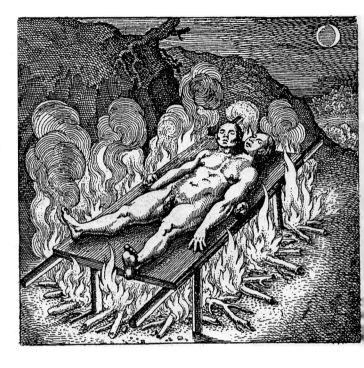

After Adam had fallen from celestial androgynity into the death-sleep of materiality, Christ followed him down into this "unreality", in order, by creating Eve, to give him the possibility of redemption. Böhme wrote: "Christ turned Adam in his sleep from vanity (...) back to the image of the angel", while he created Eve "from his essence, from the female part". "She is Adam's matrix of celestial essence (*Sophia*)". Blake called these female parts 'emanation' and the male parts the shadowy spectre. The central task of earthly existence was the redemption of the 'emanation' and the unification of the two parts. The path there leads, according to Blake, through sensual delights and physical fulfilment, and it is distorted by false moral teachings and dogmatic religiosity as the chief instruments of sexual repression.

Ill. right:
W. Blake,
Jerusalem,
1804–1820

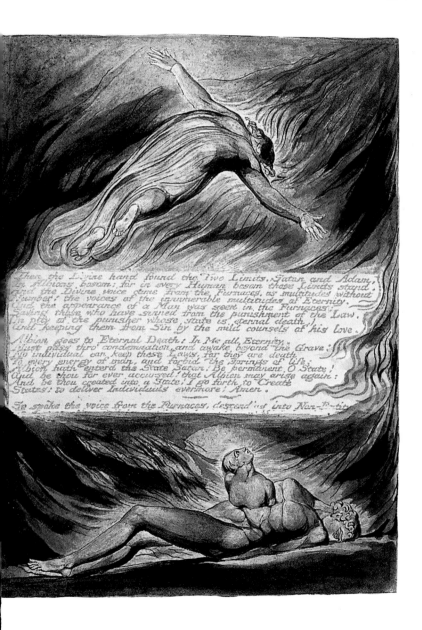

Then the Divine hand found the Two Limits, Satan and Adam,
In Albions bosom; for in every Human bosom these Limits stand,
And the Divine voice came from the Furnaces, as multitudes without
Number! the voices of the innumerable multitudes of Eternity.
And the appearance of a Man was seen in the Furnaces.
Saving those who have sinned from the punishment of the Law,
In pity of the punisher whose state is eternal death,
And keeping them from Sin by the mild counsels of his love.

Albion goes to Eternal Death: In Me all Eternity.
Must pass thro' condemnation, and awake beyond the Grave:
No individual can keep these Laws, for they are death
To every energy of man, and forbid the springs of life.
Albion hath enterd the State Satan: Be permanent, O State!
And be thou for ever accursed! that Albion may arise again:
And be thou created into a State! I go forth to Create
States: to deliver Individuals evermore! Amen.

So spoke the voice from the Furnaces, descending into Non-Entity

Androgyny

Ulmannus (early 15th century) began, like Jacob Böhme, with man's free choice between the worlds of wrath and love. "Here you have three kingdoms in which you wish to be, your works are in accordance". Man is created out of the twofold sun". The inward, spiritual sun embodies the divine hermaphrodite. He is the personification of unselfish alchemy, consisting of "jesus, the male stone of purity" (Mercurius/spirit) and "mary, the female stone of loveliness" (Luna/body). Their unity is God the Father (Sol/soul), the "petrolith", which strengthens against all the devil's temptations.

Buch der heiligen Dreifaltigkeit, 15th century

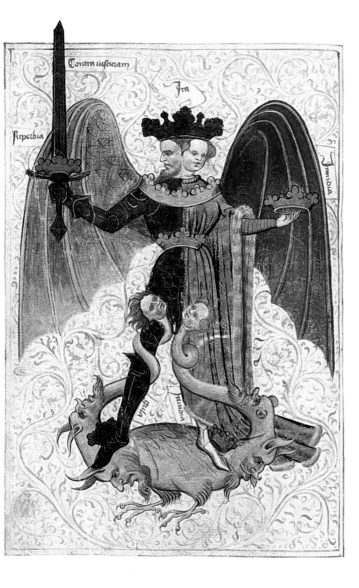

Androgyny

This androgynous being is the spectral, immodest nature from "Lucifer Anti-Christ and his mother: one body and soul, fixed and volatile. Herein consist the natural arts of this world". Their roots are the seven deadly sins. The four crowns are the elements, represented by the lower quadernity in Ulmannus' system: Mars (fire), Venus (water), Saturn (earth), Jupiter (air), "the elements bring good and evil, separated eternally". They are negatively united in the 'black memorial sun" as "sol lapis metal corporeal".

Buch der Heiligen Dreifaltigkeit, 15th century

Androgyny

The introductory page of the *Aurora Consurgens* is an allegory of wisdom, also known as 'the south wind', as a symbol both of the Holy Spirit and of the totality of sublimations.

Here, the south wind is represented as a large eagle, gradually uniting the two opposites. The three legs on which the androgynous being stands, refer to the three-footed stand on which the retort is exposed to the fire. After the coupling, Sol says to Luna, "we will rise into the order of the most ancient [that is 24 sublimations or eagles], then will a burning light be poured into me and you" (Senior Zadith, in: *Aurora Consurgens*).

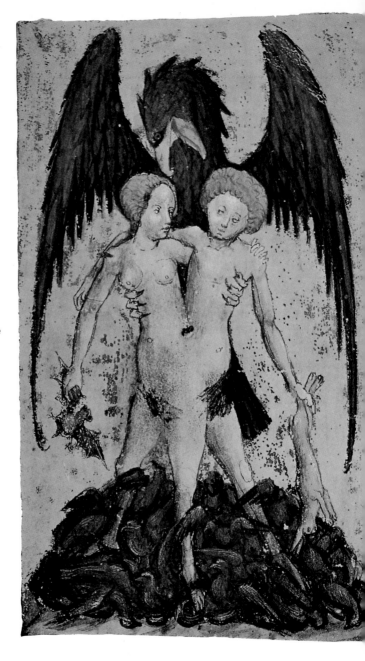

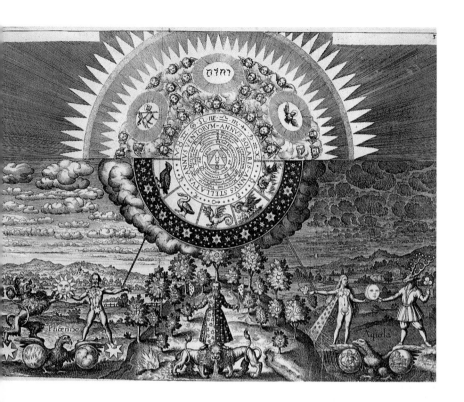

Matthäus Merian originally made this engraving for J.D. Mylius'
Opus Medico-Chymicum (1618). It was later used in the appendix to
the *Musaeum Hermeticum* (1625).

Merian presented all the components of the Great Work in a
single great synthesis: a horizontal axis separates the sphere of the
divine from the wheel of nature, which is divided into the various
phases of the Work, from raven-nigredo to phoenix-rubedo. The
dividing artist stands surrounded by a forest of metal, separating
along the verticals, in a powerful act, chaotic matter into day and
night, sun and moon, sulphur and mercury, fire and water. The great
unification occurs at the centre of the wheel, the intersection of the
axes, in the sign of the mercurial lapis, the "philosophers' hydrolith".

The deer-headed figure to the right is the hunter Actaeon, who
espies nature (Diana/Luna) unclothed. For Giordano Bruno, he is a
symbol of the fearless searcher after truth.

Hermetic Yantras

In the Hindu religion, the simplest geometrical representations of dynamic powers are called "Yantras". Heinrich Zimmer calls them "a kind of map (...) of the staged development of a vision". (*Mythen und Symbole in indischer Kunst und Kultur*, Zurich, 1951)

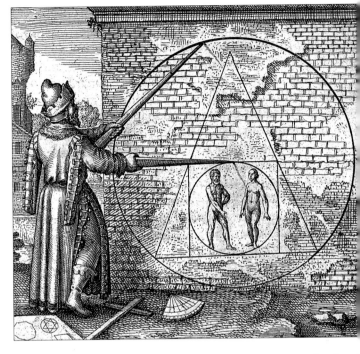

"Make of man and woman a circle, from that a square, then a triangle, then another circle, and you will have the philosophers' stone."

For the alchemists there was nothing strange about the squaring of the circle, wrote Maier. They use the square that comes from the circle to demonstrate "that from every simple body the four elements must be separated (...) By the transformation of the square into a triangle they teach that one should bring forth spirit, body and soul, which then appear in three brief colours before the redness". The body is assigned saturnine blackness, the spirit the lunar-watery whiteness and the soul the airy, citric colour. "If the triangle has now attained its highest perfection, it must be brought back into a circle, that is, an immutable redness. Through which operation the woman returns into the man and from their legs, a single one is formed."

M. Maier, Atalanta fugiens, Oppenheim, 1618

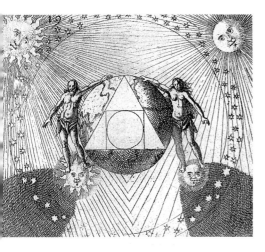

Geometrical depiction of the Pythagorean tetractys, based on the maxim of anonymous Arab alchemists, as handed down through the anthologies of the *Turba philosophorum* and the *Rosarium* since the 13th century in Europe. The inner circle represents the microcosmic One which, through the step of four, becomes the macrocosmic ten, which, in turn, as the quintessence of the alchemists, encompasses all other possibilities.

D. Stolcius von Stolcenberg, Viridarium chymicum, Frankfurt, 1624

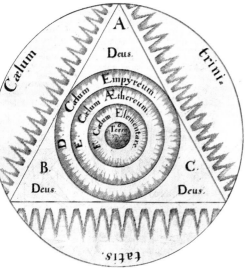

The archetypal, trinitary heaven encompasses the quadernity of the empyreal or fiery heaven, the ethereal heaven and the elemental heaven with the earth at the centre. This figure is a reflection of the tetragrammaton enclosed in a triangle.

R. Fludd, Utriusque Cosmi, Vol. I, Oppenheim, 1617

Hermetic
Yantras

The hexagram is also known as a magical 'Solomon's Seal', with which, according to legend, Solomon is supposed to have cast a spell on the evil spirits. In alchemy and theosophy, it is familiar as a "signet star", a "star or heavenly force that gives understanding to the wise and shows the way, as to the Wise Men in the East", (G. Gichtel, 1682). Six, the number of days of creation, symbolizes the Opus, and the rotating motion in the Work.

A. von Franckenberg, Raphael oder Arzt-Engel, 1639, reprinted 1925

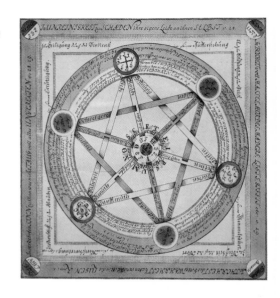

Emblem engraving from Heinrich Madathanus, *Aureum Seculum redivivum* (the Golden Age revived).

Author's motto: "The centre of the world is the corn in the field."

In the outer circle: "Of wonders there are three: God and man, mother and maid: the three and the one."

In the inner circle: "The centre in the centre of the triangle."

M. Maier, Viatorium, Oppenheim, 1618

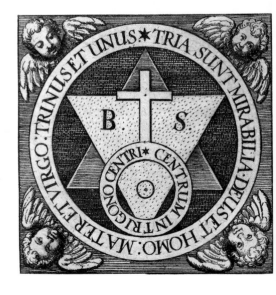

Hermetic Yantras

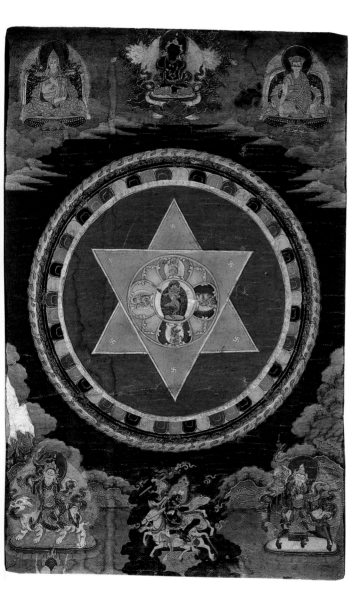

According to Tantric doctrine, the final truth consists in the complete interpenetration of Shiva and Shakti, of male and female energy, of purusha (form) and prakriti (matter). Shiva, the upward-pointing triangle, represents the static aspect of the supreme reality; Shakti, the downward-pointing triangle, represents the kinetic energy of the objective universe.

Vajravarahi Mandala, Tibet, 19th century

Hermetic Yantras

The page is divided into the two main columns of nature (left) and art (right), both resting on the foundation of the mine. The *prima materia* of nature is iron sulphate, the "green vitriol" ☿ from which, by repeated processes of distillation (eagle), what can be obtained is the "red vitriol", the fixed sulphur (lion) as the *ultima materia*. In the centre: the coat of arms with the philosophical mercury (the bird Azoth). The glyph of Mercury ☿ appears towards the bottom of the left-hand diagram, formed from the two snakes of the Caduceus. They frame a combination of letters from 'Vitriol' and 'Azoth'.

S. Michelspacher, Cabala, Augsburg, 1616

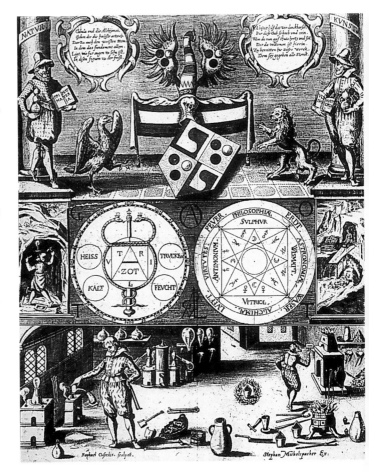

Hermetic Yantras

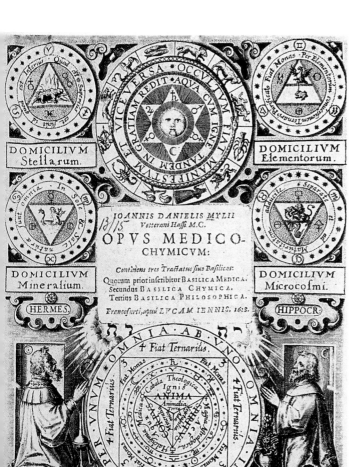

One characteristic feature of the design of Baroque title-pages is their antithetical construction. Here, as day and night, alchemy (Hermes: sun) and classical medicine (Hippocrates: moon) face one another. Mylius' intention was to harmonize the iatrochemistry of Paracelsus with the medieval theory of humours after the Greek physician Galen (129–199 A.D.). The four elements and the Paracelsian *tria prima* are the theme of the medals.

J. D. Mylius, Opus Medico-Chymicum, 1618

Trinity

"Our lapis shares its name with the creator of the world; for it is three in one." (Zosimos, 4th century)

Cornelius Petraeus, Sylva philosoph-orum, 17th century

Here the "manifest trinity" of the right, light-side of God is represented in Böhme's system, "the kingdom of love". It alone gives the shadowy dynamic natural gound of the left side, the "wheel of anguish" of Salt, Sulphur and Mercury its essentiality and vivid brilliance.

D. A. Freher, in: Works of J. Behmen, Law Edition, 1764

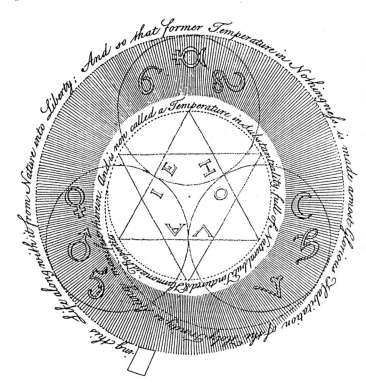

'In the Father is eternity, in the Son identity and in the Holy Spirit the marriage of eternity and identity (...) and these three are one, namely body, spirit and soul; for all perfection is based on the number three." (*Aurora consurgens*, 15th century)

The Trias in the Work is represented by the birds in the three colours of the Work. The Holy Spirit is compared in the 'Aurora consurgens' with the mercurial water, which makes everything earthly, heavenly, in a sevenfold way, and has a cleansing, enlivening and fertilizing effect.

"In every wood, stone and plant are three things (...) First, is the power from which a body comes (...) then, in the same, is a fluid that is the heart of a thing; thirdly, therein is a springing force, smell, or taste, that is the spirit of a thing, from which it grows or increases." (Jacob Böhme, *Aurora*, 1612)

Aurora consurgens, early 16th century

Trinity

In the first Work the saturnine source material is sublimated thrice by being moistened with the 'boy's urine', a well-known code name for the mercurial water. Then according to the 'Turba philosophorum', it should be cooked until the blackness passes.

After the conclusion of the third and last Work the elixir has the power to penetrate all impure metals (including common gold), transforming them into its own heavenly quality.

Trinity

There are three Works in the *Opus Magnum*. The philosophers speak of three bowls and three degrees of fixation, indicated here by the three arrows. The first Work is dissolution, and ends with the phase of nigredo, the second ends with reddening, and in the third, that of the multiplicatio, the lapis receives its tincturing power. The philosophical egg has been incubated.

Worldly power falls to its knees before the glory of the 'red son of the sun'. The three crowns symbolize its complete control over the three realms of plant, animal and mineral.

All illustrations: Speculum veritatis, 17th century

Trinity

Painfully, a father (body) separates from his only son (spirit) and entrusts him to the care of a guide (soul), who leads him up a high mountain (still head) to show him the wide world. Here, the sun hears his father's cries for help, and returns.

Lambsprinck, De Lapide philosophico, Frankfurt, 1625

"Oh, my son, in your absence I was dead (…) but in your presence I will live again." Joyfully the (dry) father embraces the (fluid) son and swallows him.

Lambsprinck, De Lapide philosophico, Frankfurt, 1625

Here, the father sweats, so that "the oil and the right tincture of the philosophers flow from him". He asks God to give him back his only son, whom he has swallowed. Hereupon, he is sent an astral rain (dew), which dissolves his body while he sleeps.

Lambsprinck, De Lapide philosophico, Frankfurt, 1625

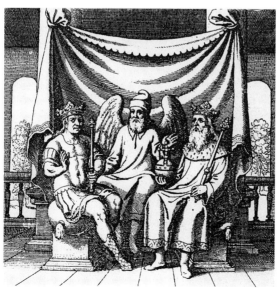

The father, now completely transformed, first into "a clear water", then into a "good earthly empire", has created a new son. "Here father, sun and guide are linked as one, so that they remain together for eternity."

Lambsprinck, De Lapide philosophico, Frankfurt, 1625

Here, one of the most complicated and fascinating systems in the history of alchemy is concealed behind the conventional apparel of a "Coronation of the Virgin". The *Book of the Holy Trinity* (1415–1419) sought to sweep away the erroneous doctrine that only God the Father and the Son are essentially one, for Mary was also born in the Holy Spirit, and had conceived in the Holy Spirit: "jesus mary mother of god he himself is she his own mother in his humanity". In countless variations, Ulmannus worked his way through the trinitary relationships of father, mother and son. The son represents the spirit (Mercury), the father the soul (Sol) and the virgin mother the body (Luna). She is the divine matrix, the great mystery from which all being springs. "If she dissolves, it is to give male nature (...), and when she congeals, it is to take on a female body."

Ulmannus described Mary as the "mirror of the Holy Trinity". Later, Böhme used the same image in reference to Sophia: she is "the exhaled force" or "what is found of the eternal Nothing, in which father, son and spirit are seen". (*Von der Gnadenwahl,* 1623)

This higher trinity of body, spirit and soul is joined by the four Evangelists, as the four sublimated elements. Luke, the bull, is fire (Mars), Matthew the angel, is water (Venus), John, the eagle, is earth (Saturn) and Mark, the lion, is air (Jupiter). In Ulmannus' system these correspond to the seven metals, the seven wounds of Christ, the seven virtues, colours, days of the week and times of day.

Particularly interesting is the large shield with the black double-headed eagle dedicated to the Emperor Frederick. Ulmannus called this shield the "a mirror of the Holy Trinity". It is an allegory of sublimation in the Work and the lapis. The black eagle symbolizes the saturnine putrefaction and the two heads refer to the twofold aspect of bodily existence: outward-material and inward-sublime. It is the earthly cross on which the Christ-Lapis raises humanity. John, to whom the black beast is assigned here, was, like Saturn, the patron saint of alchemists.

Buch der Heiligen
Dreifaltigkeit, early
15th century

Trinity

The pictures in the 'Buch der Heiligen Dreifaltigkeit' were disseminated in simple woodcuts, and interpreted on the basis of the Paracelsian doctrine of the Three Principles. The following exegesis applies to the Mirror of the Holy Trinity:

A The Philosophical eagle is born and delivered through and from blackness, with all its qualities

B The conjunction or unification of the Three Principles

C Sulphur

D Mercury

E Salt

F. Epimetheus, Pandora, Hamburg, 1727

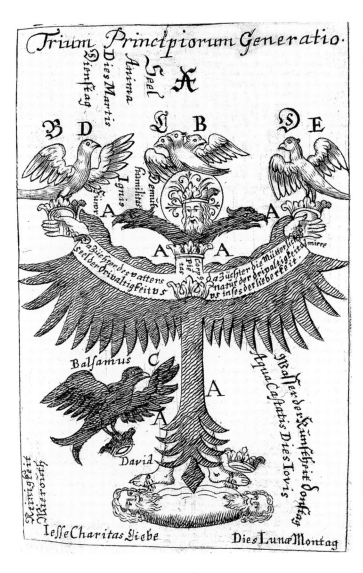

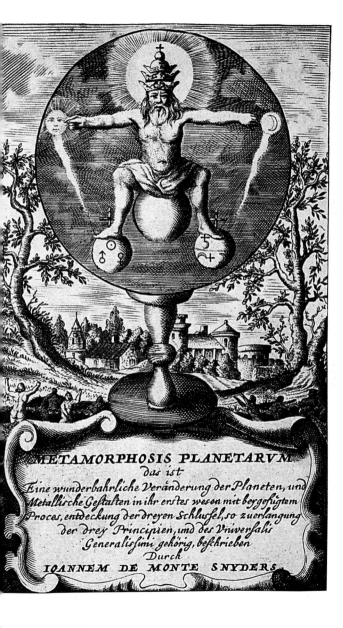

METAMORPHOSIS PLANETARVM
das ist
Eine wunderbahrliche Veränderung der Planeten, und
Metallische Gestalten in ihr erstes wesen mit beygefügtem
Proces, entdeckung der dreyen Schlußel, so zuerlangung
der drey Principien, und des Vniuersalis
Generalissimi gehörig, beschrieben
Durch
IOANNEM DE MONTE SNYDERS.

As the final result of the transformation of the planets, the universal medicine appears as the ruler of the three realms of vegetable, animal and mineral. "This new birth was given the sun at its right and the moon at its left hand, for he had the power to burn the world, to extinguish it and make it fecund again." At the bottom edge of the picture, we see the base metals begging him for help, whereupon, through the effect of fire, a "wonderful balm went from his sweat pores in the form of an oil", which led the other metals "through its magnetic nature" to the supreme degree.

J. de Monte-Snyders, Metamorphosis planetarum, 1663

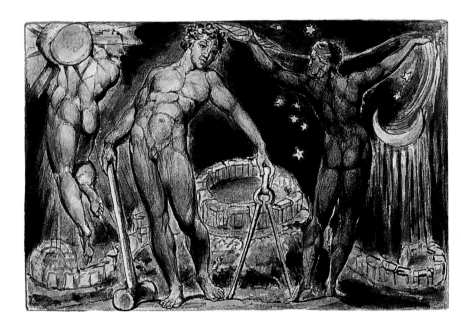

*W. Blake,
Jerusalem,
1804–1820*

William Blake's last, great, illuminated poem, *Jerusalem* (1804–1820),
concludes with the "divine vision" of the re-established harmony of
the four fundamental forces of man. The "Four Zoas" now appear in a
fourfold rainbow that heralds the end of the flow of time and space.
At the same time, limited material space opens up to Jerusalem, into
the infinite freedom of the Golden Age.

But the closing image seems less optimistic. In the middle stands
"Los demiurgos" (James Joyce, *Ulysses*), leaning on the tools with
which he forges "from the world of death the world of generation".
Urizen, calculating reason, turns this world of incarnation into a
pagan temple of snakes, which can be seen in the background. It
symbolizes the pantheistic idolatry of nature, the worship of matter.

Los is split into his male shadow (spectre), which ascends on
the left of the picture, carrying the sun of imagination (solution),
and his female "emanation", which is weaving the world of the

womb from the fibres of its body (coagulation). The composition refers to 'satanic three-dimensional space' and the trinity of directed time.

Blake developed the character of Los from various Paracelsian concepts. On the one hand, he is the "Archaeus", the inner alchemist or "craftsman of all things", who transforms the primal, spiritual forms into matter. Paracelsians such as Sendivogus and P. Spiess also called him the "governor of the sun" or the "central sun". "Now, what is Imaginatio but a sun within man!" said Paracelsus. "As the sun does lovely work, so does the imagination also. It gives fire and sets light to all materials like the sun." (Paracelsus, *De virtute imaginativa*)

The Archaeus or "inner Vulcan" is identified by many hermetics with the "secret, salt fire". And also the name "Los" can be read not only as an anagram of Sol-sun, but also as Sal-salt. In reference to the spiritual "salt of the earth", Blake called its sphere of activity, the imagination, Urthona: earth owner.

But Los is also the prophetic "Elias Artista", who, according to Paracelsus, will appear at the beginning of the Golden Age to reveal the final secrets of alchemy. By rearranging the letters, Johann Glauber came to the conclusion that behind this name there lay nothing less than the wonderful "Salia Artis", the "Salt of Art". (J. Glauber, *De Elia Artista*, 1668)

Fire

"Three are the substances that give each thing its Corpus," said Paracelsus. He explained them with reference to the example of wood: "What burns is sulphur (...) what smokes is Mercurius (...) what becomes ashes is Sal." Sal is the physical sediment, the corpse. Here Sulphur (cloud) is, unconventionally, feminine, and quicksilver (fish) is masculine.

O. Croll, Chymisch Kleinod, Frankfurt, 1647

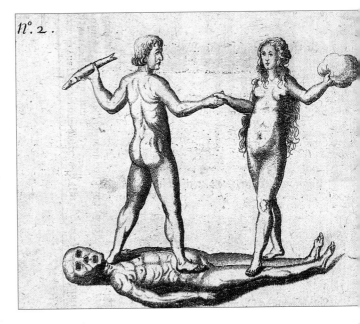

Beneath the rainbow, which shows slowly drying matter, the secret salt-fire, in the figure of the bishop, conjoins the moist Mercury Queen with the dry Sulphur King. Beside them, Neptune prepares the mercurial marriage bath.

D. Stolcius von Stolcenberg, Viridarium chymicum, Frankfurt, 1624

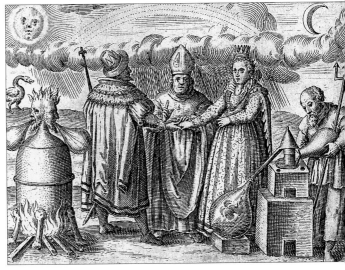

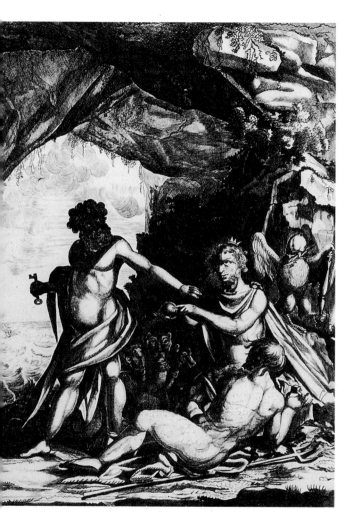

Allegorical representation of salt:

Jupiter, at the centre of the group, points to the "central fire" in which the "secret salt of nature" has its centre. (Elias Artista)

Neptune points to the tartar, which plays a part in the preparation of "our salt". "The salts are key; they open the box wherein the treasure lies." (Basil Valentine) That it is Pluto, the god of the underworld, who holds this key, refers to the idea that salts come from the ashes of death, and play the role of catalyst in the black phase of putrefaction.

B. Coenders van Helpen, Escalier des sages, 1689

Fire

"Give fire to
fire/Mercurius to
Mercurio/and it is
enough."

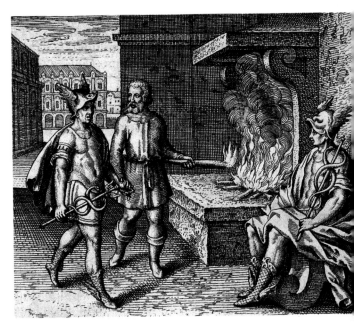

Like attracts like. For Maier, the whole
world depended on this chain of attrac-
tion. But there are "many and varied
species of fire and Mercurii":

Just as there is an inner fire which is set in
motion by the outer fire, and which then
unfolds its diverse effects, there is a hid-
den, extremely subtle mercury, the "May

dew" which is won through distillation
from the outer mercury.

The whole Work consists of the interplay
between the two opposed principles: me
cury-water provides the matter, sulphur-
fire provides the form.

M. Maier, Atalanta fugiens, Oppenheim, 16

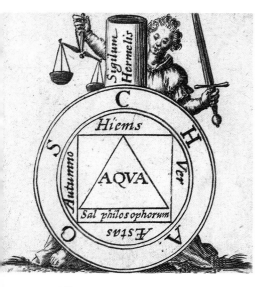

The seventh key of Basil Valentine is an allegory of the regulation of fire (sword and scales). One must, above all, ensure that the phial is hermetically sealed to prevent the escape of the spiritual water, which is inscribed here as a fiery triangle within the salt square.

The "philosophers' salt" is obtained by removing the fixing sulphur from the physical salt, and thus turning its innermost outwards.

D. Stolcius von Stolcenberg, Viridarium chymicum, Frankfurt, 1624

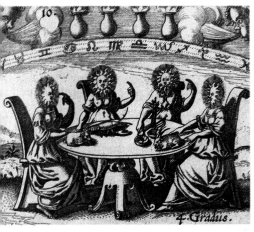

Half of the art lies in the discovery of the fire, said Arnald de Villanova in the *Rosarium*. The regulation occurs according to the colours in the Work and the seasons. In the spring, in Aries, a powerful fire is used to calcinate the metals, in the summer, in the sign of Cancer, a gentle one for dissolution, in autumn, in Libra, a medium fire for sublimation and in the saturnine, Capricorn phase of Putrefaction and Fermentation a constant lukewarm horse-dung heat.

D. Stolcius von Stolcenberg, Viridarium chymicum, Frankfurt, 1624

Fire

According to Paracelsus, the salamander lives in fire, but not in dark, material fire, but rather in the essential 'spirit-fire of nature'.

"Salamander comes from sal, salt, and from mandra, which means table, but also cave, lair (...). Lying on the straw of a crib in the grotto of Bethlehem, is not JESUS himself the new sun, which brings the light of the earth (...) this spiritual fire, which has been made flesh and assumed form in salt." (Fulcanelli, *Les Demeures Philosophaes,* Paris, 1930)

"All matter can be brought back to a salt form. It is the world of God made material; in the specialized salt is a heavenly agent, a son of the divine fire of the sun is united with a passive earthliness into a salt incarnation (...) True alchemy is 'Halchimia',

salt-cooking (Greek 'hal', salt and 'chyo', I cook)."

(M. Retschlag, "Von der Urmaterie", 1926 quoted in: Bernus, *Das Geheimnis der Adepten,* Sersheim, 1956)

Jacob Böhme called the "secret fire" the "fire-crack" or "schrack", the lightning that "originates in the heavenly salitter". Inwardly, this salitter or secret saltpetre is "the seed of the entire godhead", and outwardly the roots of all material forces.

M. Maier, Atalanta fugiens, Oppenheim, 16?

Fire

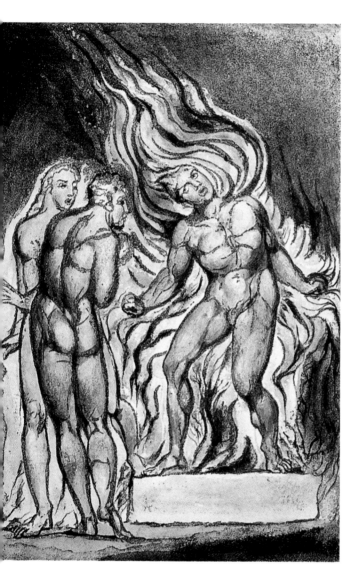

Blake's visions were diverse and open to all kinds of associations.

The burning figure signifies Rintrah, the personification of just wrath, but also Satan, egoism or Orc, the red demon of revolution. But it may also be an earthly figure, consumed in the fire of life from the view of two Eternals: "Life was (...) for Paracelsus a process of combustion. 'If I say I cannot burn, it is as much as if I said, I cannot live (...)'". (W. Pagel, *Paracelsus and the Neoplatonic and Gnostic Tradition,* Cambridge, 1960)

W. Blake, Milton, 1804–1808

Philosophical egg

"Take the egg and strike it with a glowing sword."

Maier tells of a bird that is higher than the others. Its egg must be found and then carefully burned with a glowing sword. If Mars comes to the help of Vulcan, a bird will emerge which can vanquish fire and iron.

The sword signifies the inner fire, the "Archaeus Naturae", which is driven and fired by the outer, martial fire of the oven. The sword is used as a symbol "because fire also makes everything porous and full of holes, so that water can penetrate, dissolve and make the hard soft".

The egg is the chaotic *prima materia* which is destroyed in the Putrefaction, so that new life arises from it. "After death we too enter a much more perfect life."

M. Maier, Atalanta fugiens, Oppenheim, 1618

Philosophical egg

When the mortal Castor is killed, Pollux, the immortal one of the two twin sons of Leda, also opts for a transitory life to remain united with his brother. From now on they spend one day in heaven with the gods and one in the underworld.

G. Stengelius, Ova Paschalia Sacro Emblemata, Ingolstadt, 1672

the eggshell signifies mankind's limited field of vision, "an immense/hardened shadow of all things upon our vegetated earth, / enlarged into dimension and deformed into indefinite space". (W. Blake, *Milton*, 1804) After his death, man tears his "veil of nature" which freezes all life.

W. Blake, The Gates of Paradise, 1793

Philosophical egg

In the *Aurora consurgens* a passage is quoted from the *Turba philosophorum,* an Arab compilation of Greek alchemical treatises and doctrines which circulated in western Europe from the 13th century onwards, and became one of the fundamental works of European alchemy. The art, the text has it, is comparable to the egg, " in which four (things) are connected. Its outer shell is the earth, and its white is water; but the very fine membrane attached to the shell (...) is air (...). Further, its yolk is fire". (*Turba philosophorum,* Ed. J. Ruska, Berlin, 1931) The fifth element or quintessence is the young chick. Alchemists compared the embryonic centre of the yolk from which the chick develops with the rising sun and the lapis. They called it the "red point of the sun in the centre".

Aurora consurgens, early 16th century

Philosophical egg

"The sun needs the moon, like the cock the hen."

The cock, as the sun-animal, embodies the power of sulphur, said Maier. The egg from which the pair have hatched is called Latona, after the mother of Apollo and Diana. "For the philosophers (...) Sol, Luna and Latona are one, like cock and hen, because they hatched from an egg and leave eggs behind them."

M. Maier, Atalanta fugiens, Oppenheim, 1618

The lapis is the 'philosophers' egg', a "clarified body with the gift of immortality, which (...) has risen above the four elements into the purest centre as the fifth being of the whole nature, and is now much more splendid than his great parents, the sun and the moon". (L.C.S., *Drei geheime Traktätlein,* Mainz, 1749)

D. Stolcius von Stolcenberg, Viridarium chymicum, Frankfurt, 1624

Philosophical egg

The *materia prima*: "The egg of nature they call me, known to all the philosophers (…) Quicksilver or Mercury fine I am called in general (…) An old dragon, an old man, I am everywhere near and far (…) I fly away, unless/one binds me with measure./I have much of form, colour and shape/I carry in me the force of men and women." (*Theoria Philosophiae Hermeticae*, Hanover, 1617)

Heinrich Jamsthaler, Viatorum spagyricum, 1625

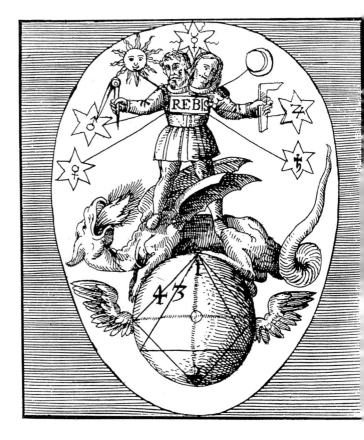

Philosophical egg

The rebis, which appears here in the three main colours of the work, is the "two bodies of art, namely sun and moon (…) Man and woman and they give birth to four children". Those are the four elements that the androgynous being holds in his right hand. In the centre is a mirror that presents the Opus or the *prima materia* in which, it is said, one can see the whole world.

The egg that he holds in his other hand is supposed to show how, from the four elements – the shell, the white, the membrane and the yolk – the quintessence arises at the centre: the young chick or the lapis.

*S. Trismosin,
Splendor solis,
London,
16th century*

Philosophical egg

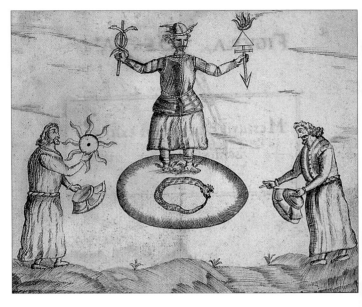

"Mercury is cold and moist, white in its appearance and cold in its moisture, but deep within (...) it is red, which is hot and dry. Hence the old masters called it an egg". (J. I. Hollandus, *Die Hand der Philosophen, Vienna,* 1746)

This inner heat is the 'hidden sulphur', whose glyph Mercury holds in his left hand. The snake's egg symbolizes the eternal circulation in the Work.

Speculum veritatis, 17th century

Philosophical egg

Await the star (of David), call Mary.

G. Stengelius, Ova Paschalia Sacro Emblemata, Ingolstadt, 1672

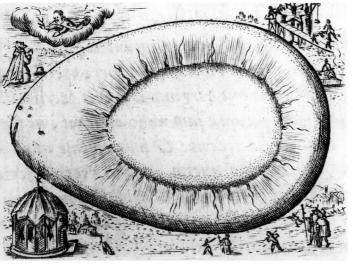

"The egg preserves life and being," says Paracelsus. "(...) therefore know that air is nothing other than chaos, and chaos nothing but the white of an egg, and the egg is heaven and earth." (*Paragranum II*, 1530)

Detail from H. Bosch, Garden of Delights, c. 1510

Matrix

In Hildegard von Bingen's fourth vision, there appeared a "vast glow, which flamed as if in countless eyes, and aimed its four corners at the four points of the compass". This is the omniscience of God, at the middle of which "there appears another glow, like red sky at morning, gleaming in purple lightning". From this heavenly matrix comes the red fiery sphere of the soul, which gives life to the embryo in the mother's body.

Figures appear bearing various fatty cheeses in clay vessels, some of them containing decay. This is an image of man's semen with its various tendencies.

Hildegard von Bingen, Scivias (Rupertsberg Codex), 12th century

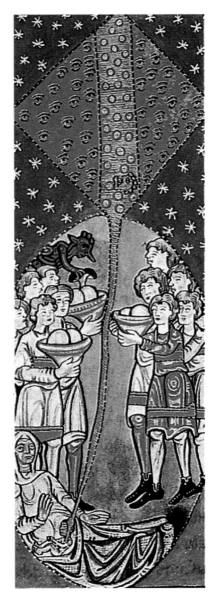

Piero della Francesca, Madonna with saints, Tempera on wood, c. 1470

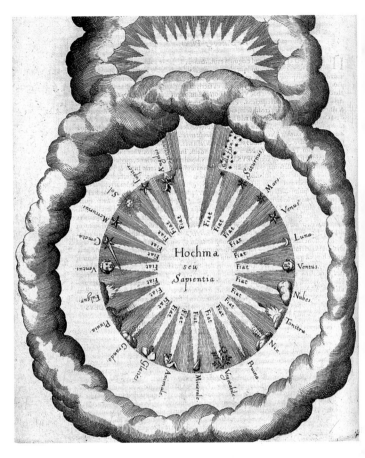

In this illustration, Fludd followed the interpretation of Genesis in the first book of the Zohar, which provides a highly visual description of the way in which, in the concealed depths of the divine unground, the En-Soph, first forms a fog, from which a spring then erupts. In this, the primal point, called "Reshith", lights up, the beginning, "the first word of the creation of all things". The Cabalists identified this primal point as the wisdom of God, his "Sophia". It corresponds to the second Sefira Chochma or Hochma. The seed of all things lies folded into it. "He created all forms in it, carved into it all its characteristics."

R. Fludd, Philosophia Sacra, Frankfurt, 1626

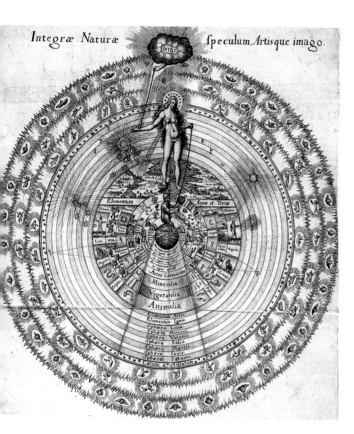

"Mirror of all
nature and symbol
of art."

e "Golden Chain of Homer", which Fludd
entified as the "Invisible Fire", leads
om the hand of God via Virgin Nature to
e Ape of Art. This represents the
tellectual and technical abilities with
hich man imitates nature and seeks to
prove it.

ature, the nursing mother of all things,
nnects the divine fiery heaven, the
tral, ethereal heaven and the sublunary,
emental world. She is the "soul of the
orld", the mediator between the divine

spirit and material expression. "On her
breast is the true sun, on her belly is
the moon." Her heart gives the stars their
light, and her womb, the spirit of the
moon, is the filter through which the astral
influences reach the earth. "Her right
foot stands on the earth, her left foot in
the water, thus showing the connection
between Sulphur and Mercury, without
which nothing can be created."

Robert Fludd, Utriusque Cosmi, Vol. I,
Oppenheim, 1617

Wisdom is the female emanation of God, through which his spiritual seed is realized, first in the uttered word of heavenly Sophia, then in matter through the womb of Nature. The latter is the fallen, lower Sophia, and is identified with Mercury, the root of all metals.

From her two breasts flows the red, sulphurous "sweat of the sun", and the white Mercurial "virgin's milk", which together produce the fruit of her womb, the tincture. Anyone who wants to see her naked should "seek the friendship of Archaeo, the trusted doorkeeper".

Geheime Figuren der Rosenkreuzer, Altona, 1785

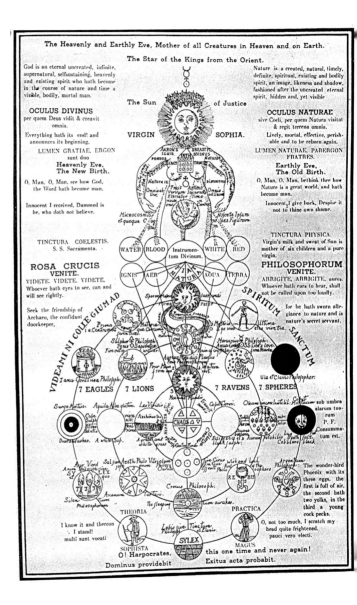

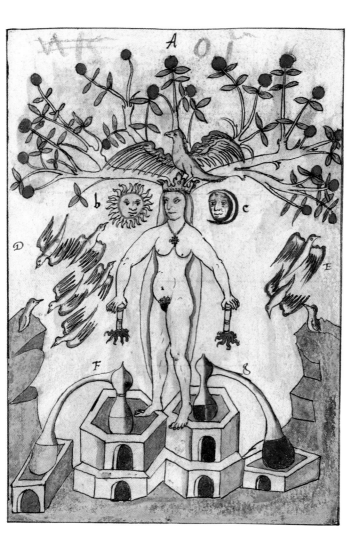

The tree growing out of the Mercurial virgin mother, which bears "ineffable fruits of diverse effect", "comes from the seed of man (birds on the left) and of women (bird to the right)". The honouring of Sophia as the mystical bride of the philosophers or 'mistress of the inner world', as Georg von Welling called her, often intersects with worship of the divine Mercurial water. Mercury is called 'our dear virgin', because, like Mary, he conceives the 'solution of heaven', and then brings it forth as a cleansed lapis.

Hieronymus Reussner, Pandora, Basle, 1582

Matrix

Nature advises the "aimlessly wandering alchemist" to leave the narrow circle of mechanical laboratory chymistry: "You will never attain knowledge of anything if you come not to my forge." This forge is the tree that grows from the three roots Mineralia, Vegetativa and Sensitiva. Here, the earthly germ of all metals, animals and plants is separated by lengthy cooking into the four elements, and sublimated into the uppermost blossom of the elixir or the "vegetable gold".

Alchemy follows the work of nature, but tries to shorten the ripening process.

Miniature painting by Jehan Perréal, painter at the court of Margaretha of Austria, 1516

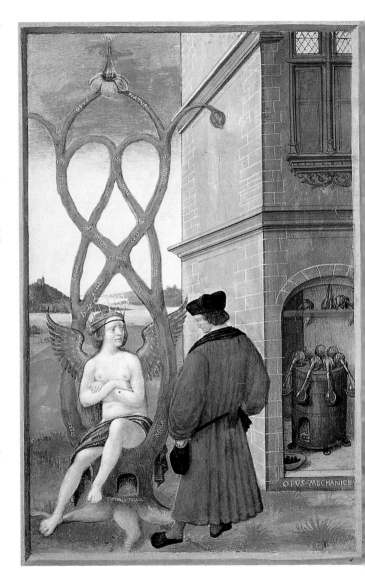

"Let nature be thy guide."

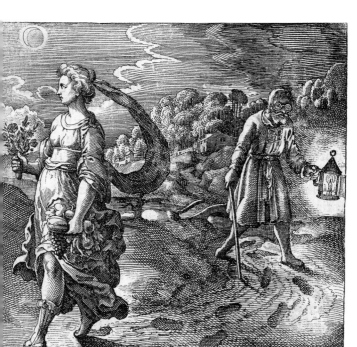

M. Maier,
Atalanta fugiens,
Oppenheim, 1618

he alchemists' attitude towards nature
was an ambivalent one. They all wanted to
follow her, some as her ape, trying to emu-
ate her work in all its parts, "for what is
made outside the limitations of nature is
either an error or something very close".
. d'Espagnet, *Das Geheime Werk*) "Nature
annot be braked or forced (...) far from it!
he rules over us, not we over her".
Heinrich Khunrath)

Others desire her fruits, "but they des-
ised nature itself and corrupted her (...)
was in their hands, to an extent sub-
cted to their violence", Nature laments,
but they knew me not." (T. Vaughan)

Paracelsus stated that alchemy must per-
fect imperfect nature, for it is "so subtle
and sharp in its things that without great
art it will not be used". (*Paragranum,* 1530)

Anyone who wishes to do laboratory work,
according to Michael Maier, must bring
four things beneath one heading: nature,
reason, experience and the study of the
many, specialist writings. He calls them the
four wheels of the philosophical chariot.
The footprints of nature are the pioneers,
reason the walking-stick, experience the
spectacles and the study of the writings
the lantern "which opens the understand-
ing and gives the keen reader a light."

The main portal of the Cathedral of Notre Dame in Paris bears a sequence of twelve late 13th-century half-reliefs, all of which, according to Fulcanelli, represent themes from alchemy. According to Victor Hugo, the cathedral as a whole represents the most satisfying summation of Hermetic science; it is its *Mute Book* in stone.

The figure of the woman is the embodiment of alchemy, touching heaven with her head. The two books in her right hand refer to the exoteric, open side and the esoteric, hidden side of alchemistic teaching. The ladder is a hieroglyph of the patience required for the Work. The nine steps presumably derive from the teachings of the Pseudo-Dionysius Areopagita.

Fulcanelli, Le Mystère des Cathédrales, Paris, 1964

For the German poet Conrad Celtis (1459–1508) Philosophia signified the universality of all spheres of nature and the spirit.

On the obelisk before the lap of Sophia in the depiction that Albrecht Dürer made for his friend Celtis, there are a total of nine steps reaching up to her bosom, including the seven Liberal Arts. At the bottom is grammar, at the top, music, the all-embracing theory of the harmonic laws. The Greek letter Phi acts as the foundation of the arts. According to the theory of Dieter Wuttke, author of a detailed study of this woodcut (Dieter Wuttke, 'Humanismus als integrative Kraft', in: *Dazwischen,* Baden-Baden, 1995), it stands for the *vita philargica,* "sensual life (as) the natural, first stage of every human being", while the concluding sign theta refers to the *vita theorica,* the highest level of pure contemplation.

The three books in Sophia's hand stand for the three areas into which philosophy is divided according to Plato: rationalis, moralis and naturalis. The five nail-points on the cover of the book refer to the five senses as the basis of all experience. The wreath surrounding the throne symbolizes the four seasons. To these are assigned the four outermost heads: the four winds, elements, temperaments and ages. The four medals on the wreath represent the stages of the history of philosophy. Ptolemy, in the upper medallion, represents its Egyptian-Chaldean origin in the sphere of astronomy. The right-hand

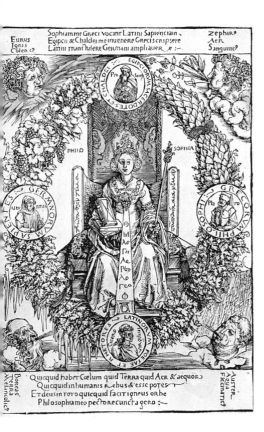

Within the woodcut the following inscriptions appear:

Top row: Eurus / Ionis / Calen c?

Sophiam me Greci vocant Latini Sapienciam ʒ
Egipcii & Chaldei me inuenere Greci scripsere
Latini transtulere Germani ampliauer e :–

Zephirʒ / Aer / Sanguineʒ

Inner medallions/labels: CHALDEI / SACERDOTES, EGIPCIORVM, PHILO, SOPHIA, GERMANORVM SAPIENTES / Alber gnus, GRECORVM PHILOSOPHI / Pla Aro, LATINORVM POETAE ET RHETORES

Bottom:

Quicquid habet Cœlum quid Terra quid Aer & aequor
Quicquid in humanis rebus & esse potes
Et deus in toto quicquid facit igneus orbe
Philosophia meo pectore cuncta gero :–

Boreas / TERRA / Melancholicʒ Auster / AQUA / Flegmaticʒ

Inscription, top: "The Greeks call me Sophia, the Romans Sapientia. The Egyptians and Chaldaeans invented me, the Greeks wrote me down, the Romans handed me down, the Germans expanded me."

Inscription, bottom: "That which constitutes the essence of heaven, earth, air and water, and that which embraces the life of man, as well as that which the fiery God creates in the whole world: I, Philosophia, bear all in my breast."

Woodcut from the 'Amores' of Conrad Celtis, Albrecht Dürer, Nuremberg, 1502

Matrix

medal shows the Greek Plato, who interpreted the hieroglyphic wisdoms of the Egyptians and handed them down to the Romans. Cicero and Virgil worked on the poetic form of philosophy and the Germans, represented by Albertus, on its continuation. Albertus refers primarily to Albertus Magnus (1193–1280), the scholastic scholar and student of nature, to whom a series of alchemical treatises have been attributed. In Wuttke's view, though, it also refers to Albrecht Dürer, whom Celtis celebrated as a new Albertus, because he added the spheres of painting and art theory to Philosophia.

Matrix

The title plate to Kircher's *Ars magna sciendi* (1669) is clearly derived from Dürer's 'Philosophia'. Even the inscription on the plinth of Sophia's throne is entirely in the spirit of Conrad Celtis' concept of education: "Nothing is more sublime than knowing everything".

In her hand she holds the alphabet of the Lullian art, whose twenty-seven hieroglyphic keys are supposed to contain the whole of human knowledge. The fifteen individual commandments of knowledge that Kircher seeks to bring together through the mechanized logic of Lullus are written on the title sash.

A. Kircher, Ars magna sciendi, Amsterdam, 1669

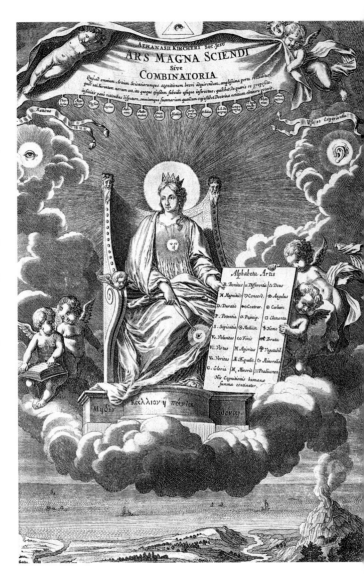

Salvatore Settis has revealed a layer of meaning in Giorgione's famous painting, in which the mysterious scenery points, as an allegory, to the situation of the first human couple after the Fall, now realizing that they are exposed to the storm of divine anger. (Giorgione's 'Gewitter', Berlin edition, 1982)

The two broken columns from Solomon's Temple, representing steadiness and

strength (Jachin and Boas), refer to the curse of mortality.

But in the striking similarity of the suckling mother-figure to the representations of Sophia in hermetic literature, Giorgione also suggests the possibility of an ascension from this nigredo state of earthly existence.

Giorgione, La Tempesta, c. 1506, Venice, Accademia

"Make Lato white and tear up your books, lest it tear up your hearts."

Lato is generally used as a term for brass and other copper alloys, but it is also a commonly-used code name for matter after the phase of decay, when it is impregnated by Jupiter, the first strip of silver in the night sky of the nigredo, and slowly begins to dry. Then it becomes Latona, the mother of the twins Diana-Moon (white stone) and Apollo-Sun (red stone). After its complete purification or whitening by fire, Azoth or sodium salt, it brings both into the world in sequence.

In this phase of whitening one should tear up the books, most of which, as Maier said, are so full of "obscure sayings (…) that the author himself can hardly understand them". We need these no longer, because what follows is "pure child's play and women's work".

M. Maier, Atalanta fugiens, Oppenheim, 1618

Because Actaeon the hunter has seen the proud virgin Diana naked while bathing, she turns him into a deer, and he is then torn to pieces by his own bloodhounds.

Giordano Bruno interprets this legend in his last work *Of the heroic passions* (1585) as a parable of the drama of the process of knowledge.

"Here Actaeon represents the intellect, on the hunt for divine wisdom at the moment of grasping divine beauty." Just when he thinks he grasps Sophia in the glass of outer nature, and lifts the veil from her lunar mystery, he himself becomes the victim or object of his own striving. "He saw himself transformed into that which he sought, and realized that he himself had become a much-desired prey for his hounds, his thoughts. Because he had actually drawn the godhead into himself, it was no longer necessary to seek them outside himself."

Actaeon is Bruno's new heroic man who, killed by his many large hounds, is radically inverted. "Here, his life in the mad, sensuous, blind and fantastic world comes to an end, and from now on he leads a spiritual life. He lives the life of the gods."

Titian, Diana and Actaeon, 1559

Matrix

"Set the toad on the woman's breast, that it may suck, and that the woman shall die, and the toad waxes very great with milk."

The philosophers, according to Maier, would never put such a poisonous animal to a woman's breast, "were the toad not her own miracle-birth and fruit, which she had brought into the world as a monster". When it has suckled its fill, the white Mercurial woman dies, becoming the red sulphur of the philosophers. "Seek to prepare from it a medicine which may draw all the poison from your heart."

The toad here refers to the solid sulphurous component of the Prima Materia. According to Ruland, Virgin's Milk is a code name for the "Mercurial water, the Dragon's Tail; it washes and coagulates without any manual labour". (Martin Ruland, *Lexicon Alchemiae*, Frankfurt, 1612)

"The old masters called Mercurius Virgin's Milk, for Mercurius is the food, nutrition and dwelling place of all metals, since it goes in and out of all parts of the metals, just as a woman's suckling of her child goes through and nourishes, for Mercurius is the food and mother of all metals (...)." (J. I. Hollandus, *Chymische Schriften*, Vienna edition, 1746)

Because of its ability to condense and solidify the matter that it passes through, this milk is also called the 'eagle's ember' or 'our rubber'. "I tell you that our rubber is stronger than gold, and those who know it consider it higher and more worthy than gold." (H. Khunrath, *Vom hylealischen Chaos*, Frankfurt edition, 1708)

M. Maier, Atalanta fugiens, Oppenheim, 1618

As the clouds passed away, I saw a lovely white virgin rising from the earth, she pressed her breasts, and from her virgin's milk she made a healing butter, with which he wished to bring the dead back to life (..) (then) I saw that after her hard pressing, because she would not stop, a thick red blood flowed from her breasts, for there was no milk left. This blood sullied the butter, so Vulcan dared to take the butter away, but the virgin wept, and said: the milk, the butter and the blood are all good, but each has its own effect (…)."
J. de Monte-Snyders, *Metamorphosis Planetarum,* Vienna, 1774)

The Arab doctor and philosopher Avicenna (Ibn Sina, 980–1037) said that the virgin's milk consists of two waters. ("Mineralia", in: *Artis Auriferae,* Basle, 1593) These are the lunar and the solar liquids, of which the "mercury of the philosophers" consists. The two must be cooked together by Vulcan, so that the philosophical sea is transformed into gold.

D. Stolcius v. Stolcenberg, Viridarum chymicum, Frankfurt, 1624

Fountain

"There are three kinds of stone and three kinds of salt, of which all our mastery consists: namely, the mineral, the vegetable and the animal. There are also three kinds of water, namely Sol, Luna and Mercury. Mercury is mineral; Luna is vegetable, because it absorbs two colours, white and red; Sol is animal, because it absorbs three things, namely solid bonding, white and red; it is called 'the great animal'. Sal ammoniac is won from it. Luna is called 'vegetable', and sal alkali comes from it. But Mercury is called the 'mineral stone', and from it comes common salt." (*Rosarium philosophorum*, Frankfurt, 1550, Weinheim edition, 1992)

Turba philosophorum, 16th century

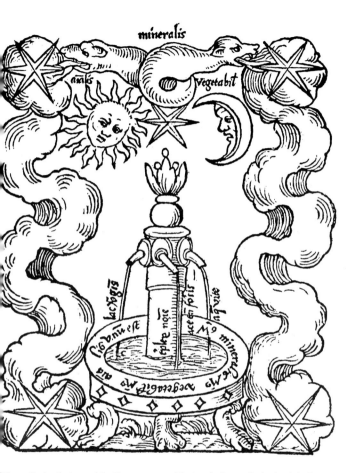

We are the beginning and the first nature of metals/Through us art makes the supreme tincture.

No spring or water is like me/I make poor and rich healthy

and I am corrosive, poisonous and deadly."

The inscription on the basin of the fountain reads: "The mineral, the vegetable and the animal Mercury are one." Beneath the headings of "virgin's milk", "sharp vinegar" and "water of life" the mercurial liquids flow into the basin. They "form a single pure, clear water; it purifies everything, and yet it contains everything necessary."

Fountain

Rabbi Abraham Eleazar, the mysterious teacher of Nicolas Flamel, is standing on a church-like athanor with the glyph of the primaterial antimony at its tip. The stream at the bottom symbolizes the long but not dangerous "moist way", which passes through many distillations. The upper, short path of the quick weasel is the dangerous, dry path of the secret salt-fire, in which saltpetre plays an important part.

A. Eleazar, Uraltes chymisches Werk, Leipzig, 1760

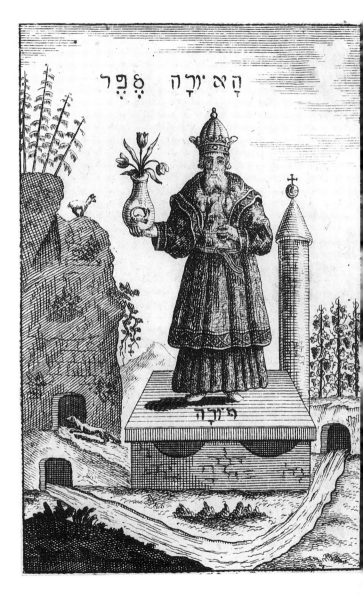

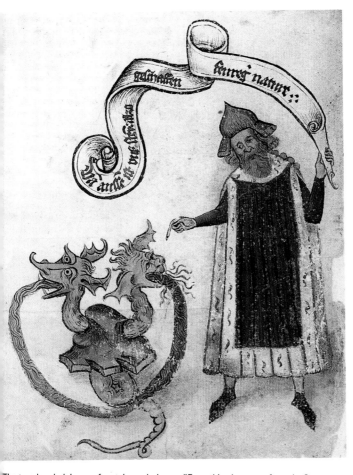

Inscription:
"Wan(n) ausse(n) ist uns(er) Ster(n): also geschaffen feureg(er) nattur" (When our star is out: then created of fiery nature)

(Deciphered thanks to Herr Reiner Reisinger.)

The two-headed dragon-fountain symbolizes the bipolar essence of the Mercurial lapis, which Ulmannus called the "water of modesty" or "stone clear white and red". Red is Sol, blood, male, and white is Luna, flesh and female.

All things are, by their first and most perfect quality, created from the fire of the sun, which represents God the Father.

"Everything has come from the Sun, everything must become the Sun again". We receive "this outer fiery sun to our flesh and blood". But the inner sun is the soul or "red sky at morning". This attracts the fire of the outer sun and leads it into the intestines.

Buch der Heiligen Dreifaltigkeit, early 15th century

Fountain

Death and corruption are the key to higher life, the fundament and the source of the whole Work. After the moisture has been drained from the dead body, "each 'thing' needs fire (Sagittarius), until the 'spirit' of that 'body' is transformed and left for a number of nights, like man in his grave, and turns to dust. After this has happened, God will give him back his soul and his spirit (...) and improved after their destruction, just as man, after his resurrection, becomes stronger and younger than he was in this world." (*Turba philosophorum*, Ed. J. Ruska, Berlin, 1931)

Aries, Leo and Sagittarius mark the periods of time in which the three operations of the Work take place.

De Alchimia, Leyden, 1526

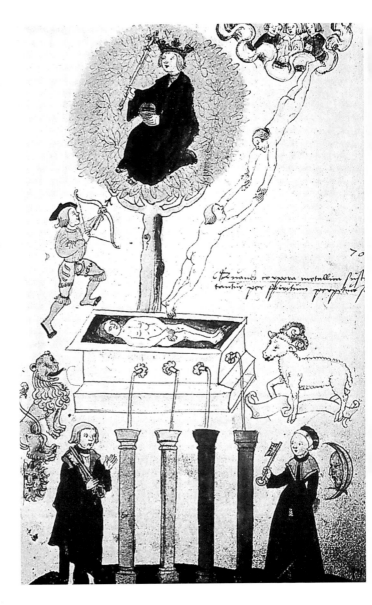

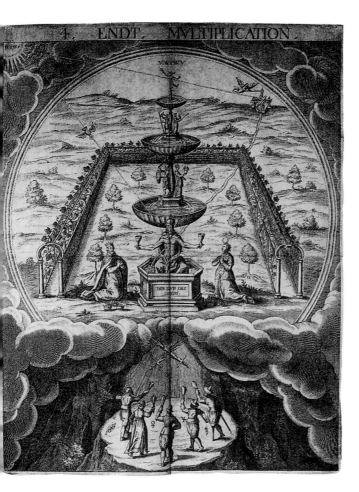

The half-bow that God placed in the clouds as a sign of reconciliation after the Flood, is closed by the blood of Christ into the roundness of the lapis. And he took the cup (...) saying, "Drink from it all of you. For this is my blood, the blood of the covenant." Matthew 26, 27–28) Through his sacrificial death he had the power to draw all base metals to himself and thus to enable them to escape the Flood of the Putrefaction ("and there was no more sea" Rev. 21, 1) into the newly opened Paradise. Here lies the "stream of living water": the three-in-one tinctural power-spring of eternal life.

S. Michelspacher, Cabala, Augsburg, 1616

Christ-Lapis

"After my great suffering and torture/ I am risen, clarified, and immaculate."

"Thy stone, Chymist, is nothing; the cornerstone that I mean/ is my gold tincture and the stone of all the philosophers." (Angelus Silesius, *Cherubinischer Wandersmann,* 1657)

Rosarium philosophorum, 1550

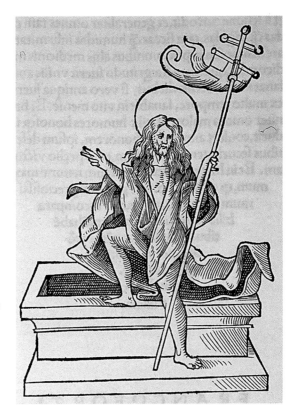

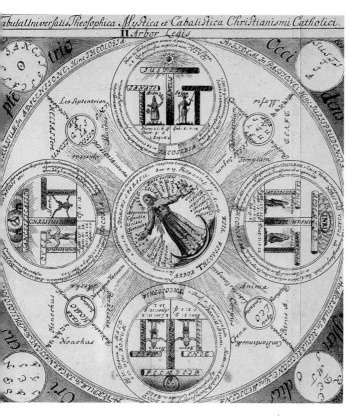

In 1638, the Silesian student of Böhme, Abraham von Franckenberg (1598–1652) wrote that he wanted to learn Hebrew "to use it fruitfully in my meditations, which are to some extent aimed at geometrical and arithmetical demonstrations". (Quoted in: W.E. Peuckert, *Das Rosenkreuz,* Berlin edition, 1973)

His book *Raphael oder Arzt-Engel*, which he completed in the same year, reveals his preoccupation with Cabalistic combinations of letters (Gematrie and Temurah). Like Giordano Bruno, whose writings he knew, Franckenberg was concerned with the production of magic seals, which he believed to have healing powers. In his view, all illnesses are based on false, self-centred imaginings, which poison the astral body (the "mummy"), and thus pollute the blood. The whole balance of the elements in the body is thereby finally destroyed.

Three kinds of medicine were available: the Cabbalistic, from the spirit and the word of Christ, the magical in the meditation of the healing serpent, and the Chymical, with wine and oil.

A. von Franckenberg, Raphael oder Arzt-Engel, 1639 (reprinted, 1925)

Christot-Lapis

Inscriptions: "The blessed lapis contains everything within itself."

"All virtue is effort in struggle". In alchemy the cross is used as a glyph for the crucible.

"In fact, the crucible is the place where the Prime Matter suffers the passion like Christ himself. There it dies, to be reawakened, purified, spiritualized and transformed." (Fulcanelli, *Le Mystère des Cathédrales,* Paris, 1964) Fulcanelli refers to the fact that the three nail-holes on the cross were read as a reference to the "three purifications with sword and fire".

Musaeum Hermeticum, Frankfurt/Leipzig, 1749

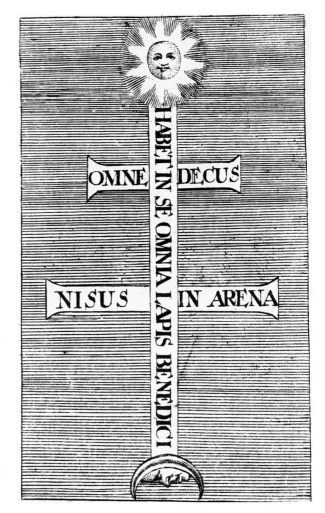

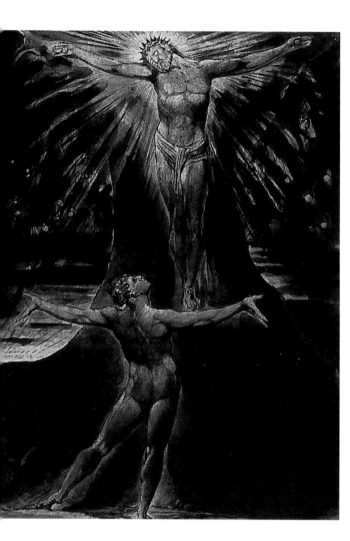

Albion, representing fallen humanity, is revived by the picture of the redeemer: "Awake! Awake O sleeper of the land of shadows; wake! expand! / I am in you and you in me, mutual in love divine."

Jesus is "imagination or the divine body in all men", the "sole, universal form" in which all things are contained "in their Eternal Forms".

Albion becomes what he sees. Here, Blake is following Paracelsian doctrine: What man thinks, "he is, and a thing is also as he thinks. If he thinks a fire, he is a fire; if he thinks a war, he is a war". (*De virtute imaginativa*, 1526)

W. Blake, Jerusalem, 1804–1820

Christ-Lapis

Mary and Jesus are one substance which is embodied in a condensed, solid state by the mother, and in a dissolved, spiritual state by the son. The sun symbolizes God the Father and the twelve stars in the three forms of appearance, "of the spirit (son), of the soul (father) and of the corpse (mother)". In the five-part "lily blue saturn luna (...) is our Lord martyr".

The seven planets, metals and virtues are assigned to his extremities, his body and the wound in his side.

Buch der Heiligen Dreifaltigkeit, early 15th century

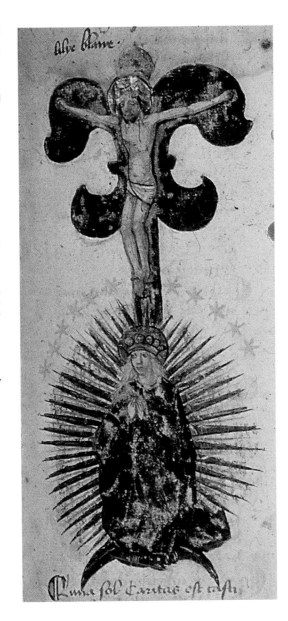

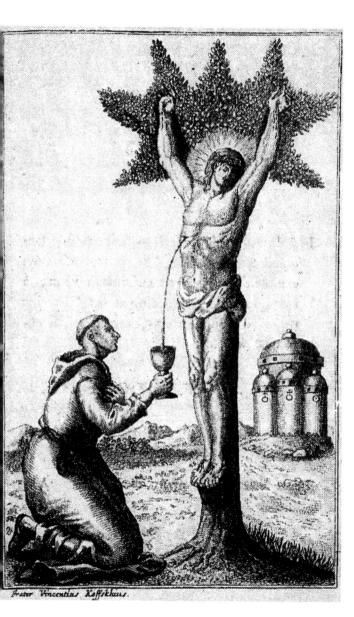

Frater Vincentius Koffskhuis.

Frater Vincentius Koffsky, a 15th-century monk of a Danzig order of preachers, whose identity has not been historically proven, is shown catching the tinctural blood of the mercurial Christ, who is crucified on the tree of the seven metals. "Here study, meditate, sweat, work, cook and do not be put off by cooking, and there will open up to you, a healing flood which springs from the heart of the son of the great world, in the face of all fragility of all material things (…) Now learn, naturally and artfully, to draw from this Catholic medicinal fountain of the living water and the oil of joy." (H. Khunrath, *Vom hylealischen Chaos*, Frankfurt edition, 1708)

From: Fratris Vincentii Koffskhii, Hermetische Schriften, Nuremberg, 1786

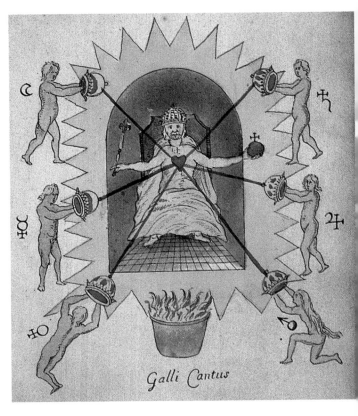

Galli Cantus

"There are seven kinds of ore (...) but the alchemists want to prove that there is only one ore, namely gold: for it is perfect and the other six are on the way to perfection, to becoming gold. And they say that the six are ill, and that the illnesses (make it possible) to cleanse them in various ways, by making gold from them and giving them the colour, the weight and the con-sistency of gold in the fire. They also say that they are all but one ore, because they all have their origin and their birth in quicksilver, moisture and sulphurous earth (...)." ("Peder Månsson, Bergbuch, 16th century", in: Otto Johannsen, *Peder Månssons Schriften,* Berlin, 1941)

La Sagesse des anciens, 18th century

Blood

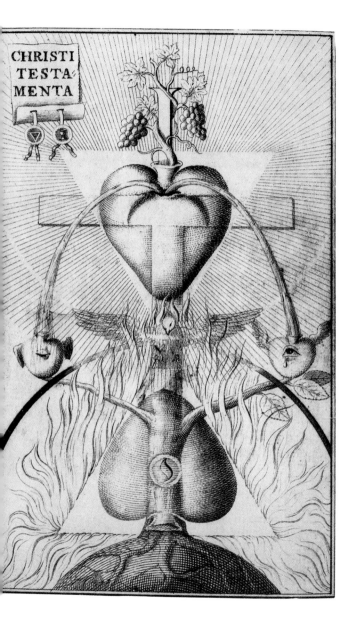

CHRISTI TESTA MENTA

The fiery soul in its natural primal state – represented in the lower inverted heart – lies "in the Father's quality" in the fire of wrath. Through the sacrament of baptism, however, the name Jesus is revealed in the name Jehovah, and the soul receives the son's fire of love: "The father baptizes with fire, the son with light." His heavenly blood transforms anger into love.

Man must, in his imagination, completely enter into Christ's sacrificial death, "thus there will grow (...) a true Christ, a grape on Christ's vine".

J. Böhme, Theosophische Wercke, Amsterdam, 1682

Blood

"In dumb silence I held my peace. So my agony was quickened, and my heart burned within me. My mind wandered as the fever grew." (Psalm 39, 2–3)

J. Mannich, Sacra Emblemata, Nuremberg, 1624

In Jehovah's fire of wrath (Tetragrammaton), according to Böhme, the heart , "as the basic source of human penitence is opened" and, in Christ's fire of love "reunited and tempered".

J. Böhme, Libri apologetici, 1764

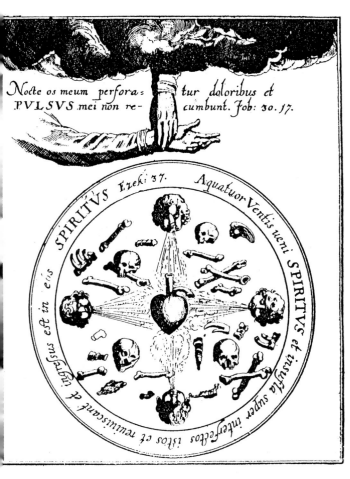

Nocte os meum perfora= tur doloribus et
P.V.L.S.V.S. mei non re- cumbunt. Job: 30. 17.

According to Fludd's theories, the funda-
mental life-functions of the organism are
set in motion by an astral "sal volatile",
which enters the organism through the
respiratory organs and maintains the spark
of life in heart and brain. Every motor
function, including the circulation of the
blood, depends on the presence of this
subtle salt.

The blood transports through the body
the life-giving divine spirit, which reaches
man from the sun via the four winds.

"Come, O wind, come from every quarter
and breathe into these slain, that they may
come to life." (Ezekiel, 37, 9)

According to Fludd, the heart is the sun of
the microcosm, the source of life. When
his friend William Harvey discovered the
circulation of the blood in 1615, his views
were reinforced.

*R. Fludd, Pulsus Seu Nova Et Arcana Pulsuum
Historia, Frankfurt, c. 1630*

Blood

In the upper half of the picture Albion, fallen humanity, collapses exhausted in the border area between the palm of spirituality and the oak of materialism. "The divine sun with the name of Jesus entered Adam's night, Adam's sleep (...) The first Adam fell down (...) and died the death of death: the other Adam *(Christ)* took the death of death within himself, as if captured in Adam's humanity." (Jacob Böhme, *De signatura rerum*)

The lower half of the picture shows Albion's female emanation, Jerusalem, lying death-like in the middle of the "sea of time and space". The winged "Cherub of concealment" is still holding her back from her marriage to the Christ-Lamb. But this Satanic shade is only a feeble imitation of the upper Divine Spirit-Sun. It is creative space-time, for which Blake used the image of a winged red blood corpuscle.

According to Böhme, blood is the "tincture of eternity", in which "the body ascends into the brilliance of the sun". (J. Böhme, *De signatura rerum*) And Blake: "Every Time less than a pulsation of the artery/Is equal in its period & value to Six Thousand Years,/ For in this Period the Poet's Work is Done; and all the Great/ Events of Time start forth & are conceiv'd in such a Period,/ Within a Moment, a Pulsation of the Artery." The earth is an infinite open plane, and its spherical form an illusion. "The Microscope knows not of this, nor the Telescope; they alter/The ratio of the Spectator's Organs, but leave Objects untouch'd./ For every Space larger than a red Globule of Man's blood/ Is visionary, and is created by the Hammer of Los;/ And every Space smaller than a Globule of Man's blood opens/ Into Eternity of which this vegetable Earth is but a shadow." (W. Blake, *Milton*)

"Space: what you damn well have to see. Through spaces smaller than red globules of man's blood they creepy-crawl after Blake's buttocks into eternity of which this vegetable world is but a shadow. Hold to the now, the here, through which all future plunges to the past." (James Joyce, *Ulysses*)

Ill. right:
William Blake,
Jerusalem,
1804–1820

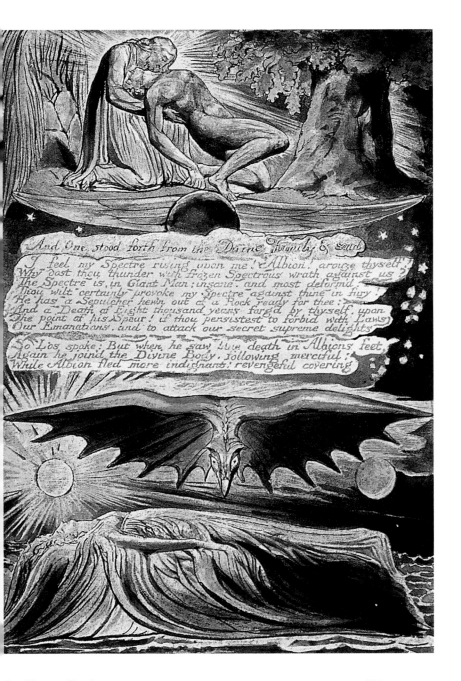

And One stood forth from the Divine Family & said

I feel my Spectre rising upon me! Albion, arouze thyself!
Why dost thou thunder with frozen Spectrous wrath against us?
The Spectre is in Giant Man: insane, and most deform'd.
Thou wilt certainly provoke my Spectre against thine in fury!
He has a Sepulcher hewn out of a Rock ready for thee:
And a Death of Eight thousand years forg'd by thyself, upon
The point of his Spear! if thou persistest to forbid with Laws
Our Emanations, and to attack our secret supreme delights

So Los spoke: But when he saw blue death in Albions feet,
Again he joind the Divine Body, following merciful:
While Albion fled more indignant: revengeful covering

Microcosm

"The world is primarily the totality of everything,
consisting of heaven and earth (...).
In the second mystical sense, however,
it is appropriately identified as man.
For, as the world has grown out of four elements,
so does man consist of four humours (...)."
(Isidore of Seville, A.D. 560–636, De natura rerum)

Human Form Divine

The magical vision of the universe of Agrippa von Nettesheim (1486–1535), which left traces in the work of Dürer, is influenced by the Gnostic doctrines of Hermes Trismegistus, which were circulating in Marsilio Ficino's translations. According to these doctrines, man was not only made in God's image, but also gifted with his omnipotence. Agrippa freed man from the tiered cosmos, and placed him at the centre of creation. "Only man enjoys the honour of participating in everything (...) He participates in matter in his own subject, and in the elements through his fourfold body; in plants through his vegetable strength; in animals through the life of the senses; in the heavens through the ethereal spirit (...), in the angels through his wisdom; in God through the epitome of everything (...) and just as God knows everything, so man can also come to know everything that can be known (...)." ("De occulta philosophia", in: Agrippa, *Die magischen Werke,* Wiesbaden edition, 1988) He can even direct the astral influences at his will.

Agrippa took the geometrical figures of "man as the measure of the universe" from Vitruvius' figures in Francesco Giorgio's *Exempada*, to which he presumably had access in manuscript form.

Human Form Divine

"Man, as the most beautiful and perfect work of God, has a (…) more harmonic bodily structure than other creatures, and contains all numbers, measures, weights, movements, elements, and everything, he is the most sublime masterpiece, come to perfection (…)" There is no part of the human body "that does not correspond to a sign of the zodiac, a star, an intelligence, a divine name in the idea of God himself. The whole form of the human body is round (…)."

Agrippa von Nettesheim, De occulta philosophia

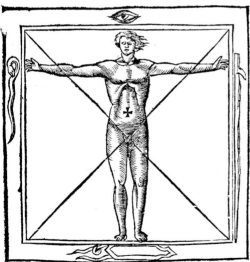

"But a completely evenly formed human body also represents a square; for if a man stands upright with arms outstretched and feet together, he forms an even-sided rectangle, the centre of which is at the lowest part of the pubic bone."

Agrippa von Nettesheim, De occulta philosophia

Human Form
Divine

"If one draws a circle from this centre point over the top of the head, and lowers the arms until the fingertips touch the periphery of the circle, and the feet on the circumference are the same distance apart as the fingertips from the top of the head, the circle is thereby divided into five equal parts, and a regular pentagon is produced, just as the two heels form an equilateral triangle with the navel."

Agrippa von Nettesheim, De occulta philosophia

"If, with arms raised thus, the feet and legs are placed so far apart that the figure is shortened by one fourteenth of his upright posture, the distance between his feet and from the lower part of the pubic bone forms an equilateral triangle, and if one places the centre point in the navel, the periphery of a circle will touch the tips of the fingers and toes."

Agrippa von Nettesheim, De occulta philosophia

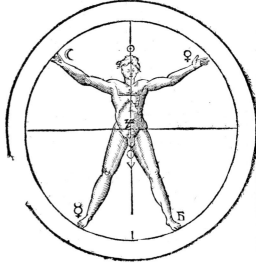

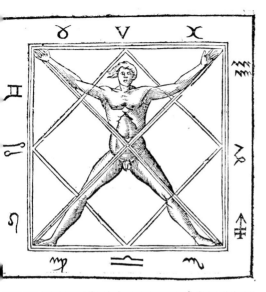

"If both feet are spread to the left and right, with the calves facing inwards, and the hands are raised upwards along the same line, the tips of the fingers and toes form a perfect square, the centre of which is above the navel."

Agrippa von Nettesheim, De occulta philosophia

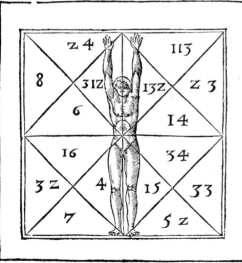

"If the arms are stretched as high as possible above the head, the elbows are in the region of the head, and if a man standing in this position, his feet remaining together, is placed in a perfect square whose opposite sides touch his soles and fingertips, the centre of the square will fall in the region of the navel, which also forms the centre betweeen the top of the head and knees."

Agrippa von Nettesheim, De occulta philosophia

Human Form Divine

The Parmasayika grid is a fundamental religious diagram which divides up the Hindu Pantheon according to the measures of the "purusha" of the cosmic primal man. The lotus grows from the central point of his navel, and from it "brahma" or the vital principle of the universe. The greatest deities are grouped around the centre, the lesser around the edge.

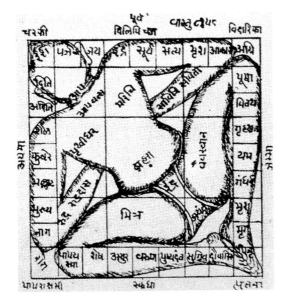

The diagram was used as a ground plan for temple buildings, and also for the arrangements of cities, with the places of the divine hierarchies corresponding to the districts of human classes or castes. It was the architect's task to reproduce the human prototype of the universe in his constructions.

ROGA	AHI	MUKHYA	BHALLĀTA	SOMA	BHUJAGA	ADITI	DITI	AGNI
PĀPA-YAKSHMAN	RUDRA						ĀPA	PARJANYA
ŚOṢA		RĀJA-YAKSHMAN	PRTHIVIDHARA			ĀPA-VATSA		JAYANTA
ASURA		MITRA				ARYAMAN		INDRA
VARUNA				BRAHMA				SŪRYA
KUSUMA-DANTA								SATYA
SUGRĪVA		INDRA	VIVASVĀN			SAVITR		BHRŚA
DAU-VĀRIKA	JAYĀ						SĀVITRA	ANTAR-IKṢA
PITARAH	MRGA	BHRNGA-RĀJA	GAN-DHARVA	YAMA	BRHAT-KṢATA	VITATHA	PŪṢAN	ANILA

Human Form Divine

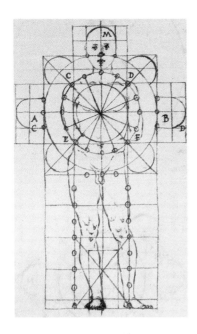

Blueprint of a basilica on the measure of a human figure.

In his writings, Francesco Giorgio (1460–1540) linked the Pythagorean theory of harmony with hermetic and Cabalistic speculations.

"The ancients also divided their temples, public buildings and the like according to the structure of the human body (...) just as he *(God)* himself gave the whole machine of the universe the symmetry of the human body."

(Agrippa von Nettesheim, *De occulta philosophia*)

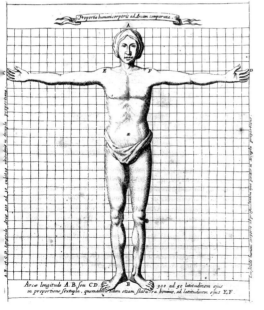

"When man stretches out crosswise, so that the circle touches the extremes at hands and feet, the centre is the navel, but if he puts his feet hard together (...) the centre is the middle in the human member. It was according to this measure of the human body that Noah is supposed to have built his ark and Solomon his temple."
(A. Kircher, *Musurgia universalis,* Schwäbisch Hall edition, 1662)

A. Kircher, Arca Noë, Amsterdam, 1675

Human Form Divine

According to Giordano Bruno, the number five is the number of the soul, as it is composed of even and odd. "Because the figure of man is bounded by five outer points, the dastardly race of black magicians casts effective spells through the pentagram. Anyone who wants to know unworthiness should seek it in the books of these windbags (…)"

(Giordano Bruno, *About the Monas,* 1591)

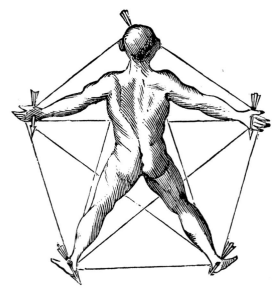

Among the Egyptians, the image of Veiovis (Mars) as the image of misfortune looked like this.

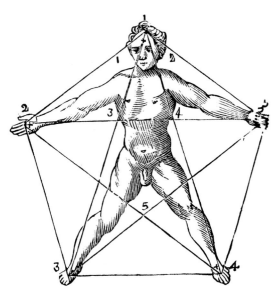

But the image of good fortune of Diovis (Jupiter) looked like this.

Giordano Bruno, Vol. 1, Naples, 1886

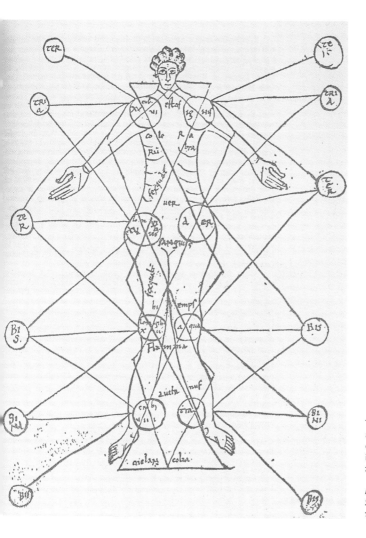

The bodily fluids
and the elemental
qualities in man
in relation to the
zodiac.

*Burgo de Osma,
Spain,
11th century*

Human Form Divine

Fludd's monumental five-volume work, *Utriusque Cosmi*, was published in 1617–1621 by the German publisher Teodor de Bry, probably through the agency of Michael Maier, who had visited Fludd in England in 1615. The engravings, based on Fludd's detailed drawings were made by de Bry's son-in-law Matthäus Merian.

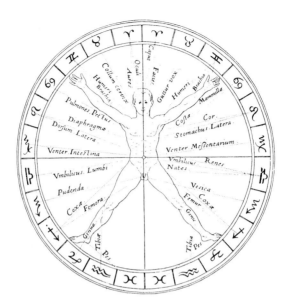

The two diagrams show the influences of the twelve signs of the zodiac (top), and the seven planets (bottom) on the regions of the human body.

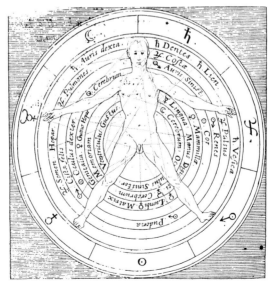

Human Form Divine

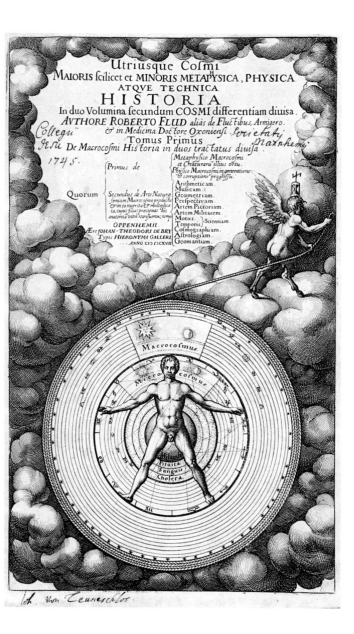

The frontpiece to the first volume of *Utriusque Cosmi* shows, in the outer circle, the Ptolemaic macrocosm, whose reflection in all parts is man.

In the innermost circles are the four humours of man, corresponding to the elements. To the central, black circle corresponds the outermost macrocosmic boundary of goat-footed Chronos-Saturn, who unrolls the great universal year.

The swastika-like sign on his hourglass represents the polar forces that govern the whole universe: systole-sulphur and diastole-mercury, sun and moon of both cosmoi.

Utriusque Cosmi, Vol. I, Oppenheim, 1617

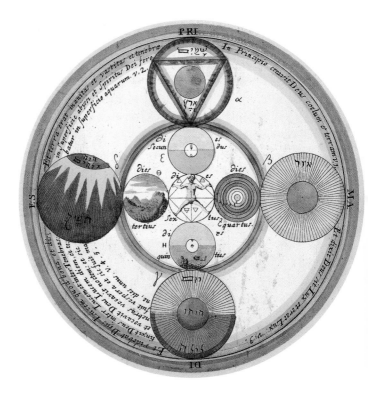

According to the Biblical account of Creation, man was created on the final day. Welling took this as grounds to assume "that the most wise Creator had not only pulled his master stroke in man as the final creature, but also concentrated and resolved the beginning and the end of all creatures, that is, to allow the whole universe to run together and accumulate within this one circle."

In Welling's view, the elemental creation consists in the splitting or division of the heavenly, primal element "Shamayim" into fire and water and into light and darkness. Only man contains this primal element in its pure form "so that he himself is a little spark of the living deity".

*Gregorius Anglus Sallwigt (alias von Welling),
Opus mago-cabalisticum, Frankfurt, 1719*

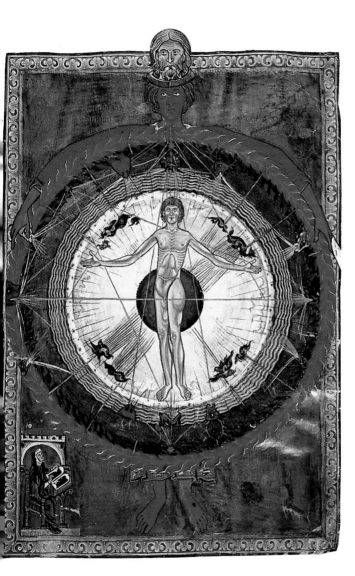

Human Form Divine

The last visions of Hildegard von Bingen, written down in 1163–1173, concern the involvement of man in the order of God's creation. The divine love of the son appears to her as a red, cosmic figure in the sky, dwarfed only by the goodness of the Father. In his breast appeared the 'Wheel of the World' with the bright fire of light and the black fire of justice as the outermost bounds of the universe. The twelve animals' heads represent winds and virtues, which together produce the system of reference in which man can exist as the crown of creation.

Hildegard von Bingen, Liber Diviorum Operum, 13th century

Human Form Divine

"Now you are Christ's body, and each of you a limb or organ of it." (1 Corinthians 12, 27)

"And (God) put all things under his feet, and made him (the Son) the head over all things in the church, "which is his body, and as such holds within it the fullness of him who himself receives the entire fullness of God." (Eph. 1, 22–23)

From this divine fullness (Pleroma) flows the Holy Spirit, the breath of life of the Church.

The Church as the mystical body of Christ, Opinicus de Canistris, 1340

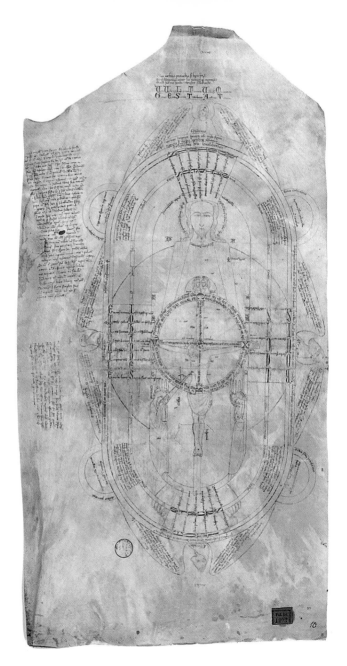

Human Form Divine

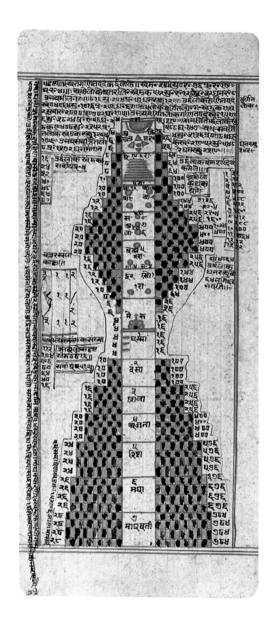

In the pre-Aryan Indian tradition of Jainism, cosmic man is not an immaterial God-figure, but the organism of the world itself. This anthropomorphic cosmos "never had a beginning and will never end. Not 'spirit' distinct from 'matter', but 'spiritual matter', 'materialized spirit', that is the FIRST MAN". (Heinrich Zimmer, *Philosophie und Religion Indiens*, Zurich, 1961)

The individual's path of enlightenment ascends through the lower bodily regions of the Anthropos to the uppermost curve of his skull.

The form and dimensions of the cosmic primal man, Gujarat, 17th century

Human Form Divine

"All of a sudden I saw an intense bright light (the father) and in it the sapphire-blue figure of a man (the son) which burned entirely in the gentle red of sparkling flame (Holy Spirit). The bright light entirely flooded the sparkling flame and the sparkling flame flooded the bright light. And both, the bright light and the sparkling flame flooded the human figure, like a light existing in one power and strength." (Hildegard von Bingen, *Wisset die Wege,* Salzburg edition, 1981)

Representation of the Trinity as the true unity.

Hildegard von Bingen, Scivias (Rupertsberg Codex), 12th century

Human Form Divine

For decades, Kircher was based in Rome, at the information centre of the global Jesuit mission, and he acquired news and materials from the remotest parts of the world for his collection and his books.

Here, the supreme Hindu creator god Brahma is depicted in his aural, cosmic egg, from which he creates heaven and earth by splitting it. This egg consists of seven visible exoteric worlds, called 'Locas', and seven esoteric worlds. To these levels, fourteen in number, correspond the same number of concrete states of consciousness through which any person can pass.

*A. Kircher,
La Chine illustrée,
Monuments,
Amsterdam, 1670*

Human Form Divine

Blake used a number of models for the concept of his giant Albion.

In Böhme's *Aurora*, heaven is described as the interior of a human being, on the model of the heavenly primal man of the Cabbala, Adam Cadmon. In his visions, Swedenborg also described heaven and hell as anthropomorphic organisms: "Because God is man, the whole host of angels represents a single man, divided into regions and zones according to the limbs, intestines and organs of man." Also, each human being is "only a small part – particula – within the Great Man, and there is never anything in man that does not have an equivalent in the Great Man". (*Wisdom of the Angels,* Zurich, 1940) The limbs of Blake's giant Albion, on the other hand, are assigned to the earthly topography of the British Isles: his right hand covers Wales, his elbow rests on Ireland and London lies between his knees. The protagonists in Joyce's *Finnegans Wake,* H.C.E. and A.L.P. at one point assume the form of giants and occupy individual districts of Dublin.

In Cabbalistic tradition, the ten Sephiroth that structure the universe are the limbs of the primal man, Adam Cadmon. He is so vast that each of his hairs can be imagined as a stream of light linked to millions of worlds.

Adam Cadmon is also identified with the figure that Ezekiel saw on the wheeled throne, and with the appearance of the 'Ancient in Years' in Daniel 7, 13.

Jewish Encyclopedia

Human Form Divine

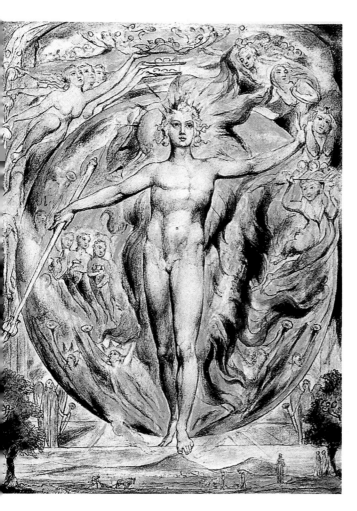

"For all are Men in Eternity, Rivers, Mountains, Cities, Villages / All are Human, & when you enter into their Bosoms you walk / In Heavens & Earths, as in your own Bosom you bear your Heaven / And Earth & all you behold; tho' it appears Without, it is Within, / In your Imagination, of which this World of Mortality is but a Shadow." (W. Blake, *Jerusalem*)

"No form, no world had existence before the form of man was present. For it includes all things, and everything that exists, only exists through it." (Zohar)

W. Blake, The Sun at its Eastern Gate, c. 1815

Human Form Divine

The "Mystical Body of Babylon" refers to the four empires hostile to God which appeared to the Babylonian tyrant Nebuchadnezzar in a vision, in the form of a large statue made of different metals (Daniel 2, 31–46). The golden head signifies the Babylonian empire itself, followed by the silver chest-zone of the Persians and Medeans, the copper belly symbolizes the Greek and the iron feet the Roman empire.

As in Blake's poetry, Terry's representation included the whole social structure in the image of a human organism. "There are more general comparisons to be made between Terry's millenarian publications and the illuminated books Blake was producing at roughly the same time. Both engravers combined interpretations of prophecy with their own designs to suggest the imminence of a political apocalypse." (Jon Mee, *Dangerous Enthusiasm*, Oxford, 1992)

Garnet Terry, 1793

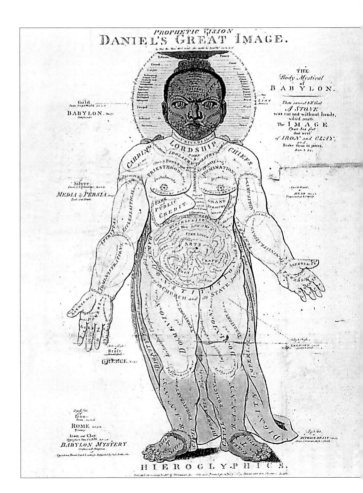

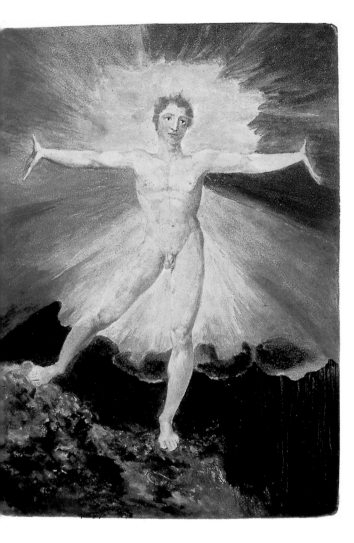

Human Form Divine

"The sphere of human nature encompasses in its human possibility God and the universe." (Nikolaus of Cusa, *De coniecturis,* c. 1443, Hamburg edition, 1988)

W. Blake, Albion's Dance, c. 1794

Human Form Divine

The "Mysterium Magnum" is the fundamental duality in one God, the "ground" and the "unground", "from which time and the visible world have flown". In his title engraving, Georg Gichtel interpreted the one duality of microcosm/macrocosm and Moses/Messiah: just as Moses was the representative of the authoritarian aspect of God for the small world of the children of Israel, Christ is the incarnation of divine love for humanity as a whole.

The trumpet-blowing angel of the end of time unveils the transfigured face of Moses, and Christ reveals himself in the perfect clock of the zodiac as ruler of the spiritual age of the lily.

J. Böhme, Theosophische Wercke, Amsterdam 1682

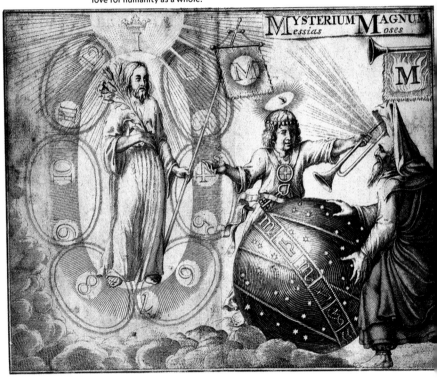

Human Form Divine

Man is "in his outward body an *ens* (being) of the four elements, and in his outward life an *ens* of the 'Spiritus Mundi' (world spirit) (...) as the great clock (the zodiac) relates to time in which the figure stands, and the 'Spiritus Mundi' also gives him such a figure in the property of outward life, it forms him as such an animal in the outward life-property, for the 'Spiritus' of the outer world of the elements cannot give other than an animal."
(J. Böhme, *Von der Gnadenwahl*)

D.A. Freher,
in: Works of
J. Behmen,
Law edition, 1764

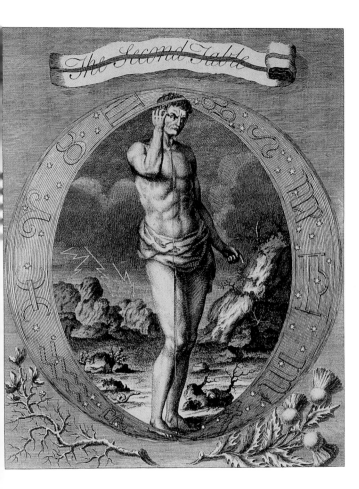

Human Form Divine

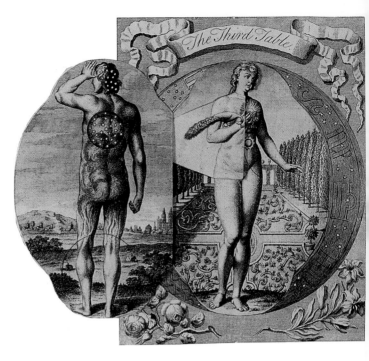

"Now man (...) stands at the centre, between the realms of God and hell, between love and wrath; which spirit he makes his own, he is of it." (J. Böhme, *Vom dreyfachen Leben*)

On the left, on the flap, we can see the outer man, standing with both feet in the abyss of the "dark world", in "God's fire of wrath". The impressions of the sidereal, world spirit are imprinted on his upper body. In Böhme's view the outer man lives imprisoned by the elemental and astral influences that keep the portals of his senses sealed. To the right is the inner man in the liberated state, as he lives in the world of light of the hidden deity.

In alchemy, the peacock symbolizes the night of decay. It is also the symbolic animal of Juno, the wife of Jupiter, who, along with Venus and Mercury, is among the three source spirits of the world of light.

D.A. Freher, in: Works of J. Behmen, Law edition, 1764

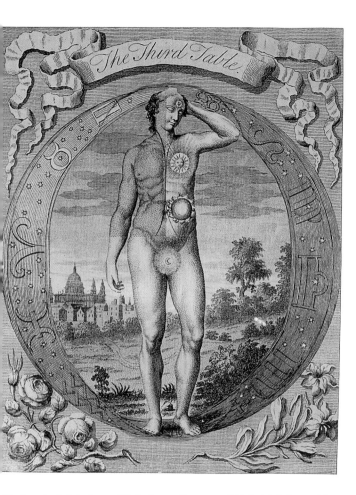

Man is made of all the forces of God, of all seven spirits of God. (...) But because he is now corrupt, the divine birth does not always swell within him. (...) For the Holy Ghost cannot be grasped and fixed in sinful flesh; but it ascends like a lightning flash (...) But if the lightning flash is caught in the spring of the heart, it ascends to the brain in the seven source-spirits like the red sky at morning: and in it are purpose and knowledge." (J. Böhme, *Aurora*)

The ascent of this "salnitric fire-crack" through the seven source-spirits has often been compared to the awakening of the snake-fire, the *kundalini* in Hindu yoga, which rises through the seven, delicate centres of the body, the chakras, above the head, where it ascends in pure knowledge.

D.A. Freher, in: Works of J. Behmen, Law edition, 1764

Human Form Divine

Fludd presented the four spiritual levels of man in the picture of the Tetragrammaton. *Yod*, the formless seed of all things, is compared to the spirit or pure knowledge. *He,* the "upper palace", is the intellect; *Vau,* "the connecting link", the soul or the life-spirit. The second *He* or "the lower dwelling-place" represents the sensual and elemental sphere.

The Cabala has three regions of the soul, although these are all contained within each other. The "vegetable soul", dedicated to the sensual life, is called *Nefesh*. It passes with death. To it corresponds the *Zelem,* the so-called ethereal or astral body. The innermost divine spark of the soul is called *Neshama*.

Similar ideas are familiar from Paracelsus. According to his theory, man, like every-thing else, consists of the trinity of salt, sulphur and mercury. Salt is the body and mercury the spirit. "But the centre between spiritus and corpore (...) is the soul and is sulphur". (Paracelsus, *De natura rerum,* 1525). To it corresponds the astral body, which also communicates between spirit and body. "It was the Platonic 'chariot of the soul'. It was imagined as a 'pneumatic shell' – on its descent it received the soul from the stars and their evil (...) 'administrators'. These are the 'Archonte' (...), in Paracelsus the 'Archei, Vullcani' or 'smiths'. The soul casts off the astral body like a garment when it makes the upward journey through the realm of the astral Archontes." (Walter Pagel, Paracelsus als 'Naturmystiker', in: *Epochen der Naturmystic,* Berlin, 1979)

R. Fludd, Utriusque Cosmi, Vol. II, Frankfurt, 1621

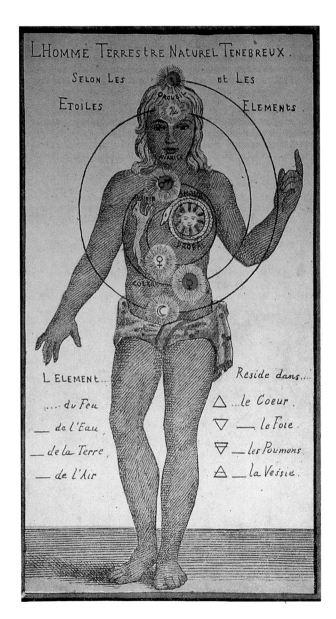

L'HOMME TERRESTRE NATUREL TÉNÉBREUX.

SELON LES et LES

ÉTOILES ÉLÉMENTS.

L'ELEMENt..

...du Feu

_ de l'Eau

_ de la Terre

_ de l'Air

Reside dans...

△ ...le Coeur.

▽ — le Foie.

▽ — les Poumons.

△ — la Vessie.

Human Form Divine

Nobody did greater service to the dissemination of Böhme's ideas than the Regensburg writer Georg Gichtel (1638–1710), who was himself devoted to a radical Sophian mysticism, and who, in exile in Amsterdam, surrounded himself with a circle of celibate 'angelic brothers'. In his *Theosophia practica* (1696) he described how the wheel of the planets lies on the body in seven diabolical seals.

G. Gichtel, Theosophia practica, 1898 edition

Human Form Divine

For his act of Creation, God descended three world octaves to breathe his spirit into man. Hence man's spiritual capacity also takes in the whole span of the three intervals of the ladder of creation: elemental, celestial and super-celestial.

R. Fludd, Utriusque Cosmi, Vol. II, Frankfurt, 1621

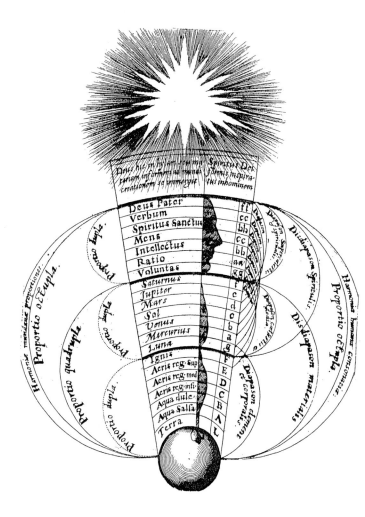

Human Form Divine

Fludd called the human body (F) a "vessel of all things", for, according to the harmonic diagram, it has the ability to connect with every region of the three worlds through various, subtle, spiritual media.

Via the so-called "middle soul" (E) which swims in the ethereal sphere, he maintains contact with the region of the elements. Its equivalent in the Cabala is the vegetable soul *Nefesh*.

Fludd calls the uppermost "pure spirit" (A) the "chimney to God".

R. Fludd, Utriusque Cosmi II, Frankfurt, 1621

Labels within the diagram:

Seraphini. Cherubini. Throni. Dominationes. Principatus. Potestates. Virtutes. Archangeli. Angeli. Primum Mobile. Cœlum stellatū. Saturnus. Iupiter. Mars. Sol. Venus. Mercurius. Luna. Ignis. Aer. Aqua. Terra.

Harmonia essentialis qua anima humana cuiuslibet trium mundi regionum portionem ad suam constitutionem sibi rapit.

Ter Diapason anima humana portionem constituens.

Diapason spiritualis. Diapente spiritual. Diapason medium. Diapente medium. Diapason materiale. Diapente materiale.

A. *Mens simplex: spiraculum Dei.*
B. *Intellectus agens primum Mentis tegumentum seu Vehiculum:*
C. *Mens & intellectus in spiritu rationali, ratione, seu intellectu patiente.*
D. *Spiritus rationalis cum Mente & Intellectu in Anima media.*
E. *Anima media in latice æthereo natans; seu lux Vitalis cum Mente*
F. *Corpus receptaculum omnium.*

Human Form
Divine

The alchemist holding the two Masonic symbols of the compass and the set-square marks the saturnine beginning of the Work, which is connected with the dark descent into the "interior of the earth". Only there, according to the famous VITRIOL acronym, will one find the philosophers' stone.

Here, the lapis is represented as the red point in the egg-yolk of the four-element Work, from which the quintessence, or the "little chick", emerges.

Theatrum chemicum, ed. Lazarus Zetzner, 1661

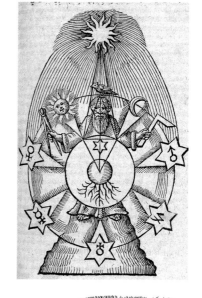

"In the usual way, understand man as composed out of the unity of the light of human nature and the difference of physical darkness; to unfold him more precisely, return to the first figure *(Figura paradigmatica).* You clearly recognize three spheres: a lower, a middle and an upper." (Nikolaus of Cusa, *De coniecturis*)

R. Fludd, Utriusque Cosmi, Vol. II, Oppenheim, 1619

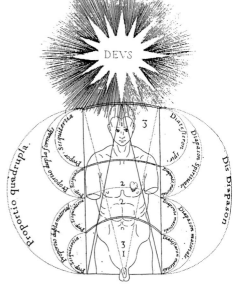

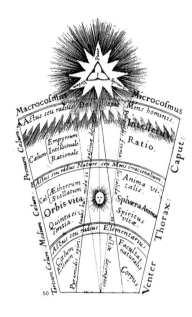

The equivalent in man to the three spheres of the Great World, with their different qualities, are three spiritual and physical levels: the sublunar elemental region is the sphere of the senses (lower body), the astral, ethereal region is the sphere of the soul (breast region) and the divine fire-heaven is the sphere of the intellect (head). The sun at the intersection of form and matter is, in the macrocosm, the seat of the cosmic soul. Its equivalent in man is the heart as the seat of the soul and the vital spirit (Archaeus).

R. Fludd, Utriusque Cosmi, Vol. II, Oppenheim, 1619

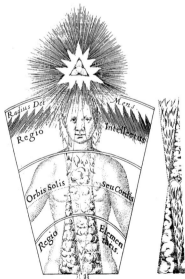

The human body in the image of the conflict between the two states into which the primal matter *(Shamayim)* is separated in the act of creation: the lower, impure waters, whose poisonous fumes rise from the lower body, and the upper, subtle spiritual fire. The two mingle in the breast region, maintaining an equilibrium in the region of the heart.

R. Fludd, Utriusque Cosmi, Vol. II, Oppenheim, 1619

Human Form Divine

"In this picture we see the wonderful harmony in which the two extremes, the most precious and the most gross, are linked." Fludd is referring to soul and body. The cosmic spirit linking the two is represented as the string of a microcosmic, monochord. At birth, the soul descends along the marked intervals from the higher spheres in man and in death it rises back along them.

R. Fludd, Utriusque Cosmi, Vol. II, Oppenheim, 1619

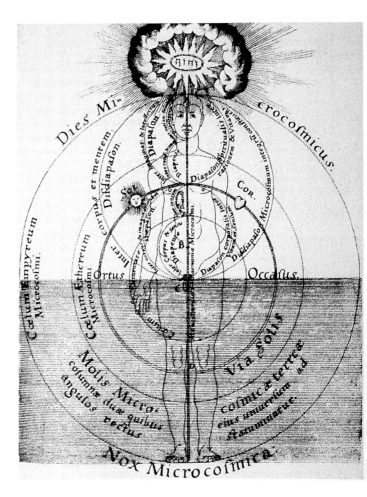

Human Form Divine

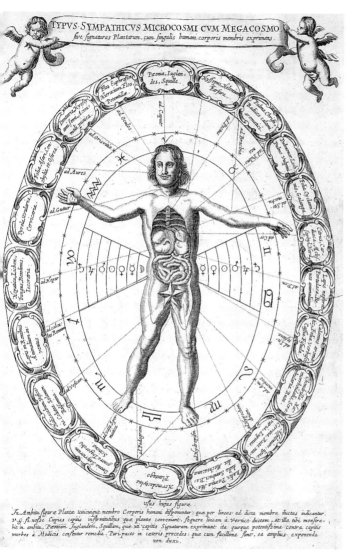

In this diagram of the correlations in the micro-macrocosm Kircher followed the theories of correspondence in the Platonic and Hermetic tradition, in which the world is described as a living organism with metabolic processes. In the *Musurgia universalis* Kircher assigned the sun to the heart, the moon to the brain, Jupiter to the liver, Saturn to the spleen, Venus to the kidneys, Mercury to the lungs and the earth to the stomach. "The veins signify the rivers, the bladder the sea. The seven major limbs signify the seven metallic bodies, the legs signify the quarries, the flesh signifies the earth, the hair signifies the grass."

A. Kircher, Mundus subterreaneus, Amsterdam, 1682

Human Form Divine

The twelve signs of the zodiac and their influence on the parts of the body:

Aries: head, suprarenal glands, blood pressure

Taurus: throat, shoulders, ears

Gemini: lungs, nerves, arms, head, fingers

Cancer: thorax, some bodily fluids

Leo: heart, back, spine, spleen

Virgo: belly, intestines, gall bladder, pancreas, liver

Libra: coccyx, hips, kidneys, glands

Scorpio: sex organs, pelvis, rectum

Sagittarius: thighs, legs

Capricorn: knees, bones, skin

Aquarius: bones, blood vessels

Pisces: feet, some bodily fluids

Hebrew manuscript, 14th century

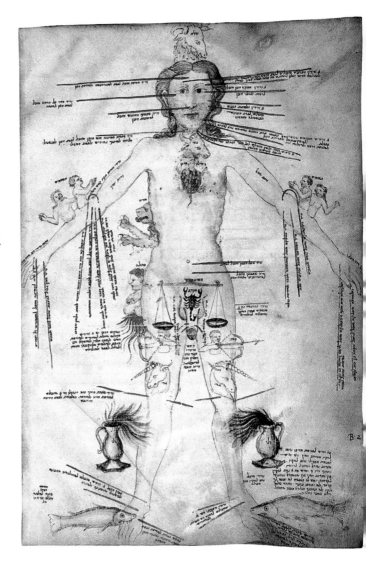

Human Form Divine

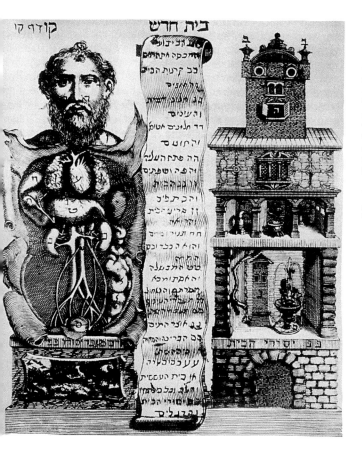

In his illustration for a medical treatise, Tobias Cohn compared the human anatomy with a four-storey house. The four storeys correspond to the four worlds in which the entire cosmos is divided in the image of the Sephiroth tree.

Tobias Cohn, Maaseh Tobiyyah, 1707

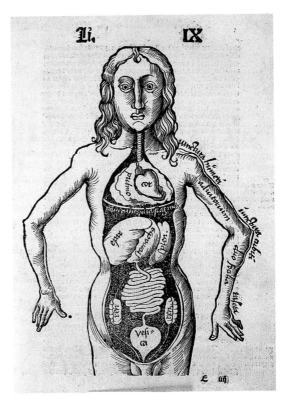

Up until the first half of the 16th century, when the first systematic dissections were undertaken, the ideas of the Roman physician Galen (3rd century B.C.), based on Aristotelean speculations, were taken as standard. Galen claimed that a "natural spirit", consumed in food, enters the blood via the liver. In his diagnoses, he therefore placed a special importance on the examination of the pulse. The "vital spirits" of the blood, which dwell in the left ventricle of the heart, are transformed in the brain by the "pneuma", the breath of spirit, into "animal spirits". He knew

nothing of the circulation of the blood. According to him, blood flows via invisible pores in the wall that separates the two ventricles.

Fludd still maintained his views of the assimilation of the Holy Spirit through the human system of vessels, and its storage in the left ventricle and the brain, entirely in accordance with Galen's theories (cf. 642).

G. Reisch, Pretiosa Margarita, Freiburg, 1503

Of the inward things of man: ...rt *(alchemy)* is also compared with the ...ain parts that are in a human being, ...amely the brain in the coldness of water ...hlegma), the heart in the warmth of fire ...alled *cholera*), the liver in the moisture of ...r (called *sanguinea*) and melancholy in ...uman transactions or limbs (...) But the ...fth power is neither warm nor cold, moist ...or dry (...) but is actually called life, which ...rings the four together and gives them a strong and perfect life." (*Aurora consurgens,* 2nd Treatise, early 16th century)

"But what and how the life of each thing is in its uniqueness, is to know that it is nothing but a spiritual being, an invisible and incomprehensible thing and a spirit and a spiritual thing." (Paracelsus, *De natura rerum,* 1537)

Aurora consurgens, late 14th century

Brain & memory

In Scholastic tradition there are three chambers of the brain which work on a cooperative basis, and which are related to the Aristotelian elemental qualities. The front chamber of imagination, *cellula phantastica,* is hot and dry. Blake called it the "furnace of Los", in which sensory information (in Blake's mythology the larks, the messengers of Los) is shaped into glowing, visual images and etched into the brain. The central chamber of reason, *cellula rationalis,* is warm and moist. Here, the minted images are brought into ordered contexts to create knowledge. The linguistic arts of grammar, dialectics and rhetoric were assigned to it. Heinrich Schipperges calls the back chamber of memory, *cellula memoralis,* the "great storage room of images" (H. Schipperges, *Die Welt des Auges,* Freiburg, 1978). It is the archive or reservoir from which the central chamber draws its material for new chains of thought. Here are the "halls of Los" holding the "glowing sculptures" of all things that happen on earth. "Every age renews its powers from these works." (W. Blake, *Jerusalem,* 1804–1820)

G. Reisch, Pretiosa Margarita, Freiburg, 1503

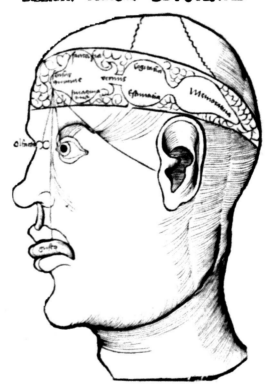

LIBER.X. TRAC.II. DE POTENTIIS

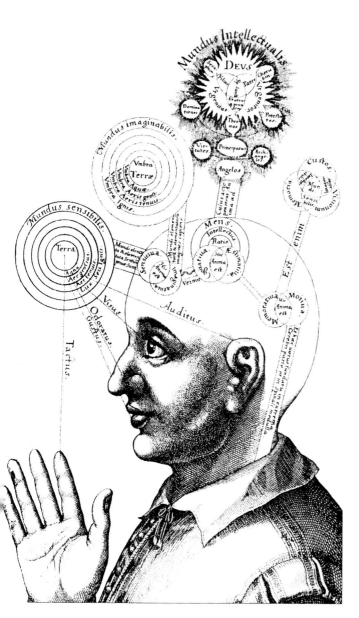

Brain & memory

On the left, above
the forehead, in
Fludd's model,
floats the circular
diagram of the
world as percept-
ible to the senses.
It is subdivided
into an elemental
quinternity which
stands in relation
to the five senses
of man: earth:
touch, water:
taste, air: smell,
ether: hearing,
fire: seeing. This
"sensitive world"
is "imagined" in
the first brain-
chamber, by the
transforming
power of the soul,
into a shadowy du-
plicate, and then
transcended in
the next chamber
of the capacity
for judgment and
knowledge:
through the keen-
ness of the spirit
the soul pene-
trates to the
divine "world of
the intellect". The
last chamber is the
centre of memory
and movement.

*R. Fludd, Utriusque
cosmi, Vol. II,
Oppenheim, 1619*

Brain & memory

Descartes compared the creation of pictures of memory in the brain with the traces left by needles in fabric. Even Plato described the working of memory with the image of impressions in a wax block.

From: René Descartes, Traité de l'homme

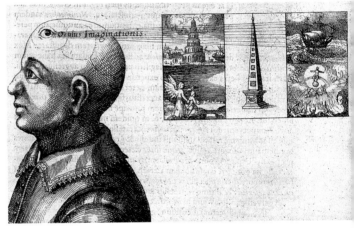

In Classical antiquity memory was held to be the "mother of the muses". As late as the Renaissance a series of polished techniques for the training of the memory were developed and handed down. They are all based on the notion that a basic repertoire of places or pictures is impressed upon the memory in a particular sequence, and that this can then be associated with random and changing images.

"The art of memory is like an inner writing Those who know the letters of the alphabet can write down what is dictated to them and read out what they have written." (Frances A. Yates, *The Art of Memory,* London, 1966)

R. Fludd, Utriusque Cosmi, Tractatus primi, Oppenheim, 1620

Fludd distinguishes between a round and a square art of memory. The round art uses fantastic and magically charged diagrams with which it seeks to draw down the celestial influences. The square art is the classical mnemonic technique, which uses real places and natural images.

R. Fludd, Utriusque Cosmi, Vol. II, Oppenheim, 1619

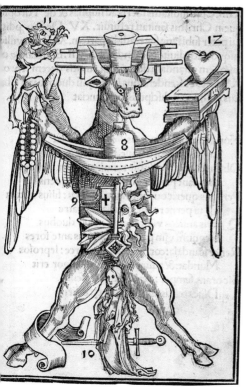

This mnemonic figure was used as a guide to impressing the Gospel according to St Luke. The individual hieroglyphs are aides-mèmoires, and mark particularly significant passages in the Gospel.

Sebastian Brant, Hexastichon, 1509

Signatures

According to Zedler's *Universal-Lexikon* (Halle, 1732–1754), physiognomy is "the art which from the outward constitution of the limbs or the lineaments of a man's body reveals his nature and emotional disposition". For a long time, it was part of the wide repertoire of the occult arts. Fludd included it alongside astrology and chiromancy among the microcosmic arts, and the universal scholar Giambattista della Porta, who founded the "Academy for the Study of the Secrets of Nature" in Naples in 1560, included it in the broad spectrum of the "Magia naturalis". At the end of the 18th century, the writings of Johann C. Lavater (1741–1801), building upon della Porta's *Physiognomia*, led to a "mania for physiognomics", to which even Goethe succumbed. He eagerly gave his friend Lavater the silhouettes of his acquaintances. Lavater also developed approaches towards a physiognomics of criminals and races. One resolute opponent of the "physiognomists" was the physicist and thinker G.C. Lichtenberg: "I physiognomics becomes what Lavater expects of it, children will be hanged before they have committed the deeds that merit the gallows (...)" (*Sudelbücher*, 1777), and "We regularly judge from faces, and we are regularly wrong". (*Über Physiognomik*)

Giambattista della Porta, De Humana Physiognomia, 1650

According to della Porta, the whole natural world consists of a network of secret correspondences which can be revealed through analogy. A plant leaf in the shape of a set of deer's antlers is related to the character of that animal. People who look like donkeys are stupid; Those who look like oxen are stubborn, lazy and easily irritated; leonine people are powerful, generous and brave.

Giambattista della Porta, De Humana Physiognomia, 1650

Signatures

With this meta-morphosis "from a frog's head to Apollo" Lavater was putting his theory of evolution to the test: the more pointed the angle of the profile, the more lacking in reason is the creature. "The first figure is thus wholly frog, so wholly does it represent the puffed-up representative of repellent bestiality." With the tenth figure "commences the first step towards un-brutality (...) with the twelfth figure begins the lowest stage of humanity (...) the sixteenth head gradually rises towards reason" and "from this up to such as Newton and Kant".

J.C. Lavater, Physiognomik, Vienna, 1829

Between 1819 and 1820 Blake carried out spiritualist seances with the astrologer and landscape painter John Varley, producing "visionary portraits". In 1828 Varley described how the "spirit of a fly" appeared to Blake. "During the time occupied in completing the drawing, the fly told him that all flies were inhabited by the souls of such men as were by nature blood-thirsty to excess, and were therefore providentially confined to the size and form of insects; otherwise, were he himself, for instance, the size of a horse, he would depopulate a great portion of the country."

W. Blake, Spirit of a Fly, 1819

Signatures

The Italian doctor and astrologist Hierony-mus Cardanus (1501–76) developed a system of the relationships between moles and the signs of the zodiac. Moles on the bridge of the nose were assigned to Libra, on the cheekbones to Scorpio and Sagittarius, between nose and upper lip to Aquarius, on the chin to Pisces. Moles on the neck predicted saturnine misfortune, and possibly decapitation.

H. Cardanus, Metoposcopia

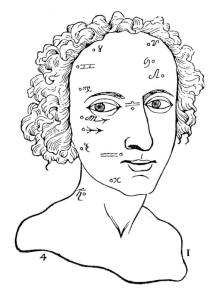

"Just as, in the firmament, we see certain figures formed by the stars and constellations, which tell us of hidden things and deep secrets, so on the skin (…) there are certain figures and signs which are, we might say, the stars and constellations of our body. All of these forms have a hidden meaning (…) for the wise who can read in the face of man." (Zohar)

H. Cardanus, Metoposcopia, Paris, 1658

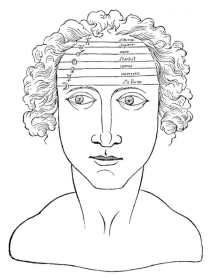

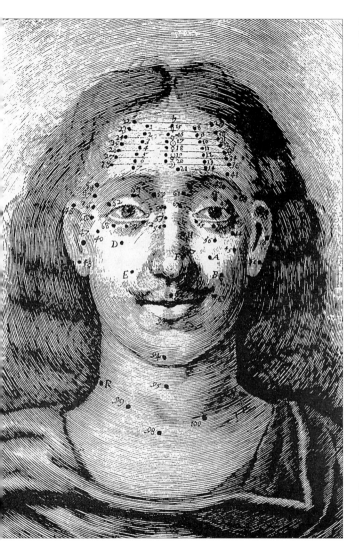

On mole no. 1 (on the top right-hand side of the brow):

"The man and woman who have a mole on the right-hand side of the brow beneath the line of Saturn (...) but one which does not touch that line, also have one on the right-hand side of the chest. Such people can expect luck in tilling, sowing, planting and ploughing. And if such a mole is the colour of honey or rubies, they will have good fortune during their lifetime; if it is black, the person's fortune will be changeable (...) This mole has the nature of Venus, Mercury and Mars, and is named after the Lyre (Vega), a star of the first magnitude."
(K. Seligmann, *Das Weltreich der Magie,* Stuttgart, 1958)

Richard Saunders, Physiognomy, London, 1671

Signatures

"There is no thing in nature created or born that does not reveal its inner form outwardly as well, for the internal always works towards revelation (...) as we can see and recognize in stars and elements, and in creatures, and trees and plants (...) Thus in the signature there lies great understanding, in which man not only comes to know himelf, but he may also learn to recognize the essence of all beings." (J. Böhme, *De Signatura rerum,* 1622)

Nature in all its facets was seen as a kind of secret writing, a huge cryptogram of God which the wise man could decipher with the help of certain techniques. Paracelsus included among these geomancy (the art of fortune-telling from dots or earth), physiognomy, hydromancy (fortune-telling from water), pyromancy (from fire), necromancy (conjuring the dead), astronomy and berillistica (crystal-reading). "All stars have their unique nature and consistency, whose signs and characteristics they communicate, through their rays, to our world of elements, stones, plants and animals. Thus each thing has a particular sign or characteristic impressed on it by the star that shines upon it." (Agrippa von Nettesheim, *De occulta philosophia,* 1510) Not only stars sign, however; Paracelsus called the "Archeus", the inner smith a signator. He is the one who transforms the information of intangible heavenly influences into physical tangibility. He sets, so to speak, the script of the genetic code.

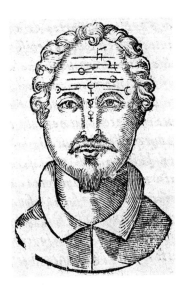

'Metoscopy', the study of the lines in the forehead, divides the human forehead into seven planetary zones.

Ciro Spontoni, La Metoposcopia, Venice, 1651

b)

Signatures

a. Brow of a peace-loving and successful man.

b. Brow of a spiritual man with an inclination towards the priesthood.

c. Brow of a man who will die a violent death.

d. Brow of a successful soldier.

e. Brow of a man threatened by an injury to the head.

f. Brow of a poisoner.

"A brow is idiotic if it has, in the middle and beneath, an elongated hollow, even one that is barely noticeable, and if it is itself elongated – I say if it is barely noticeable – as soon as it is noticeable everything changes." (J.C. Lavater, *Von der Physiognomik*, 1772)

From: H. Cardanus, Metoposcopia, Paris, 1658

d)

f)

Signatures

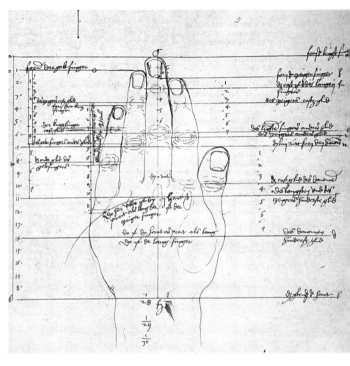

The construction of the left hand with the measurements and proportions.

"The length of the nails is exactly half the length of the outermost finger-joints." (Agrippa von Nettesheim, *De occulta philosophia,* 1510)

The hand is the "Little World" of man, whose proportions, according to Agrippa, correspond to those of the body as a whole: it is the reflection of macrocosmic harmony.

"Of the signs of chiromancy, know this, that they have their origin in the upper stars of the seven planets (…) Chiromancy is an art that consists not only in reading the hands of men and taking knowledge from their lines, branches and wrinkles, but includes all plants, all wood, all quart and gravel, the soil and all flowing water and everything that has lines, veins, wrinkles and the like." (Paracelsus, *De signatura rerum naturalium,* 1537)

A. Dürer, From the Dresden Sketchbook, 152?

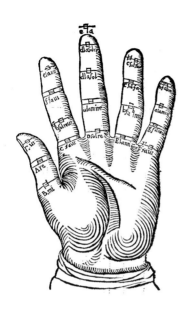

The proportions of the finger-joints in re-lation to musical intervals. "Similarly, the elements, qualities, humours and fluids enjoy particular relationships." (Agrippa von Nettesheim, *De occulta philosophia*, 1510)

A. Kircher, Musurgia universalis, Rome, 1650

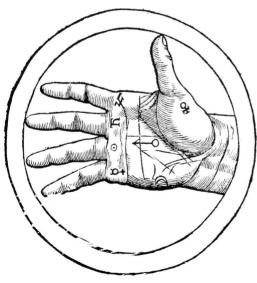

The palm of the hand is read as a land-scape with mountains, valleys and rivers. The seven mountains or elevations of the hand correspond to the seven planets. Their different formation provides information about the development of the area of life assigned to the planet in question; the Mount of Venus of the thumb, for example, informs us about the subject's love affairs, while the Mount of the Sun beneath the ring finger tells us about his creativity and his sensitivity to beauty.

Agrippa von Nettesheim, De occulta philosophia, 1510

Signatures

The Carthusian monk Johannes von Hagen, called ab Indagine (c. 1424–1475), influenced the magical works of Johannes Trithemius and Agrippa von Nettesheim with his many treatises.

He identified three main lines for the interpretation of one's fate fom the palm of the hand: the centre line (linea media), the life or heart line (linea vitae) and the liver line (linea hepatis), which was thought to indicate disturbances in the digestive system.

Johannes ab Indagine, Introductiones Apostelesmaticae, 1556

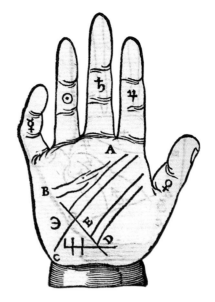

Sigmar Polke, Correction of the lines in the hand

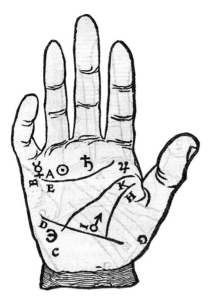

A Imperfect table line

B Sister of the lifeline

C Line of the liver and the stomach

D Sister of the nature line

E Lifeline

Johannes ab Indagine, Introductiones Apostelesmaticae, 1556

A Line of table or fate

B Line of life or of the heart

E Central nature line

F Line of liver or of the stomach

Johannes ab Indagine, Introductiones Apostelesmaticae, 1556

Signatures

This engraving was taken from the model of a Roman bronze sculpture decorated with gnostic embems. The ram's head is a symbol of Jupiter, the pine cone on the thumb stands for spirituality and rebirth. The royal power of the Magic Hand was supposed to protect against all possible diabolical influences.

Anonymous, The Hand of Fate

The fish symbolises the mucal-moist Mercury. It is "beginning, middle and end, it is the copulator, the priest who brings all things together and conjoins them." Here, Mercury means the male seed from which all metals are created. The fire or sulphur "is the woman that brings forth fruit".

J. I. Hollandus, Chymische Schriften, Vienna, 1773

Signatures

pag. 11.

"This is the hand of the philosophers with their seven secret signs, to which the ancient sages were bound.

The thumb:
Just as the thumb powerfully closes the hand, so does saltpetre do in art.

The index finger:
Next to salpetre, vitriol is the strongest salt. It penetrates all metals.

The middle finger:
Sal ammoniac shines through all metals.

The ring or gold finger:
Alum gleams through the metals. It has a wonderful nature and the most subtle Spiritus.

The ear finger:
Common salt is the key to art.

The palm:
The fish is Mercury, the fire Sulphur."

J. I. Hollandus, Chymische Schriften, Vienna, 1773

Signatures

"The ancient philosophers (…) marked out the contellations, figures, seals and characters which nature itself has illustrated with the rays of the stars in stones, in plants and their parts, as well as in the different limbs of the animals." (Agrippa von Nettesheim, *De occulta philosophia,* 1510)

"This writing has expressed itself adequately, a match for the bright light of day. And yet for us it is hidden and vague." (Giordano Bruno, *About the Monas,* 1591)

Astrologers and geomancers, on Sir John de Mandeville's Travels, Bohemia, 1410–1420

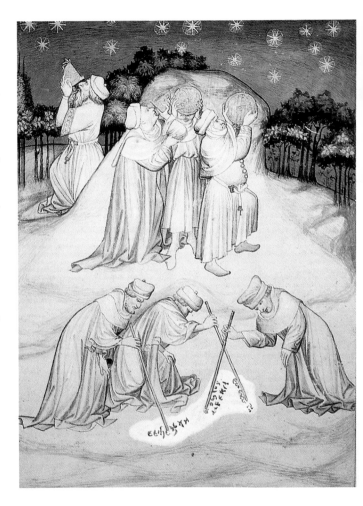

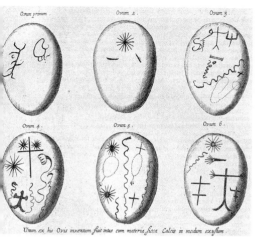

"People go many different ways. Anyone who follows and compares them will see wonderful figures appear; figures that seem to belong to that great script of ciphers that one sees everywhere, on wings, eggshells, in clouds, in snow, in crystals and in stone formations, in frozen water, inside and outside mountains (…) and in the particular conjunctures of chance. In them, one senses the key to this wonderful script, its grammar."

(Novalis, *Die Lehrlinge von Sais,* 1800)

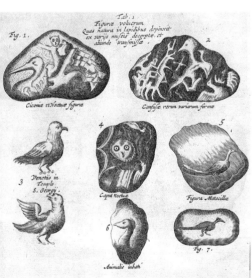

"I was further confirmed in my view of assigning a soul to the earth (…) that there must be a shaping force in the bowels of the earth which, like a pregnant woman, depicts the events of human history, as they played out above, in the frangible stone (…)." (Johannes Kepler, *Harmonices Mundi,* 1619, Leipzig edition, 1925)

A. Kircher, Mundus subterraneus, Amsterdam, 1682

Signatures

"This is the appearance of a small crab found in the Öresund: Cancer maenas. It is not an exception, but the rule; when I bought twenty of them along that part of coastline, all twenty were marked by the same, sleepy facial expression. (…) What it means? I don´t know!"

August Strindberg,
A Blue Book,
Munich, 1918

"The heart is based on the curve of the diaphragm, but the axis is inclined at an angle of 23°, like the axis of the earth against the path of the sun. And the heart is like the bud of the lotus flower, says the Chinaman, while the Egyptians worshipped the flower of the sun (Isis). The eye shows the same adjustment and inclination towards the earth's axis or the sun's path, for the optic nerve is situated 23° beneath the yellow patch which resembles the sun and receives the image on the aperture of the iris. The outer ear is a shell (mytilus), but the inner ear is a snail (planorbis). The most curious thing is that the little bones in the ear (right) bear a passing similarity to the animal in the mud-snail, Limnaeus (left)."

August Strindberg, A Blue Book,
Munich, 1918

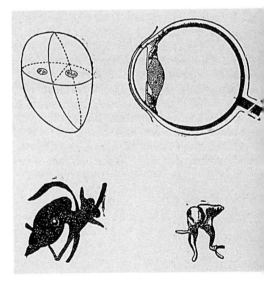

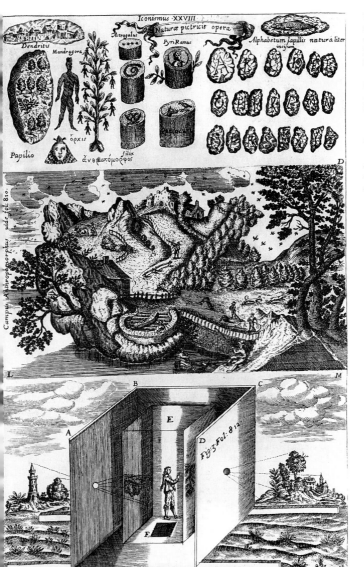

III. top: Nature as
an artist: signa-
tures and fossils,
including an alpha-
bet of stones.

III. middle:
Anthropomorphic
landscape.

III. bottom:
Camera obscura.

*A. Kircher, Ars
magna lucis,
Amsterdam, 1671*

Script
& seal

According to Kircher, Adam's primal knowledge, the *prisca sapientia,* was handed down in unbroken succession to Noah. This knowledge was based on man's ability to communicate directly with the spiritual worlds through the primal or natural language, which was then split into the multiplicity of regional languages in the wake of the Babylonian confusion of languages. After God had allowed Noah and his family to survive the flood in an ark, Noah's sons began to repopulate the earth. Shem, cursed by his father, moved to Egypt, and thus became the source of all wisdoms as captured in the hermetic writings. Despite the respect in which the Egyptologist Kircher held that country's cultural achievements, he also saw Egypt as the mother of all religious errors such as polytheism, the doctrine of reincarnation, idolatry and black magic practices.

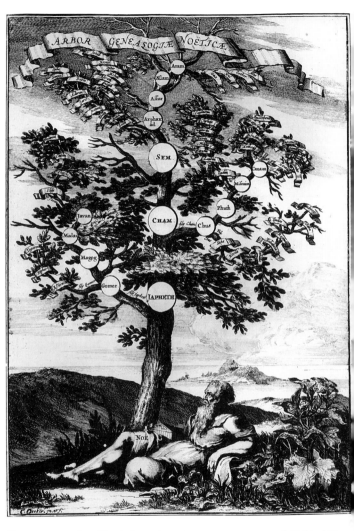

These were passed on to all parts of the world which, in his view, were colonized by Shem's descendants. They include India, China, Japan and America.

A. Kircher, Arca Noë, Amsterdam, 1675

The primal script (in the second column) was revealed directly to man by the angels. The Hebrews called it the celestial script "because it is illustrated in the stars". (Agrippa von Nettesheim, *De occulta philosophia*, 1510) From it developed the Hebrew and other related alphabets. Kircher also traced the Egyptian hieroglyph back to divine revelation, which was protected and preserved in the hermetic reserve of a sacred sign-system. Unlike subsequent research based on decoding the individual hieroglyphs as letters, Kircher gave symbolic meanings to his attempts at decipherment.

A. Kircher, Turris Babel, Amsterdam, 1679

A
B
C
D
H
V
Z
Ch
T
I
C
L
M
N
S
Ayn
P
Ts
QK
R
Sch
Th

"Combinatory table in which (…) the forms of the original letters, like all those descended from them, are represented in terms of their development over time. From them, it can be deduced that the alphabets of all languages reveal traces of the ancient characters."

II

IV III

"It is highly likely that the children of Sam, who colonized even the outermost ends of China, also introduced the letters and characters here (...) Even if the characters of the Chinese were similar to those of the Egyptians, they differed greatly in the manner of writing, and in the fact that

Egyptians never (...) used hieroglyphs in everyday conversation, as none but the ruler was allowed to learn them. In addition, the hieroglyphs were not simply words, but expressed general ideas and entire concepts."

VII

VI V

Chinese characters, like Egyptian hieroglyphs, are derived from pictograms taken from the sphere of natural things. The characters in fig. II from agricultural things, Fig. III from birds and in Fig. IV from worms.

A. Kircher, La Chine illustrée: Monuments, Amsterdam, 1670

XVI XV

The characters in Fig. XV are based on fish. "Fig. XVI with the letters KLMNO could not be deciphered, so we do not know what it means."

A. Kircher, China Monumentis, Amsterdam, 1667

"The Chinese are thought to have used the figures on the shell of the tortoise as a model for the oldest characters of their alphabet. The most curious 'games of nature' include the drawings on the snail 'conus marmoratus' from the Indian Ocean. It shows a clear similarity to cuneiform writing (...) Experts might study this snail-text. At first, I thought of sending it to Professor Delitzsch, but then thought I would wait (...)." (August Strindberg, *A New Blue Book, Munich, 1917*)

A. Kircher, China Monumentis, Amsterdam, 1667

Despite the testimony of his 16th century contemporaries, the actual existence of the black magician John Faust, made famous in the plays of Marlowe and Goethe, is not easily proven. Several of the best-known magic books, some of them from the 18th century, have been attributed to him.

These seals are supposed to have been used in a magic rite granting the magician "wealth, honour, glory and pleasure". "For after death, everything ends."

The striking similarity of many magical seals to Arabic characters is explained by their origins. The most important source is considered to be a Spanish-Arabic collection of magical formulae, astrological discourses and alchemistic recipes entitled *Picatrix*, which was in circulation in Latin translation from the end of the 13th century.

From: Doktor Fausts Höllenzwang, 18th century, Stuttgart edition, 1851

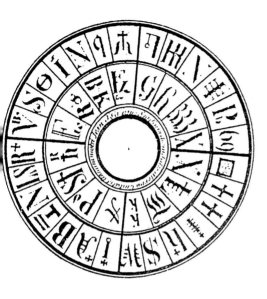

According to the Picatrix, the planets possess powers "which can exert effects specific to their own nature. Accordingly, the makers of talismans produce drawings of them, when the planets are above them, to achieve certain effects, and through well-considered combinations of particular secret things known to them they achieve everything they desire". (*Picatrix*, London, 1962) It is therefore important for the magician to know what earthly things are sympathetic or affiliated to a particular star, in order to be able to quote the desired astral influence in the form of spirit beings or demons.

The magic seals used for this are energy stations which "have a certain similarity to a heavenly picture or with that which the soul of the agent desires". (Agrippa)

Pentaculum Mercurii, in: Doktor Johannes Fausts Magia naturalis, Stuttgart, 1849

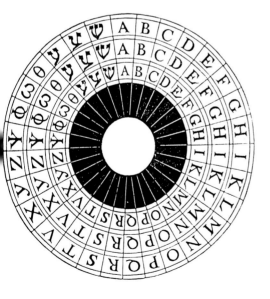

In his complicated magical system Giordano Bruno combined the classical art of memory with the rotating discs of Lullian combinatory art, assigning the decan images of the zodiac, the pictures of the planets and the pictures of the phases of the moon to the individual rubrics.

G. Bruno, Opera II, Naples, 1886

Script
& seal

The *Monas Hieroglyphica* of the English astrologer and mathematician John Dee, first published in 1564 in a treatise of the same name, enjoyed great popularity among the early Rosicrucians and alchemists, since it interpreted the glyph of "their mercury" as the crowning summation of all the signs of the zodiac.

The upper semicircle is the moon, the circle with the point beneath it is the sun, and so on. The cross refers to the four elements, but also points to birth, crucifixion and resurrection. "Dee's hieroglyph represents the whole of being, both macrocosm and microcosm. This can be applied to every hieroglyph. The cipher always stands for the whole of being, even if it only consists of one triangle, the simplest and most frequently used figure." (Dietrich Donat, "Sakrale Formeln im Schrifttum des 17. Jh.", in: *Slavische Barockliteratur I*, Munich, 1970)

A. Kircher, Oedipus Aegyptiacus, Rome, 1653

⊙
Sol

Saturnus Cruce Lu — ex & na.

Venus Solis cha- &ere & Cruce.

Iuppiter Cruce Lu — ex & na.

Mercurius omnibus.

Mars Solis ra&ere & duobus cornibus Arietis. — ex cha- &

Luna

Exaltatio Lunæ in Tauro.

In his *Obelisci Aegyptiaci,* Kircher derived the origin of the Monas hieroglyph from the *Ankh*, the well-known Egyptian sign of life.

A. Kircher, Obelisci Aegyptiaci, Rome, 1666

Crux ansata in manibus simulacrorum irconspicua

Tabula Solis in abaco.

6	32	3	34	35	1
7	11	27	28	8	30
19	14	16	15	23	24
18	20	22	21	17	13
25	29	10	9	26	12
36	5	33	4	2	31

In notis Hebraicis.

ו	לב	ג	לד	רה	א
ז	יא	כז	כח	ח	ל
יט	יד	טז	יה	כג	כד
יח	כ	כב	כא	יז	יג
כה	כט	י	ט	כו	יב
לו	ה	גל	ד	ב	לא

Solis.

Signacula siue characteres Intelligentiæ Solis.

Demonij Solis.

Script & seal

Magic square of the sun, with the diagonal total of 111 and the overall total of 636. "The divine names that fill this table include both an intelligence for good and a demon for evil." The names of the star-spirits are produced by a match between the numerical values and the Hebrew alphabet.

Agrippa von Nettesheim, De occulta philosophia, 1510

Sigmar Polke, Telepathic session II, 1968

Script
& seal

The alchemists derived their language of signs and riddles directly from the patriarchs of their art, from Hermes Trismegistus, who is identified with the Egyptian Thoth, the inventor of hieroglyphic writing. It is said that he wished to "remove that superior part of the wisdom of the world, concerned with God, the angels and the world (…) even that science *(alchemy)* which is the holiest and most superior of all, from the reading of the unworthy". (Adamah Booz, *Splendor lucis,* Frankfurt, 1785)

Alongside the aim of pure obfuscation in the use of these signs and symbols by the hermetics, there was also an attempt at elevating the expressive possibilities of language into the realm of the sacred. Thus, for example, Marsilio Ficino was convinced that the divine ideas of things are conveyed directly in hieroglyphs. "That will be the Golden Age, when all words – figure-words – myths – and all figures – language figures – will be hieroglyphs." (Novalis, *Freiberger naturwissenschaftliche Studien,* 1798)

Medicinisch-Chymisch und Alchemistisches Oraculum, Ulm, 1783

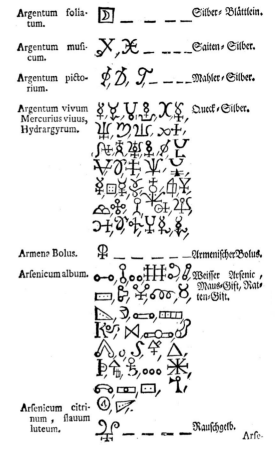

Tab. 5.
Proben ihrer innern Schrift.

Script & seal

In 1826 the Swabian poet, doctor and occultist Justinus Kerner took the seriously ill clairvoyant Friederike Hauff into his home, and tried to heal her with magnetic cures devised by Mesmer. In his *Clairvoyant of Prevorst*, published in 1829, he also describes her ability to express herself in her own "inner language and writing". "She said (…) that one could survey one's whole life after death in a single such sign." Kerner drew comparisons with Adam's primal language which went to the heart of things and named every creature by its true name.

J. Kerner, Die Seherin von Prevorst, Stuttgart, 1829

Script
& seal

"In the wide space of heaven (…) are figures and signs with which one can discover the deepest secrets. They are formed by the constellations and stars (…) These brilliant figures are the letters with which the Holy and Glorious One created heaven and earth (…)." (Zohar)

"According to the Hebrew rabbis, the letters of their alphabet are formed from the figures of the stars and are thus full of heavenly mysteries, both because of their shape, form and meaning and also because of the numbers contained therein (…)." (Agrippa von Netteheim)

Karl von Eckhartshausen, Aufschlüsse zur Magie, Munich, 1788

The celestial alphabet of the southern hemisphere

The celestial alphabet of the northern hemisphere

Apparitions

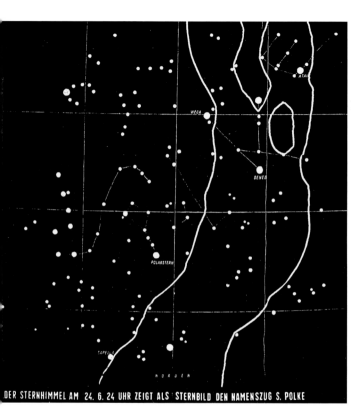

DER STERNHIMMEL AM 24. 6. 24 UHR ZEIGT ALS STERNBILD DEN NAMENSZUG S. POLKE

"The night sky on 24.6.24 shows the name S. Polke as a constellation"

Sigmar Polke, Night-Sky Cloth, 1968

Apparitions

In 1857, Justinus Kerner published his ink-blot pictures, a technique with which he had experimented for decades, in the belief that he had found in this aleatory art a medium that would bring him into closer contact with the spirit world. Since 1921 Kerner's invention has been applied in psychotherapy, in a slightly altered form, as the "Rohrschach test".

Kerner was an early exponent of spiritualism, which had developed in the Romantic age, strongly influenced by Swedenborg's visions. In 1788 a Swedenborgian group in Stockholm had supposedly managed to communicate with spirits via mediums in a mesmeric trace. But it was not until the middle of the 19th century, when some spectacular cases of table-rapping had become famous, that interest in spiritualism and so-called psi phenomena spread like an epidemic, forming fertile soil for the success story of the Theosophical Society.

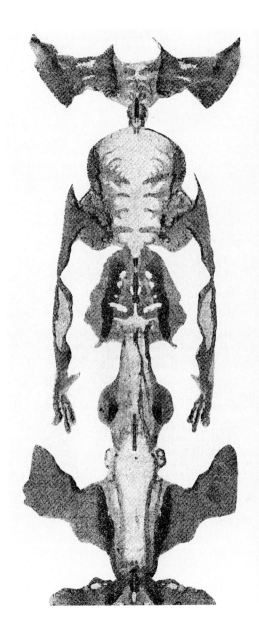

Yves Klein, The Vampire, 1960

Apparitions

In 1894, from *the fin de siècle* occult store-house, the dramatist August Strindberg developed a radical, aleatoric concept which he applied, amongst other things, in the field of photography and photo-chemical experiments. Thus he took portraits with a camera of his own manufacture containing a lens of unground glass, to capture the soul more authentically on the plate. Or else, as these illustrations show, he exposed the plates to the night sky in the developing bath, on the assumption that the light would be directly transferred via the electromagnetic waves, recently discovered by Röntgen.

A. Strindberg, Celestographs, 1894

"Quite clearly the spirits, like we mortals, have become realists (...) for on certain days the pillow represents terrible monsters, gothic dragons, lindworms (...) A newly discovered art from nature! Naturalistic clairvoyance! Why complain about naturalism when, full of possibilities for growth and development, it ushers in a new art? The gods are returning (...)."
(A. Strindberg, *Inferno*, Berlin, 1898)

A. Strindberg, Inferno painting, Stockholm, 1901

"A mirror lay on my table, reflecting the picture of the moon. I thought: how does the mirror capture the moon and reflect it when the lens and camera of my eye are not there to distort? From the perspective of optics, each point on the flat surface of the mirror must reflect the light of the moon after such and such a law. (...) So I switched the mirror for a silver bromide plate to achieve a more poweful effect, put it in the developer and exposed it at the same time."
(A. Strindberg, *Sylva Sylvarum,* 1897)

A. Strindberg, Celestographs, 1894

Five years before the theosophist Wassily Kandinsky formulated the foundations of abstract painting, Annie Besant and Charles Leadbeater, who followed Blavatsky as director of the Theosophical Society, published a book of fifty-seven abstract paintings, "thought forms" (1905).

Plate 8: Unspecified selfless love:
"A revolving cloud of pure love".

C.W. Leadbeater, Annie Besant, Thought-forms, New York, 1905

Apparitions

"Those who think a great deal are extremely materialistic, because thinking is matter. Thought is also matter, like the floor, the wall, the telephone. Energy, which acts as a stencil, becomes matter." (Krishnamurti, *Breakthrough into freedom,* Frankfurt edition, 1973)

The Hindu boy Krishnamurti, whom Leadbeater and Besant had hailed as a new Messiah, parted company with the Theosophical Society in 1929, and began to work as an independent teacher.

Plates 49 and 50: Helpful thoughts

Leadbeater and Besant, Thought-forms, New York, 1905

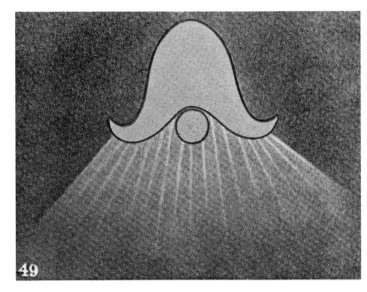

Apparitions

The dream of a deluge-like rain, from which Dürer awoke on the night of 8 June, 1525, was connected with the fear of a flood prophesied by various astrologers for 1524.

A. Dürer, Dream vision, 1525, water-colour

Sigmar Polke, Developing phenomena, Venice Biennale, 1986

Apparitions

At the end of time, the prophets Elijah and Enoch, who are said to have been sent alive to Paradise, will appear and, with these signs, show the imminent destruction of corrupt Babylonian Christianity: the triple cross is the Trinity, now revealed in all things as their true signature. The sword and the rod announce that Babylon's force will turn against itself. The "grim wrath-fire of God" will soon engulf them both, and will begin the Golden Age of natural language "in which that which has been lost in the spirits of the letters will be rediscovered".

Die letzte Posaune an alle Völker oder Prophezeiungen Jacob Böhmes, Berlin and Leipzig, 1779

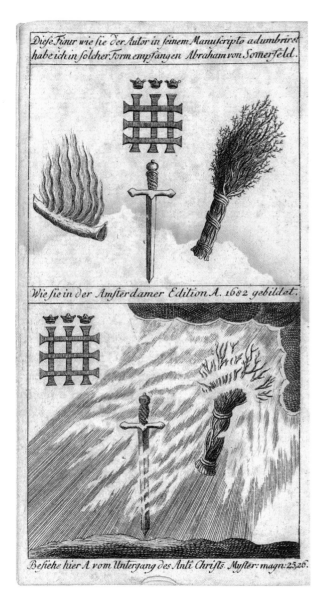

"It seems not to be generally known that sound produces form as well as colour, and that every piece of music leaves behind it an impression of this nature, which persists for some considerable time, and is clearly visible and intelligible to those who have eyes to see."

Here we see the music of Mendelssohn, which emerges from the organ in the form of a balloon through the roof of a church. "The height of this form above the tower of the church is probably a little over a hundred feet." (C.W. Leadbeater, Annie Besant, *Thoughtforms,* New York, 1905)

Leadbeater and Besant, Thoughtforms, 1905

LOCO ET TEMPORE.

ROTATION

"The essence of God is like a wheel (...),
the more one looks at the wheel,
the more one learns about it its shape,
and the more one learns,
the greater pleasure one has in the wheel (...)."
(J. Böhme, 1612)

Whirl & magnet

" – Three quarks for Muster Mark!"
(J. Joyce, *Finnegans Wake*)

In 1895 Annie Besant and Charles W. Leadbeater began a decade-long series of experiments, in which they attempted to penetrate the micro-level of matter by using meditation techniques. They assumed the existence of seven aggregate states of matter, including the ethereal, the super-ethereal, subatomic and atomic, all of which could be "seen through" by clairvoyant people.

Newton's hypothesis of stones as solid, inpenetrable particles, had been in existence for a long time, but as early as 1895 it was suspected that these consisted of still smaller, electrically charged particles, electrons.

In the rotating hydrogen atoms which appeared to the two theosophists, they discovered smaller particles in which points of light appeared, the so-called "subatomic or hyper-meta-proto-elements". These smallest particles each consisted of ten intertwined whirls, which formed a heart-shaped body. These particles form units, of which Leadbeater and Besant were able to differentiate a total of seven basic shapes.

Leadbeater and Besant, Occult Chemistry, 1908

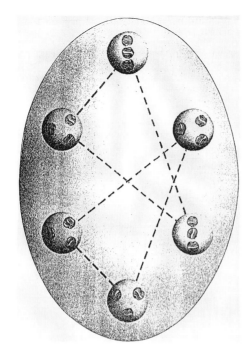

Whirl & magnet

"The whole (hydrogen) atom spins and quivers, and has to be steadied before exact observation is possible. The six little bodies are arranged in two sets of three, forming two triangles that are not interchangeable, but are related to each other as object and image." In each of the six particles, there appear three points of light, the subatomic whirling elements.

Leadbeater and Besant, Occult Chemistry, 1908

The subatomic "hyper-metaproto-element", also called a primal atom, consists of ten energy whirls, three thick, lighter main whirls and seven subsidiary whirls. Besant and Leadbeater compared this structure with that of the Sephiroth tree.

Leadbeater and Besant, Occult Chemistry, 1908

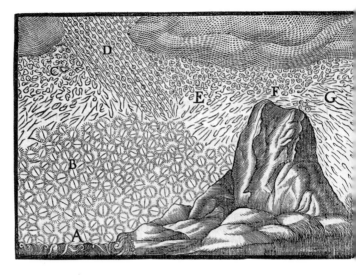

René Descartes (1596–1650) refuted the assumption of the Scholastics that the planets move in a vacuum. According to his theory, space is filled with a material that he called 'plenum'. This consists of tiny particles which set each other in centrifugal motion and thus form the heavenly bodies. "We must assume that the entire matter of the heavens (...) rotates constantly like a whirl, with the sun at its centre (...) Just as one can observe the formation of whirlpools in rivers, that individual grasses floating in it run with the water, while others rotate around their own centre and rotate faster the closer they come to the centre, it is easy to imagine the sam of the planets." (*Principia Philosophiae*)

This spiral theory inspired William Blake to write a passage in his poem 'Milton', in which the Puritan poet, upon returning to earth, where he must redeem the female parts of his soul, dashes like a comet through the solar system. (The snaking line in the illustration opposite describes the path of a comet through Descartes' whirl.)

René Descartes, Principia Philosophiae, Amsterdam, 1656

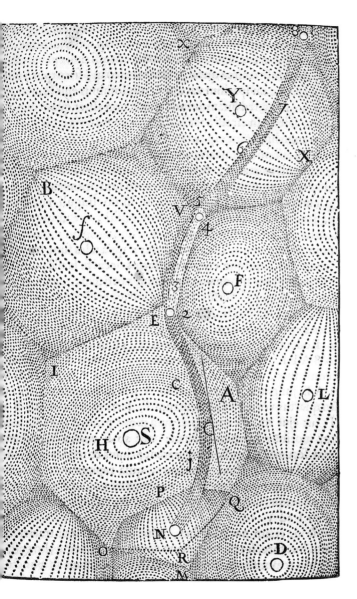

"The nature of infinity is this: That every thing has its/ Own Vortex, and when once a traveller thro' Eternity/ Has pass'd that Vortex, he perceives it roll backward behind/ His path, into a globe itself infolding like a sun, / Or like a moon, or like a universe of starry majesty,/ (...) As the eye of man views both the east & west, encompassing/ Its vortex (...) / Thus is the earth one infinite plane, and not as apparent/ To the weak traveller confin'd beneath the moony shade." (William Blake, *Milton*, 1804)

René Descartes, Principia Philosophiae, Amsterdam, 1656

Whirl & magnet

Emanuel Swedenborg (1688–1772) was, before he devoted himself entirely to his vision of the Beyond, one of the most noted scientists of his time. His theories about the origin of the solar system were considerably influenced by Descartes. He took the smallest particles to be points which put each other in spiral orbits, and thus formed the first substance. He termed them "the first or simple Infinite". With the addition of the magnetic element, the original solar ocean became a Cartesian whirl and it was here that the Finita of the fourth order emerged. These formed a kind of crust around the solar whirl – which Swedenborg identified with the chaos of the ancients ." (Inge Jonsson, "E. Swedenborgs Naturphilosophie", in: *Epochen der Naturmystik,* Ed. Faivre/Zimmermann, Berlin, 1979) (Fig.1) This crust dilates until it breaks (Fig. 2) and forms an equatorial belt (Fig. 3). The matter thus liberated forms spheres on the level of the zodiac (Fig. 4), which now revolve around the sun as autonomous planets and satellites (Plate XXVII).

"This concept marks a further stage of development in Descartes' hypothesis, that the planetary system arose out of an influx of matter from outside into the solar whirl. Swedenborg's ideas were actually

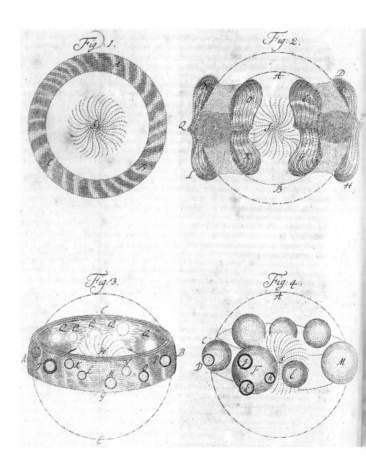

Emanuel Swedenborg, *Opera philosophia et mineralia*, Dresden and Leipzig, 1734

Whirl & magnet

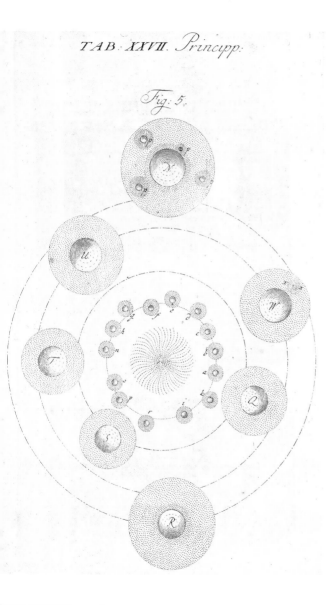

Whirl & magnet

The investigation of magnetic phenomena was a central focus in Swedenborg's nature studies. In the 17th and 18th centuries magnetism was a blanket term covering all possible phenomena in the threshold zone between mind and matter. Goethe called the magnet "a symbol of everything left over, for which we need seek neither words nor names". *(Sprüche in Prosa zur Farbenlehre)*

"And thus you too, my dear man, see magnetic man while he is still bound to the body and thus to the world of the senses, emerging with extended antennae into the spirit world, of which he will be your witness." (Justinus Kerner, *Die Seherin von Prevorst,* 1829)

Emanuel Swedenborg, Opera philosophia et mineralia, Dresden and Leipzig, 1734

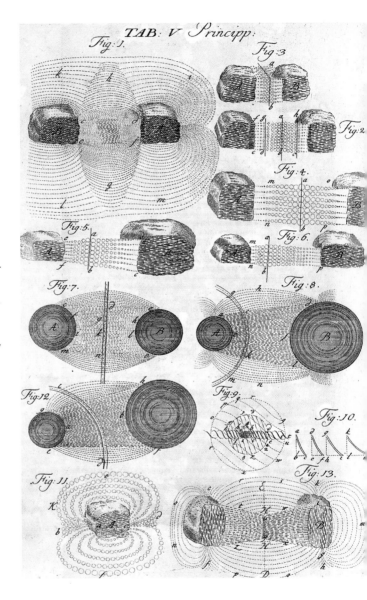

*E. Sibley, A Key to
Magic & the Occult
Sciences, c. 1800*

One major influence on the Romantic philosophy of nature was the spectacular and widespread magnetic cures of the Austrian doctor Franz Anton Mesmer (1734–1815) and his theory of "animal magnetism". The Freemason and patron of Mozart was familiar with the theories of Paracelsus and the healing practices of Robert Fludd. Like Fludd, he based his work on a magnetic bipolarity of the human body and the influence of an all-pervasive vital fluid. Illnesses derived from an unharmonic distribution of this fluid life-force. At first Mesmer attempted a balancing influx via group therapy, involving the touching of magnetic objects, later transferred directly from the doctor to the patient through the power of suggestion. Thus, Mesmer became a pioneer of hypnotherapy.

Divine
Geometry

Ernst Chladni (1756–1827) illustrated his book *Entdeckungen über die Theorie des Klangs*, (1787), the first comprehensive treatment of scientific acoustics, with a large number of the sound-figures that are produced when a plate covered with a fine powder is vibrated with a violin bow.

The origin of the Indian Yantras is also thought to derive from sound-patterns such as these. "Everything that we see and feel in the universe, from thought or idea to matter, is sound in a particular concentration." (Ajit Mookerjee, *Tantra-Kunst,* Basle edition, 1967/68)

Novalis, impressed by Chladni's experiments, observed: "Might the letters originally have been acoustic figures, letters a priori?" (Novalis, *Das Allgemeine Brouillon,* 1798/99)

Ernst Chladni, Entdeckungen über die Theorie des Klanges, 1787

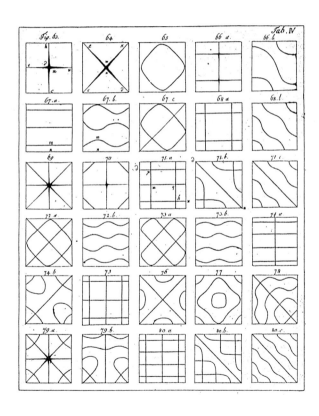

Divine Geometry

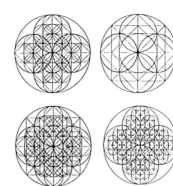

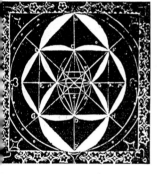

from: 14 Hauptschlüssel der Steinmetz-
zeichen, in: Der Steinmetz, Hallein, 1980

"Geometry existed before the creation of things, as eternal as the spirit of God; it is God himself and gave him the prototypes for the creation of the world." (Johannes Kepler, *Harmonices Mundi*, 1619)

"The order of a unique figure and the harmony of a unique number give rise to all things." (Giordano Bruno, *About the Monas*, 1591)

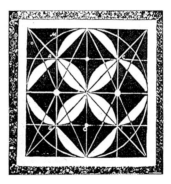

Figure of love, Giordano Bruno, Articuli centrum..., Prague, 1588

Figure of the spirit, Giordano Bruno, Articuli centrum..., Prague, 1588

Divine
Geometry

In an idea of Plato's, supposedly based on the secret teachings of the ancient Egyptians, the smallest particles in the world consist of regular triangles. These form five regular bodies, the basic units of the five elements. (ether, or the celestial fire, was seen as quintessence.)

According to calculations carried out by Johannes Kepler in 1596, the "Geometrical God" had allocated these five bodies to the precise distances between the planetary orbits: to the Saturn-Jupiter sphere the six-sided cube standing for the element "Earth", to the Jupiter-Mars sphere the pyramid-shaped four-sided tetrahedron (Fire), between Mars and Earth the twelve-sided dodecahedron (Ether), between Earth and Venus the twenty-sided icosahedron (Water), and between Venus and Mars the eight-sided octahedron (Air).

Kepler had no doubt that in making this discovery, which he had to revise a short time later, he had tapped into the ancient hermetic source of wisdom. "I have robbed the golden vessels of the Egyptians," he confessed, "to build a holiness for my God, far from the borders of Egypt." (*Harmonices Mundi,* 1619)

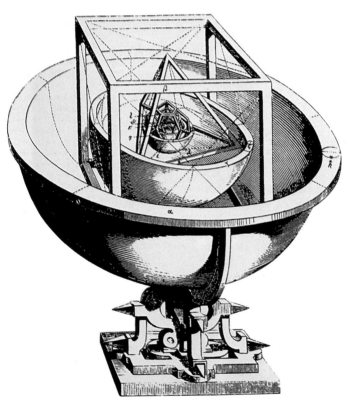

*J. Kepler,
Mysterium Cosmographicum, 1660*

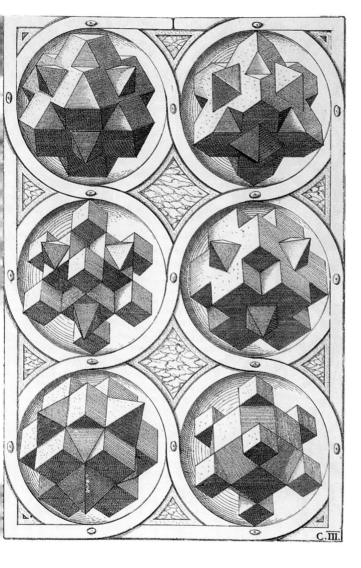

Divine Geometry

Just as the infinite variety of natural things emerges from the five Platonic elemental bodies, infinite variations of perspective can also be deduced from their fundamental, geometrical structures. Nuremberg goldsmith Wenzel Jamnitzer (1508–1585) constructed 140 such geometrical figures, then had the Zurich artist, Jobst Amman make copper plates of them. "The definitive theory of matter will, as in Plato, be characterized by a series of important requirements of symmetry (…). These symmetries can no longer simply be explained through figures and pictures, as was possible in the case of the Platonic bodies, but through equivalents." (Werner Heisenberg, *Schritte über Grenzen,* Munich 1971)

W. Jamnitzer, Perspectiva Corporum Regularium, Nuremberg, 1568

Divine Geometry

Blake's illustration refers to a passage in Milton's poem on melancholy, 'Il Penseroso' (1631), in which Hermes Trismegistus and the spirit of Plato appear to him at night to reveal the metaphysical worlds.

In accord with his motto, 'opposition is true friendship', Blake reserved his most violent attacks for the figures who had been the source of the greatest stimulation: Trismegistus-Mercury fetters the imagination with his abstract and materialistic doctrines, and Plato's philosophy is characterized by bellicose morality and virtue (Mars in the central sphere). Blake depicted Plato's God as a hard-hearted geometrist with the compass of deadly reason in his hand (right-hand sphere).

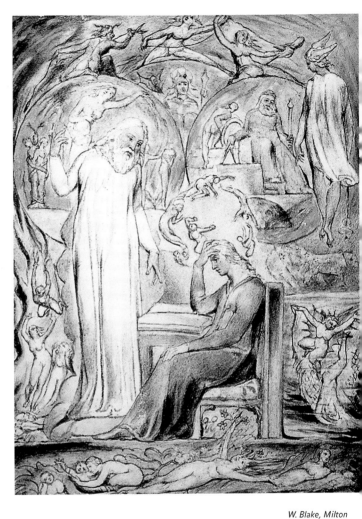

W. Blake, Milton and the Spirit of Plato, c. 1816, watercolour

Divine Geometry

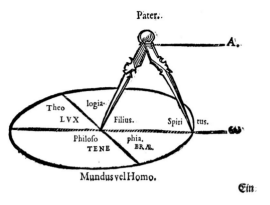

Pater.

A.

Theo logia·
LVX
Philoso phia.
Filius. Spiri tus.
TENE BRÆ.

Mundus vel Homo.

Ein

"Note this, that of the knowledge of God there are two kinds, one natural, from the light of nature, which does not yet bring rebirth or bliss *(Philosophia as the dark side)*, and a supernatural knowledge from the light of faith or mercy, and herein lies complete bliss *(Theologia as the bright side)*."

V. Weigel, Introductio hominis, in Philosophia Mystica, Neustadt, 1618

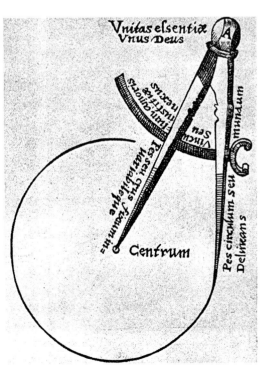

Vnitas essentiæ
Vnus Deus

Centrum

The oneness of God is expressed in the visible, elemental world, by the polarity of rest and movement as the fixed and the drawing legs of the compass. The two are linked by "the bond of love or justice".

R. Fludd, Utriusque Cosmi, Vol. II, Frankfurt, 1621

"The One is not
included by any
Limits. The Heav-
ens of Heavens,
comprehend Thee
not."

*D.A. Freher, Para-
doxa Emblemata,
manuscript,
18th century*

> 14
>
> *The One is not included by any
> Limits.*
>
> *The Heavens of Heavens, compre-
> hend THEE not.*

The 'Paradoxa Emblemata' of Dionysius
Andreas Freher (1649–1728) never
appeared in print, but they did circulate in
a number of handwritten copies in English
bohemian circles, including the Philadel-
phia society headed by John Pordage and
the Anglican mystic Jane Leade.

By this means they are Combined. 1⁵⁷

Here is Labour, & there is Rest.

"By this means they are Com-
bined. Here is
Labour, & there is
Rest."

*D.A. Freher, Para-
doxa Emblemata,
manuscript,
18th century*

The extraordinary level of abstraction in these 153 hieroglyphs or emblem pictures corresponds to the theme: the relationships between unground and ground, between nothing and something, unity and variety. The Zohar and Böhme both identify the primal point present in all things, the eye of the needle that connects the two ends, with Sophia, the divine matrix.

Divine Geometry

In Masonic symbolism the compass stands for reason. While work is done in the lodge, the compass and the set-square lie crossed on the Bible. They are called the 'three great lights', testimony to "the omnipotence, justice and mercy of the supreme architect of heaven and earth". The plumb tests inner authenticity and outer straightness.

"Through labour and experience", "the first and final *(corner-)*stone of the Church of Jerusalem" is found: "light from the darkness".

P. Lambert, Freemasons at work, London, 1789

Divine Geometry

In the Pythagorean-Christian cosmology of the Freemasons, God is the supreme architect of a perfect geometric cosmic order, with brotherly love as the measure of all things.

"For we are labourers together with God: ye are God's husbandry, ye are God's building. According to the grace of God which is given unto me, as a wise master-builder, I have laid the foundation, and another buildeth thereon. But let every man take heed how he buildeth thereon. For other foundation can no man lay than that is laid, which is Jesus Christ." (1 Corinthians 3, 9–11)

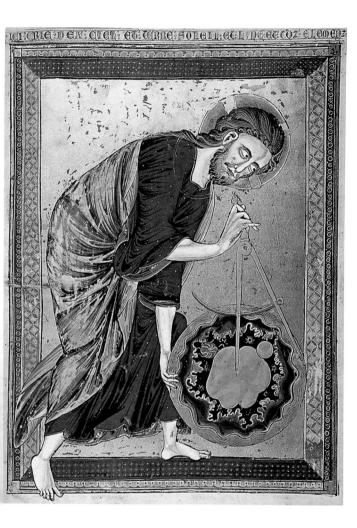

God measuring the world with the compass, c. 1250, Bible Moralisée

Divine Geometry

For Blake, reason represents the outer limit of energy. If separated from its centre, the imagination, it becomes a Satanic, veiling power. Here, the saturnine creator God, Urizen, is creating the 'mute sphere' (Ulro), the "circled cage or the distempered sphere of imagination of frozen heaven" in which man "runs about in the circle of his earthly body". (Abraham von Franckenberg, *Oculus sidereus*, 1643)

Urizen is the hidden God of the Deists, separated from his mechanical universe and his creations.

W. Blake, Europe, 1794

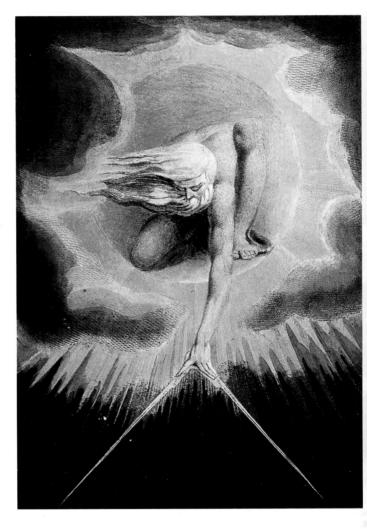

Divine Geometry

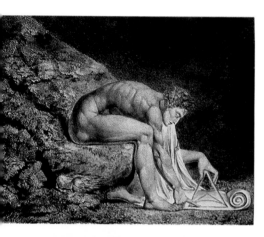

Here, Newton is sitting in the gloomy waters of Ulro, constructing a physical eye. The whole world is God's organ of perception, he wrote in the first edition of the *Opticks* (1706). For Blake, however, Newton's design of a material and functional universe mirrors his own 'simple vision'. "He who sees the infinite in all things sees God. He who sees the ratio, sees only himself." (*There is no Natural Religion*, 1788)

W. Blake, Newton, 1795

Franciscus Aguilonis, Optica, 1611

oyce interprets the circle that Newton is rawing with the compass in Blake's icture as a 'cyclone'. (*Finnegans Wake,* . 294) The word refers on the one hand o Blake's own 'optics', according to which ght, borrowing from Descartes and

Böhme, acts like an open, creative whirl. On the other hand it refers to Newton's materialistic 'one-eyed-ness' (Cyclops), based on the idea that one can "see with the eye and not through the eye". (Blake)

'OTATION: Divine Geometry

633

Divine
Geometry

On the subject of his book 'Finnegans Wake', on which he was working at the time and which was to occupy him for seventeen years between 1922 and 1939, Joyce wrote to a patron: "I'm working on a machine with only one wheel. Without spokes, of course. The wheel is a perfect square."

Joyce would not be Joyce if the gap that clearly yawns between the two phrases could not be meaningfully closed. There is much in the book about keys that must be found, and the closing passage includes the words: "The Keys to. Given!".

FW 293

Not only does the 'Wake' deal in many places with hermetic motifs, subjecting language itself to a fundamental process of transformation – its external structure is also based on the alchemistic process. Like Blake and Swift, Joyce used the techniques which Fulcanelli identified as characteristic of the language of the alchemists: 'Double meanings, approximations, word-play and homophonies". (Fulcanelli, *Le Mystère des Cathédrales*, Paris, 1925)

The "rotary processus", designed to transfer the four-elemental disharmony of the *prima materia* and the four chapters of the book into the perfect roundness of the lapis, is externally accomplished in the well-known effect whereby the closing words of the book, "(...) a long **the**" are supposed to flow into the opening: "riverrun past Eve and Adam's (...)".

Joyce provided crucial references on pages 293–294, in which the twin sons of the protagonist Anna Livia Plurabelle are pre-occupied with finding the solution to a geometrical problem. Joyce took the diagram from a commentary to Euclid by the Neoplatonist Proclus. The intersections ALP stand for the initials of the mother. The accompanying text, full of references to Blake's mythology and his picture of Newton, reveals that behind the point P for Plurabelle stands the Greek letter Rho, which is written like the Latin P. (Cf. Alexander Roob, *CS IV, der Punkt rho*, Ed. Kunsthalle Nuremberg, 1992)

A is inverted as V or U on the mirror-axis L (for Liffey, the river that flows through Dublin), and thus we have, as a lower *(plutonic)* counterpart to the transcendental *platonic* αλπ, Blake's world of darkness, Ulro, the "vegetable cell" (295) in which

man vegetates in a purely physical sense.

rho/P is the "cloukey to a worldroom beyond the roomworld" (100), and the nagram of rho: "Ohr für oral, key for crib" (302) serves not only as a key to the cryptogram, but also to the cryptic nature of the book itself, which is a sound-book, word-music. Here, Joyce used a series of ncryption techniques similar to those of ohn Dee in his *Monas Hieroglyphica*.

Nestling in the seam between the beginning and end of the book lies 'theohri' (heory), and it should be born in mind hat the beginning of the book, as in Plato's cycle of the world, is a recursive ne, as the following reading suggests: the ohr/er'. ("Or that both may be contemplated simultaneously?" 109)

Joyce was also familiar with Madame Blavatsky's interpretation of the letter T (Greek 'Tau') as an androgynous symbol of the "reciprocal containment of two opposite principles in one, just as the Saviour is mystically held to be male-female". (H. P. Blavatsky, *The Secret Doctrine*, 1888) This might mean, for the end of the book, that an invisible **theos** contains not only a **he-rho** (hero) but also a **she-rho** (chi-rho: Christ).

"Exclusivism: the Ors, Sors and Fors, which?" (299) 'Rho/P' generates a whole series of hermetic associations, familiar from the picture series of Janus Lacinius: English 'rope', the 'Tau' (dew) of the Rosicrucians; French 'roi', the king, and 'or', gold and, in Hebrew, light. And of course the tail-biter 'ouroboros', as the prototype of endless rotation.

*Alexander Roob,
CS V, Ed. Bernd
Schulz, Klagenfurt,
1995 (after Ernst
Mach, Analyse der
Empfindungen,
1886)*

Divine Geometry

Against the abyss of uncreated matter stands the divine Trinity, and, through the holy name, it generates the three consonant intervals of the octave, the fifth and the fourth, which, according to the law of the Pythagorean tetractys, produce the entire spectrum of phenomena in the elemental, the celestial and angelic worlds.

R. Fludd, Utriusque cosmi, Vol. II, Oppenheim 1619

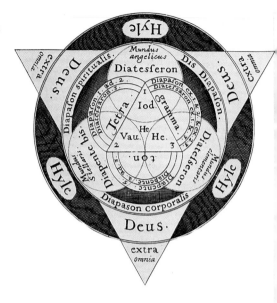

"Although God himself delights in the odd number of the Trinity, nonetheless he unfolds himself profoundly through the quadrinity in all things: thus he finally enters the physical for the sake of its comprehensibility." According to Bruno, the geometrical figure is the visible number. Through the power of numbers "humans can become cooperators of operating nature". (Giordano Bruno, *On the Monas,* Hamburg edition, 1991)

Figure of the quadrinity, from Giordano Bruno, Vol. I, Naples, 1886

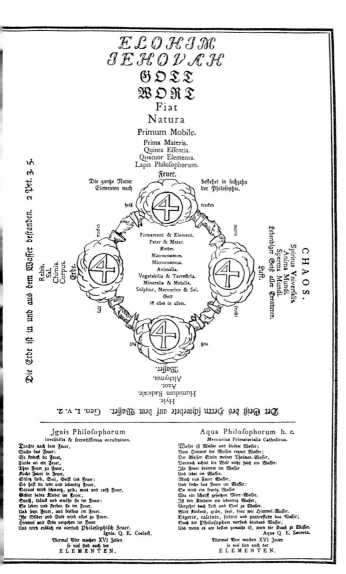

"Transforming nature is nothing but driving the elements around in a circle." (Arnald de Villanova, *Chymical Writings,* Vienna edition, 1749)

Secret figures of the Rosicrucians, Altona, 1785

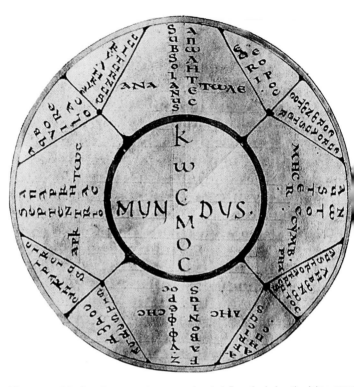

The system of the four elements and humours has a macrocosmic equivalent in the four compass points and the winds. Isidore of Seville, the greatest encyclopaedist of the Middle Ages (c. A.D. 560–636) added two further winds to each of the main winds, in analogy to the elemental qualities. These bring good or bad weather.

Left: the rough north wind *(septentrio)* is cold and brings snow. Added to it are *circius* (Greek *thrascias*), which brings snow and hail, and *aquilo (boreas),* which is frosty and dry.

Top: the east wind *(subsolanus)* is moderate. To its left blows the drying *vulturnus*

(caecias). Eurus (sorios) on the right, waters the clouds.

Right: the south wind *(auster),* which is also used as a symbol for the Holy Spirit, brings heavy clouds and light showers, and encourages the growth of plants. *Euroauster (euronotus)* on the right, is warm, *austroafricanus (libonotus)* on the left, warm and mild.
Bottom: the west wind (*Zephyrus*) is the gentlest wind. It blows away the cold of winter. *Africus (lips)* on the right, brings heavy storms, *corus (agrestes)* on the left, brings clouds to the east.

Encyclopaedic manuscript anthology, Cologne c. A. D. 800

Wheel

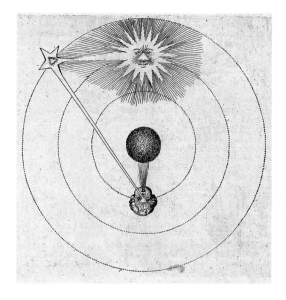

In the sun dwells the divine central fire, the 'soul of the world', which is shown here transmitting its vivifying ray of energy to Saturn, which in turn guides it into the north wind. Fludd called the winds "the angels of the Lord (…) which realize the word of God". They are "his lambent servants", which bring the salt of life.

R. Fludd, Philosophia Sacra, Frankfurt, 1626

A. Dürer, Die Armillarsphäre, 1525

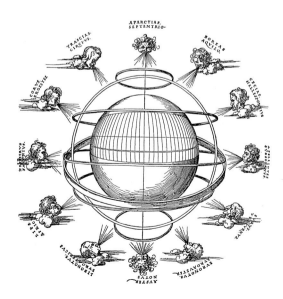

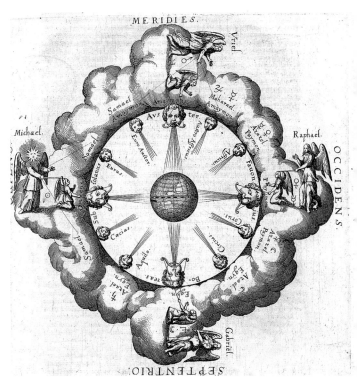

In a vision of the prophet Zechariah (6, 1–8), the four winds appear in the form of four chariots pulled by horses of various colours. There are correspondences in the elements, humours and four stages of the hermetic Work to these four directions and colours.

"The black horses pull northwards *(Earth, Melancholy, Nigredo),* the white pull westwards *(Water, Phlegm, Albedo),* the red eastwards *(Fire, Choler, Rubedo)* and the bay southwards *(Air, Sanguis, Peacock's Tail)"*.

"Four angel princes are placed above the four winds (...), Michael above the east wind, Raphael above the west wind, Gabriel above the north wind, Uriel above the south wind. (...) Likewise there are also four of the evil spirits (...) The Hebrew rabbis call them (...) Samael, Azazel, Azael and Mahazael. Among them, in turn, there rule other princes and heads of legions. Vast is the number of demons which have their own particular tasks." (Agrippa von Nettesheim, *De occulta philosophia,* 1510)

R. Fludd, Philosophia Sacra, Frankfurt, 1626

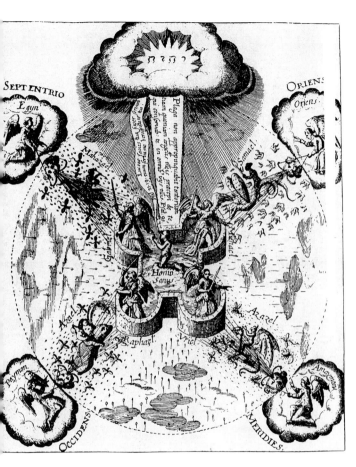

n the visions of Fludd and Böhme, influ-
enced by the Cabbala, God consists of the
two centrifugal and centripetal forces of
will and unwill, or light and darkness. From
his dark side emerge the demonic powers
which bring illness. Human beings "as
creatures of light can only be saved and
remain healthy by praying to God." The

drawing shows prayer being listened to,
and man protected by the four archangels
in the 'Fortress of Health'. They success-
fully repel the stimuli to illness, which
Fludd called 'invisible seed'.

*R. Fludd, Medicina Catholica,
Frankfurt, 1629*

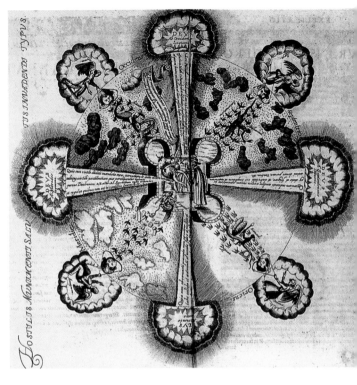

Here the "Fortress of Health" is being successfully attacked by the demonic powers, as the patient has in various ways broken the Commandments. Doctor Fludd is taking his pulse and examining his urine. These are indicators of the level of "volatile salts" in the body. These salts alone keep the life in the body in working order, for they are fluid, divine sparks of light. They are transported to man as God's messengers, and drawn from the air by the chemical action of the left ventricle of the heart. The impure parts are exhaled and excreted in the urine as sal ammoniac.

In a series of alchemical experiments with wheat, which Fludd described in his *Philosophicall Key* (*Robert Fludd and his Philosophicall Key,* Ed. A.G. Debus, New York, 1979), he tried to isolate this spiritual substance. He described a "white christalline spirit" a pure saltpetre. Böhme called it the 'celestial salitter'.

R. Fludd, Integrum Morborum Mysterium, Frankfurt, 1631

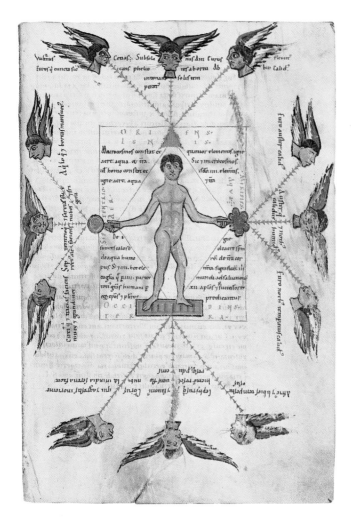

The microcosm at the intersection of the compass points, with the four main and eight subsidiary winds. The north wind on the left corresponds to the element air (sanguis), the east wind at the top corresponds to the element fire (choler), the south wind on the right corresponds to the element water (phlegm), the west wind at the bottom corresponds to the element earth (melancholia).

Astronomical manuscript, Bavaria, 12th century

Wheel

According to Johan Künigsperger, the hot and dry east winds (top) are the healthiest, while the warm and moist south winds (right) come "from warm countries / with many poisonous beasts / that poison the air". They "dull the blood in man", and are therefore to be avoided. The moist and cold west winds "bring fog and clarity/ and all three are healthy". The cold and dry north winds are also "all healthy/ and strengthen and empower".
(*Temporal des Johan Künigsperger*, Frankfurt, 1502)

Wind table, manuscript of Hradisko Benedictine monastery, 12th century

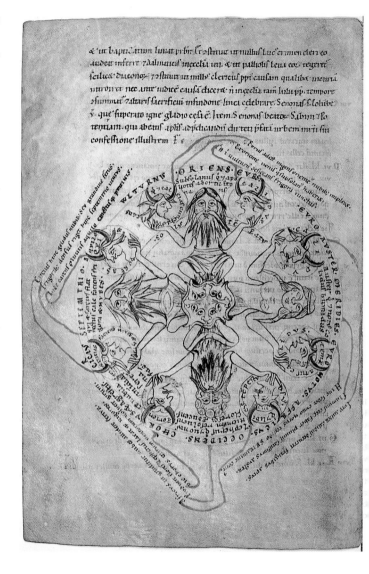

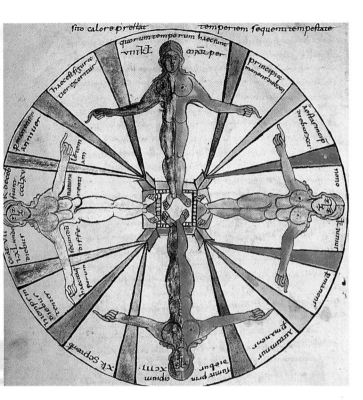

In the 6th century, Isidore of Seville collected the traditions of the ancient, natural philosophers and combined them with the teachings of the Church Fathers. The basis for his macro-microcosm diagrams were Empedocles' theory of the four elements (5th century B.C.), the Aristotelian theory of the qualities and the transferability of the elements, which forms the basis of alchemy and Hippocrates' theory of the four humours (5th century B.C.)

The four figures represent the seasons in the wheel of the twelve months. Their microcosmic equivalents are the four humours. Autumn corresponds to black gall (Melancholia – Earth), summer to yellow gall (Cholera – Fire), spring to the sanguine (Air) and winter to the phlegmatic humour (Water).

Isidore of Seville, De natura rerum, manuscript, 9th century

For Böhme the cross was the fundamental signature of all things, consisting of the two axes of the machinery at work through all three worlds. The glyph of this wheel ⊕ appears in Rosicrucian alchemy as the symbol of the arcane 'salt of the bond', which God sealed with the people of Israel, and which was renewed by the body of Christ for the whole of humanity. And, according to Böhme, it signified the heart of God, which "is like to the round ⊕, like the whole rainbow, which appears divided, for the cross is its division."

The rainbow that rose above the ebbing Flood is the most familiar Old Testament sign. Newton's optics gave it a new twist as a physical phenomenon occurring when light is broken down. Goethe and Blake called this phenomenon an illusory 'spectre'. And thus, in Blake's mythology, the appearance of the complete rainbow arising from the perfect harmony of the four elemental creatures (Zoas) and over the dark sea of time and space, heralds the triumph of the visonary over the restrictions of the physical world of phenomena.

To arrive at these four compass points of the cross-signature, Böhme had to transform the fundamental Paracelsian trinity into a quadrinity, by dividing the original sulphur into two aspects through the salnitric fire-crack emanating from it: 1. Sul: Soul, light and 2. Phur: sharp fire. In addition there are, 3. Mercurius: desire and mobility and 4. Sal: fearfulness. In Gichtel's title engraving, the four creatures or Evangelists are set out in the outermost circle of the zodiac: Taurus ♉ (Luke), Lion ♌ (Mark), Eagle: Scorpio ♏(John), man: Aquarius ♒ (Matthew).

The six planets fall within the inner circle of the Great Wheel. Only Mercury is absent, because in its mobility it embodies the wheel itself. This wheel is "the source of life and rain, and the source of the senses (…) and as the Planetary Wheel has its instanding, so too is the birth of a thing". This 'instanding' (Instehen) could be read from the signatures or lineaments of a creature, for each planet or 'source spirit' is expressed in a specific proportion in each being.

Wheel

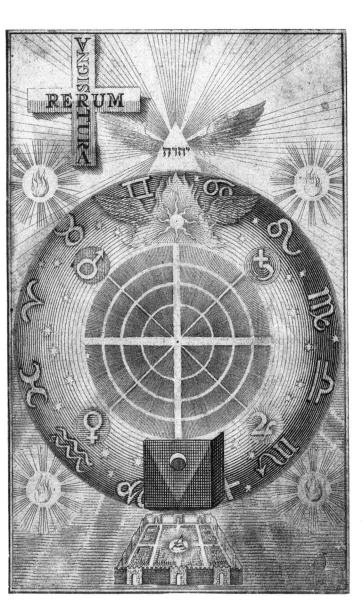

The properties of the seven planets or 'source spirits':

Saturn is contraction (sour); Jupiter: mildness in Sul; Mars: power in Phur; Venus: sweet desire; Sol: the heart-centre. In her double aspect, Luna Sophia is both earthly body and 'celestial being' (tincture). She is the bride of the Christ-Lamb, which gleams like an inner sun through the celestial Jerusalem or the spiritual form of the zodiac.

J. Böhme,
Theosophische
Wercke,
Amsterdam, 1682

Wheel

Christ as a cosmic man surrounded by the four points of the compass, the four main winds and four wind-demons.

Weltchronik, Heiligenkreuz, early 13th century

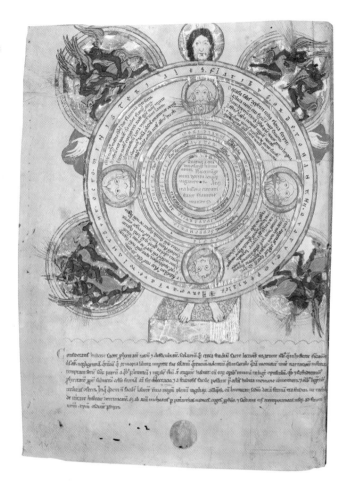

Wheel

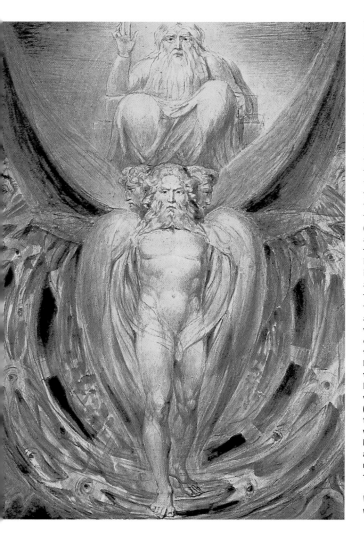

The vision of Ezekiel, who saw four figures: "And every one had four faces, and every one had four wings. (...) As for the likeness of their faces, they four had the face of a man, and the face of a lion, on the right side; and they four had the face of an ox on the left side; they four also had the face of an eagle (...) and their appearance and their work was as it were a wheel in the middle of a wheel (...) and their rings were full of eyes round about (...) And when the living creatures went, the wheels went by them (...) for the spirit of the living creatures was in the wheels (...) And above the firmament that was over their heads was (...) the appearance of a man (...)." (Ezekiel 1, 4–26)

W. Blake, Ezekiel's vision, c. 1805

Wheel

Through the circulatory transformation of the elements and humours, the opposites are united and matter passes fom its temporary, heterogeneous state into a permanent, homogeneous state.

"Because the first Adam and his descendants had their origin in the fragile elements, so the same combination must necessarily perish. But the second Adam (...) is made of pure elements, so that he remains eternal. What consists of simple and pure substance remains indestructible in eternity." (*Aurora consurgens*, early 16th century)

L. Thurneysser, Quinta essentia, 1574

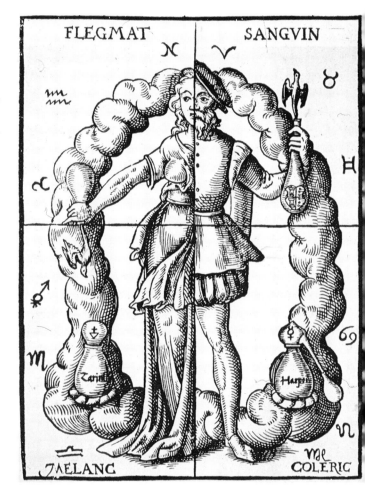

A work in the insular style of manuscript painting featuring Celtic ornamentation, whose influence spread to the continent in the 7th and 8th centuries with the foundation of Irish monasteries.

The "tetramorph" is formed from various parts of the emblematic animals of the evangelists. Joyce called it "Mamalujo": "They were the big four, the four maaster waves of Erin (..) Mat and Ma and Lu and Jo". (Finnegans Wake) They squat in pairs, and their quadrinity gradually becomes a rotating circle. Now they are "signs on the salt" (p. 393), ⊕ Celtic crosses.

Miniature in a Gospel from Trier or Echternach, c. 775

Wheel

The 'Zoas' (Blake used the Greek plural 'Zoa' as a singular) are the four "living creatures" that appear in the vision of Ezekiel and in the Revelation of John. Blake called them the "four Mighty Ones in every Man", they embody his "eternal senses", and their four faces look in the direction of all four worlds. In the west dwells *Tharmas,* the physical body. As-signed to it is the element Water, the sense of taste, painting, the world of birth (generatio) and the continent of America. In the south rules *Urizen,* reason, with the element Air, the sense of sight and architecture. Its world is dark Ulro and its continent Africa. *Luvah* in the east is passion. To it belongs fire, the sense of smell, music, the intermediate realm of imagination

nd the continent of Asia. *Los-Urthona* in he north embodies the twofold salt- spect of the imagination. Urthona is the celestial salitter", and Los its earthly epresentative (Sol, Sal or Archeus). Its lement is the earth of Paradise, its sense rgan the ear, which receives the sounds f the spheres, its art is poetry, its world is ternity and its continent Europe.

Vhen Adamic humanity, in the form of the iant Albion, had imagined itself away from the divine centre into the periphery of egoism, and began to protect its celestial companion Jerusalem from her regular bridegroom, the Christ-Lamb, Albion fell into the death-sleep of Ulro. This event, in which Luvah took over the world of Urizen in the south, brought in its wake the endless war of the Zoas. Since then the emotions have ruled reason, which in turn suppresses the imagination, the divine in man.

Gospel of Rossano, 6th century

The basic powers of man in the Indian symbol of the team of horses:

"The self (atma, the divine core of being) owns the chariot, the body is the chariot, intuitive distinction and recognition is the charioteer; the function of thought is the reins; the powers of the senses are the horses; and the objects or spheres of sensory perception are the track. Man, in whom are combined the self and the powers of the senses and of thought, is called the eater or the enjoyer."
(Katha Upanishad, 8–6th century B.C.)

The horses, shown wild and uncontrolled in the picture, are interpreted in sequence from the finest to the coarsest sensory perceptions: hearing – seeing – smelling – tasting – feeling.

Bhaktivedanta Book Trust, 1987

The Sufi-influenced teachings of the Caucasian G.I. Gurdjieff (1873–1949) were aimed at destroying man's illusory self-image, and revealing him as a being guided by mechanical reflexes. Gurdjieff distinguished four centres in man: the centre for motion, thought and feeling and that of the form-giving apparatus. These four should be correctly organized as a hierarchical team of passenger, chariot, driver and horse. On the cover for the programme of his institute, which he founded at Fontainebleau in 1922, they are shown as the four creatures in the enneagram.

Gurdjieff's most famous pupils and acolytes included the Russian mystic P.D. Ouspensky, who, with his writings on the fourth dimension, influenced suprematism, the theatre director Peter Brook, the architect Frank Lloyd Wright and the composer de Hartmann, who worked with Kandinsky.

Alexander de Salzmann, cover-design for the programme of the "Institute for the Harmonic Development of Man", Tiflis, 1919

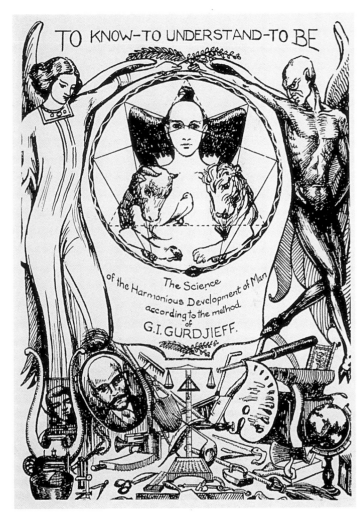

Wheel

Gurdjieff: "The enneagram is *perpetual motion* (...) The understanding of this symbol and the ability to make use of it give man very great power. It is the *perpetuum mobile* and it is also the *philosophers' stone* of the alchemists." In order to understand it, one must think of it "(...) in motion". (P.D. Ouspensky, *In Search of the Miraculous*)

Origin of the 'Primum Mobile', from: Robert Fludd, Philosophia Sacra, Frankfurt, 1626

The figure of the enneagram is formed by linking the *two* "sacred cosmic fundamental laws" of the *Triamasikamno* (Trinity) and the Heptaparaparschinoch (Sevenness). The former consists of the powers *Surp-Ortheor* (affirmation: father), *Surp-Skiros* (negation: son) and *Surp-Athanatos* (reconciliation: holy spirit).

The enneagram indicates the two points in the octave (3 and 6) at which forces must come from without so that the direction of motion is not reversed. To free the active will of man from the mechanical associations of the ordinary, Gurdjieff began to study the diagram with his pupils as a choreographic figure, assigning special motions to the individual points.

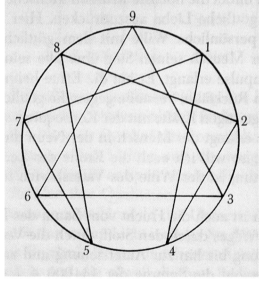

Gurdjieff: "Every complete whole, every cosmos, every organism, *every plant* is an enneagram (...) But not every one of these enneagrams has an internal triangle. The internal triangle indicates the presence of higher elements according to the table of 'hydrogens' in a particular organism."

"*Everything* can be included and read in the enneagram. A man can be quite alone in the desert and he can trace the enneagram in the sand and in it read the eternal laws of the universe" (P.D. Ouspensky, *In Search of the Miraculous*).

Joseph Beuys, Lady's cloak (Detail), 1948

According to the research of his pupil J.G. Bennett, Gurdjieff encountered the enneagram around 1900, as a dance-figure in a community of Naqshbandi dervishes in Uzbekistan. Their teaching methods and rules bear remarkable parallels with Gurdjieff's own techniques. The Naqshbandi are said to refer to the traditions of the secret association of the 'Pure Brothers of Basra', formed around A.D. 950. They developed an influential universal system in which Greek, Persian, Hebrew, Chinese and Indian traditions merged beneath the overall heading of a pseudo-Pythagorean numerical mysticism. They taught that all worlds and natural phenomena are structurally based on the number nine. Their encyclopaedic writings, which "are among the most important works in the history of chemistry (...) that have come down to us from the early Arab period" (E.O. von Lippmann, *Enstehung und Ausbreitung der Alchemie*, Berlin, 1919–1954), spread to Spain around the year 1000. Ramon Lull may have come across them in the 13th century, using them as the foundation for his 'Ars generalis' based on the number nine (cf. p. 286 ff).

R. Lull, Ars brevis, Paris, 1578

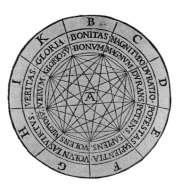

1. Combinatory figure

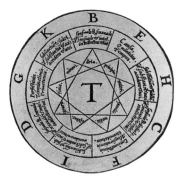

2. Combinatory figure

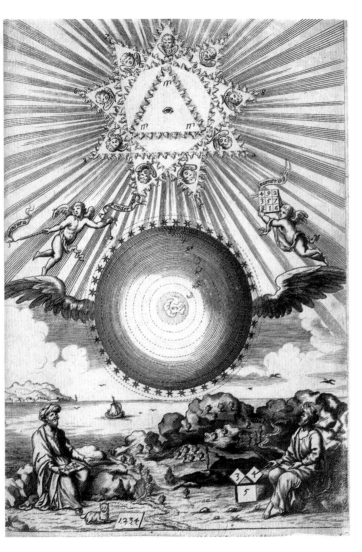

Above the worldly "Perpetuum Mobile" of the zodiac and the planets, the enneagram from Lull's second combinatory figure ascends into the super-celestial sphere. Here, it represents the 3 x 3 celestial hierarchies.

According to the teachings of the pseudo-Dionysios Arepagita, the lowest rank of angels is the "purifying order", the middle is the "illuminating order", and the topmost is the "perfecting order".

As God "descended through the 3x3 divided angelic orders to us humans, so should we rise through the same, as on Jacob's Ladder, to God". (A. Kircher, *Musurgia Universalis*)

A. Kircher, Arithmologia, Rome, 1665

Wheel

Angels set in motion the sphere of fixed stars, which in turn drives all the other spheres.

Miniature, France, 14th century

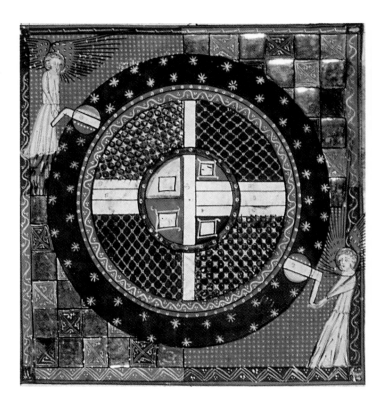

Wheel

Apart from the image of the egg, according to Hildegard von Bingen the wheel is the symbol best suited to explaining the working of the macrocosmic plan. And like the world, the godhead is entirely round like a wheel, circling in its love. The outer, fiery layer of divine anger consolidates the firmament, so that it does not flow away, the ethereal realm moves it, the region of watery air moistens it, the animal-shaped winds keep it in circulation, and the lowermost layer of air awakens the green of the earth. This is represented here as the hub of the wheel of the world, criss-crossed by the spokes of the four seasons and parts of the world.

Hildegard von Bingen, Liber Divinorum Operum, 13th century

Wheel

Blake distinguished two kinds of machinery, representing two contrasting expressions of time. Those that "revolve wheel within wheel in freedom, in harmony & peace" represent the creative time of Eden, in which all the events of the cosmic year exist permanently (at the top of the illustration). Los, the inner alchemist, forges them and must contantly rise and fall in the plan of creation, "lest a moment be lost".

The intertwined structures of Blake's poems are based on a view of the simultaneity of all events in space and time, diametrically opposed to Newton's world, simply and absolutely set in a place: "*nebeneinander*. Sounds solid: made by the mallet of Los *demiurgos*". (J. Joyce, *Ulysses*) The various levels or dimensions in which events occur in parallel are transparent and open up, often with surprising shifts of perspective, one into the other.

The second machinery (at the bottom of the illustration), the "wheel to wheel which with their teeth, under force, set each other tyrannically in motion", represents the mechanical time of the industrial revolution: "Five, six: the *Nacheinander*". (J. Joyce, *Ulysses*) It consists of a vicious circle of twenty-seven errors set before the creative present like a dulling filter. Böhme said one must "go from the illusion of historia into being", and for Paracelsus, too, time was a purely qualitative concept that cannot be broken down into measurable units. For Blake, the chief purpose of his work in the present, iron age of Mnemosyne, memory, was "to restore what the Ancients call'd the Golden Age". (A Vision of the Last Judgment)

In hermetic philosophy, eternity is to time as the centre is to the periphery, or Sun-gold to Saturn-lead. The goal of the "Opus Magnum" is the complete reversal of inside and outside, the rejuvenating return of old Chronos/Saturn to his original, paradisal state. Saturn also embodies sharpness of mind and analytical intelligence, and thus his reversal also means a transformation of thinking, for "thinking is an excrescence of what has been, it is based entirely on the past (...) No human problem can be solved by thinking, since thinking itself is the problem. The end of knowledge is the beginning of wisdom". (J. Krishnamurti, *Ideal and Reality,* Bern, 1992)

The lower snake-cycle represents the scale of the twenty-seven eternal errors, into which the transient individual imagines himself in the course of his earthly life. This cycle is divided into three large genealogical sections: the first two, from Adam to Lamech and from Noah to Terah, mark the barbaric stage of religion, with human sacrifices and punishments; the final stage, which leads back to the beginning, leads from Abraham via Moses and Constantine to Luther. It represents the discordant and militant condition of the state churches.

W. Blake, Jerusalem, 1804–1820

Wheel

Using the "mill-wheel of the seven virtues", in his "Buch der Heiligen Dreifaltigkeit", Ulmannus established the following relationships:

"*Sobrietas* moderation is Saturnus lead, *Castitas* modesty is Jupiter tin, *humilitas* humility is Mars iron, *pietas* mildness is Venus copper, *Sanctitas* holiness is Mercurius quicksilver, *caritas* charity is Luna silver, *puritas* purity is Sol gold."

On the wheel, the planet-virtues are arranged in the precise sequence of the planet-hours "as they follow one another day by day, year in year out and determine the activity of the alchemist" (W. Ganzenmüller, *Beiträge zur Geschichte der Technologie und der Alchemie,* Weinheim, 1956): Mars-Sun-Venus-Mercury-Moon-Saturn-Jupiter. Thus, every day of the week begins with the hour of the planet it is called after. Thus, for exmple, the third hour of Wednesday (Mercury) is the hour of Saturn, and it "rests in coagulation".

*Buch der Heiligen Dreifaltigkeit,
early 15th century*

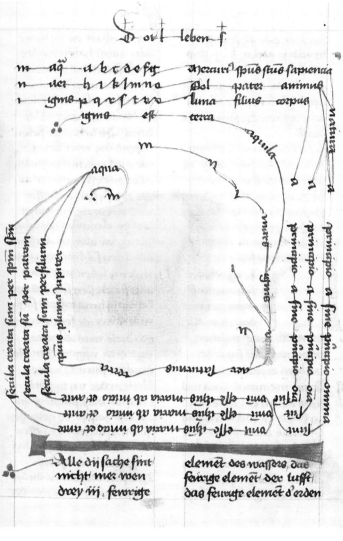
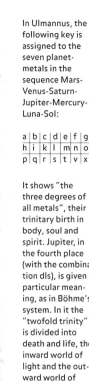

In Ulmannus, the following key is assigned to the seven planet-metals in the sequence Mars-Venus-Saturn-Jupiter-Mercury-Luna-Sol:

a	b	c	d	e	f	g
h	i	k	l	m	n	o
p	q	r	s	t	v	x

It shows "the three degrees of all metals", their trinitary birth in body, soul and spirit. Jupiter, in the fourth place (with the combination dls), is given a particular meaning, as in Böhme's system. In it the "twofold trinity" is divided into death and life, the inward world of light and the outward world of darkness. The virtue assigned to it, modesty, is the precondition for the reception of the Mercurial Christ-Lapis.

Buch der Heiligen Dreifaltigkeit, early 15th century

Wheel

"One the whole, the Point, the Center, the Circumference, and whatsoever is therein."

The wheel of the seven source-spirits, which shows the dynamic, basic structure of the process of nature, is an eternal in- and outfolding of the divine un-ground, the three-in-one, miraculous eye of eternity. From the fourth, solar source-spirit, in which the dark and light qualities part, both the flash of enlightenment and the visible four-elemental world arise.

D.A. Freher, Paradoxa Emblemata, manuscript, 18th century

One the whole, the Point, the Center, the Circumference, and whatsoever is therein.

100.

Nothing to the Unwise: To the Wise, more than enough.

"If I should de-
scribe to you the
godhead (...) in
the greatest
depth, it is thus: as
if a wheel stood
before you with
seven wheels, one
made into the
other (...) Seven
spirits of God.
They are forever
giving birth one to
another, and it is
as if when one
turned one wheel,
there were seven
wheels inside one
another, and one
aways turned dif-
ferently from the
others, and the
seven wheels were
rimmed one within
another like a
round sphere. And
the seven hubs in
the middle were
like one hub which
moved around all
over the place as it
turned, and the
wheels, forever
giving birth to the
same hubs, and
the hub forever
giving birth to the
spokes of all seven
wheels."

J. Böhme,
Theosophische
Wercke,
Amsterdam, 1682

Wheel

"It is finished when Seven are One."

"The curse of God has entered the seven figures, so they are in conflict with one another." Just as the human will was transformed "into eternal sun, calm in God", "so in the Philosophical Work must all figures be transformed into one, into Sol. From seven must come one, and yet it remains in seven, but in one desire, as every figure desires the others in love, so there is no longer any conflict". (Jacob Böhme, *De signatura rerum*)

D.A. Freher, Paradoxa Emblemata, manuscript, 18th century

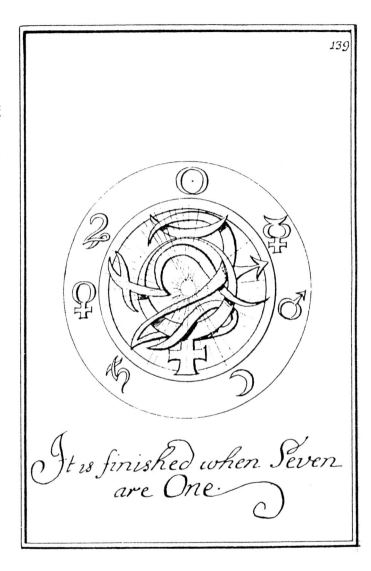

It is finished when Seven are One.

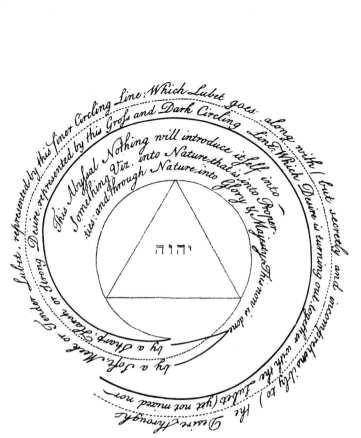

Within the circling text:

This Abyssal Nothing will introduce itself into Something Viz: into Nature: that is into Proper: ries: and through Nature into Glory & Majesty. This now is done by a Soft, Meek or Loving Flame, or by a Sharp, Stern or Fierce Flame. Desire represented by this Gross and Dark Circling Line: Which Lubet goes along with (but secretly and incomprehensibility to) the Lubet (yet not mixed nor: Desire through. Desire is turning out together with the Lubet. Which Desire) Lubet, represented by this Finer Circling Line: Which Lubet goes along with

(Hebrew in center): יהוה

"A and Ω, the eternal beginning and the eternal end, the first and last. Unground without time and space. Chaos. Mirror eye of eternity." (Freher)

The unground leads itself in a spiral into a will, and this splits into the two spheres of love and wrath.

D.A. Freher, Paradoxa Emblemata, manuscript, 18th century

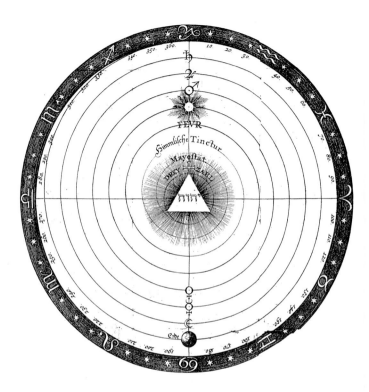

"The birth of life winds as a wheel into itself; and when it reaches the innermost point, it achieves freedom, not of God, but rather of the tincture from which life burns: for that which wishes to reach God must pass through fire; for no being reaches God unless it exists in fire, its own fire: If it were lit the world would melt. By this we do not mean the fire of the monster, which is not fire but only harsh fury." (J. Böhme)

J. Böhme, Dreyfaches Leben, 1682 edition

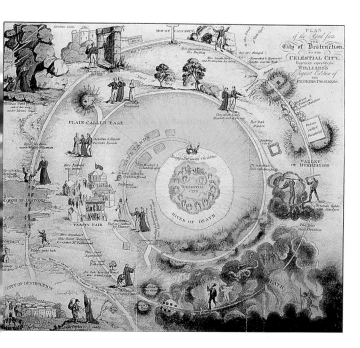

John Bunyan, a lay preacher in an English Baptist community, wrote his edifying Puritan book, *The Pilgrim's Progress,* between 1667 and 1678 while he was imprisoned for preaching without a licence. The book is one of the most widely translated works in world literature.

The spiral map of the journey shows all the stages that the *Pilgrim Christian* passes through on his journey from the *City of Destruction* to the *Celestial City of Jerusalem*. At first, he almost sinks in the *Slough of Despond*, in the *Valley of Humiliation* he must fight with the heathen *Apollyon*. At *Vanity Fair* he is mocked, and later, with his companion *Hopeful,* he meets the giant *Despair*. In the vineyards and gardens of Beulah, the *Land of Matrimony*, the two are lovingly cared for before they must leave behind their "mortal garments" to cross the *River of Death*, for only in this way can they reach their goal, the *Golden City of Jerusalem*.

From: Williams' edition of 'The Pilgrim's Progress', 19th century

Wheel

Dee likened the origin of the planets to the metamorphosis of an egg made up of the four elements, which a scarab brings along a spiral path. At the end of the rotations, the white of the moon will have disappeared beneath the yolk of the sun. The "Small Work" of the moon includes Saturn in the first rotation, and in the second Jupiter, the "Great Work" of the sun includes Mars and Venus. Mercury consists of both qualities.

John Dee, Monas Hieroglyphica, Antwerp, 1564

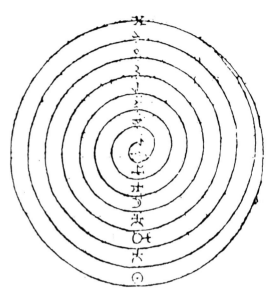

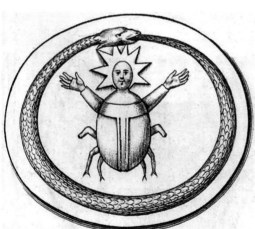

The scarab, the holy "ball-roller" of the Egyptians, embodies the self-generating T-shaped, hermaphrodite principle of Sun-Osiris and Moon-Isis. Like the lapis, it originates out of putrefied matter in the form of a rotating ball of dung. The Egyptians held this to be a symbol of the rising sun, the 'aurora'. Both, the Ouroboros and the Scarab are an expression of the 'hen to pan', the eternal transformation of the Ever Unchanging.

Johannes Macarius, Abraxas en Apistopistus, Antwerp, 1657

*A.Kircher, Oedipus
Aegyptiacus, Rome,
1652–1654*

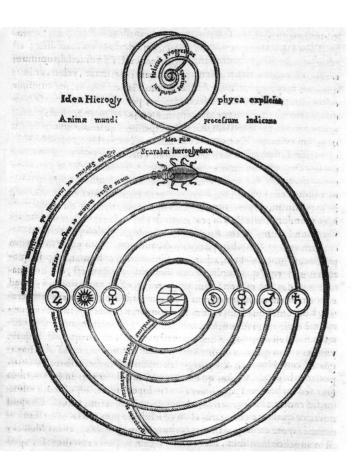

Here, Kircher built on John Dee's idea that the planetary metals arose from the spiral paths of the hermaphrodite scarab, which represented the cosmic spirit. On the left, are the planets of its solar male half, on the right, those of the lunar female half. The picture of the double helix shows a reversal of internal and external which is supposed to occur in the course of the rotations in the Work. From its inner, invisible centre in the upper spiral the cosmic spirit scarab winds further and further into the physical periphery, to return from the outermost point of the earth: "For the centre is nothing but a (…) circumference wound around a "kleuel" (…). Just as the circumference (…) is an unwound centre extended entirely. Hence Hermes says: (…) That what is below is like that which is above (…)". (Julius Sperber, *Isagoge, Deutsches Theatrum Chemicum*, Nuremberg, 1730)

Wheel

Alchemical wheel with the seven-pointed star of the chemical substances, the square of the elements and the zodiac as the outer rim. In the Gnostic text of the *Corpus Hermeticum*, the zodiac is called a dark circle of twelve vices. This "wheel of anxiety of outward nature" is, according to Böhme, based on the wheel-shaped "eternal nature of God".

M. Maier, Viatorium, Oppenheim, 1618

Ripley's wheel of "lower astronomy", contained in his famous 'Compound of Alchemy' (the twelve gates), must be rotated three times and pass three times through the matter of the alchemical zodiac, until the four elements have turned into the homogeneity of the tincture or "medicine of the third order". A start should be made in the pale west (right), where the red man is conjoined with the white woman. Purgatory in the black, midnight north (bottom) is "the perfect medium of inward change". In the white east (left), the day-bright, full moon brings the beginnings of clarity, and when the sun is at its zenith in the red south at the first rotation, "your elementa have through circulatio become water" (George Ripley, *Chymical Writings*); the second time they pass through, they are fixed, and the third time they are fermented and multiplied.

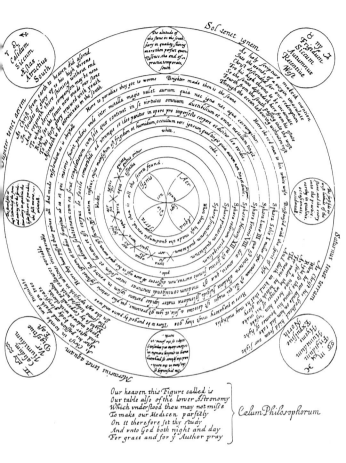

Ripley's wheel, in: Theatrum chemicum Britannicum, 1652

The innermost circle of the diagram contains the words: When thou hast made the quadrangle round, then is all the secrete found". The quadrangle consists of the four outer circles with the chymical and elemental qualities:

. reserved: cold and dry (West: Saturn, Earth)

. expelling: cold and moist (North: Mercury, Water)

3. leaching: hot and moist (East: Jupiter, Air)

4. attracting: hot and dry (South: Sun, Fire)

To these correspond the four stages of the raising of the Christ-Lapis

1. incarnation 2. passion 3. resurrection 4. ascension

Wheel

"Sol and Luna and Mars hunt with Jupiter/ Saturn must wear the yarn / If Mercury sets to the right with the wind / Venus' child is caught." This riddle describes the preparation of the universal medicine from copper vitriol, which Basil called the highest of all salts. On the outside it is green, but inside it is, from its father Mars, a fiery red, an oleous balm.

"When Venus begins to rush, many hares does she make. So, Mars, ensure with your sword that Venus does not become a whore."

The hare is a well-known symbol of mercurial volatility.

Basil Valentine, Chymical writings, Hamburg, 1717

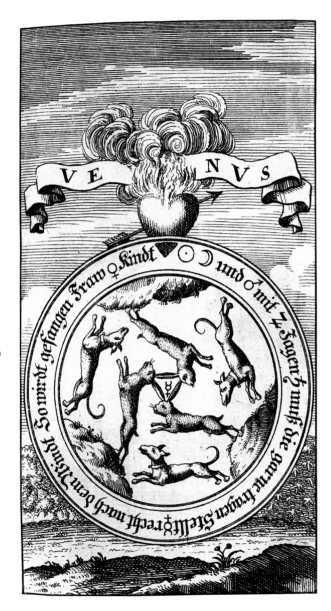

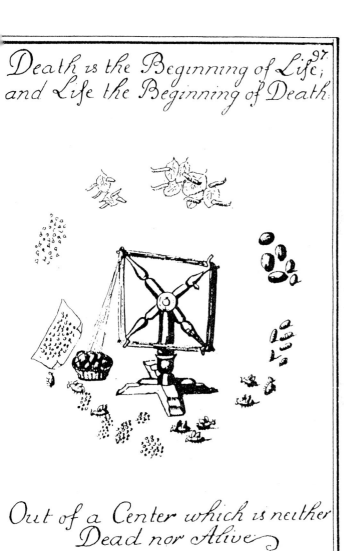

Death is the Beginning of Life, ⁹⁷
and Life the Beginning of Death

Out of a Center which is neither
Dead nor Alive

"Death is the Be-
ginning of Life,
and Life the Begin-
ning of Death: Out
of a Center which
is neither Dead nor
Alive".

"What was seed
becomes plant,
what was plant be-
comes grain, what
was grain was (...)
bread, from it am-
niotic fluid, from it
seed, from it em-
bryo, from it man,
from it corpse,
from it earth, from
it stone, and it can
become all natural
forms (...) Thus is
matter, just as the
substantial form
of the things, the
soul, is indestruct-
ible (...): aptitude
of all aptitudes,
reality of all real-
ities, life of all
lives, essence of
all essences."
(G. Bruno, *Cause,
Principle and One,*
New York edition,
1950)

*D. A. Freher, Para-
doxa Emblemata,
manuscript,
18th century*

Wheel

The ninth key of Basil Valentine describes the brightly coloured phase in the Work, called the "peacock's tail". It occurs under the rule of Venus in the sign of Libra, and shows that the matter is gradually drying. The threefold Ouroboros refers to the *tria prima* and the three large sections of the Work. The whole figure is based on the glyph ☿ of the antimonic *prima materia*.

D. Stolcius von Stolcenberg, Viridarium chymicum, Frankfurt, 1624

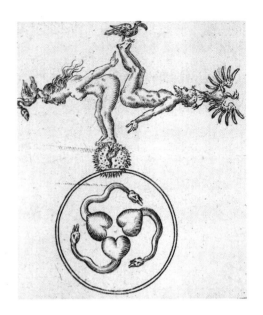

Breath and the vivifying spirit, the *pneuma* of the alchemist, set in motion the Great Work, which consists of the transformations of body, soul and spirit. "All things are brought together and all things are dissolved again (...) for nature, turned towards itself, transforms itself." (Zosimo of Panopolis, 3rd century)

Alchemistic manuscript, 17th century

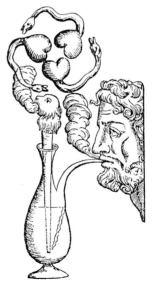

> *What Thou hast of One yield to that One again, if thou intendest to keep it.*[76]
>
> *Only by so doing canst thou be a perpetuum Mobile.*

"Give what thou hast of the One back to the One" (Thomas Vaughan alias Philalethes, Magia Adamica, London, 1650)"

"What Thou hast of One yield to that One again, if thou intendest to keep it. Only by so doing canst thou be a perpetuum Mobile."

"See only the daily play of nature, its clouds and fogs, as an airy stage formed in a moment, returning to the earth's womb. When the sun dries them up, it can absorb everything drawn up into the clouds and fallen down to it, and, like the philosophical dragon, devour its own tail."
(Thomas Vaughan, also known as Philalethes, *Magia Adamica*, London, 1650)

D.A. Freher, *Paradoxa Emblemata*, manuscript, 18th century

Wheel

This alchemical wheel with a crank is supposed to have been the mark of the Danzig monk Koffskhi.

Like Dee's Monas hieroglyph it is assembled from the various signs of the *tria prima* and the seven metals, on the basis of an inverted glyph of Mercury: "For quicksilver is a mother of all metals, and the Sun (…) it is also Sulphur."

Frater Vincentius Koffskhi, Hermetische Schriften (1478), Nuremberg edition, 1786

The rotations should be repeated "until the earth is heavenly and heaven is earthly and connected with the earth, then the Work is completed." (D. Mylius, *Philosophia reformata,* Frankfurt, 1622)

Marcel Duchamp, Rotorreliefs, 1935

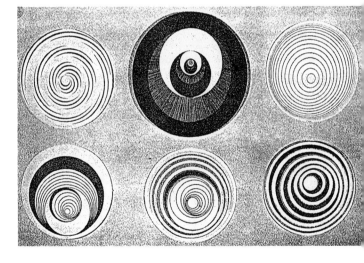

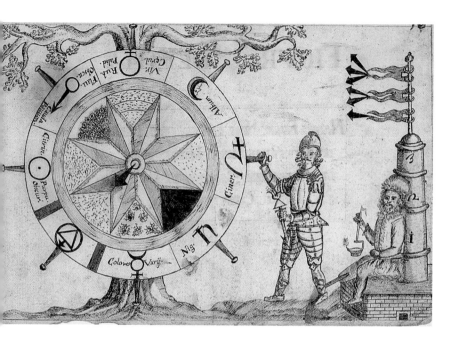

...ere Cadmus, the serpent-slayer who em-
...odies the fixative properties of sulphur,
...s giving the philosophical colour-wheel its
...irst rotation. Vulcan watches him attenti-
...ely from his threefold oven, for "the
...olours will teach you to rule fire" (Hein-
...ch Keil, *Philosophisches Handbüchlein,*
...eipzig, 1736). The mercurial source mat-
...er is shown as a chameleon with changing
...olours, the first phase of Saturn is black,
...upiter: ash-grey, the Moon: white,
...'enus, changes from bluish green to a
...ale red, Mars from reddish yellow to the
...right colours of the peacock's tail, and
...he sun tends from pale yellow towards
...he deep purple of the red dawn. "The

Circulatio of the Elements is effected by
two kinds of wheel; a large and extended
wheel, and a small or constricted wheel.
The extended wheel fixes all the elements
(through the sulphur) (...) The rotation of
the small wheel is concluded with the ex-
traction and preparation of every element.
But in this wheel there are three circles
which always drive the materials with
unceasing and involved movements and
in different ways (...) seven times at least."
(*Chymisches Lustgärtlein,* Ludwigsburg,
1744)

Speculum veritatis, 17th century

*D. Molinier,
Alchemie de
Flamel, 1772/73*

The idea of the colour-circle develops out of the figure of the
Ouroboros, constructed in the emblems of Nicolas Flamel from the
two self-consuming dragons of light and darkness. The former
symbolizes the dry, sulphurous principle; the latter he called the
"volatile black woman", mercurial moisture.

According to Flamel's theory, the sequence of colours in the
Work arises out of the different levels of moisture in the matter. The
deep black of cold wetness is followed by dark blue, light blue and
yellow, in which the two extremes are in balance. After this comes
the brightly coloured phase which ends in dry and hot, white-yellow.
Through calcination this passes first to a yellow-red, and finally to
the purple of the red lion, which rises above the zodiac or the colour-
circle.

"But they *(the alchemists)* drew no conclusions from all these
observations, and the theory of chemical colours was not extended
by it, as could and should have been the case", wrote Goethe in his
History of Colour Theory.

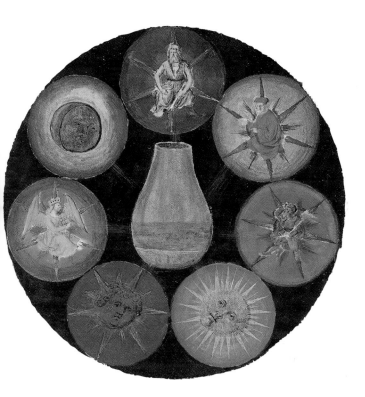

"(...) the red of dawn is at the middle between day and night, which shines with two colours, namely red and citrin *(yellow)*. Likewise, this art produces Citrine and Red Colour, the two in the middle are black and white." The red of dawn is "the end of the night, and a beginning of the day, and a mother of the sun. So the dawn at its greatest redness is an end of the whole darkness, and a banishment of night (...)".

(Aurora consurgens) Purple is the indestructible sulphur, the fire of the lapis. In Goethe's colour theory, purple is the supreme intensification of all colours, and "no one who knows the prismatic origin of purple will think it paradoxical if we claim that this colour (...) contains all other colours".

Aurora consurgens, early 16th century

The basis of the alchemical colour concepts on which Kircher, Goethe and Steiner built, is the Gnostic idea of the "brightly coloured texture of the world", from the dawning of the divine light in the darkness of the lower waters. According to Basilides, a 2nd-century Alexandrian Gnostic, darkness once wished to mix with light, but light restricted itself to pure looking "as through a mirror. A reflection, then, that is a breath (color!) of light only, reached the darkness". (Werner Foerster, *Die Gnosis: Zeugnisse der Kirchenväter,* Zurich edition, 1995) Basilides likened the seed of the world to a peacock's egg laid in the sublunary sphere into the sevenness of the colours.

Paracelsus held Sulphur, the mediator between body and spirit, to be the origin of the colours "probably because he was struck by the effect of acids on colour and colour phenomena, and acid is present to a high degree in common sulphur". (Goethe, *History of Colour Theory*) And of course salt also plays an important sole, having been considered "coagulated light", and the "ground of all physicality". According to Paracelsus, the salt of fire gave rise to the colours of the rainbow. "(…) and as you see a fire flaming up *(in individual colours)* when a salt is cast therein (…) the rainbow shares its colours (…) which it has taken from the power of the salt-spirit that lies in the element of Fire". (Paracelsus, *De natura rerum,* 1526)

Colour wheel after R. Fludd, Medicina Catholica, Frankfurt, 1629

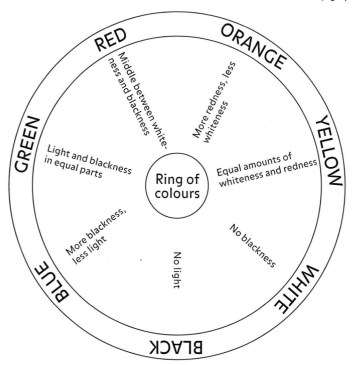

RED
ORANGE
Middle between whiteness and blackness
More redness, less whiteness
GREEN
YELLOW
Light and blackness in equal parts
Equal amounts of whiteness and redness
Ring of colours
More blackness, less light
No blackness
BLUE
No light
WHITE
BLACK

The creation of colours from the two polar principles of sulphur and mercury, sun and moon, fire and water, light and darkness.

Initium sapientiae est timor domini, manuscript, 17th century

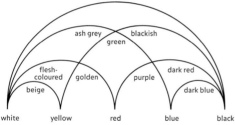

the analogy between things and colours

white	yellow	red	blue	black
pure light	toned light	coloured light	shadow	darkness
sweet	medium sweet	bitter sweet	sour	bitter
fire	air/ether	atmosphere	water	earth
God	angel	man	animal	plant

In Kircher's *Ars magna lucis et umbrae,* according to Goethe, "it is clearly and thoroughly demonstrated for the first time that light, shade and colour are to be understood as the elements of seeing; even if the colours are represented as the monstrous births of the first two". (*Colour Theory,* 1810)

His own colour theory had been kindled by the experiments of Newton, who had arrived at the conclusion that all colours are already potentially present in light, while for Kircher and Goethe they arose out of the mixture of light and darkness. For both of them, the phenomena of optics and colour theory were the expression of a universal bipolarity "like that handed down to us in the theory of magnetism, electricity and chemistry". (*Colour Theory,* 1810)

A. Kircher, Ars magna lucis et umbrae, 1646

In the beginning Newton's God "created matter in massive, solid, hard, impenetrable and moving particles (...) so that nature would be of constant duration." (Isaac Newton, *Principia Mathematica,* 1686–1887).

Even light, which was seen as the supreme manifestation of the divine in nature, consisted, in Newton's view, of a stream of these hard little spheres (globuli) and like the heavenly bodies these were also subject to the general law of gravity, which he had developed around 1680. He was inspired to do this by the first three natural qualities in Jacob Böhme's system: Newton's *centripetal force* corresponds to the first attracting source-spirit of Böhme, the "contracting astringency", *centrifugal force* corresponds to "extending bitterness", and the *rotation* that arises from the

conflict between attraction and repulsion is "anxiety" or the "birth-wheel of nature", the third source-spirit. And just as, in Newton's colour theory, white light, hitherto considered elemental, was now seen as composed from the seven colours of the spectrum, in the work of Böhme, too, light is seen as being born from all seven source-spirits at once.

But Goethe, too, who was suspicious of Newton because of the 'mystical' number seven, was able to find much that he needed in Böhme's rich trove of visionary, natural mystical concepts, concerning both the 'sensual and moral effect of colours' and its origins from the polarities. For Böhme, white is the only colour that lies not in the 'mystery of nature', but in the deity. It is "the son of God" who "shines into the sea of nature" (Jacob Böhme, *Aurora*), and black is the cabbalistic En-Soph, the divine non-being underlying the diversity of all phenomena.

"Many things can be schematized in the triangle, as can the colour phenomena, in such a way that through doubling and limitation one arrives at the old, mysterious hexagon." (Goethe, *Colour Theory,* 1810)

From: P. O. Runge, Posthumous writings, 1810

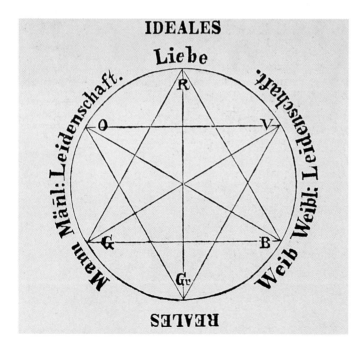

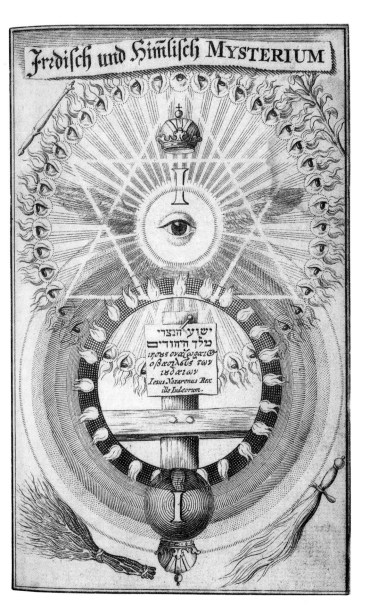

Jrdisch und Himlisch MYSTERIUM

"We recognize the essence of the Holy Trinity in the light of eternity for the deity *(top)*, and in the fire for eternal nature *(bottom)*." The celestial majesty of the divine son stands in the head of the lower natural world in the image of the tortured Jesus as the mocked king of the Jews. From the 'Centrum Naturae', the salnitric crossground, there emerges in various degrees of the mixture of fire and water the mystery of colours.
1. Blue: entity
2. Red: father in the brilliance of fire
3. Green: life
4. Yellow; son
5. White: brilliance of God's majesty as a quintessence.

J. Böhme,
Theosophische
Wercke,
Amsterdam, 1682

Wheel

Influenced by Jacob Böhme's writings, which the writer Ludwig Tieck had recommended to him in 1801, P.O. Runge began to develop his own mystical colour theory, which he applied in all his painting. He assigned the three basic colours to the divine trinity: blue – God the father, red – son and yellow – holy spirit.

The source of the three-dimensional arrangement of the colours on the sphere lay in the main colours being complemented by the two poles of light and darkness to form the quinticity of the pure elements.

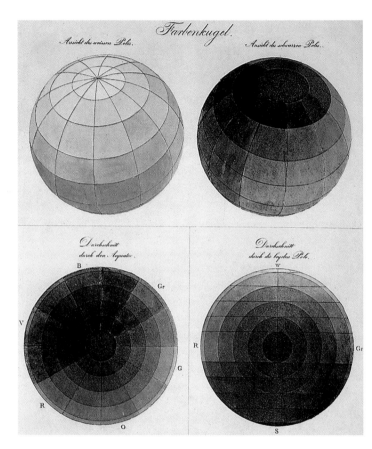

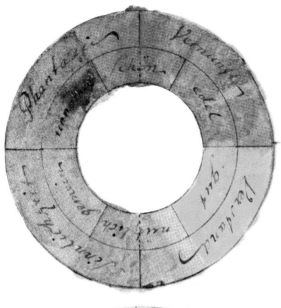

Goethe tried to connect the qualities of colours as experienced by the senses with ethical categories. Here he assigns the four spiritual capacities of man to the six colours of his circle: to the plus or day-side of the warm colours he attributes reason and intelligence, to the minus or night-side of the cold colours sensuality and imagination.

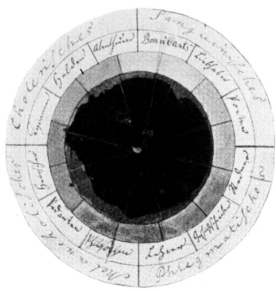

On this "rose of the humours", a collaboration between Goethe and Schiller in 1799, the four humours of man are assigned to Goethe's colour circle.

"The cross stands wound densely round with roses./ Who has put roses on the cross?/ (...) And from the middle springs a holy life/ Of threefold rays from a single point (...)." (Goethe, *Die Geheimnisse,* 1784–1786)

In alchemy, the white and the red rose are well-known symbols for the lunar and the solar tincture, from which the "precious rose-coloured blood" of Christ-Lapis flows. And the Shehina, the brilliance of celestial wisdom on earth, is understood in the image of the rose, and "the collec-tion of honey" stands for the common inheritance of theosophical knowledge. "Thus the whole parable of the Song of Solomon finally refers to the object of our rose-cross (...): 'I am the rose of Sharon and the lily of the field'". As regards "the correct procedure for attaining the rose-red blood of the cross that is poured *(as quintessence)* in the centre of the cross", Fludd used the image of wisdom: the work of the architect as a labourer of God on the building of the temple

R.Fludd, Summum Bonum, Frankfurt, 1629

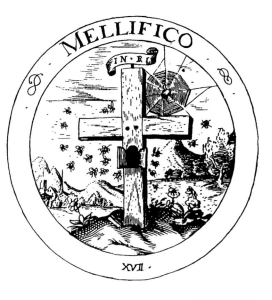

I make honey

The death of the cross was accursed
In the view of God
Now it is entirely lovely
Through the judgement of Christ's death.

Daniel Cramer, Emblemata Sacra, 1617

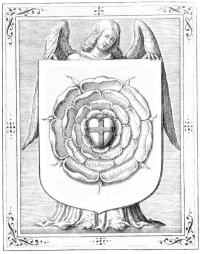

The name and emblem of the Rosicrucian brotherhood refer to Martin Luther's coat of arms. The "General Reformation" that it had proclaimed at the beginning of the 17th century was a revival of Protestantism – which had sunk into orthodoxy – through the spirit of Paracelsian nature mysticism. One declared goal was the struggle against the "tyranny of the Pope", which a few years previously had burned Giordano Bruno at the stake.

Van der Heyden, detail, from: Sigillum Lutheri, Strasbourg, 1617

Pilgrim

**The traveller
hastens at evening**

"Thro' evening
shades I haste
away to close the
Labours of my
day."

*W. Blake, The Gates
of Paradise, 1793*

How sweet I roamed from field to field,
And tasted all the summer's pride,
Till I the prince of love beheld
Who in the sunny beams did glide.

He showed me lilies for my hair,
And blushing roses for my brow;
He led me through his gardens fair,
Where all his golden pleasures grow.

With sweet May-dews my wings were wet,
And Phoebus fired my vocal rage;
He caught me in his silken net,
And shut me in his golden cage.

(William Blake, 1769–78)

W. Blake, Songs of Innocence and of Experience, 1789–1825

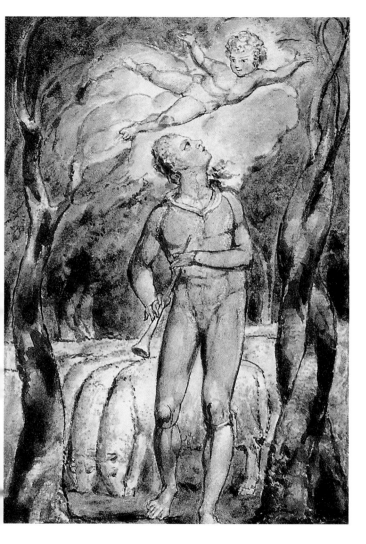

Pilgrim

The evening before Easter an angel gives the legendary founder of the Rosicrucian order, Christian Rosencreutz, an invitation to the mystical wedding of bride and bridegroom. With a blood-red sash hung across his white apron, and with four red roses on his hat, he sets off the following day.

In Andreae's uninspired and overloaded Baroque allegory the alchemical symbolism appears only as a rather tired backdrop. In our own time, Rudolf Steiner and the modern Rosicrucian associations have subjected the Work to a number of thorough and serious interpretations.

Johann Valentin Andreä, Die Alchemische Hochzeit von Christian Rosenkreuz (1616), Ed. J. van Rijckenborgh, 1967

"Are we not all, here below, on a pilgrimage to the land where our saviour Christ has gone before us? (…) Great Phoebus himself, the God of the Sun, travels across the broad sky day after day. The heart of man beats and pulses in his breast from the first hour of life to the last (…) The trader crosses land and water to buy produce from the most far-off lands; but more worthy goods by far are knowledge and science. They are the goods of the spirit. (…) For all these reasons I had the idea that it would be both interesting, pleasant, worthy and also extraordinarily profitable for me to follow the example of the whole world and undertake a pilgrimage with the goal of discovering that wonderful bird the Phoenix *(Lapis)*." (Michael Maier, "Secreta Chymiae, Die Geheimnisse der Alchemie", in: *Musaeum Hermeticum*, Frankfurt, 1678)

Salomon Trismosin, Aureum vellus,
Hamburg, 1708

Pilgrim

Pilgrim's dream: "I dreamed, and behold, I saw a man clothed with rags, standing in a certain place, with his face turned away from his own house, a book in his hand, and a great burden upon his back." A man called Evangelist meets him and advises him to flee "the wrath to come". "Do you see yonder narrow gate?" The man said, "No". (...) "Do you see yonder shining light? (...) Keep that light in your eye, and go up directly thereto: so shalt thou see the gate; at which, when thou knockest, it shall be told thee what thou shalt do". (John Bunyan, *The Pilgrim's Progress*, 1678)

W. Blake, Illustration to Pilgrim's Progress, 1824–1827

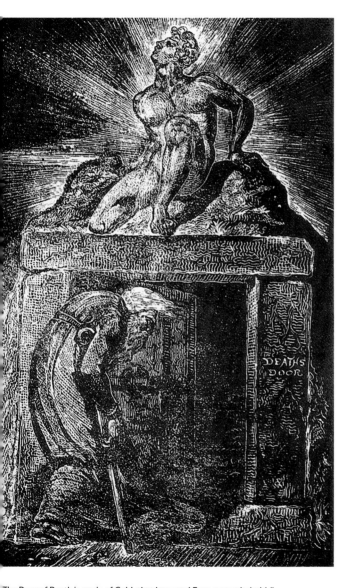

Blake developed a special process of relief etching, transferring his drawings and texts to the copper plates with an acidic fluid and corroding away the spaces with nitric acid. This process enabled him, as in this illustration, to combine black-lined contours with white-lined hatching. (Discussed in greater detail in: D.W. Dörrbecker, *Konvention und Innovation*, Berlin, 1992). This reversal of gravure into relief printing is constantly reflected in his poetry: the gaps are the "temporary individual states" that disappear in the purging fires of the Last Judgment. What remains are the "eternal lineaments", the "signatures of all things".

W. Blake, Death´s Door, c. 1806/07

The Door of Death is made of Gold, that Immortal Eyes cannot behold."

Pilgrim

In Amos Comenius' 1631 "Labyrinth of the World" the Saviour appears in person to the pilgrim at the end of his wanderings: "I saw you when you wandered; but, my dear son, I wanted no longer to wait for you; so I brought you to yourself and into your own heart." So that he may now see the world from the correct perspective, he is given a new pair of spectacles. "Its frame was the word of God, the glass was the Holy Spirit."

D.A. Freher, Paradoxa Emblemata, manuscript, 18th century

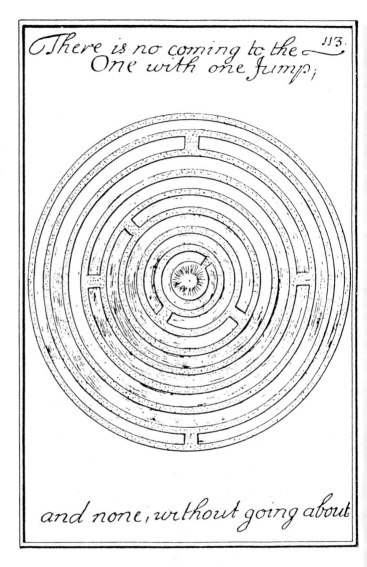

There is no coming to the — 113. One with one jump;

and none, without going about

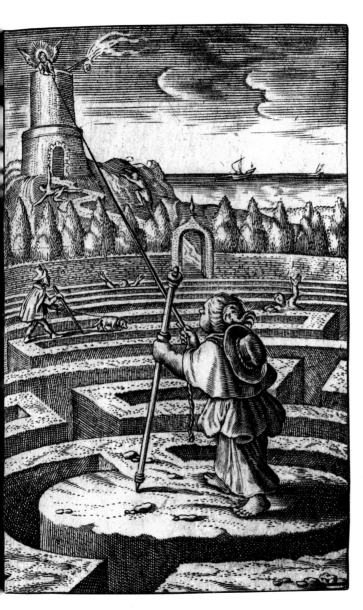

The soul of the Christian pilgrim is guided by the word of God:

"O that my paths may be guided/ to keep Thy laws (Psalm 118, 5)/ In the tangled maze/ With all its twists and turns/ I walk and will without fear await/ The help promised by Thy Word./ From far away I see that here and there some will fall/ Who are otherwise cautious enough and probably the boldest:/ I go blindly onwards and my arts are all in my devotion to Thee my friend!/ (...) This life is a maze;/ That the journey may be safe/ Thou must without guile wait in blind faith for God/ In pure love without artifice."

Hermann Hugo, Gottselige Begierde, Augsburg, 1622

Pilgrim

St James was the patron saint of physicians and alchemists. According to the 'Legenda aurea', in Spain he defeated "Hermogenes" or "Hermes Trismegistus" and was therefore in charge of his secret knowledge.

The route to his grave in Santiago de Compostela was seen as the earthly projection of the Milky Way, "the road to St Iago", the symbol of the Mercurial Work. "Narrow and slippery is the way," as one German hymn to St. James from 1553 has it, "surrounded by water and fire". But the Hermetic pilgrims were not only in search of religious edification; they were also eager to encounter Jewish and Arab secret knowledge that began to spread into Christian Europe from Spain in the 12th century.

Stephan Praun's pilgrim's costume, 1571

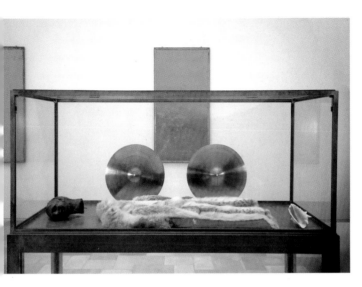

"In secret symbolism, the 'Compostela scallop' *(coquille St. Jacques)* (…) represents the principle of Mercury, which is still called the 'traveller' or the 'pilgrim'. In the mystical sense it is worn by all those (…) who try to obtain the star *(Lat. compos: possessing, stella: star)*."

In order to decipher his mysterious bark codex in the early 15th century, Nicolas Flamel called upon the support of St James and set off for Santiago. "That is the point at which all alchemists must begin. With their pilgrim's staff as a guide and the scallop as a sign, they must undertake this long and dangerous journey, half on water, half on land. First as pilgrims, then as pilots." (Fulcanelli/Canseliet, *Le Mystère des Cathédrales,* Paris, 1925, 1964 edition)

Joseph Beuys, Palazzo Regale, 1985

Pilgrim

"Let us leave theories there and return to here's hear." (J. Joyce, *Finnegans Wake*)

Marcel Duchamp, Door as a substitute for two doors, Paris, 1927

Index

Bibliography

Select bibliography of the Hermetic art of illustration

Blake, William: *Illuminated Books,* Vol. I–VI, annotated facsimile series, Tate Gallery and William Blake Trust, London 1991–1995.

Erdman, David V.: *The Illuminated Blake. All of William Blake's complete illuminated works with a plate-by-plate commentary,* Garden City, New York 1974.

Freimaurer, Eigenverlag der Museen der Stadt Wien, 1993.

Godwin, Jocelyn: *Athanasius Kircher. Ein Mann der Renaissance und die Suche nach verlorenem Wissen,* Berlin 1994

Godwin, Jocelyn: *Robert Fludd. Hermetic Philosopher and Surveyor of Two Worlds,* London 1979.

Klossowski de Rola, Stanislas: *Alchemy. The Secret Art,* London 1973.

Klossowski de Rola, Stanislas: *The Golden Game. Alchemical Engravings of the Seventeenth Century,* London 1988.

Van Lennep, Jacques: *Alchimia,* Brussels 1985.

Lindner, Erich J.: *Die Königliche Kunst im Bild. Beiträge zur Ikonographie der Freimaurerei,* Graz 1976.

W.K. MacNulty: *Freemasonry,* London 1991.

Acknowledgments:

I should particularly like to thank the Institut für Untersuchungen von Grenz-zuständen ästhetischer Systeme in Bamberg (INFuG), James Gecelli, Uta Gerlach, Heiner Roob, Tim Sann, Wolfgang Schibel and Oliver Siebeck.

About the author:

Alexander Roob (b. 1956 in Laumersheim, Germany) studied painting at the Hochschule der Künste, Berlin. Since 1985 he has been working on the continuing novel in pictures "CS", which has been published in five parts so far, and which con-sists of several thousand drawings in A4 format. In exhibitions, these are assembled into volumes that branch out like wires in an electrical circuit.

For some years Alexander Roob has been translating the later poetic work of William Blake, and for this reason began to assemble an extensive archive of pictures and texts.

Illustration sources:

Arlington Court, The National Trust, Devon: p. 433; Patrick Arnal, Paris: p. 382; Badische Landes-
bibliothek, Karlsruhe: p. 186, 204, 261, 290, 350 top, 358 bottom, 411, 412 top, 506; Bayerische
Staatsbibliothek, Munich: p. 84, 208, 321, 462, 479, 514, 520, 524; Berlinische Galerie, Museum
für Moderne Kunst, Photographie und Architektur, Berlin: p. 236; Biblioteca Apostolica Vaticana,
Rome: p. 77, 474, 475, 496, 546, 681; Biblioteca Arciepiscopale, Rossano: p. 653; Biblioteca
Estense, Modena: p. 232, 233; Biblioteca Medicea-Laurenziana, Florence: p. 307; Biblioteca
Nationale Marciana, Venice: p. 422; Biblioteca Nazionale, Florence: p. 297, 305, 539 top; Biblio-
thèque de l'Arsenal, Paris: p. 200, 375, 442–447, 464; Bibliothèque Municipale, Laon: p. 645;
Bibliothèque Nationale, Paris: p. 42, 43, 63, 406, 566; British Museum, London: p. 174, 182 top,
586 top, 632; Collection Mrs William T. Tonner: p. 437; Deutsches Freimaurer-Museum, Bayreuth:
p. 348; Deutsches Museum, Munich: p. 685 top; Diözesan- und Dombibliothek Cologne: p. 44,
639; Domschatz Trier: p. 651; Duke of Sutherland Collection, on loan to the National Gallery of
Scotland, Edinburgh: p. 511; Frick Collection, New York: p. 696; Galerie Karl Flinker: p. 605; Galle-
ria dell'Accademia, Venice: p. 509; Germanisches Nationalmuseum, Mainz (photographs: Achim
Zschau): p. 33; Friedrich Gottschalk, Vienna (photograph: Heinz Walka): p. 347; Gutenberg
Museum, Mainz (photographs: Arno Garrels, Berlin): p. 568, 570, 573 bottom; H.M. Treasury, The
National Trust, Petworth House, Sussex: p. 163; Hamburger Kunsthalle, Elke Walford Fotowerk-
statt, Hamburg: p. 241; Fyr Helge Dahlstedt, Lindingö: p. 606 bottom; Herzon August Bibliothek,
Wolfenbüttel: p. 76, 691 bottom; Images Colour Library, London: p. 255; Jewish National Univer-
sity Library: p. 100, 311; C.G. Jung Institut, Küsnacht: p. 414, 415; Kantonsbibliothek (Vadiana),
St. Gallen: p. 367, 452–454, 456, 515; Kröner Verlag, Stuttgart: p. 39; Kunsthistorisches Museum,
Vienna: p. 609 top; Ravi Kumar, New Delhi: p. 99, 272, 280, 547; Walter Klein, Düsseldorf: p. 701;
Library of Congress, Lessing J. Rosenwald Collection, Washington: p. 192; Library of Congress,
Washington: p. 338, 429, 642; Library and Museum of the United Grand Lodge of England, Lon-
don: p. 26; Erich Marx: p. 657; Mary Evans Picture Library, London: p. 621; Musèe Guimet, Paris:
p. 337, 469; Musèe Marmottan, Paris: p. 504; Museo Catedralicio, Burgos de Osma: p. 541; Museo
del Pardo, Madrid: p. 125, 195, 497 bottom; Museum Grootoosten, The Hague: p. 349; Museum
of Fine Arts, Boston: p. 649; Österreichische Nationalbibliothek: p. 81, 92, 631, 643, 644, 648;
Philadelphia Museum of Art, Louise and Walter Arensberg Collection, Philadelphia (PA): p. 157
bottom; Bibliothèque municipale de Boulogne-sur-Mer/Lauros – Giraudon, Paris: p. 85; The
Pierpont Morgan Library, New York: p. 551, 626; Ramat Aviv, William Gross Collection: p. 316;
Rheinisches Bildarchiv, Cologne: p. 65 bottom; Rijksuniversiteitsbibliothek, Leyden: p. 194; Lucile
Rosenbloom Collection: p. 697; Ajit Mookerjee Collection, New Delhi: p. 407; Collection of
St Catherine's Monastery, Sinai: p. 291; Scala Istituto Fotografico, Antella (Florence)/ Biblioteca
Lucca: p. 545, 661; Schiller-Nationalmuseum, Deutsches Literaturarchiv, Marbach: p. 604; Staat-
liche Museen zu Berlin – Preussischer Kulturbesitz – Kupferstichkabinett, Berlin: p. 203, 463, 507,
517, 664, 665; Staatsbibliothek zu Berlin – Preussischer Kulturbesitz – Handschriftenabteilung:
p. 155 bottom, 160 top, 180 bottom, 206, 210, 333, 353, 363, 369 top, 371, 396, 397, 473, 492, 508,
658, 683; Stadtbibliothek Mainz (photographs: Arno Garrels, Berlin): p. 52, 54–57, 60, 61, 71, 72,
78, 79, 88, 91, 93, 95, 98 top, 101 bottom, 104–112, 116, 117, 158, 180 top, 188, 191 bottom, 193, 214
top, 215, 224 top, 256, 257, 262, 263. 269–272, 273, 282, 288, 289, 317, 330 bottom, 336 bottom,
340, 342 top, 351, 357, 360, 364 bottom, 365 bottom, 366 top, 394, 421, 467 bottom, 468 bottom,
490, 500, 501, 565, 572 bottom, 573 top, 576, 589, 598 bottom, 602, 616, 617, 639 top, 640, 656
top, 659, 674; Stiftung Weimarer Klassik, Weimar: p. 689, 691 top; Strindberg Museum, Stock-
holm: p. 606 top, 607 top; Tate Gallery, London: p. 2, 176, 259, 553, 577, 633 top, 693; The Bhak-
tivedanta Book Trust: p. 432, 654; The British Library, London: p. 147–153, 181, 198, 199, 211, 212,
234, 246, 309, 341, 393, 395, 405, 448, 495, 555–557, 588, 660; The Warburg Institute, London: p.
352; The William Blake Trust, London: p. 69, 119, 201, 202, 213, 229–231, 461, 482, 489, 523, 531,
652, 663; Prague Unversity: p. 339; Universitätsbibliothek Heidelberg: p. 16, 24, 47 top, 65 top,
68, 70, 73 bottom, 83, 89, 94, 113, 121, 127–145, 183, 190 top, 205, 216–220, 228, 237, 240, 243–249,
252 top, 342 bottom, 343, 354, 355, 368, 369 bottom, 399–402, 404, 423, 425 bottom, 428, 430,
431, 468 top, 491, 497 top, 516, 521, 522, 527, 528 top, 532, 534–537, 539 bottom, 540, 544, 549,
554, 584, 586 bottom, 587, 591–595, 597 bottom, 598 bottom right, 600, 601, 610, 627 top, 633
bottom, 636 bottom, 647, 667, 676, 680 top, 685 bottom, 687, 695, 699; Unversitätsbibliothek
Mannheim (photographs: Arno Garrels, Berlin): p. 49–51, 53, 64, 66 bottom, 87, 178, 179, 189, 191
bottom, 197, 224 bottom, 225–227, 242 bottom, 265 bottom, 359 bottom, 361, 366 bottom, 370,
398, 409 top, 424, 435 bottom, 458, 459, 467 top, 480, 484, 487, 513, 543, 562 top, 574, 575 bot-
tom, 580, 584 top, 585, 618–620, 673, 678 top; By courtesy of the Board of Trustees of the Victo-
ria and Albert Museum, London: p. 164; Zentralbibliothek Zurich, Ms. Rh. 172: p. 80, 187, 207, 239,
350 bottom, 362, 439, 569

All illustrations not listed here come from the author's archive. Despite intensive research, the
copyright could not be established in all cases. We would welcome any further information.